ISBN 978-1-330-83577-7
PIBN 10111755

1 MONTH OF FREE READING

at

www.ForgottenBooks.com

By purchasing this book you are eligible for one month membership to ForgottenBooks.com, giving you unlimited access to our entire collection of over 700,000 titles via our web site and mobile apps.

To claim your free month visit:

www.forgottenbooks.com/free111755

English
Français
Deutsche
Italiano
Español
Português

www.forgottenbooks.com

Mythology Photography **Fiction**
Fishing Christianity **Art** Cooking
Essays Buddhism Freemasonry
Medicine **Biology** Music **Ancient**
Egypt Evolution Carpentry Physics
Dance Geology **Mathematics** Fitness
Shakespeare **Folklore** Yoga Marketing
Confidence Immortality Biographies
Poetry **Psychology** Witchcraft
Electronics Chemistry History **Law**
Accounting **Philosophy** Anthropology
Alchemy Drama Quantum Mechanics
Atheism Sexual Health **Ancient History**
Entrepreneurship Languages Sport
Paleontology Needlework Islam
Metaphysics Investment Archaeology
Parenting Statistics Criminology
Motivational

JOURNAL

OF A

LANDSCAPE PAINTER IN CORSICA.

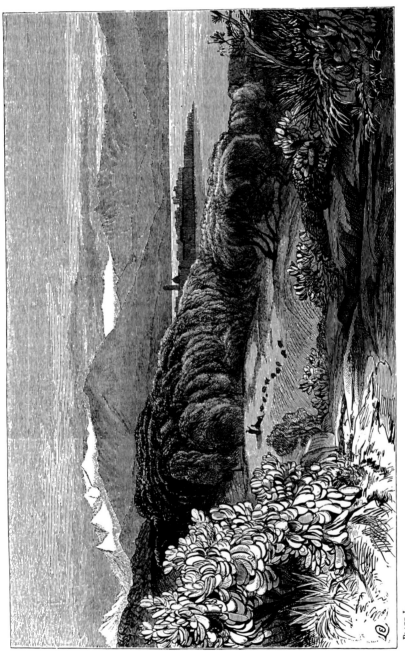

AJACCIO.

PLATE I.

JOURNAL

LANDSCAPE PAINTER

IN

CORSICA.

BY EDWARD LEAR.

" So, then, you were ... to come and see Corsica? You h ... done ...
... for in ... e, few years, than... to the h ind of progress and civilisat...n, they wh...
Corsica will not find it."—*The Corsican Brothers*, a Dramatic Romance.

"If the diurnal record of the traveller be not always the form of natural
it is, or ought to be, more faithful than any other, and consequently more
countries described, especially when those countries have been little expl *It w*
Greece, COL. LEAKE, Vol. I.

LONDON

ROBERT JOHN BUSH, 32, CHAR ...

1870.

[*The Right of Translat* ...

AJACCIO.

PLATE I.

JOURNAL

OF A

LANDSCAPE PAINTER

IN

CORSICA.

BY EDWARD LEAR.

"No apology shall be made for presenting the world with an account of Corsica."
An Account of Corsica, JAMES BOSWELL, 1768.

"So, then, you were determined to come and see Corsica? You have done rightly to hasten your visit, for in a very few years, thanks to the hand of progress and civilisation, they who come to seek for Corsica will not find it."—*The Corsican Brothers,* a Dramatic Romance.

"If the diurnal record of the traveller be not always the form of narrative most agreeable to the reader, it is, or ought to be, more faithful than any other, and consequently more useful to those who visit the countries described, especially when those countries have been little explored."—*Travels in Northern Greece,* COL. LEAKE, Vol. I.

LONDON·

ROBERT JOHN BUSH, 32, CHARING CROSS.

1870.

TO

FRANKLIN LUSHINGTON, Esq.,

OF THE INNER TEMPLE,

FORMERLY MEMBER OF THE SUPREME COUNCIL OF JUSTICE,

IN THE IONIAN ISLANDS,

AND STILL EARLIER THE COMPANION OF MY TRAVELS IN GREECE,

THESE ILLUSTRATED JOURNALS IN CORSICA ARE INSCRIBED

BY HIS AFFECTIONATE FRIEND,

EDWARD LEAR.

London, 1869.

PREFACE.

———◆———

IN the years 1846, 1849, and 1852, I published illustrated journals of tours in Central and Southern Italy, and in Albania, three books which met with a successful reception from the Public, and were very kindly noticed by the Press.

The present volume consists of journals written with the same intent and plan as those which preceded them. They describe, nearly word for word as they were written, my impressions of the nature of the landscape in those portions of Corsica through which I travelled. It is possible that the literary part of this book may not prove of equal interest with that of the publications above named; not, indeed, from any want of merit in the subject, but because I have now no longer the help of friends who then kindly assisted me by their criticisms, especially the late Robert A. Hornby, Esq., and Richard Ford, Esq. But the aim of all these journals should be looked on as the same, simply to be aids to the knowledge of scenery which I have visited and delineated.

I passed last winter at Cannes, intending to return early in the spring to Palestine, for the purpose of completing drawings and journals for a work already partly advanced; but circumstances having prevented me from carrying out this plan, I decided on going to Corsica, rather perhaps on account of its being a place near at hand and easily reached, than from any distinct impression as to the nature of the country, or from any particular interest in its history, inhabitants, or scenery. It is true that the Corsican mountains are sometimes visible from Cannes at sunrise, and latterly I had read M. Prosper Merimée's beautiful little tale of " Colomba," the scene of which lies in Corsica; but I confess to having been chiefly led to think of going there by that necessity which the wandering painter—whose life's occupation is travelling

for pictorial or topographic purposes—is sure to find continually arising, that of seeing some new place, and of adding fresh ideas of landscape to both mind and portfolio—

> " For all experience is an arch, wherethrough
> Gleams the untravell'd world, whose margin fades,
> For ever and for ever when I move."

It was growing late in the spring when I had decided on going to Corsica, and time did not allow of my procuring books (though plenty have been written on the subject) or maps. Valery's "Voyages en Corse," published so long back as 1837, was the only guide I could obtain; nor did I happen to fall in with any one who knew the Corsica of 1868. M. Prosper Merimée's visit to the island had occurred many years back (though he most kindly procured me letters of introduction which proved of great value). One friend wrote that though there were roads, there were no carriages ; another that a yacht was the only means of seeing a place, the interior of which was intolerable for want of accommodation. My ignorance was *not* bliss, and I would have got knowledge if I could ; but as there was no remedy, and as I intended to pass some eight or ten weeks there, I prepared to go to Corsica as I should have done to any other land of unknown attributes, where I might find the necessity of roughing it daily or nightly, or the contrary ; it cannot, I thought, be worse than travelling in Albania or Crete, long journeys through both of which countries I have survived.

A few words on the arrangements preliminary to such travelling may be allowed. Some there are who declaim against carrying much luggage, and who reduce their share of it to a minimum. From these I differ, having far more often suffered from having too little " roba " than too much. Clothing for travelling comfortably in hot or cold climates, such as must be experienced in the plains and mountains of an island so varied in formation as Corsica, and for different phases of social life during an extended tour; great amount of drawing material, folios, paper, &c. ; an indian-rubber bath; above all, a small folding camp or tent bed, of good use in many a long journey in Albania, Syria, &c., and in which I am sure of sleep anywhere ; these, mostly contained in a brace of strong saddle-bags, form a goodly assortment of luggage, and eventually I found it to be not one iota too much.

Then, as to travelling alone, the prospect of which is dreadful to some, I

almost always do so by preference, because I cannot otherwise devote every moment to my work, or so arrange plans as to insure their success. Sometimes, indeed, I have made exceptions to this rule, yet only in cases where my fellow-travellers were not only as eager draftsmen as myself, and where I, being their senior, as well as instructor in sketching, could define and follow all my own plans exactly and without hindrance. Strictly speaking, however, it is long since I made any tours really alone, as various sharp illnesses have taught me the great inconvenience of doing so ; and I have frequently been thankful for the care of a good servant who has travelled with me for many years. George Kokali, a Suliot, speaking several languages, sober, honest, and active, saves me all trouble and gives none ; now carrying a weight of cloaks and folios and "daily bread" for a twenty-mile walk or more, anon keeping off dogs and bystanders when I am drawing, or cooking and acting as house-servant when stationary ; a man of few words and constant work.

Those who go to Corsica hoping to study antiquities will be disappointed ; for the manifold charms of classical countries are wanting there ; the long lines of Grecian plains, so crowded with spots full of historic and poetic memories, vast and beautiful remains such as those of Sicily, Syria, or Egypt, do not exist in it ; neither will he find the more modern beauties of architecture, the varied forms of tower or castle, mosque, cathedral, or monastery, with which Albania or Italy abound. On the other hand, the ever varying beauties of light and shade in mountain and valley, the contrast of snowy heights and dark forests, the thick covering of herb and flower, shrub and tree, from the cyclamen and cystus to the ilex, oak, beech, and pine, these are always around him, and he will find that every part of Corsica is full of scenes stamped with original beauty and uncommon interest. Equally will the tourist through the Corsica of our days fail in finding anything of romance there, except in the traditions of the past. If it were, in travelling through Calabria twenty years since, a disappointment to find no pointed hats, and no brigand costume, how much more so is it to find that Corsica, once the very fountain-head of romance, no longer possesses any, that you may walk from Capo Corso to the Straits of Bonifacio in the undisturbed monotony of security, and that all gloomy atmosphere of risk and

danger has for years past been dispersed by the broad daylight of French administration and civilisation? With old customs and costumes, mystery and murder have alike disappeared from the Corsica of 1868.

A slight sketch of Corsican history, together with some information concerning its geography, its inhabitants, &c., matters which to many readers will prove of interest, but which it was not easy to incorporate with the "Journal," will be found separately annexed ; and copious details are added in the shape of notes extracted from books I have read since my return from the island (*see* list, page 269), from which may be gathered impressions of the improved state of Corsica now, contrasted with that it was in at the time of the visits of earlier authors.

A certain monotony of narrative must needs be the result of monotony of travel ; and the recital of a tour made in a carriage, cannot, I imagine, be made very attractive, if the writer simply records his own impressions. Many of the illustrations, however, were made in short pedestrian excursions, particularly in the forests, at some distance from the high road.

One drawback to my visit, but one I could not avoid, was its shortness · far too little time was devoted to delineating so large a space of country.

To these remarks I will add, that in spite of the want of classical interest throughout Corsica, the memory of my visit to it becomes fresher and more interesting as time goes on ; nor do I despair of returning to it, to see some portions of the island I much regret not having visited—Niolo, the Casinca, the Coscione, Rostino, and the coast from Calvi to Porto. Of the Corsicans, too, I would gladly add a word as to their general courtesy and good breeding, and their hospitable welcome in places where no inns exist; and, among other pleasant recollections, this should not pass unnoticed, namely, that there are no beggars in Corsica, a fact contrasting agreeably with the persecutions met with in some other countries.

NOTE.—*With the exception of six of the large plates, and ten of the vignettes, the whole of the eighty illustrations have been drawn on wood by myself, from my original sketches. And I gladly take this opportunity of thanking MM. Pibaraud, Pégard, Pannemakèr, Badoureau, and Mr. J. D. Cooper, for the care and accuracy with which they have engraved the drawings submitted to their care.*

LIST OF ILLUSTRATIONS.

VIGNETTES.

—◆—

CONTENTS.

CHAPTER I.

CHAPTER II.

CHAPTER III.

CHAPTER IV.

CHAPTER V.

CHAPTER VI.

CHAPTER VII.

CHAPTER VIII.

CHAPTER IX.

CHAPTER X.

CHAPTER XI.

CHAPTER XII.

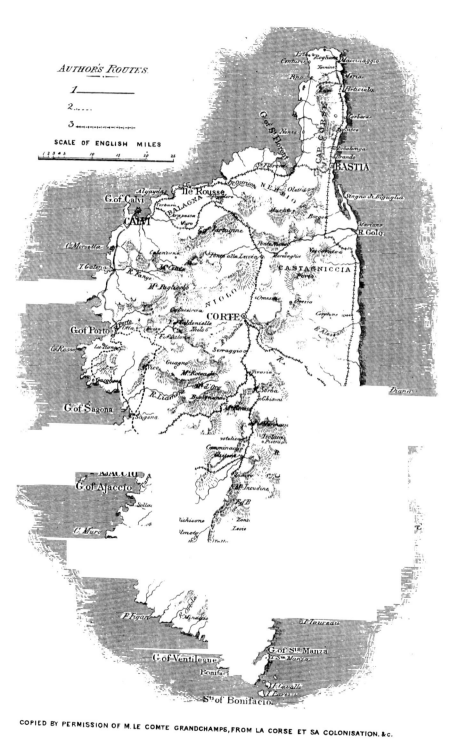

JOURNAL

OF A

LANDSCAPE PAINTER IN CORSICA.

———

CHAPTER I.

April 8, 1868.—It seems a pity to leave Cannes just as the most pleasant
and beautiful season is beginning; but if a sketching tour is to be made in
Corsica, this is the right and perhaps the only time to choose, at least if all
parts of the island are to be visited; earlier, the snow would have made the
higher districts unavailable to the landscape painter; later, the heat would
prevent work being easy or possible. So I close my rooms in M. Guichârd's
house, and say good-bye for the present to the cheerful town and its quiet
bay, with the beautiful Esterelles on the horizon.

Off by rail to Nice, whence every week a steamer starts for Corsica, going
alternately to Ajaccio on the west coast, and to Bastia on the east. This
week Ajaccio is the point, and the "Insulaire" is to leave the port at
eight P.M., a roomy and well appointed steamboat, fares thirty-one and
twenty-one francs for first and second class places. I go from the pier at
seven, and on reaching the boat meet with a pleasant surprise in finding my
friend J. A. S., with Mrs. J. S. and the little Janet already on board.

Meanwhile clouds cover the sky—so bright and clear all day—the wind
rises before we are fairly off at 8.30, and instead of the smooth sea, full moon-
light, and other delicacies of a night voyage fondly hoped for, the most ugly
forebodings are heard concerning a rough passage, whereby the landscape

B

painter, always a miserable sailor, begins to repent of his decision to draw all Corsica, and, were it possible, would fain return to land. But it is too late ; and the only alternative is to cultivate sulkiness and retreat instantly to bed ; the cabin will be at least a tolerably quiet one, for of passengers there are but few. Neither on deck is any living being left but two fat and perpetually backwards-and-forward trotting poodles.

April 9.—The night voyage, though far from pleasant, has not been as bad as might have been anticipated. He is fortunate, who, after ten hours of sea passage can reckon up no worse memories than those of a passive condition of suffering—of that dislocation of mind and body, or inability to think straight-forward, so to speak, when the outer man is twisted, and rolled, and jerked, and the movements of thought seem more or less to correspond with those of the body. Wearily go by

"The slow sad hours that bring us all things ill,"

and vain is the effort to enliven them as every fresh lurch of the vessel tangles practical or pictorial suggestions with untimely scraps of poetry, indistinct regrets and predictions, couplets for a new " Book of Nonsense," and all kinds of inconsequent imbecilities—after this sort—

Would it not have been better to have remained at Cannes, where I had not yet visited Theoule, the Saut de Loup, and other places ?

Had I not said, scores of times, such and such a voyage was the last I would make ?

To-morrow, when " morn broadens on the borders of the dark," shall I see Corsica's " snowy mountain tops fringing the (Eastern) sky ?"

Did the sentinels of lordly Volaterra see, as Lord Macaulay says they did, " Sardinia's snowy mountain-tops," and not rather these same Corsican tops, " fringing the southern sky ?"

Did they see any tops at all, or if any, which tops ?

Will the daybreak ever happen ?

Will two o'clock ever arrive ?

Will the two poodles above stairs ever cease to run about the deck ?

Is it not disagreeable to look forward to two or three months of travelling quite alone ?

Would it not be delightful to travel, as J. A. S. is about to do, in company with a wife and child ?

Does it not, as years advance, become clearer that it is very odious to be alone ?

Have not many very distinguished persons, Œnone among others, arrived at this conclusion ?

Did she not say, with evident displeasure—

" And from that time to this I am alone,
And I shall be alone until I die " ?——

Will those poodles ever cease from trotting up and down the deck ?

Is it not unpleasant, at fifty-six years of age, to feel that it is increasingly probable that a man can never hope to be otherwise than alone, never, no, never more ?

Did not Edgar Poe's raven distinctly say, " Nevermore ?"

Will those poodles be quiet ? " Quoth the raven, nevermore."

Will there be anything worth seeing in Corsica ?

Is there any romance left in that island ? is there any sublimity or beauty in its scenery ?

Have I taken too much baggage ?

Have I not rather taken too little ?

Am I not an idiot for coming at all ?——

Thus, and in such a groove, did the machinery of thought go on, gradually refusing to move otherwise than by jerky spasms, after the fashion of mechanical Ollendorff exercises, or verb-catechisms of familiar phrases———

Are there not Banditti ?

Had there not been Vendetta ?

Were there not Corsican brothers ?

Should I not carry clothes for all sorts of weather ?

Must THOU not have taken a dress coat ?

Had HE not many letters of introduction ?

Might WE not have taken extra pairs of spectacles ?

Could YOU not have provided numerous walking boots ?

Should THEY not have forgotten boxes of quinine pills ?

Shall WE possess flea-powder ?

Could YOU not procure copper money ?

May THEY not find cream cheeses ?

Should there not be innumerable moufflons ?

Ought not the cabin lamps and glasses to cease jingling ?

Might not those poodles stop worrying ?——

thus and thus, till by reason of long hours of monotonous rolling and shaking, a sort of comatose insensibility, miscalled sleep, takes the place of all thought, and so the night passes.

At sunrise there are fine effects of light and cloud ; but, alas for my first impression of that grand chain of Corsican Alps about which I have heard so much, and which were to have been seen so long before reaching the island ! Nothing is visible at present beyond the leaden, unlovely waves, except a low line of dark gray-green coast, and above this there are glimpses from time to time between thick folds of cloud, disclosing for a moment mysterious phantom heights of far snow and rock, or here and there some vast crag dimly seen and less remote, imparting a sensation of being near a land of lofty mountains, but none of any distinctness or continuity of outline.

As the steamer approaches the island, cape after cape is passed, and on one a village is seen, which the pilot tells me is Carghésé, the Greek settlement, of which I had heard from M. Prosper Merimée. The coast is deeply indented in bays and gulfs, and so far as cloud allows of seeing inland, seems remarkable for its greenness.

About ten we arrive at the pointed rocky islets called Les Îles Sanguinaires, and passing between them and the Punto della Parata, enter the Gulf of Ajaccio.(¹) The islands, on one of which there is a lighthouse, are picturesque ; but the weather has now become cold and windy, and the gulf, presumed by the enthusiastic to be ever "lake-like" and placid, is anything but calm or beautiful ; on the contrary, its aspect is gloomy, and its inquietude

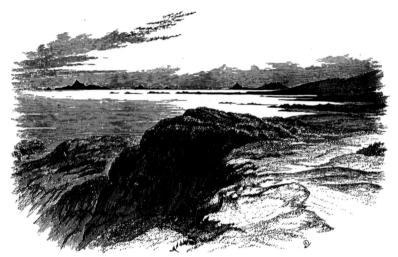

LES ÎLES SANGUINAIRES.

disgusting. Thick clouds hide all the hills, and this beginning of Corsican travel is certainly far from propitious.

We proceed along the north side of the gulf, and pretty near the shore.

(¹) The Gulf of Ajaccio is one of the most magnificent formed by nature . . . Its sheltered and excellent port might become one of the first arsenals of Europe. The capital city of Corsica is, however, but an embryo, placed in a desert, with numerous new promenades, detached rows of Government buildings, and hardly any streets, a garrison, employés, and very few inhabitants. In spite of a certain pompous exterior, Ajaccio, which should contain a population of 40,000, does not succeed, &c.—*Valery*, i., p. 152.

Ajaccio lies at the northern end of a gulf reckoned among the finest in the world. Its two coast lines are of unequal length ; the northern one is shorter, and runs on in a westerly direction as far as the Punto della Parata, a point of land opposite which are the Isole Sanguinarie ; the southern side of the gulf trends from N. to S. with many curves, as far as Cape Muro, sailing round which you come into the bay of Valinco. . . . The new town, with the citadel, was founded by the Bank of St. George of Genoa, in the year 1492.—*Gregorovius*, p. 346.

The Port of Ajaccio, situated at the head of the gulf of the same name, is incontestably the greatest

Close at the water's edge is a line of buildings, some so small as to be not unlike bathing machines; others resembling tiny dwellings, or rather those little places of worship, Ebenezers or Houses of Sion, observable in many English villages; but these are neither. They are tombs, small chapels, or sepulchral monuments, forming the Campo Santo, or cemetery of Ajaccio,([1]) but the pilot tells me that it is a more general usage in Corsica for the inhabitants to bury their relatives either on their own family property or in some conspicuous spot near their dwellings, thus never removing far from the living the memories of those who were with them in life.

Presently we near the head of the gulf, where Ajaccio stands out gloomy and gray on a point of land that forms an inner and an outer harbour. The city does not appear promising in a picturesque point of view, though on this boisterously windy morning,

in Corsica. It would easily shelter a whole fleet, and the bottom is excellent throughout. It includes three anchorages; one at the side of the citadel of Ajaccio, the second opposite the city, the third at the head of the gulf, 1,500 mètres from Ajaccio. —*Grandchamps*, p. 90.

The Gulf of Ajaccio, like many others, has been compared to the Bay of Naples; but, I think, without much reason, except for the colouring lent by a brilliant and transparent atmosphere to both sea and land.—*Forester*, p. 217. [I agree with Mr. Forester.—E. L.]

([1]) The neighbouring heights of Ajaccio are covered with detached little white cupolas, standing picturesquely above vineyards and other verdure. These cupolas, which have something of an oriental look, and recall Mussulman cemeteries, serve as tombs for different families—such is the custom of the country—on their own land. The brightness of these little buildings contrasts sadly with the gloom of the houses of the living.—*Valery*, i., p. 181.

CEMETERY, NEAR AJACCIO.

when all is sombre and sunless, and when the surrounding scenery is blotted and half hidden by clouds, it is premature to judge ; finer weather may change my opinion.

Before eleven we are anchored not far from the city ; boats come off to take the passengers, and I fancy that every one of these leave the " Insulaire" with pleasant recollections of its clean and good arrangements, and its careful and attentive captain and pilot, possibly, too, of the pair of funny little poodles continually trotting about its deck.

On a nearer approach Ajaccio([1]) does not seem to me to present any special beauty or interest ; no charm either of colour or architecture in public or other buildings salutes the eye of the painter. There are lines of respect-

([1]) Ajaccio is the prettiest town in Corsica. It has many very handsome streets and beautiful walks, a citadel, and a palace for the Genoese governor. The inhabitants of this town are the genteelest people in the island, having had a good deal of intercourse with the French. In Ajaccio are the remains of a colony of Greeks settled in Corsica, &c.—*Boswell*, p. 25.

The general plan of the town is very simple. One broad street leads from the sea to the barracks ; another nearly as wide, but much shorter, cuts the former at right angles ; besides these there are many subordinate streets extremely narrow and dirty.—*Benson*, p. 3.

Ajaccio is situated on a tongue of land, the point of which is occupied by the castle. Next to this follows the town, extending also in both directions along the gulf. . . The houses are high, but without any fine architecture ; the gray Venetian blinds, which are preferred in Corsica instead of the bright green ones of Italy, are characteristic features ; they give a dull and monotonous expression to the houses. All the more considerable houses of the Corso stand on the right hand side (entering from the Bastia road), the little theatre, the prefecture, and the barracks. I was surprised by the rural stillness in all these streets of Ajaccio ; their names only appeal to the traveller, and tell the story of Napoleon—Cours and Rue Napoléon, Rue Fesch, Rue Cardinal, Place Létitia, Rue Roi de Rome. . . Parallel with the Cours Napoléon runs the Rue Fesch ; the former leads on to the broad Place du Diamant, which commands a fine view of the gulf and its southern shore ; the latter ends in the market-place and leads to the harbour. These, and one which runs at right angles to the other two, are the chief streets of Ajaccio ; small by-lanes unite them, and traverse the tongue of land. . . Ajaccio is a land and sea town at the same time—you live in the midst of nature.—*Gregorovius*, p. 347.

Ajaccio is the oldest town in Corsica. In 1420 Alphonso of Arragon was welcomed there. At that time it stood further towards the end of the gulf, but for reasons of health it was rebuilt in its present situation about 1490. In 1506 it was ineffectually besieged by pirates, and taken by the French in 1553. In 1794 Ajaccio was taken by Paoli, and evacuated by the English in 1796. Napoleon I. has endowed his native town with benefits ; he created its fountains, constructed its quays, and finished the road from Ajaccio to Bastia. · · · The softness of the climate, the beauty of the gulf, the purity of the sky, and the majestic aspect of the mountains which surround and shelter it from the north, all indicate it as a haunt of those—idle or invalid—who love to frequent the cities of the south. In summer the gulf and land breezes temper the heat, and sea-bathing would be at Ajaccio as salubrious as at Cette or Marseilles. During the night the atmosphere is of an incomparable clearness, and the air from the mountains brings with it the perfumes of the "maquis." In one word, Ajaccio unites all that can attract and retain strangers ; all that is required is to embellish it, &c. . . Fashion, good hotels, and doctors in repute, would do the rest. · · · It is difficult to meet elsewhere with more picturesque and varied scenery : the highest mountains of Corsica stand like an amphitheatre around the Gulf of Ajaccio, the loftiest and farthest peaks cutting the sky in sharp and defined lines ; the landscape, severe and grand, is enlivened by the boats of the gulf and the smoke of the brushwood or maquis from fires lighted by shepherds on the hills. Sepulchral chapels relieve the dark verdure of the myrtle and olive, and the snowy summits of the d'Oro and Rotondo rising afar off complete this magnificent picture.— *Grandchamps*, p. 25.

The commercial future of Ajaccio depends on the utilisation of the valleys of the Gravona and the Prunelli ; but, separated as this city is by the highest mountains from the eastern side of the island, its influence on Corsica will always be limited. The great size of the gulf makes it difficult to defend,

able-looking, lofty, and bulky houses—they may be likened to great ware-houses, or even to highly magnified dominoes—with regular rows of windows singularly wanting in embellishment and variety; but there is no wealth of tall campanile or graceful spire, no endless arches or perforations or inde-scribable unevennesses, no balconies, no galleries, as in most parts of Italy, in the dull lines of buildings here; no fragmentary hangings, no stripes, no prismatic gatherings of inconceivable objects, far less any gorgeous hues, as in eastern worlds. Perhaps the place I thought of at first as being likest to Ajaccio was Rapallo, on the Riviera di Levante, a town, if I remember rightly, one of the least gay or ornamented on that beautiful coast.

Still more striking is the absence of colour, and of any peculiarity of costume in the dress of both sexes.[1] Almost all are in black, or very dark brown, and, to a new comer who has travelled in the East and South, everything has a dull and commonplace, not to say a mournful, air. The boatmen who convey me, my man, and luggage, to the shore, are quiet and solemn; and, on reaching the landing-place—ah, viva! once more the solid ground!—the sober propriety of demeanour in the groups standing round is remarkable; the clamour and liveliness of an Italian port, the wildness and splendour of an Eastern quay are alike wanting; the coun-tenances of both men and women are grave, and the former have an inactive and lazy manner; so that, whether or not I am prejudiced by the damp and overcast gloom of the day, my first impressions of the Gulf of Ajaccio and of the capital of Corsica are not of a lively character. Among the notes I have had forwarded to me by the last post from friends in England who knew of my coming to this island, are some written by a naturalist, who mentions, among other creatures peculiar to Corsica, the *Helix tristis ;* and, in my present mood, I feel that the melancholy snail was right when he chose a sympathetic dwelling.

No trouble whatever is given at the Custom House; the officials are civil and obliging. I walk on up a broad street, leading to an open place or square—where, or near which, I am told, the best hotels are to be found —in search of a lodging; to the right a street stretches along the quay, to the left appears to stand the more populous part of the city. On the way

&c. The future development and prosperity of Ajaccio depend on the drainage and cultivation of the plains of Campo dell'Oro, and on the impetus given to the neighbourhood by the presence of rich or invalid visitors.—*Grandchamps*, p. 27.

The cathedral, finished about 1585, in the form of a Greek cross, with a majestic cupola, recalls the good Italian architecture of that period. They show in it the font of white Luni marble where Napoleon was baptised the 21st of July, 1771, nearly two years after his birth, a custom not uncommon in Corsica. —*Valery*, i., p. 156.

[1] In the dress of the men of Corsica, the pointed velvet bonnet has almost entirely disappeared, and has given place to the woollen cap, to which the round cap of cloth is fast succeeding. The dress of the women is no longer what it was, the Corsican cloth, velvet, &c., have given way to woollens of finer texture or muslins, and it is rarely only that in the present day women are met with dressed in their original and picturesque costume. — *Galletti*, p. 54.

I pass a large fountain, with lions; how gloomily dressed are the women
filling their water-jars! but they carry them gracefully, and are well made—
their features regular, and rather of a Greek type, except that the nose is
longer.([1]) At the top of the street (the Rue Napoléon) is the Place du Diamant
(the large open space above alluded to), three-sided; the fourth, open to the
sea, containing the equestrian statue of Napoleon and those of his four
brothers. And now, for the weather shows signs of clearing, the opposite or
southern side of the gulf is for the first time visible. Out of this Grande Place
du Diamant the Cours Napoléon opens. In it are barracks, the Préfecture, the
theatre, the post, &c., and the Hôtel de l'Europe; and at one of its corners
stands the Hôtel de France, to which I go, but only to find that it contains no
vacant rooms. My next trial was at the Hôtel de Londres, which stands in a
small street at the north-west corner of the Place du Diamant, and is by no
means so well situated as the last I had entered. Each of these inns occupies
a single flat in a large square building. Here, although the entrance and
staircase are very objectionable, being extremely dirty, and encumbered by
small children who cling parasitically to the steps and balustrades, and
though it is at once evident that the arrangements of the floor used as
the hotel leave much to be desired, I find one very clean room looking to
the front for myself, and one on the other side of the establishment for my
servant. These are the only two unlet; my own is far too near the kitchen
to be agreeable—abundant noises; odours, and flies may be expected—yet,
for one may go farther and fare worse, I order my luggage to be brought
up-stairs, and settle myself for a sojourn of some days, the more readily that
my first impressions of the owners of the inn are prepossessing. Valery's
volume is the only book I have with me as a guide to Corsica, and from
that I gather that Ajaccio will be my best point as head-quarters while I
remain in the island.

 1 P.M.—My host, M. Ottavi, has produced an excellent breakfast—fresh
whitings, omelette, the famous broccio or cream cheese of Corsica, &c.;
and it must be allowed that the assiduity of the landlord and his wife go
far to atone for the shortcomings of their "salles à manger"—as various
many-tabled roomlets or boxes are with dignity named. Other apartments
there are, and of a larger size, but these are used by officers of the garrison,
and other regular pensioners of the restaurant.([2]) Since breakfast, I have

([1]) Occasionally one meets with handsome females, but they cannot generally be called so. They
have, however, eyes of singular brightness, and long glossy hair._–Benson, p. 36.

([2]) It may be stated here that I had no reason to repent my decision, and that I cannot speak in too
high terms of the Hôtel de Londres, or of its proprietors, M. and Mdme. Ottavi. Their constant atten_
tion to the wants of their inmates as far as the limited nature of their hotel allowed, the extreme cleanli_
ness of their rooms, the good qualities of their cookery, their reasonable charges, and their untiring
civility and cheeriness, it is a pleasure to remember. Nor should the first-rate coffee of Madame be for-
gotten (the Ottavi had long kept an hotel at Algiers), nor the industry and good humour of Boniface, the
waiter.

been out to the Préfecture; but M. Géry, the Préfet, to whom M. Merimée has kindly procured me two introductory letters, is in France; so I leave these at the office of the Secretary-general, M. Galloni. The Préfecture, which stands back from the Cours Napoléon, in a garden, is the handsomest public building I have seen in Ajaccio. The backs of the houses here have many picturesque accompaniments denied to their bald staring fronts; from my window in the hotel, as I look at the back or north side of the houses fronting the sea on the Place du Diamant, there are clusters of wooden balconies, little flights of glittering pigeons, and pigeon-houses to suit, mysterious zig-zag lines of jars up and down the walls, unaccountably linked together like the joints of some mighty serpent, and various other small incidents of interest. On the whole, however, I feel happy that there is little or nothing for me to do in the way of street-scenery drawing at Ajaccio.

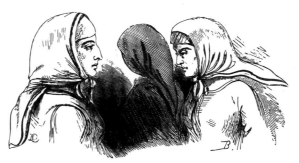

HEAD-DRESS OF AJACCIO WOMEN.

The day becomes finer; crossing the spacious place by the equestrian statue of the first Emperor Napoleon, I go down to the sea by a broad car-riage road, which, at its outset, is sheltered by a pleasant avenue of plane trees, and afterwards leads on to the Capella de' Greci, and to the public cemetery which I had remarked in steaming up the gulf. I wander on—as is my way in coming to new places—in order that by seeing a little on all sides, the best sites for making characteristic drawings may be ascertained; along this shore there are many beautiful bits, but chiefly about the small mortuary chapels, where cypress-trees and various shrubs flourish, and in the frequent combination of granite rocks with the sea and opposite gulf shore. Very few people seem about, though the city is so close by; the cut of the peasant-women's dress is much like that of the Ionians, the skirt full, with many small plaits or folds, the boddice and short jacket close-fitting—a graceful costume, but in nearly all cases of a dark hue, brown or purple, more usually black. The elder women—many of whose faces recall the portraits of Madame Mère—mostly wear a black handkerchief tied closely over the head; but the younger,

who are not so frequently pretty as they are particularly gráceful, wear two handkerchiefs, the one tied round the forehead and fastened behind the head (and of this kerchief only a portion of the front is seen), the other over the top of the head, fastened below the chin and falling on the back of the neck in a point like the head-dress represented in old Italian pictures. As for the men, they have a look as of porters or tradesmen out of work, carrying their hands in their pockets with what seems an idle and disconsolate air, and are in no wise picturesque or remarkable.

Leaving the shore drive—for there is a broad and good road all along the sea-side for some miles—I ascend by a short cut to the Cours Grandval, a noble promenade leading from the Place du Diamant, opposite to the Rue Napoléon, of which in fact it may be called a continuation, since from its termination you may see the harbour and the quay at the other extremity, to the hills which shelter Ajaccio on its west side. This Cours Grandval is really fine ; a wide carriage road with a footpath on each side, and in its position, high above the sea, most beautiful ; and now that the clouds are lifting, disclosing a vast semicircle of lofty mountains at the head of the gulf, besides a pro-longed line of lower heights on its southern side, I begin to foresee that my opinions concerning Corsican scenery have yet to be formed—all the more that as I walk on I find a magnificent luxuriance of vegetation filling up, not only every portion of the gardens and of parts of the uncultivated space on each side of the Cours Grandval, but of the hills beyond, where a profusion of olive growth waves low down, and a rich carpeting of underwood or shrubbery clothes their sides higher up. Close to this beautiful, but appa-rently little-frequented promenade, stand the four houses lately built, known as " Les Cottages " (and calling at one of these, Dr. Ribton's, I learn that my friends the J. S.'s are at the Hôtel de l'Europe). Nearly opposite these four dwellings stands the fine house of M. Conti, Receveur-général; and beyond them a large convent school seems at present nearly the only other building on the Cours Grandval, except a solitary house at its termination, where, so to speak, the city ends and the country begins.

Going down again to the shore, I wander on to the Capella de' Greci.(¹) Now that the features of this gulf scenery are beginning to be discernible, though even yet the summits of all the higher mountains are cloud-covered, a grand and lofty serenity seems its character. Somehow, a kind of lonely

(¹) From the pretty church Del Carmine, called the Greek church, there is a superb view of the Gulf, the Îles Sanguinaires, and the mountains, which stretch as far as Cape Muro. The church has its name because in its neighbourhood were buried many Greeks who fought in a Genoese army defeated by the Corsicans. It was built at the commencement of the last century by Paul Emile Pozzo di Borgo. — *Valery*, i., p. 168.

Charming is the walk on the northern side of the gulf, along the strand. There are many small chapels scattered about, of manifold shapes, round, quadrangular, domed, in the form of a sarcophagus, in that of a temple, surrounded by white walls, and among cypresses and weeping willows. There the dead have their country seats ; they are family vaults, their position on the coast in full view

sadness forms part of the landscape, and it is difficult to realise the fact that one is in the near neighbourhood of a city. The vegetation is surprisingly beautiful and vigorous, especially that of the cactus, broom, cistus, myrtle, asphodel, and lentisk; the almond-tree in full flower, and the fig-tree in leaf, showing how much warmer is the climate here than at Cannes or Nice, where as yet not a leaf of these trees is out.

But—I speculate professionally—what can I make of Ajaccio itself as a drawing? What though some of the very best views of the city are to be found along this walk by the shore and towards the end of the Cours Grandval, how are its blocks of houses seven stories high, square as warehouses, white evenly spotted with black, to be wrought into material for the picturesque? Possibly, at sunrise, when the light will be behind the buildings and all their poverty of good detail hidden, its general form may then be utilised as a single dark mass.

Returning to the town and through the Place du Diamant, I walk along the Cours Napoléon, which runs eastward and at right angles to the Cours Grandval and the Rue Napoléon; from it, numerous narrow lanes descend to the inner or east harbour, and to the Rue Fesch. But although perhaps there is more appearance of life in this broad street than in any other part of the city, I find little to admire in its uniform lines of tall houses, and am not sorry to come to the end of it, opposite what needs must be, when the mountains are unveiled—for all are now once more invisible—very grand views of the Gulf-head and the surrounding shores.

But how rural—now that I have explored most parts of Ajaccio—does this city seem! How little activity and movement in its streets! How abounding with children, and how destitute of men! How scantily furnished is the sea with craft! How lazy seem a great portion of its inhabitants! The brisk little French soldiers alone redeem the dulness of the town scenes, their bright red trousers almost the only gleam of colour in a world of black and brown; their lively walk and discourse nearly the only signs of gaiety. City, quotha! might it not, O sympathetic *Helix tristis*, rather be called a village?

Although my friends were out when I called at the Hôtel de l'Europe, the landlady begged me to see all the rooms in her inn, consisting, like the other hotels here, of one large flat containing various apartments. The situation of the Hôtel de l'Europe certainly has advantages which the de Londres cannot boast of; but for all that, I do not regret having selected to live in the latter.

At 6.30, having prowled and wandered till too tired to search any longer

of the beautiful gulf among the green bushes, and their elegant form, produce a very cheerful and foreign picture. The Corsican is not fond of being buried in the public churchyard; agreeably to the ways of the ancient patriarchs, he desires to be interred in his own land, among his own dear ones. From this cause the whole island is dotted over with little mausoleums, which often enjoy the most charming situations, and enhance the picturesqueness of the landscape.—*Gregorovius*, p. 404.

for the picturesque, I return to Ottavi's, to rest, write, and think what can be extracted from Ajaccio as food for pencil and paint. The Gulf mountain lines seem unmanageable from their great length, and difficult to represent except by portions; but perhaps a clear sky may show things differently to-morrow : " Bakalum " (we shall see), as the Turk says ; and being here for a purpose, all that is possible in topographic illustration must be tried.

By the crowding of officers and others here, and by the narrowness of the allotted space, I am reminded of the inn at Cattaro in Dalmatia, and of its

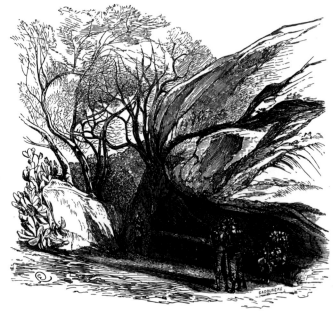

NAPOLEON'S GROTTO.

multitudinous frequenters and noises. The cook here, however, is a loftier artist than he at the foot of the Montenegrin mountain ; so the discomfort has its compensations. After the dry air of Cannes and Nice, how warm and damp does this feel !

April 10, 5 A.M.—It is blowing a hurricane, and pouring with rain. A pleasant beginning for study in Corsica, O painter !

But at seven the rain ceases, and gleams of sunshine gladden the gulf. I walk out, up to the end of the Boulevard or Cours Grandval, to make if possible a commencement of work, but find the wind far too high for any drawing. The solitary house, the last on the left hand on the road, now uninhabited, belonged, they tell me, to Cardinal Fesch, and here at one period

the Buonaparte family resided during summer, the great detached group of granite rocks a little farther on, known now by the name of "Napoleon's Grotto," being, I suppose, at that time within the bounds of the garden.([1]) At present these form, one may say, the terminus of the Cours Grandval, and are very picturesque, their gray sides shaded by light olive trees, and surrounded by a wild growth of cactus and all sorts of verdure. At this hour the grotto, and all the neighbourhood of the old Buonaparte house, are gay with French soldiery, and resounding with bugles and drums, this being the practising ground for those art-students.

From all about this spot are seen some of the best views of Ajaccio, and of the central chain of mountains, for the ground rises from the city to the end of the Cours Grandval, and commands most extensive prospects eastward ; the city, wholly in shadow, looks its best in early morning, as I guessed it would. Beyond the grotto, winding gravel paths lead downward to a most charming little dell ; you descend through a wilderness of heath, cistus, broom, and asphodel, till you come to gardens of fig and olive, when, passing one or two tiny cottages, you find yourself on the farther side of the little valley, whence other pleasant paths cross and border the hill sides down to the Campo Santo on the sea-shore carriage-road. Everywhere throughout these rambles there is a sensation of freedom—rarely do you see a creature— nothing interrupts the quiet. A flock of sheep and a shepherd are the only living things I have seen since I left the Cours Grandval ; the sheep are the first I have met with in Corsica, diminutive little beasts, all jetty black ; black, too, is the dress of their guardian.

On by the sea to the Campo Santo ; the tombs which had appeared like dwellings from the steamer are very numerous and of every kind, from the large plain or ornamented chapel to the simple headstone or cross. Generally they exhibit good taste, often standing in a small detached garden, walled or railed round, and planted with shrubs and flowers. Many of these plots of ground are evidently kept with care. Beyond them a large space is marked

([1]) At about a mile from Ajaccio one meets with two stone pillars, the remains of a doorway lead-ing up to a dilapidated country-house, formerly the property of Cardinal Fesch. . . This house was generally the summer residence of Madame Buonaparte and her family. Surrounded almost by the wild olive, the cactus, the clematis, and almond, is a very singular and isolated granite rock, called Napoleon's Grotto. . . The remains of a summer-house beneath the rock are still visible ; the entrance to it is nearly closed by a very luxuriant fig-tree. It was once Napoleon's favourite retreat, in which he fol-lowed his studies during the vacation allowed by the college of Brienne.—*Benson*, p. 9.

I went to see the Casone, a large garden covered with olive trees and Indian figs, and in it is a grotto which enjoys some celebrity. Formed by great rocks, opposite the sea, and not unpicturesque, it has been held as the spot where Napoleon used to meditate as an infant, and some enthusiastic travellers have visited it as such. I am sorry to destroy their illusions, but the Casone, an old villa of the Jesuits, which after their suppression passed to the State, was never possessed by the Buonaparte family except as national property.—*Valery*, i., p. 168.

Near Ajaccio, in the old Jardin Casone, belonging to the Buonaparte family, is the grotto formed of great blocks of granite stone, where Napoleon I., when a child, often passed whole days studying his lessons.—*Galletti*, p. 150.

out for a public cemetery, the practice of separate sepulchres in the vicinity of cities being, I am told, now prohibited, or about to be so in a short time. Passing these homes of the dead, the road runs on towards the Îles San-guinaires, here in full view, but wind and cloud forbid all drawing to-day, so, giving up further exploring, I return ; only two or three peasants in rude carts, and some half a score on foot, all dressed in triste black, passing me on my way back to the city, so quiet and little frequented are these environs of Ajaccio.

At the Hôtel de l'Europe I find my friends the J. S.'s preparing to migrate to-day to Dr. Ribton's. The longer I stay in Ajaccio the more I am surprised at the crowds of children, not so much in its streets as in the passages and doorways and on the stairs of the houses. These they lay claim to as their own particular property, and seem to think it odd if you ask them to allow you to pass ; nevertheless, it should be added that these little urchins are invariably civil and good-humoured. Another surprise to me is that everybody talks an Italian which is quite easy to understand, especially by one used to the dialects of Southern Italy—a facility of com-munication I was not prepared for, as I had heard the Corsican dialect described as a mere jargon, whereas it is not at all so.

11 A.M.—To breakfast in one of the small salle à manger boxes. M. Ottavi is Corse, but has passed most of his life in Algiers ; Madame is of Strasbourg, but a Pole in origin : both spare no pains to please, and are profuse of good food and wine—the latter a strong red sort, and not unlike a Burgundy in flavour. An elderly Corsican breakfasts in the same "salle," who asks what part of the island I intend to see ; having, as yet, no fixed plan, I mention the Greek colony of Carghésé as one of the places I had some idea of visiting first. "But," says my acquaintance, "you would find that place triste !" (To myself I added, Helix tristis ! If the capital is triste, why not the remote villages ?) One of the Carghésé Greeks, it seems, has married this gentleman's daughter, and he obligingly offers me an introduction to him. "You will, however," he adds, "find no costumes in the present day at Carghésé ; the people there, who originally came from Maina, in the Morea, have for a long time past intermarried with Corsicans, and, although among themselves they keep up their own language, they can hardly, except in that one particular, be any longer called Greek." This is disappointing intelligence ; for I have been looking forward to brilliant Greek costumes as a set-off to the paucity of colour here. I decline the friendly offer of this gentleman—a M. Martinenghi—to inscribe my name in the cercle, or club ; for, should the weather become clear, there will be little enough time for drawing before June, none at all extra for "dawdling" or "society"—terms at certain times nearly equivalent.(¹)

(¹) [I have been sorry since my return from Corsica, that my short stay there did not admit of seeing more of Corsican society ; what little I had the advantage of knowing was pleasant, hearty, and full of

Noon.—The air is as damp and chill as it used to be at Mountain Civitella di Subiaco after a two days' rain; but I would it were as certain as it was wont to be there, that weeks of clear sunshine would follow this "soft weather"—there, where rain was so regularly succeeded by a bursting forth of light over that wild space of landscape from Olevano to Segni, one of the most beautiful scenes I have ever known. How would it be to pass whole months here, as of old one did in those Italian hills? Would isolation and undisturbed study atone now, as then, for the want of society and much else? Meanwhile, I write out all M. Prosper Merimée's and Mr. Hawker's notes for use, till, the rain holding up, I try to see the Secretary-general, but he is *indisposto*, and in bed. So I come back and give myself up to the fixed conviction that this is truly the land of the *Helix tristis*, the melancholy snail.

Later, a most violent wind blows; yet who can stay for ever indoors? So I set out eastward, to explore some new ground, with G., cloaks, and a folio, in case there should be an opportunity of pencilling anything beyond the blackness of attire of men, women, and children, and the multitudinous congregating of the latter at doors and on stairs. All about the eastern or inner harbour many interesting drawings might be made, weather permitting; but the boats partake of the unpicturesqueness of all things artificial in Corsica. Oh, for a few of the beautiful rainbow-tinted boats of Malta or Gozo! But here, like the goats and the sheep, and the dress of the human beings, the boats, too, are all black! (Mems., zoological and others :—Observe 1st. Goat tied to tail of a horse; goat greatly disquieted by being obliged to gallop. 2ndly. Swallows in small parties, flitting about, battling with the fierce wind, or sitting puffily-ruffled upon the telegraph wires, saying, "We have come to Corsica too soon." 3rdly. Many of the peasant women hereabouts wear low-crowned straw hats, like those in use at Antibes, but not so flat.)

High up, on one of the many hills—for the Gulf of Ajaccio is entirely backed by heights—is a lofty monument, and a wayside man informs one that it is the tomb of Count Andrea Pozzo di Borgo,[1] who was a native

intelligence and good taste ; and by the warm welcome I received at the only two gentlemen's houses where I stayed, I am convinced that the old hospitable virtues of the island are unaltered.—E. L.]

[1] The house of the ancient family of M. Pozzo di Borgo is solid and well situated ; they show the one-windowed room where he was born.—*Valery*, i., p. 177.

Pozzo di Borgo died in Paris, February 15, 1842.—*Gregorovius.*

Two grenadiers deserted from a French regiment, auxiliaries of the Genoese, and fled to Alata, living in the Macchie, but secretly sustained by a goatherd. M. de Mozières, colonel of the regiment, having obtained a clue to their hiding-place, went to the shepherd's house, and interrogated his son Giuseppe on the subject, the young man finally accepting four louis d'ors as a bribe to betray the retreat of the deserters, which he did by pointing with his finger to certain rocks behind which they lay. The father of the young man, returning to his cabin, learned the treason, and having prepared his son for death shot him with his own hand.—*Gregorovius*, p. 397.

[One of M. Prosper Merimée's beautiful tales is founded on this incident.—E. L.]

of Alata, a village adjoining. Turning off from the main or Bastia road, one less wide leads to the left, and I follow it, as somewhat more sheltered ; it goes, they tell me, to two large convict establishments or *penitenciers*, called Castelluccio, and beyond that to Milelli, another old Buonaparte country house ; also to the chapel and rocks of St. Antoine, and to one or two more distant villages. And if there is no possibility of work, owing to the wind, at least this walk is interesting, as showing much beautiful landscape all around—in depths of olive-grown valleys, in cultivation near at hand, and in glimpses of the eastern mountains, where, amid gloomy cloud, many grand and transient effects gleam out. The peasants, or, possibly gentry (for all who pass me are dressed alike), are mostly riding the wiry little ponies for which the island is noted. Some of these persons wear hood-cloaks, like those used in Crete ; but generally they wear black cloth caps, black beards, and black velveteen dresses. Far down in the leafy valleys, and high up on the hill-sides, everywhere peer forth from the olive or ilex groves solitary tombs, many of them domed, and very much like Mahometan welys ; others are quaint little temple-like structures, or plain chapels. (*See* notes pp. 5 and 10.) But it becomes too tiresome to fight on against this furious wind, so by 5 P.M. I am again back at the city, and sit awhile with the S's—all three of us indulging in disrespectful remarks on the climate of Ajaccio in April, 1868, and half wishing we had never visited the native land of *Helix tristis*.

Last of all I went to the Piazza Létitia, one side of which is formed by what was the family dwelling of the Buonapartes when Napoleon I. was born, in 1769. But this, the very greatest lion of Ajaccio, it is too late to see this evening ; yet one cannot contemplate even the outside of the house without feelings of singular interest. Nor, till now, did I know that the family occupied a palazzo of such size and of so much appearance of well-to-do condition.

April 11, 5 A.M.—All is cloud and mist, and small seems the chance as yet of settled fine weather, though rain has fallen all night. But it clears later, as it did yesterday, and allows me a couple of hours for drawing at the end of the Cours Grandval, and at the Grotto of Napoleon, where the lichen-grown granite boulders are a picture, and the growth of vegetation on all sides charming. My work, however, is cut short by a sharp storm of hail, and for nearly ten minutes a fall of sleety snow makes the grotto a welcome refuge. (As usual, they tell me "such weather in April was never before known in Ajaccio !" but was not the same said to me, April 12, 1864, concerning the weather in Crete ?)

At 9, to the Prefecture, where I find M. Galloni d'Istria, the Secretary-general. This gentleman, whose time during the absence of M. le Préfet is

so fully occupied that I hardly expected him to be able to devote much atten-
tion to the casual bearer of introductory letters, receives me with the greatest
friendliness ; and the interest he takes in my desire to see Corsica thoroughly,
and to portray its scenery, is very encouraging ; for the advice of one so inti-
mately acquainted with every part of the island is invaluable. He suggests
I should go to Sarténé, Bonifacio, and Porto Vecchio (whence I may visit
the forests of Spedale named to me by M. Merimée), then cross the mountains
from Solenzaro, and return again to Sarténé by the pass and forest of Bavella.
By this route, he tells me, I shall traverse some of the finest inland Corsican
scenery, as well as visit the most interesting towns in the southern part of the
island, and that the whole of the tour can be made in a carriage, provided
it be a light one ; for the broad Route Impériale, or diligence road, does
not cross the mountains at Bavella ; the last part of the journey, moreover,
is not so certain to be effected if any heavy fall of snow should occur in the
high forest passes. Nor did the active help of M. Galloni d'Istria cease here.
He gave me a first-rate map of the island, and promises letters of introduction
to persons residing in the places through which I must go while making the
first tour he has thus indicated, and on my return to Ajaccio, he will
provide letters to all other parts of the island I may wish to visit. It does
not always happen that an artist's topographical tour should be so completely
entered into and so warmly assisted by an official personage ; and I leave
M. Galloni d'Istria, feeling not only much obliged to himself, but also to
M Prosper Merimée for having so kindly procured letters for me to M. le Préfet.

Returning to the hotel, after a visit to the J. S.'s, the next step is to decide
finally in what mode of travelling I can best manage to make characteristic
drawings of so large an island as Corsica during the short time at my disposal.
Four plans present themselves, and it becomes urgent that I should fix on
one of these, and carry it into execution.

First—To go to the principal towns by Diligence—certainly a cheaper plan
than any other. But as these public vehicles go by night as well as by day, the
object of my visit—to study scenery—would be but half gained, nor, indeed, so
much as half, for a diligence could not be stopped for the sake of drawing a
landscape, though never so beautiful; and many disadvantages, to wit, jolting,
crowding, and dirt, would assuredly more or less interfere with work after
some twenty-four hours' journey. Moreover, from Porto Vecchio or Solenzaro
no Diligence roads cross the island, and once arrived at the first-named of
those places, further progress would be stopped, as there are no vehicles for
hire at all on the east side of the island, excepting at Bastia. Plan No. 1
is therefore abandoned.

Secondly—To hire horses and ride ; doubtless, great freedom of action
is ensured by such an arrangement. Yet against it there are numerous
personal objections not to be overruled. So exit plan No. 2.

Thirdly—Luggage might be sent on by Diligence, and I might walk, my servant carrying folios and food for the day, a plan I have constantly worked out in Greece, Italy, Crete, &c. But in Corsica this system could hardly be effected, for, from what I can learn, the towns are sometimes farther apart than even the longest day's walk could manage, and with no halting place between them ; very often too much time would thus be wasted in such a plan, because great portions of the island would probably not present any interest for the pencil. To go on foot through some of the forest scenery may be necessary ; but a quicker process for seeing and drawing the greater part of Corsica in ten weeks must be adopted.

Fourthly—There remains this plan, on which, after looking at the matter in all its bearings, I finally decide—namely, to hire a two-horse carriage for the whole time of my stay, paying for it so much daily, and using it for long or for short journeys, either as there may be much or little to draw, or according to the distance of halting places. In this way I should be free to make drawings in the neighbourhood of the principal towns, or to make excursions from them to various points ; and if any scene on the high road could not easily be returned to, owing to too great distance, I might halt my vehicle while I worked, or perhaps oftener send it on and walk ; on the other hand, I could drive as quickly as possible through districts in which there is little of the picturesque. This plan of travelling, though apparently the most expensive, will economise time, and in the end, I believe, will prove the cheapest; for my object in coming to Corsica being that of carrying away the greatest possible number of records of its scenery, the saving some outlay will not compensate for a meagre portfolio, and I might ultimately discover the least costly process to be also the least satisfactory. In support of which hypothesis a fable taught me long years ago by one dead and gone recurs to my memory.

Once upon a time three poor students, all very near-sighted, and each possessing a single pair of horn-rimmed spectacles, set out to walk to a remote university, for the purpose of competing for a professorship.

On the way, while sleeping by the road-side, a thief stole their three pairs of horn-rimmed spectacles.

Waking, their distress was great : they stumbled, they fell, they lost their way ; and night was at hand, when they met a pedlar.

" Have you any spectacles ?" said the three miserable students.

"Yes," said the pedlar, " exactly three pairs ; but they are set in gold, and with magnificent workmanship; in fact, they were made for the king, and they cost so much —— "

"Such a sum," said the students, " is absurd ; it is nearly as much as we possess."

" I cannot," the pedlar replied, " take less ; but here is an ivory-handled

frying-pan which I can let you have for a trifling sum, and I strongly recommend you to buy it because it is such an astonishing bargain, and you may never again chance to meet with a similarly joyful opportunity."

Said the eldest of the three students, " I will grope my way on as I can. It is ridiculous to buy a pair of this man's spectacles at such a price."

" And I," said the second, "am determined to purchase the ivory-handled frying-pan; it costs little, and will be very useful, and I may never again have such an extraordinary bargain."

But the youngest of the three, undisturbed by the laughter of the two others, bought the gold-rimmed sumptuous spectacles, and was soon out of sight.

Thereon, No. 1 set off slowly, but, falling into a ditch by reason of his blindness, broke his leg, and was carried back, by a charitable passer-by in a cart, to his native town.

No. 2 wandered on, but lost his way inextricably, and, after much suffering, was obliged to sell his ivory-handled frying-pan at a great loss, to enable him to return home.

No. 3 reached the University, gained the prize, and was made Professor of Grumphiology, with a house and fixed salary, and lived happily ever after.

Moral.—To pay much for what is most useful, is wiser than to pay little for what is not so.

Two other matters have to be settled before starting " to see all Corsica." First, the direction in which to travel, and the time at which to undertake certain tours; and, secondly, the division of baggage, with regard to daily and nightly comfort. The first question has been already partly settled by M. Galloni d'Istria's advice, for it is doubtless best to commence with the southern coasts of the island, as in all probability the heat will be soonest felt there; and thence, if possible, to see all that is necessary of the eastern plains, as, at the end of May, they begin to be malarious and unwholesome, that is, for a working painter; since it is one thing to travel rapidly through feverish air, and quite another to sit drawing in it for several hours, or to halt in it when heated, &c. Tours to the higher forests, and the centre of the island, may be postponed till all risk of snow and rain are passed.

Next as to baggage. Not knowing in the least what sort of accommodation is to be met with, I shall carry a good supply. Dividing my "roba," and leaving part of it with my host, M. Ottavi, I shall take lots of drawing material, and clothing for hot and cold weather, besides my small folding bed; so that, with my servant's help, I may at least be as comfortable as in Albanian khans, Cretan cottages, or Syrian sheds. For it is certain that at fifty-six "roughing it" is not so easy as at thirty or forty, and if good rest at night is not to be procured, the journey may as well be given up, for

there would be an end of work. Last of all, a fitting carriage and driver are
to be found, and price, &c., agreed on.

Here is a visit from M. Martinenghi ; he kindly offers to show me some
pictures in his possession, some by Salvator Rosa, &c., and appears con-
founded at the little enthusiasm I express on the subject, and at my declining
the proposal. In this hotel there resides an English lady—a Miss C.—who
has not only been here for some months, but has visited many parts of the
island ; and before I set off I shall venture on a visit to her, to get some hints
about my journey.

Noon.—What is going to happen ?—a remarkable clattering noise fills
the air. I look out of window, and behold a torrent of children—a hundred,
at least—all carrying bits of wood, which they knock, and bump, and rattle
against all the railings, doorsteps, and walls, as their procession passes on.
Now, in most southern places where Christians are desirous of celebrating
Easter by triumphant noises, pistols and crackers are fired off at the proper
time ; every one who has been in Rome at that season is aware of the uproar
made on the Saturday preceding Easter Day ; and in the Maltese villages,
at Alexandria, and other eastern cities, the hullabaloo is fearful. But here, in
Corsica, no firearms of any sort are at present allowed to be in the hands of the
people, and so the popular piety finds vent in this singular outburst of rattling
pieces of wood, which, I am told, has a dim reference to Judas Iscariot, the
thumps on the rails and stones being typical of what the faithful consider that
person's bones, were he living, should receive.([1])

At 1 P.M. I go out to the broad Cours Grandval, and pass most of the
afternoon in making drawings near the Grotto of Napoleon. For the day
is now finer, the clouds higher, and the mountains at intervals nearly
clear. The view over Ajaccio from this point is indeed fine ; the noble range
of snowy heights beyond the head of the gulf rise magnificently above the
city, and the ugliness of its detail is lost in the midst of so large and glorious
a picture, of which it forms so small a part. The colour of this landscape,
too, is very beautiful ; the deep-green clustering foliage in the middle
distance, and the gray olives, the purple nearer the hills, and the dazzling white
snow-line more remote, the calm blue of the sea (to-day really lake-like), and
the exquisite variety of vegetation in the foreground, combine to make one of
the most delightful of scenes—one, however, by no means easy to convey a
just idea of on paper. (*See* Plate 1.)

I feel that I am beginning to be fascinated by Corsica, and to discover
that it is far fuller of landscape beauty than I had thought ; those long vistas

([1]) I remember how, being in Ajaccio on Good Friday, all the town resounded at noon with the
discharge of guns and pistols from every window and every shop, in order to celebrate the glory of the
Resurrection with greater distinction. One would have thought the town besieged and being taken by
assault —*Valery*, i., p. 156.

of valley and mountain must needs contain stores of interest and novelty, and far away the high silver Alp-like points speak of grand and majestic scenery, well worth an effort to visit, all of which has been hidden until now by the thick cloud-covering of the distant hills.

At 5.30, after a peep at the J. S.'s in their new dwelling at Dr. Ribton's, in one of the four cottage villas, I went up the hill on the north side of the town, immediately above the Hôtel de Londres ; there are very charming walks among olive trees here, as well as on an open kind of common, where cactus growth and granite boulders form a thousand ready-made foregrounds. This is one of the most striking views I have yet seen in the neighbourhood of Ajaccio ; far below lies spread out the whole city and the broad gulf, across which you look to the high range of hills stretching out to Capo Moro, while to the east the gorge of Bocognano and the lofty snow-topped walls which shut in the valley of Bastelica rise in great splendour and beauty. The line of the hill cape opposite is, however, one only to be managed in a picture with delicacy, by breaking it with cloud shadows, for its uniform length is wanting in variety of outline. Pitifully barren of interest is the city as to architecture. In what place along the two Riviere, or the Gulf of Spezzia—or, indeed, in what part of Italian coast scenery in general—should one not feel a desire to sketch some arch, some campanile, or even the whole town or village ? Here, on the contrary, you seek to avoid drawing a space literally filled by great warehouse-like buildings, unrelieved in the slightest way except by parallel lines of windows. This, and the gloomy darkness of the dress of both sexes, are certainly drawbacks to Ajaccio in a picturesque sense.

At dinner, M. Ottavi tells me that from fifteen to twenty-five francs daily may be asked for a two-horse carriage. But he is to enquire further.

April 12, 6 A.M.—At the end of the Cours Grandval. The morning is lovely, and there is a delicious fresh and light mountain-air sort of feeling in the atmosphere. The distant heights are absolutely clear, a wall of opal, and to-day, for the first time, I see this remarkable view in perfection. No amount of building, even should this part of Corsica become eventually as villa-covered as Mentône or Cannes, Torquay or Norwood, can ever affect the character of this exquisite prospect, which depends on elements far above all risk of change ; on the wide extent of its horizon and on the great majesty of the two dark ranges of hills opposite, connected by a line of heights still loftier, conveying a forcible impression of the solemn inner mountain life of the island ; on the broad and generally placid gulf ; on the long and marked form of the hills to the south side of it ; and on the wide expanse of water towards the western sea. All these cannot alter. The olive-grown slopes, the almond groves, the gardens, and the breadth of shrubby wilderness and high cactus may disappear, but the general aspect of the distance cannot

change. Why, I ask myself, do people compare this Gulf to the Bay of Naples? To me it seems that no two places more dissimilar can exist.

Scarcely any one comes to this part of the neighbourhood of Ajaccio; a few boys and girls are seen searching for wild asparagus, and one or two individuals with surprising chimney-pot hats taking a morning walk. So till nine I draw quietly, and, after a talk with the J. S.'s, return to the town and get letters from the post. If I wanted any confirmation of my resolve not to go about the island in diligences, I could have none better than an examination of the vehicles which start at 11 A.M. for Sarténé and Bonifacio, for Vico, and for Bastia viâ Corte. To be shut up in one of these might be endured if duty or necessity so ordered; but on no other consideration whatever.

On coming back to the hotel the plague of little boys bursts forth again in a new phase. It pleases some twenty to have instituted a blockade inside the street-door of the house, and the fun is to hold it closed against the battering and hammering of some twenty outside, wholly irrespective of the interests of the frequenters of the establishment; and this lasts till the outer party conquer and the door is beaten in, when the calamity ceases, and a passage up-stairs becomes possible. At no time does the impression of multitudinous little-boyhood leave me in Ajaccio; no sooner am I up-stairs than I happen to look beyond the houses of the Place du Diamant towards two high and slanting walls following the direction of the steep hill-side hard by. Now, in any other place where I ever was, such walls would be infested by cats, or pigeons, or swallows; but here I count twenty-eight little boys, all crawling up the wall-tops after the fashion of lizards, and sliding down again—which pastime goes on all day long.

M. Galloni d'Istria pays me a visit, and obligingly goes over the ground I am about to visit on the Government map with me. He quite concurs with me as to the advantage of a carriage tour, and recommends me to stay first at Sarténé, one of the four Sous-préfectures of the island, and where, by means of letters he will supply me with, I can learn more definitely from M. le Sous-Inspecteur of Forests, what may be the condition of the high passes as to snow in the neighbourhood of the Forest of Bavella, through which I am to return to Ajaccio. He recommends me to visit the plains on the east side as early as I can, on account of their great unhealthiness late in the season, and to leave the high forests on the west and in the centre of the island till the snow is melted and the chesnut woods out in leaf. I decide, therefore, to start on the 14th or 15th, if, meantime, I can find a carriage to suit me.

2 P.M.—To the Necropolis on the sea-shore road. Many of these tomb-temples are very pleasing in form, and the view from the last of them looking back to the gulf head and mountains is striking. They stand all along the shore, at the foot of the hills which form the northern side of the gulf, ending

in Punto Parata, separated by the carriage-road from the granite rocks that
stretch out into the sea, a sad but picturesque landscape, and one somewhat
recalling the Via Appia or other sepulchre-bordered roads. (*See* Vignette, p. 5.)

Beyond the Campo Santo all along the road-side the growth of myrtle,
lentisk, cactus, and asphodel, is luxuriant beyond description ; and the Îles
Sanguinaires form numberless combinations with such foregrounds. Masses
of pale granite, covered in part with cystus, are at the outer edge of the road,
and run óut into the gulf in spurs, white foam breaking over them and
catching the sunlight, while the pointed islets on the horizon gleam darkly
purple against the deepening sky tints. (*See* Vignette, p. 4.)

Returning, there are more persons walking, as it is a fête day, than I have
yet seen in the neighbourhood of Ajaccio. The head-dress of the women, so
graceful and becoming, is generally, among those not in mourning, of buff or
purple, with a broad white border. The short Greek spencer and fluted dress
is most frequently worn, though there are a few of more modern or fashion
able cut. I observe hardly any girls whom one might call beautiful, but
nearly all have a very pleasing expression and a look of intelligence. Among
the gloomily dressed men, a group of French soldiers here and there in red
and blue form a pictorial relief.

In the town the small-boy plague has gone into another form to-day,
besides the passage-swarming and door-blocking. Crowds of urchins have
taken to rushing to and fro with small barrows with shrilly shrieking wheels ;
each barrow contains three small Corsicans, and is pushed and pulled by
twice as many more.

After dinner I visit Miss C.; whose acquaintance indeed is well worth culti-
vating. Her interest in Corsica and all it contains is extreme. The collection
of plants and natural history she has made in the island, and her drawings of
the numerous fish found here, must have fully occupied her leisure through
the winter ; she has already accomplished some long mountain excursions, and
really knows the island well. A person uniting great activity of mind,
physical energy, good judgment and taste, as this lady appears to do, and
bent on introducing Corsica to the English South-seeking public, may
really become instrumental in bringing about great changes in Ajaccio.

April 13, 5 A.M.—Off once more to the cactus and asphodel lands beyond
the Cours Grandval, to finish or proceed with drawings ; mountains perfectly
clear—gorgeous purple, silver, and blue. I doubt if any double range can be
finer, what though the refinement of Greek outline and the contrast of plains
be wanting. If the city were tolerably supplied with picturesque architecture,
few finer subjects for a painting could be found, so good is the middle
distance of trees, so rich and varied the foreground vegetation. I work, too,
this morning at another drawing nearer the city, and quite on the shore (*see*

Plate 2); in the first hours of morning this view is very imposing, the vulgar detail of the houses being hidden in shade, and the high snow mountains appearing to rise directly above them.

M. Galloni has not yet sent the promised budget of letters ; neither have I found a carriage; so it seems clear that a start to-morrow cannot be accomplished. The landlord here asks me if he shall give me a letter of introduction to some " banditti," a few of whom are still known to live in the Macchie, or woods of the interior. " They are rich," says M. Ottavi, "ils ne manquent rien—they have plenty of sheep and do nobody any harm." But Madame O., on the contrary, says, " Ah, je vous prie donc, ne vous en allez pas, ils vous abimeront !—do not go, I implore you, they will destroy you !" At breakfast time my host and hostess generally supplies one of the broches, or broccie([1]), a sort of cheese or preparation of milk, for which Corsica is famous ; it is made of sheep's milk, and is precisely the same as the Ricotta of Italy. Generally it is eaten with sugar. With fresh fish, broccie, and the good ordinary red wine for daily fare, might not a painter do well to come here— air and landscape being such as they are ? Already I begin to feel infected by Corsica-mania, the more that the quiet of the country adjoining this city reminds me of Olevano and Civitella and other mountain places where I studied painting in early days. Assuredly Ajaccio is a place where activity and bustle are little known ; very seldom you see a carriage in its streets, barring those of the postal service ; and even carts are rare objects.

By-and-by comes the man who is to let me the carriage and two horses. We agree on the price, fifteen francs a day—this is to include all expenses of driver and horses, and I am to pay neither more nor less, whether I remain stationary or use the trap daily. To-morrow I am to make a trial excursion.

It is discovered that my man Giorgio (of whom, in some twelve or thirteen years' service, there exists no tradition of his having been known to forget anything), has left my flask on board the steamer, so we must take to gourds, which, indeed, are the popular and appropriate media for carrying fluid in Corsica. Almost every peasant carries one, slung to his shoulder by a string ; those in common use are generally of large size, but there are others smaller, very pretty and delicate, and these, when polished and finished with silver stoppers and chains, are really elegant.

2 P.M.—What is there to do ? There is " Napoleon's house " to be seen ; or rather that in which he was born. So, not being in an industrious mood

([1]) After the cheese they make the renowned *broccio*, in the following way. The milk which drains from the cheese is heated in a copper with a certain quantity of pure milk, and is stirred with a large spoon. The pure milk becomes condensed by slow degrees, care being taken to skim off the scum produced by the boiling, and then the condensed part is taken up in the large spoon and placed in moulds, which are made of fine rushes woven together, and is left for some time to drain and to cool. The price of the fresh cheese varies from twenty to forty centimes the pound. The *broccio*, which is more highly appreciated, is sold at from forty to sixty centimes the pound.—*Galletti*, p. 49.

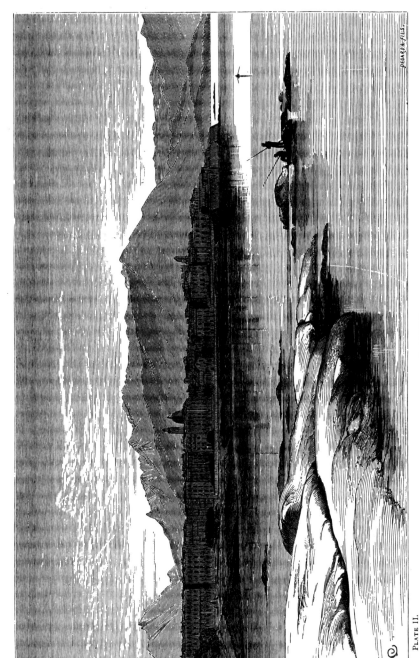

PLATE II.

A ACCIO.

(and, indeed, the cloudiness of the day prevents colouring out of doors, as I had intended), I go to the Place Létitia, a small square, of which, as I before mentioned, the Casa Buonaparte forms almost the whole of one side. Although I confess to having gone to this sight with a kind of routine or duty feeling, the visit gave me very great pleasure. The house—there is now an inscription above the door recording that Napoleon I. was born there, with the date of his birth—is much more roomy and pleasantly habitable than its exterior would lead one to expect, and it is easy to see that it was one of a superior class in Ajaccio a century back.(¹) Nearly all the furniture passed into the possession of the Ramolini (Madame

(¹) The house in which Napoleon Buonaparte was born is among the best in the town ; it forms one side of a miserable little court leading out of the Rue Charles. It is very accurately given in the recent work of Las Cases. At present it is inhabited by M. Ramolino, one of the deputies for the department of Corsica. Among other curiosities which this residence contains is a little cannon that was the favourite plaything of Buonaparte's childhood. It weighs thirty French pounds.—*Benson*, p. 4.

The house where Napoleon was born is to the imagination the first monument in Ajaccio. Before it, a little square, planted at the four corners with acacias, has received the name of Place Létizia ; the house, in height only a single storey above the ground floor, is little changed, and indicates the dwelling of a well-to-do family. It was pillaged in 1793 by peasants opposed to the Republic, after the flight of Madame Létizia and her children to her country-house of Melilli, while Napoleon was at Bastia. A fine portrait of Napoleon in imperial costume, by Gerard, is in the salon next to the bed-room, and it was in this salon that Napoleon was born. The little bronze cannon, a plaything of his infancy, disappeared some years ago ; they tell me it was stolen, and that no trace has been found of it. The European house of Napoleon has passed into the hands of strangers to his race ; no furniture of the time exists there, no inscription is read above the door ; and by-and-by this house will not be distinguishable from any others in the city.—*Valery*, i., p. 160.

From the street of St. Charles you emerge on a small rectangular place. An elm tree stands before an old-fashioned, yellowish gray, stuccoed, three-storeyed house, with a flat roof, and a gallery on it, with six windows to the front, and worn-out looking doors ; on the corner of this house you read the inscription, "Place Létitia." No marble tablet tells the stranger who comes from Italy—where the houses of great men announce themselves by inscriptions—that he stands before the house of Buonaparte. . . . The house, but little altered since his time, is, if not a palace, yet, at any rate, the dwelling of a family of rank and consequence. This is declared by its exterior ; and it may be called really a palace, in comparison with the village-cabin in which Paoli was born. It is roomy, comfortable, cleanly. But all furniture has disappeared from the rooms, &c.

In this house, the cradle of a race of princes, the excited fancy seeks them in all the rooms, and sees them assembled round their mother ; ordinary children, like other men's ; schoolboys toiling at their Plutarch or Cæsar, tutored by their grave father and their great-uncle Lucien ; and the three young sisters growing up careless and rather wild. . . There are Joseph, the eldest son ; Napoleon, the second born ; Lucien, Louis, Jerome ; there are Caroline, Elise, and Pauline ; all the children of a notary of moderate income, who is incessantly and vainly carrying on lawsuits with the Jesuits of Ajaccio to gain a contested estate which is necessary to his numerous family, for the future of his children fills him with anxiety. What will they be in the world ? and how shall they secure a comfortable subsistence ?

And, behold ! these same children, one after the other, take to themselves the mightiest crowns of the earth—tear them from the heads of the most unapproachable kings of Europe, wear them in the sight of all the world, and cause themselves to be embraced as brothers and brothers-in-law by emperors and kings ; and great nations fall at their feet, and deliver their land and people, blood and possessions, to the sons of the notary of Ajaccio ! Napoleon is European Emperor ; Joseph, King of Spain ; Louis, King of Holland ; Jerome, King of Westphalia ; Pauline and Elise, Princesses of Italy ; Caroline, Queen of Naples. So many crowned potentates were born and educated in this little house by a lady unknown to fame, the daughter of a citizen of a small and seldom mentioned country town, Letitia Ramolino, who, at the age of fourteen, married a man equally unknown. There is not a tale in the "Thousand and One Nights" would sound more fabulous than the history of the Buonaparte family !— 1852, *Gregorovius*, pp. 351, 352.

Uninhabited, and without a vestige of furniture, except some faded tapestry on the walls, the desolate

Letitia's family), who inherited the property; but there are still in the apartments mirrors, old framework of chairs (like the walls, they appear to have been formerly covered with red or gilt tapestry), marble chimney-pieces, and large fireplaces, one or two highly ornamented chests, an ancient spinet-piano, the sedan-chair of Madame, her bedstead, and a few portraits; all beside, as far as I saw, is bare unfurnished wall, and much of what I have named has been collected by the present emperor of the French from various places. The long gallery, the terrace and courtyard at the back of the house, the dining-room, every part of the building has its interest of association, and by walking through the apartments one is carried back to the days when the most wonderful man of modern times lived in it as a boy. To me, who years ago was in the habit of frequently visiting one branch of the Buonaparte family, the place is doubly interesting; and when I remember the group of the late Prince Canino's numerous children, of whom in those days I saw so much, I seem to be more able to realise the circle of the first Napoleon's mother and her little ones. The elderly person who showed me the house had lived in the service of Princess Caroline Buonaparte-Murat, Queen of Naples, and was interested at hearing me speak of the houses at Musignano and l'Arricia, where I was wont to be so kindly received in former days. No Buonaparte now resides at Ajaccio, except the Princess Mariana, wife of Prince Louis Lucien, a younger brother of Charles Lucien, late Prince of Canino. There is plenty of food for reflection in a visit to the Casa Buonaparte in Ajaccio.

3 P.M.—I wander through this town, so like a village in its outskirts, and sit on a wall to write journal notes and cast up accounts. There is a statue of General Abbatucci close by, with posts, chain-connected, at a little distance all round it. I count fifty-three children swinging on these chains, and rather more swarming up some carts not far off. Certainly, the multitude of children is a striking feature in Ajaccio street scenery, and M. Ottavi tells me that numbers of the male population emigrate to the continent for a part of the year, so that the apparent comparative fewness of grown-up men or youths may be thus accounted for. After walking a mile or two I turned back when near the Palazzo Bacciocchi, a handsome building which stands in gardens towards the head of the gulf, and thence, repassing the town, regained my favourite

and gloomy air of the birthplace of the great emperor struck me even more than the deserted apartments at Longwood from which his spirit took its flight.—*Forester*, p. 216.

The house has been renovated by the present emperor, the old family furniture has been sought out and brought back, and everything has been replaced as much as possible in the same position as when the rooms were occupied by the Buonapartes in former days.—*Bennet*, p. 255.

On the subject of the antiquity of the Buonaparte family, M. Valery, citing as his authority the historian Limperani, states that a deed, by which in the year 947 certain seigneurs gave some property at Venaco to an Abbot of Montecristo, was witnessed by one of that family, and that the name is spelled Bonaparte. Filippini mentions one Gabriel Buonaparte, chanoine de St. Roch, as a theological lecturer at the end of the sixteenth century.—*Valery*, i., p. 158.

spot at the end of the Cours Grandval. Here, in spite of the cold and chilly afternoon, I find Mrs. J. S. making a good view of the scene, for she hath an able hand and eye ; but I, too idle to recommence work, employ myself in constructing an artificial and beautiful foreground of cactus-leaves and asphodel-stalks stuck endways into a tall pyramid of stones for that lady to copy, who, far from applauding, not only censures my performance as absolutely deficient in natural grace, but absolutely declines to make a faithful portrait of it in her sketch.

Back to the hotel, after sitting some time with J. A. S., and here I find that M. Galloni d'Istria has very kindly sent me the promised budget of introductory letters for Olmeto, Sarténé, Bonifacio, and Porto Vecchio. All to-day, after the first hour or two of early sunshine, has been gloomy and cloudy. *Helix tristis* prevails.

CHAPTER II.

Trial Trip in a Carriage—The Lower Penitencier at Castelluccio—St. Antonio, its Grand Scenery and Granite Boulders—Visits with Miss C.—The Préfecture—Moufflons—Leave Ajaccio for the South of the Island—Peter the Coachman—Miss C.'s Predictions—Campo dell' Oro—Valley of the Prunelli, and Beautiful Scenes—Cauro—"Hotels" in Corsican Villages—Mrs. Paoloni and her Inn; its Accommodation, &c.—The Col di San Giorgio—"Maquis" and Wild Flowers—Valley of the Taravo—Descent to Grosseto—The "Hotel des Amis;" Civil People and Good Fare—Ilex Trees—Quiet Civility of Corsicans—Beautiful Drive by the River, and Ascent to Bicchisano—Winding Mountain Road to Casalabriva, and Descent to Olmeto—The "Hotel"—Picturesqueness of the Town and its Situation—Tombs—Olive Slopes and Woody Scenery—Rain—Visit to a Sick Englishman—Leave Olmeto—Charming Scenery—Gulf of Valinco—Propriano and its Port—Valley of the Tavaria—Extremely fine Landscape—Long Ascent to Sarté",—Description of the Town—"Hôtel d' Italie"—Fatima of Sarténé—Views of Sarténé and the Valley—M. Vico, and his advice about farther Travelling; Bavella, &c.—Constant Work for the Painter—A Day by the Rocks of the Tavaria; Exquisite Subjects for Pictures—Granite Rocks and Foliage by the River—Mourning in Corsica—Fatima's Opinions about Household Cleanliness.

April 14. — Still thick cloud, not a mountain-top visible: Corsican topography thriveth not. Nevertheless, at seven I go out to the cactus land and granite rocks, for one can make foreground studies; but no, it begins to rain, and I have to return. Is there, as I said this time four years ago in Crete, no settled weather here in April? So I sit down to write letters, especially one to M. Galloni d'Istria, thanking him for his assistance.

Miss C. went yesterday to Bastelica, but as yet those high regions are too heavily laden with snow; so that she came back instead of staying there. This lady is very obliging in answering my innumerable questions about numerous places in Corsica.

At 9, when it rains less, I call at Dr. Ribton's to see the J. S.'s. You enter their "salle à manger" straight from the road, a system which—all the world being seated at breakfast—is destructive to the peace of the delicate-minded intruder.

Says a Frenchman to me, and truly—speaking of the slow-walking people in the Piazza here—"ils se promènent, ces Corses, comme des estropiés, ou comme des limaçons—these Corsicans walk like cripples or snails"—*Helix tristis* to wit. And, certainly, on a wet day it would be hard to find so dull a place as Ajaccio. Suli, in Albania, is gay by comparison, Wady Halfa, in Nubia, bustling; for those are places of by-gone times, whereas we are here in a "city."

An inevitable necessary, money, is next to be obtained through a letter of credit to M. Conti, Receveur-général; and after that comes a visit to Miss C., who prophesies that I shall repent employing the people of whom I have hired the carriage. Meanwhile the carriage in question comes; it

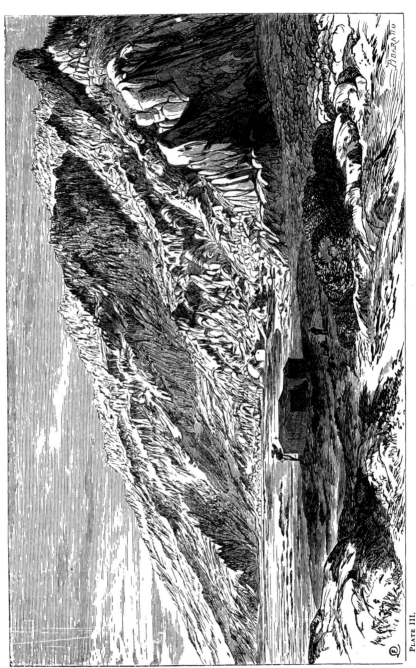

PLATE III.

INF

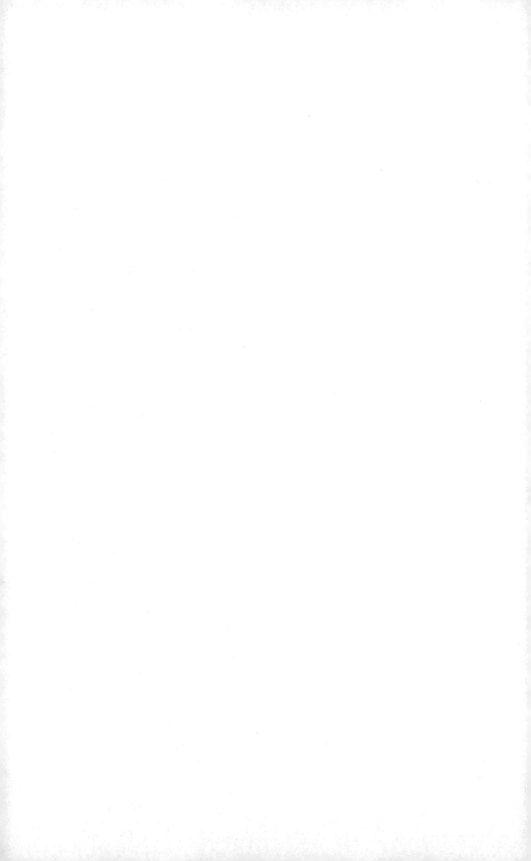

seems a comfortable and strong trap, and I do not think fifteen francs a day will be dear if the driver and horses are good ; of the latter G. remarks, " εἶναι ὡσὰν ποντικὸι—they are like rats "—and small they certainly are.

2 P.M.—After hard rain all the morning it is now moderately fine, so I set off to try the vehicle, the driver of which I own has a face—if there be any truth in physiognomy—not at all indicative of good character. The trap does not go badly—which, as it may be one's daily home for a couple of months, it is pleasant to know—and the two poor little horses shuffle along quickly enough. We take the road to Castelluccio, the upper Penitencier, or convict establishment, but turn off at the lower building, whence a bridle road goes on to St. Antonio, a place Miss C. recommends me to visit as one of the most picturesque hereabouts. All around the Penitencier convicts are working, and fast changing these bare or maquis-covered hills into vineyards.(¹)

Leaving the carriage here, I follow a winding track, which, leading to the rocks of St. Antonio, very soon leaves all traces of habitation and humanity, and might be exceedingly " remote from cities " instead of close to a capital. The walk along the hills is delightful, and the "maquis," of which I have heard and read so much, full of charm—orchids, cyclamen, lavender, myrtle, cystus, absolutely a garden of shrubs and flowers. As the path approaches the mountain which stands immediately above the chapel of St. Antonio, the views of this "wild waste place" become wondrously grand. Such granite crags and boulders I think I have only seen at Philæ and in the peninsula of Sinai ; and from the little platform, whence the whole mountain side is visible, with the western sea beyond, the strangely desolate prospect is greatly impressive. The chapel, a small and ancient building, can only be portrayed together with the rocks from one or two positions ; but the cliff or mountain is in itself a world of study, an endless storehouse of chasms, boulders, and peaks. Many new and great ideas of landscape may be gained by the painter who visits St. Antonio. (*See* Plate 3.)

Returning to the trap, I drive to the town, and, at G.'s request, go to the fish-market, which is really well worth a visit, for the strange beauty of colour and the novelty of form of the fish there. Then a little more study at the " grotto gardens " and a visit to J. A. S. wind up the day.

At 1 or 2 to-morrow I hope to start on my way to the south of the island, sleeping the first night at Cauro.

(¹) The wild shrubberies, by the natives called " máquis," clothe great parts of the country through which we passed. This term is generally applied to the wild vegetation so common in this island. It seems to be a corruption of the Italian word " macchia."—*Benson*, p. 13.

A large portion of the surface of Corsica—I may say, all that is not a primeval forest, or under cultivation—is covered with what they call "máquis." I do not like to use the word brushwood or scrub, for such are very common words to apply to groves of underwood composed of myrtle, arbutus, cystus, rock-roses, and Mediterranean heath ; and yet of such is the interminable "máquis" composed.— *Bennet*, p. 251.

The Corsican mountains are covered with the arbutus or strawberry tree, which gives a rich, glowing

April 15, 5 A.M.—Heavy rain has fallen all night, and there is much more snow on the mountains, a sign probably of settled fine weather. For a short time I drew at the "grotto gardens," from which beautiful spot the landscape never tires; this morning the mountains are of the very darkest purple, and the freshness of the flowers and foliage after rain delicious. The drums and bugles of the soldiery make an odd accompaniment to scenery so tranquil and poetical. At Dr. R.'s, where I call to say good-bye to the J. S.'s, I find S. far from well, and leave them uneasily with a feeling that his inability to travel may detain them here longer than they anticipate.

Arrangements for the afternoon's start, bill settling, &c., occupy me till noon, and then follows a visit with Miss C. (with whom the *Helix tristis* has nothing in common, for she is always merry and active) to the Hôtel de France, where the F. W. family are staying; thence, with two more ladies, we adjourn to the house of the Princess Louis Lucien, or, as she is more generally called, the Princess Mariana Buonaparte. This lady, who has still the remains of great beauty, has much charm of manner, and is much liked by those who know her. Her rooms, pleasant in situation, were full of interesting portraits of the Buonaparte family. Her pleasure in speaking of Musignano, where she found I had formerly been used to study, was very evident, and my offer to send her a small view of the house was received with delight.

Our party then go to the Préfecture, where Miss C. wants to show us some young moufflons or muffoli; there are two of them, lambs or kids, call them as you will, well made, active little creatures, shy and wild, notwithstanding their early captivity. The moufflon, an animal partaking of the goat nature and of that of the sheep, inhabits only the highest and most savage districts of Corsica, and comes down to lower levels only when compelled to do so by winter's heavy snows.

It was 2.30 before the trap came to the hotel, and careful packing commenced; one of my saddle-bags (or bisacchi) and the portable bed are stowed behind, well secured against rain by two wild boar skins; inside the carriage, my servant's package and my leather hand-bag for small objects (Valery's volume, my only guide, included) leave good room for self, besides a large folio in the old Coliseum—a case or sack so called by my servant from its extreme antiquity and venerable look, used for holding drawing materials or food in many expeditions—and G. on the outside seat with

appearance as far as the eye can reach (p. 46). . Theophrastus, in his history of plants, expatiates on the wonderful size of the Corsican trees, to which, he says, the pines of Latium were nothing at all. He also says the trees were immensely thick here. Καὶ ὅλως τὴν νῆσον δασεῖαν καὶ ὥσπερ ἠγριωμένην τῇ ὕλῃ —the whole island seemed crowded and savage with woods.—*Boswell*, p. 47.

What struck us most, independently of the general effect, was the extraordinary verdure and exuberance of the vegetation, which overspread the surface of the country far up the mountain sides, not only as contrasted with the sterile aspect of the coasts of the continent we had just left, but in being, in itself, different from anything which had before fallen under our observation in other countries, whether forest, underwood, or grassy slope.—*Forester*, p. 31.

the coachman, whose appearance is objectionable, and whose name is Peter, complete the arrangement. The kindly Miss C. has sent me a flask in place of the one lost, and calls from the window, cheerfully, " You should have taken my man Jean ! all your luggage will fall off ! your horses will tumble ! everything will go wrong !" Absit omen ! and finally we start at 3.30.

. The way is along the Cours Napoléon, and out of the city towards the head of the gulf, leaving on the left the roads to Castelluccio, Alata, and Bastia, and passing the Villa Bacciocchi and its gardens, with some scattered villas and mulberry plantations—all these environs of Ajaccio are considered unhealthy in summer-time, on account of the marshy ground at the end of the gulf, parent of malaria fever. From this side of Ajaccio the view of the city is rather wanting in interest, though with a " composition " of boats it might be made more worthy; perhaps from near the Lazzaretto, or Fort d'Aspretto it is best. The blackness of the crows on the shore, and that of the dress of the peasantry, alike wanting in liveliness, are the foreground accompaniments. Leaving the coast the road passes along the Campo di Loro (or dell' Oro), (1) a flat plain with here and there those wide spreading marshes, so unfriendly to the health of the city. The rivers Gravona and Prunelli, which flow from the high mountains of Renoso and dell' Oro, by the valleys of Bocognano and Bastelica to the sea, are crossed by long bridges. In winter time, when the snow lies on the heights at the head of these valleys, many beautiful pictures might be made here among the broad green meadows ; just now, heavy storm clouds obscure the distance ; flocks of blackest sheep and a world of glittering silver-blossomed asphodels are the chief objects noteworthy. From the river Prunelli, where the road turns inland, and begins to rise, the scenery becomes more rugged and severe, reminding me of that of the valley of the Kalamà in Albania, hemmed in by hills of no great height, above which are glimpses of far purple and snow.

At 5 the ascent becomes steeper and winding, and I avoid the high road to walk by short cuts, pleasant paths by heath-like slopes above a stream, beside which groups of large and as yet leafless chestnut trees are scattered. Every

(1) The Campo dell' Oro was the scene of the heroic exploit recorded by Germanès, of the twenty-one shepherds of Bastelica who came down from the mountains and routed 800 Greeks and Genoese of the garrison of Ajaccio. Intercepted at length by infantry embarked on the little river of Campo dell' Oro, and surrounded by the marshes of Ricanto, they were all killed excepting one, a young man, who, stretched among his comrades, and with his face discoloured with blood, feigned death. Discovered by the Genoese hussars, who decapitated these noble victims, he was condemned by the Commissioner of Genoa to die, having first been led through the streets of Ajaccio carrying six heads, those of his relatives. He was afterwards quartered and exposed on the walls.—*Valery*, i., p. 183.

The valleys of the Gravona and the Prunelli, the waters of which discharge themselves into the Gulf of Ajaccio, are barely cultivated ; the plains situated at their mouths are unhealthy and marshy. It would be easy to drain and irrigate them, and thus increase their value tenfold. Besides, the neighbourhood of Ajaccio would excite not merely the emulation of ordinary labour, but also the spirit of speculation and calculations regarding the future, for sooner or later that city will become a rendezvous for those who seek health or pleasure.—*Grandchamps*, p. 30.

turn of the way up the hill shows changes of lovely green scenery, dells of crowded ilex, and a bosky richness of foliage, with now and then knots of tall trees on slanting turf, such as Stothard might have painted; and then, looking back, the whole Gulf of Ajaccio is spread out to the western sun, and the capital of the island, the rocky hill of St. Antonio, and the long lines of the hills on the northern side of the gulf, fill up the picture.([)

Higher up still, the view into the valley of the Prunelli becomes most grand, and from a point in the road near some wayside houses (they call the place Barraconi), the mountains shutting in the valley are particularly imposing, and I am sorry that it is too late (6 P.M.) to do more than jot down a memorandum

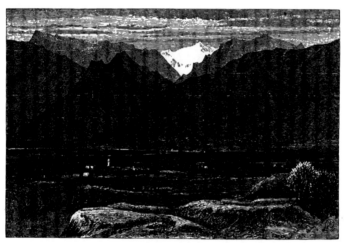

VALLEY OF THE PRUNELLI.

of the exquisite effect of sunset which just now makes this scene so fine. As the sun goes down, the high snowy summit of Mont Renoso seems on fire, seen through a rose-coloured veil of mist above the nearer dark purple moun tain ; below this, in deepest shadow, are great masses of rock, and at their foot lies the rich hollow valley and village of Suarella—a scene which I trust to return to.

6.30.—The village of Cauro is reached slowly, and by a stiff last pull, just as the sunset hues of gold and crimson—bright as those blazing dying day glories on the Nile—have turned to lilac and cold gray. The chief part of the village and its church stands back above the high road on the right (you may see it glittering against the hill-side as you stand at the grotto of Napoleon at Ajaccio, or at the end of the Cours Grandval), that with which I have to do

([) At Cauro I had a fine view of Ajaccio and its environs.—*Boswell*, p. 355.

is a row of mean-looking houses by the wayside on the left, and I am curious to know what sort of accommodation Corsican mountain travel will really exhibit. Two of the dwellings are lodging-houses, or, as they are called in this island, "hotels," a term applied here to the least pretentious of inns, such as we might call pothouses in an English village, and of these two the first applied to is full, and cannot take me in. Nor does there seem much better fortune at the second "hotel," at the door of which two very civil landladies inform me, with many regrets, that their three rooms are taken up by a party of officials on a tour of inspection of boundaries, and that they have but their own apartment left, which they will give up. This, as a beginning of Corsican journeys, is not encouraging; but there is no help for it, for it is too late to go on or to go back ; and, besides, having undertaken "to see all Corsica," the matter must be gone through as it best may. So the " roba " is brought up to the third floor by a rickety ladder-stair, and in a little while my man sets up my bed, to the extreme amazement of the two hostesses, and makes things tolerably comfortable in one corner, while a mattrass in the farther one is to do for himself. The hostesses, with all the family, are to sleep in the kitchen, and Peter, the coachman, inside the trap.

Meanwhile, Mdme. Angela Paoloni, the chief landlady, brings notice that M. the Inspector, and the other officials, are about to sit down to supper, and she intimates plainly that unless I and my servant do so too, no other opportunity may present itself; so that the occasion is seized without delay. Miss C. had already told me that there would rarely be a chance of master and man eating separately, and that in her journeys she and her maid had always been co-partners at meals

In a small but clean-looking front room there was a large round table, which every one sat down to. The quality of the food served was quite unexpected in so rough-looking a roadside hostelry ; there was a tolerably good soup, and after it the inevitable boiled beef and pickles, then a stew, a timballo, roast lamb and salad, and a superb broccio. Capital wine, and plenty of it, was supplied.

Hardly had I sat down to supper than I found I had committed an error, into which a little previous thought might have prevented my falling ; yet, with the very best intentions, a man may sometimes " rush in where angels fear to tread." One of the party spoke French with a Parisian accent, the others were Corsicans. "Vous êtes donc Français, Monsieur ?" said I; a remark which directly produced a sudden chill and pause, and after that came this reply—" Monsieur, nous sommes tous Français," I had yet to learn that the words " French " and " Corsican " are not used by the discreet in this island ; you should indicate the first by " Continental," and the second by " Insulaire " or " du pays." It is as well, indeed, to recollect that there are old men still living who can remember the hopes of Corsican independence even up to

D

the end of the last century, and, consequently, all allusions by a stranger to differences of race are as well avoided, now that both people are under one government.

The fact, too, that I spoke Italian with greater facility than French evidently puzzled my supper companions, and when I asked questions about the country, there was a kind of occult distrust observable ; travellers in Corsica—in out-of-the-way places at least—are rare ; might I not be a revolutionary agent ? I asked about the wines made in the island, but when ill-luck urged me to speak about Sardinian produce, dumbness or short replies ensued, and at once I found that Sardinia was a tabooed subject. The better I spoke Italian and the more I hesitated in French, the less respectable I became, and since at the commencement of travelling in a new country one has all to ask and learn, my numerous inquiries were received and answered with caution, and my evil genius having suddenly prompted me to ask something about the Straits of Bonifacio, there was again a full stop, and a sensation as if all Caprera-cum-Garibaldi were about to burst into the room.

After this I confined myself strictly to observations on the nature of the supper and upon the climate of Ajaccio, and as the conversation afterwards was chiefly on local or municipal topics, I was glad to get away to rest for an early start to-morrow.

Earnestly entreating my servant to snore as little as possible (he can hardly occasion more disturbance than F. L., and I used to suffer in Greek khans from old Andrea), I congratulate myself on my forethought in bringing my little military bed, and think that if Corsican travel brings no greater hardship than this of its first day, it may be very bearable.

April 16.—Mdme. Angela Paoloni, of the " Hôtel " or " Café Restaurant du Cours," at Cauro, did not certainly overcharge for her supper and lodging, and for coffee this morning—to wit, three francs per head. A desire to oblige, and a homely sort of friendly manner, are also what I have to note down respecting this the first Corsican country inn I have come to.

By 6 A.M. Peter and the trap are ready, but as the road is an ascent as far as the Col San Giorgio, eight kilométres onward, and, as the morning is lovely, I set off walking, after having searched in vain for some spot whence I could make a characteristic drawing. of Cauro ; moreover, the landscape looking westward from above the village, though very beautiful, is of such magnitude and so full of detail as to be quite out of the pale of an hour or two's sketching. When the day is but just commenced, and the amount of what may be available for work is as yet unknown, it is not prudent to sit down to make a drawing, the time given to which may be proved later in the day to have been ill bestowed, in comparison with what should have been given to scenes which the painter is then reluctantly compelled to pass by in haste.

All the way up to the Col San Giorgio (the road throughout is broad and good, and the ascent not very steep) a succession of beautiful mountain scenery delights the eye ; and from a spot whence the majestic Monte d'Oro forms the principal point above all the surrounding heights, it is impossible not to pause to get a drawing. Yet the fine distance hardly attracts the attention more than the near at hand details of the excessively rich foliage which is the characteristic clothing of all the hills. This "maquis," or robe of green, covering every part of the landscape except the farthest snowy heights, is beyond description lovely, composed as it is of myrtle, heath, arbutus, broom, lentisk, and other shrubs, while, wherever there is any open

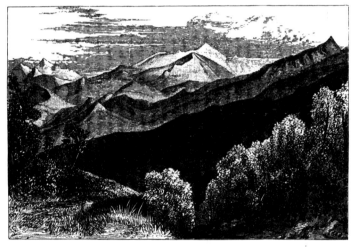

BOCCA DI SAN GIORGIO.

space, innumerable crimson cyclamen flowers dot the ground, and the picturesque but less beautiful hellebore flourishes abundantly. Here groups of ilex or chesnut rise above the folds of exquisite verdure ; there, but rarely, you pass a plot of cultivation, or a vineyard, in which stands one of those branch-woven towers supported on four poles, and not unlike a Punch and Judy box, called Torri di Baroncello, such as one used to see in days of Calabrian sojourn.(¹) The freshness of the morning mountain air adds to the pleasure of this walk, and as it increases higher up, this compensates for the

(¹) The leafy huts, called Pergoliti, formed by four young pine-stems fixed on small elevations in the middle of the vineyards, with a sort of first floor and a roof of clay, have a picturesque effect. In them abides the Garde Champêtre, called, absurdly, Baroncello.—*Valery*, i., p. 181.

In the vineyards curious watchmen's boxes are frequently seen . . . called Pergoliti. They consist of four young pine-stems, bearing a little straw-thatched hut, in which the watchman can lie down, high in the air.—*Gregorovius*, p. 400.

gradually barer scenery of the col, just below the summit of which, marked by a single roadside house, is a plentiful fountain of excellent water.

From the Col San Giorgio the road now turns eastward to descend into the great valley through which the river Taravo flows from the Col di Verde, joined on its way by streams from Zicavo, Sta. Maria, &c., into the Gulf of Valinco. The wide hollow, or basin, presents quite a new prospect full of variety and beauty ; on the farther side of it you see the village of Bicchisano, and above that, the road will pass the highest hills that bound the valley, and again dip down to the sea at Propriano, between Olmeto and Sarténé.

Meanwhile, the descent to the next village, Grosseto, where Peter the coachman says we must make a mid-day halt, and whence the road instead of following up the valley towards the mountains runs directly across it, continually increases in beauty ; the wild outspread of mountain form beyond, the profuse luxuriance of foliage, the refreshing greenness on all sides are really enchanting ; a continual succession of park scenes, groups of large chesnuts and venerable ilex trees, great shadowy snow-topped pine-grown heights far away, or huge granite masses close to the road, giving a constant interest to the scenery.[1] Often I could have liked to make a drawing, but thought it better not to delay at present, for the day's journey may be a long one, and the landscape is of a character to require sustained and attentive work. A landscape painter might well pass months in this valley of foliage, villages, mountain, and river.

9 A.M.—Grosseto is reached, and Peter not a little surprises me by saying it is quite necessary to remain the night there, declaring that the village of Bicchisano is twenty-two kilométres, or some fourteen miles, farther on, but on inquiry I find the distance to be but fourteen kilométres, and that if I prefer doing so I may easily, when the horses have well rested, say by eleven o'clock, get on to Olmeto before evening.

Grosseto is a village of scattered houses, and of the most quiet and rural appearance. Among five or six of its dwellings grouped together is one, neatly white, with " Hôtel des Amis " inscribed on it, to which we have driven ; a little beyond the inn, and standing alone, is the church, sheltered by fine ilex-trees, and a picture in itself (the ilex grows to an extreme size hereabouts), behind it are more evergreen groves and pastures, and the road which leads by Santa Maria Zicché to Zicavo.

Some time must pass before breakfast, which G. has ordered, can be ready, and I would gladly employ the time in sketching ; but, as is usual when an artist is obliged to stop anywhere for some such commonplace cause as horse-

[1] I seek in vain for any well-known district of Italy to give an adequate idea of such Corsican mountain valleys as these. The Apennines would approximate to them in many places. But these Corsican mountains and valleys seemed to me far grander, wilder, and more picturesque, from their chesnut groves, their brown precipices, foaming torrents, and scattered blackish villages. — *Gregorovius*, p. 411.

baiting, eating, or sleeping, the spot to which destiny nails him happens to be the least picturesque in the neighbourhood, and on the present occasion, without going back some distance, it is not easy to hit upon a subject for drawing, unless one made an elaborate study of an evergreen oak. The whole of this beautiful valley seems full of "silent woody places," but all the scenery is of a grave, or as some would say a Poussinesque character, for the sombre foliaged cork and ilex give ever a sad and dark tone to landscape, and a hasty sketch can convey but little idea of its character.

The village church is the only subject I can commence on, but, perversely enough, this can be done as I wish but from one single spot, to wit, in the road ; so I send for a chair and draw in public. But there is no fear of being disturbed ; a few men, all grave-looking, and dressed in shabby black and brown, stand round, but are quite well-behaved, and do not interrupt me, while groups of children look on silently at a greater distance. These Corsicans all appear to me intelligent ; I cannot recall having as yet seen a dull or stupid countenance in man, woman, or child ; nor is the intelligent expression one of sharp cunning, but rather of thought and good sense, always, however, with a shade of gravity—very little gaiety have I yet seen in Corsica. During this morning's progress I do not think I saw more than eight or ten peasants, and of those, three were close to a mill hard by this village, yet this is the high road to the south of the island, and the Diligence stops to bait at the "Hôtel des Amis" daily.

At 9.30 I go into the little wayside inn, and through a dirty entrance and by a bad wooden staircase arrive at a middle room, which seems that used by the family, and on each side of this are very clean and tidy little chambers, vastly better than the outside of the house would lead one to expect. In one of these, where prints of the Emperor and Empress, and of some of the acts of Napoleon I., adorn the walls, and in every part of which there are evident marks of attention to neatness and cleanliness, a small table is covered with a clean cloth, and breakfast is soon brought. The hostess, a homely but pleasant-mannered widow, with two rather nice-looking daughters, and a son who acts as waiter, apologise in few words for having little variety of eatables. Travellers, they say, come very unexpectedly, and for long intervals not at all ; so that, excepting at the times of arrival of the Diligences, they seldom have food in the house beyond such as they now set on the table, namely, eggs and salame (or ham sausage), a plate of good trout, and an indifferent steak, but, above all, a famous broccio, for which, on G. asking if they had any, they had despatched a messenger half an hour ago to some sheepfolds nearer the hills. Assuredly, after much that one has heard of wild and savage Corsica, the interior accommodation of this little inn surprises me, and the particular civility and desire to please, unaccompanied by any servility, are as satisfactory as the Widow Lionardi's charges, three and a half francs for breakfast for

me and my servant, a good bottle of wine, besides coffee, for myself being included in the sum.

11 A.M.—Off again, the road following the course of a clear stream, which makes its way to the Taravo, at times by the edge of steep banks and precipices, which I prefer coasting on foot, because there are no parapets, and Peter the coachman drives "whiles" more crookedly than is agreeable. The weather just now is delightful, and it is no small pleasure to walk below the beautiful shady trees—groups of immense aged evergreen oaks—through this charming valley, where the first cuckoo of the year is heard, and all along which the scenery, of a grave hue, reminds me frequently of that in " Epirus' valleys," although both this and that has each its own particular characteristic— Corsica, the broad carriage road which I see ahead for miles ; Greece or Albania, pastoral incident and the brightness of gay costume. Now the stream becomes more picturesque, dashing and foaming over granite boulders, like the Tavy or the Lyd; farther on it runs through a deep hollow filled with trees—and such trees ! And then it falls into the Taravo, the main river of this fine valley, over which a bridge carries the high road. Hence the landscape generally is less like southern scenery than Welsh or Scotch, though now and then a bit of Greece seems before me, where, as here, the evergreen oak is so characteristic a tree. One or two of these spots completely recall the wood scenes of Eriligova, in Thrace. Would that here there were the village girls of those parts, with their gold and coin chains, their red caps, and their festoon'd flower head-dresses ! Meanwhile it is much to sit below huge brown-armed trees, full foliaged, shading a green slope of freshest turf and fern, less green, indeed, than coloured with cranesbill, cyclamen, and forget-me-not ; my man the while gathering huge bunches of watercresses from the streams about, aidful of supper supply at the next halt. Where that halt will be does not seem certain, for the sky is becoming cloudy and threatening, and Bicchisano, still far up on the opposite hill, seems to have no especial attraction, though doubtless in fine weather the views from its high position and those of the snow-powdered rocks close above it, would be worth a stay to study.

In winding up the ascent above the Taravo Peter seems less and less to control his horses, which are apt to make for the side of the road with an abruptness that would be alarming were there such precipices as those nearer Grosseto; but Peter, whom I suspect to have been frequently, more or less asleep, apostrophises them with a lively fervour—" What, then, did you think that wall a house and stable ? Do you want water, and run to that rock to find a fountain ? "

At 12.30 Bicchisano, the mountain village extolled by some as a good summer residence, is reached ; it appears to be a collection of hamlets, and there is said to be one of the best little inns here on the road between Ajaccio

and Bonifacio, but the day has now become cold and windy, and as there would not be a chance of exploring the upper valley of the Taravo, I resolve to drive on to Olmeto, a decision clinched by a sharp storm of sleet and rain, which adds to my desire to exchange this high and shivering situation for a warm one, which Olmeto is considered to be.

A long ascent leads from Bicchisano [1] to another village, Casalabriva, pass-ing obliquely up the south side of the valley of the Taravo, commanding a constantly widening view towards Capo di Porto Pollo, on the Gulf of Valinco, in front, and looking back to the high central range near Mont Renoso, now of a dark smalt-blue under the shadow of heavy clouds, with here and there strips of fierce light on the snow. The promontories or spurs which, descend-ing from the mid-island heights form the walls of these deep and long valleys, are evidently constant characteristics of Corsican scenery on its west side. Throughout this ascent the road winds in and out along the mountain side, now carried round deep recesses or gorges full of enormous ilex, anon passing great masses of granite, shaded by great trees growing from their crevices; at several points clear fountains gush out by the wayside, but neither habitation nor human being was visible for the two hours employed in this part of the journey.

The top or col of this long climb is reached at 2.40 P.M., and turning abruptly round the hill, the long lines of the green valley of Taravo disappear, and Peter halts at Casalabriva, a more compact village than Grosseto or Bicchisano, but, with the exception of some rocks and evergreen oaks at its entrance, not promising in appearance. Nor, even were the weather fine, should I care to draw the place, the houses of which have no pretensions to the picturesque, though there are some peculiarities in their structure which speak volumes as to their discomfort and uncleanliness.[2]

From this height [3] the road descends very rapidly into the next valley which adjoins that of the Boracci, a stream flowing into the Gulf of Valinco

[1] At Bicchisano, a town of 800 inhabitants, there is a charming view from its new chapel and promenade. The prospect extends over a vast cultivated valley, with a glimpse of the sea and the Gulf of Taravo.

[2] [I regret not having visited Sollacarò, which is not far from Casalabriva.—E. L.]

Sollacarò, a village of 600 inhabitants, is distinguished for its view and for the number and variety of its historical associations. It was at Sollacarò, during one of the sojourns of Paoli, that Boswell visited him, and he speaks (*Boswell*, p. 354) of the house of the Colonna, in which he lived, as much decayed, and admitting both wind and rain. Here, too, it was that the widow came to General Paoli with her second son, " I have lost my eldest in the defence of his country, and I have come twenty leagues to bring him who remains, that he may serve you."—*Valery*, i., p. 197.

Sollacarò was a village always celebrated in the history of the island. It was the residence of the Signori d'Istria, and at some distance from the village stands their feudal castle, almost entirely destroyed. The ancient house of Vincitello d'Istria still exists on a high perpendicular rock in the village. The dungeons into which that tyrant threw his prisoners may still be seen.—*Galletti*, p. 155.

But Sollacarò may have more interest for the public of the present day from its connection with a romance of Alexandre Dumas, and the play founded upon it, than from Paoli's having held court, or Boswell's visit to him there. —*Forester*.

[3] It is called the Col Celaccia separating the valley of the Taravo from that of the Boracci, and is 576 mètres in height.

—and for a while hereabouts I fancy that I see the hills of Sardinia " fringing the southern sky," but am not sure whether the vision be land or cloud—and sending on Peter and the trap to whatever hotel there may be at Olmeto, I walk down the steep zig-zags leading to that little town, which stands perhaps half way down between the col and the shore. Thick wood, mostly evergreen, is the characteristic of this valley, which, unlike that of the Taravo, is narrow and closely shut in by heights, the tops of which are bare ; and their sides are covered with dense maquis, as well as groves of ilex and wild olive, and these, as the nook in which Olmeto is built expands lower down into the broad vale of the Boracci, are exchanged for rich plantations of cultivated olive, fruit trees, and corn.

3.30 P.M.—Olmeto, which from this approach you do not see till you are close upon it, is wholly unlike those villages of Corsica I have hitherto seen, and resembles many a hill town in Italy ; compact, and very picturesque, its houses looking towards the south and east, and hanging as it were in a steep hollow of hill which entirely shelters it from the west wind ; it is gifted with galleries and inequalities, and varieties of light, and shade, and colour, delightful to the painter's eye. The entrance is gloomy and dirty ; a narrow street runs through the village from end to end, and it is thronged with people, all in dark dresses, and all sitting or standing idle.

Nearly at the end of the street is Peter with the trap, at the door of the hotel—a most forlorn looking structure, entered by a flight of steps, eminently suggestive of possible bone fractures, being composed of very high and slippery stones without any parapet; and at the top of this is a small ante-chamber of equally forbidding appearance, leading to a sitting-room similarly unprepossessing. Half one end of this is occupied by a large open fireplace, with chimney-corners, where a wood-fire is blazing, a not unnecessary set off against the cold and damp of the day, and in which a little boy who perpetually coughs is crouched on a small stool. A very tiny bed-room, far cleaner than the appearance of other parts of the house would warrant one to expect, just allows of my camp-bed being set up in it, and my servant can be put up on a sofa in the " salle à manger ;" so, as dinner is promised by the landlady at sunset, I consider myself settled at Olmeto for the present. The hostess indeed, Mdme. Paolantonuccio, seems to be well satisfied with her hotel, and she tells me two gentlemen have been living for more than a month in it.

Meanwhile I go out in search of a point to make a drawing of Olmeto, which is in truth a beautiful place, and for general position, details, and surrounding scenery, as picturesque in every sense as any Italian town I ever saw. When you have passed out of the west end of the single street—there is a very large fountain here, as at the other extremity of the town—you perceive high above you, among the great towering rocks, one of those solitary sepulchre-chapels so remarkable in this island ; and beyond it, a cross on a

slight elevation above the high road, at once marks the precise spot from which a view of Olmeto must be made. Thither I went, and laboured at a large drawing, until showers of rain stopped my work.

No more beautiful site than that of Olmeto can be pictured. Immediately below the town the ground dips steeply down, covered with corn or turf, or

TOMB AT OLMETO.

in terraces of vineyard, varied with large groups of fine olive trees, resembling those thick clustering masses below Delphi in North Greece ; and these stretch away to gardens and other olive grounds down to the shore. Above the village a vast growth of vegetation climbs the heights, and besides huge rounded boulders of granite and dark bosky shades of olive and ilex, there are tangles of every shrub the island produces, the wild olive or oleaster being one of the most elegant. Across the valley all the lofty hills seem one solid mass

of " maquis," vivid green where lit by gleams of sunlight, or streaked with dark purple and gray as clouds rest on the upper heights or flit across the sky. And in the midst of this setting of every shade of green the little town of Olmeto stands out full of picturesque accidents of form and light and shade, its lower houses growing as it were out of granite crags, and surrounded by fruit trees. Nor does there lack foreground to this picture in the shape of rocky masses, creeper-and-lichen-grown, and imbedded in foliage of innumerable kinds. Certainly, if Corsica turns out thus increasingly beautiful from day to day, I shall have more than enough to do; but may weather be more propitious! (*See* Plate 4.)

Every part of the heights close to the town abounds with little picture-subjects—here a chapel, there a tomb exactly like " Absalom's Pillar " in the Valley of Jehoshaphat ; the dress of the peasantry alone is uninteresting in all this catalogue of picturesqueness.

Before sunset, however, I am glad to leave it all, as damp and chill increases, and to come to the hotel, where, having ejected four cats, a dog, and the coughing boy, the rest of the evening is passed. The fare, as usual in these untoward-looking hostelries, is far better than could be expected, though woe to the traveller who cannot eat omelettes! Mdme. Paolantonuccio, however, piques herself on abstruse and scientific cookery—eggs dressed with tomatoes, and other surprises, besides boiled and roast lamb, and the unfailing and excellent broccio, and wine of capital quality, the neighbourhood of Sarténé producing some of the best in Corsica.

A young man brings in the dinner, the hostess being employed in serving the two English gentlemen, who it seems are still in the village, though at another house. One of these two he describes as hopelessly ill, and I think I had better send or call to-morrow to know if any help can be given to a countryman in so out-of-the-way a place.

April 17, 5.30 A.M.—This inn, wretched enough as to its exterior and its entrance, is, after all, not intolerable, and again I note in the people of the house the obliging manner which thus far into Corsica I have invariably met with. The view from Olmeto is one marked by extremely delicate beauty. The olives on the slopes below the town more than ever remind me of those at Delphi at this hour, when the landscape is in deep shadow—for, alas! clouds are rapidly rising on all sides, and I fear rain. Most observable is the thickness and redundance of the vegetation here, the mingling of gray granite and green "maquis." But what could make M. Valery (Vol. i., page 200) write that Olmeto, a village clustered among rock and woods half way up a mountain, reminded him of Nice, a place of boulevards and promenades at the edge of the sea ?

The weather holds up sufficiently to allow of my working a good bit on

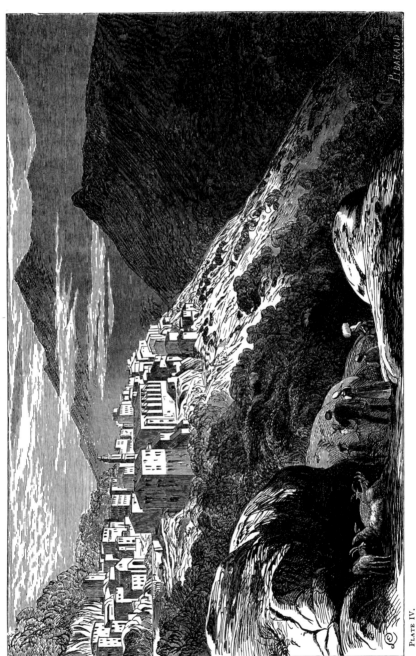

PLATE IV.

the detail of the drawing I commenced yesterday, but cloud and gloom increase every minute. While thus occupied, a good many of the men of Olmeto, going out toward their vineyards, pass where I sit, and some few stand still to see me draw. All are civil ; very dusky looking and slow, clad in the universal black or dark brown, and blackly bearded. But, on the whole, the people here appear a rougher set than those I have seen, and some of the children shout out, " O Anglais !"--As yet, however, since I landed in Corsica, I have not met with a single beggar.

At 7.30 there is but just time to return to the hotel before a violent down-pouring commences, and they say it will probably not cease all day. A conviction of dampness impresses me at this place ; and to-day, as well as yesterday, I observe very many people coughing. Fires, they tell me, are generally in use, and I cannot help thinking that the high hill which quite screens the town from the west, depriving it of afternoon sun, must be pre-judicial to dwellers in Olmeto, though, on the other hand, it saves them from the mistral.

After breakfast there is nothing better to do than to draw portions of the town out of a side window, and I send a card to the sick Englishman to learn if he would like to see me, in case I can in any way help him. To this a messenger brings word that he will gladly do so at noon, on which I am taken to a small house not far off, and by a very dirty staircase reach a floor, where in a room, far more comfortable within than its exterior predicted, was the sick man, whom, to my extreme surprise, I found to be Mr. B., the eldest son of Lord E. B. Already in ill health, he had come to this island in search of a warm winter climate ; but by a fall from his horse had received a serious internal injury from which it is next to impossible that he can recover. Though suffering greatly at times it did not appear to me that he was in want of anything, and he had with him one who seems an attentive and good domestic or companion. When I left him I promised to return and dine with him at seven, if the weather did not hold up, which, they say, it is not likely to do, though I am not without hopes of it. Meanwhile I come back to the hotel and find sleep the best occupation.

At 2 G. wakes me, saying "$\iota\dot{\alpha}\tau\rho\epsilon\acute{\upsilon}\epsilon\iota$ \dot{o} $\kappa\alpha\iota\rho\acute{o}s$—the weather is curing itself "—and certainly the rain has not only ceased, but the clouds are breaking, and a decision must be come to at once, since 3 or 3.30 is the very latest at which I may start from here in time to get to Sarténé, my next halt. I write, therefore, to Mr. B., stating that I am going to leave Olmeto, and then ordering Peter to get the trap ready, leave him and G. to follow, and set off on foot. Madame Paolantónuccio recommends me to go at Sarténé to the Hôtel d'Italie, where her son is cook.

All the way down to the sea-level the road from Olmeto zig-zags and curves through beautiful scenery, of similar character as to luxuriant foliage with

that higher up, but opening out more and more to broad green slopes and corn-fields dotted with olives, and spreading into wide distances of Claude Lorraine landscape, either looking west or towards the hills at Fozzano,([1]) in the valley of the Boracci. At every step there are studies for pictures, if only in the hedges, which are in some places literally blue with a beautiful climbing vetch.

The bridge over the Boracci, which runs into the sea here through some low marshy ground, green and pleasant to see, but exceedingly unwholesome as to air, is passed at 4 P.M. At the head of the Gulf of Valinco,([2]) which, spite of the bright sun now once more shining, has a sad and deserted look, the road follows the shore, and soon reaches Propriano, which stands on the sea, and appeared to me a dull and uninteresting place, containing some very tall and particularly ugly houses; once a week the steamer which goes from Ajaccio to Bonifacio touches here, but it seems a place of small traffic.

Striking inland, the road, after an uninteresting ascent, soon dips into the valley of the Tavaria, and here all at once the scenery becomes most beautiful in character, but unlike that I have passed through hitherto. Some of the scenes on the broad part of the river, which runs below exquisitely wooded hills, might be in Scotland or in Wales, and there are masses of granite and tufts of foliage perfect as foreground studies. One of the hills to the

([1]) Fozzano, a village of 700 inhabitants, the very hotbed of vendetta, is divided into two parts, composed of the most distinguished families, whose wealth and position enable them to continue this curse. These "vendette" (or vengeance), dating back forty or fifty years, have ruined this village, once one of the richest in Corsica. . . The aspect of this place at war with itself was shocking; every peasant walked about armed; the houses were fortified and barricaded, and the windows blocked up with bricks. A fourth of the whole population is in "vendetta;" between the families of the upper and lower village (di sotto e di sopra) such furious hostility exists that their members remain shut up in their dwellings, while even their children cannot go to school, for they would not be spared. More-over, these little rustic urchins know very well how to fire off their own pistols, and sometimes they have even their own private "vendette." On April 10, 1834, for instance, Louis Coli, a boy of thirteen years, shot another boy of Ajaccio in the head, taking him, while standing at a window, for one of his comrades with whom he had quarrelled.—*Valery*, i., p. 202.

Arbellara and Fozzano form part of the canton of Olmeto. Both have acquired a bad celebrity from the sanguinary and inveterate enmities which have long existed between their wealthiest and most dis-tinguished families. At present, in appearance at least, they enjoy perfect peace; but, oh, may such calm endure, and not be but the precursor of fresh tempests! In these villages are houses which resemble fortresses, and which are surrounded by walls serving as ramparts.—*Galletti*, p. 157.

[Fozzano is said to be the scene of M. Merimée's beautiful romance of "Colomba."—E. L.]

([2]) The Gulf of Valinco, into which the Taravo and the Rizzanesi flow, the two most important rivers of the west of Corsica. Like the Gravona and the Prunelli, they descend from the highest central mountains; their slopes are wooded and cultivated. The port of Propriano, the outlet for the produce of these valleys, is not safe; and the best anchorage in the Gulf of Valinco is at Porto Pollo.—*Grand-champs*, p. 28.

The basins of the Taravo and the Rizzanesi are separated from Bonifacio by several small uncul-tivated and wild valleys, which labour would fertilise, but which are now only frequented by flocks of sheep.—*Grandchamps*, p. 29.

Porto Propriano, open to S. W. winds, is not safe. Porto Pollo will be the most frequented of the ports on the western side after Île Rousse. The Port of Bonifacio, frequented by ships of small tonnage only, which carry on what trade exists between Corsica and Sardinia, is difficult to enter, and narrowed constantly more and more by detritus of ravines.—*Grandchamps*, p. 92.

Not far from the bridge over the Boracci, at the end of the Gulf of Valinco, stands Propriano, remarkable for its pretty houses, its commerce, and the number of its warehouses.—*Galletti*, p. 156.

right of the valley, with craggy outline and hanging woods, forms infinite fine pictures, and I have seen nothing in Corsica hitherto so classic and poetical. Beyond these succeed levels of cystus and asphodel, and then, after passing the opening of the valley of Tallano, the River Tavaria, which flows down it, is left, and the road begins the long ascent to Sartène, which stands at a great height, and has been visible since I came over the hill close to Propriano.

Sartène, ([1]) one of the four Sous-préfectures of Corsica, and a large, important place, is truly grand as approached from this side, though its architecture seems of questionable picturesqueness ; nevertheless, as a whole, it has an imposing look, and resembles Bova, in South Calabria, more than any place I can compare it to, though wanting in the castle-like groups of buildings which so adorn that Italian town. At Sartène, the massive square houses are more detached ; and in that respect it has a certain look of Arghyrò-Kastro, in Albania. As the road winds up the very long ascent to the town, the views of the great valley below, so varied with graceful lines and undulations of cultivated ground, and so rich in wood, and of the splendid snowy heights of the long range of mountains opposite, terminating in the lofty regions of the great Monte Incudine, are exceedingly noble, and perhaps give me greater pleasure than all I have hitherto seen of the landscape in this island. The town is approached by a fine bridge over a torrent, and from this point the whole valley, down to the Gulf of Valinco, is seen—one of the wildest and loveliest of prospects, and such as I had not at all anticipated to find in Corsica. (*See* Plate 5.)

Sartène seems to be a populous place, with many large houses ; but it was past sunset when I reached it, and I went at once to the " Hôtel d'Italie." For the Ajaccio diligence, which leaves Sartène at 6.30 P.M., had come thundering down the hill an hour before we arrived at the top of it, and, I suppose, to avoid any possibility of my being smuggled into any opposition locanda, the son of Madame Paolantonuccio, had come down to meet me,

([1]) Valery, writing of his visit to Sartène in 1834, says—This town of 2,700 inhabitants, in a fertile territory, considered the granary of Corsica, had been for a long time one of the most peaceable parts of the island. At present, however, it only breathes war and vengeance. Hostilities recommenced on September 16, 1830, and (says M. Valery, after describing a succession of battles in 1833 and 1834, productive of bloodshed, death, and increased hatred) it is difficult to conceive the existence of such a state of society with French government ; they have regulated half Europe, but are powerless against the nature, manners, and passions of the Corsicans.— *Valery*, i., p. 223.

Sartène suffered terribly from the Saracens. After repeated incursions, the Moors surprised the town in the year 1583, and in one day carried off 400 persons into slavery, probably a third of the population. *Gregorovius*, p. 416.

After the French revolution of 1830, Sartène was for years the scene of a horrible civil war. It had been split ever since the year 1815 into two parties, the adherents of the family Rocca Serra, and those of the family of Ortoli. The former are the wealthy, inhabiting the Santa Anna quarter ; the latter the poor, inhabiting the Borgo. Both factions entrenched themselves in their quarters, fastened their houses, shut their windows, made sallies at intervals, and shot and stabbed one another with extreme rage. The Rocca Serras were the white or Bourbonists, the Ortoli the red or liberals ; the former had denied their opponents entry into their quarters, but the Ortoli, being determined to force it, marched one day

and ensured my going to the right place by piloting me there himself. (Did I not, when I met that public conveyance, feel glad that I had not chosen to travel in it, knowing that the whole of the beautiful scenery from here to Grosseto would have been passed in the dark, seeing that the diligence only arrives at Cauro to-morrow morning at 7 A.M.!)

At the hotel—as usual, occupying only one floor of a house, in this instance a good sized one—I found several decent apartments untenanted, and was accompanied to the one I chose for myself by the landlady, a person of most astonishing fatness; her face was nice and pleasant, but in figure she was like nothing so much as Falstaff disguised as the "Fat Woman of Brentford." This bulky hostess looked on me with great favour, on finding that I was well acquainted with her native place, Como, and went into raptures when I talked about Varese and other Lombard localities. Nevertheless, at one moment I thought our acquaintance was to be of no long duration ; for, having discovered me in the act of putting up my camp-bed—which at first, I believe, she thought was a photographic machine, or something connected with art—she suddenly became aware of its nature, and, calling Giovanni and others of her household, shouted out, "Ecco un signore chi sdegna i letti di Corsica!—here is one who despises the Corsican beds!" —and I did not know what might have followed this discovery, till my servant assured her that this was my constant habit, and by no means referred to her particular hotel, by which announcement the amiable Fatima allowed herself to be pacified.

Later, the supper she provided was excellent, and she could not be satisfied without bringing far more dishes than were required, with fruits and smaller delicacies, such as olives, pickles, butter, &c., and the best of Tallano wine.

April 18.—Coffee was very obligingly got ready some time before sunrise, and the early part of the morning went in making a drawing below the town,

with flags flying to the limits of Santa Anna. The Rocca Serras instantly fired from their houses, killing three men and wounding others, and this was the signal for a bloody battle. On the following day many hundred mountaineers came with their guns, and besieged Santa Anna. The Government sent a military force ; but, although this to all appearance produced tranquillity, the two parties still kept assailing one another, and killed several men of their adversaries. The variance still continues, although the Rocca Serra and Ortoli have met amicably at the festival of Louis Napoleon's election to the Presidency for the first time after an enmity of thirty-three years, and allowed their children to dance together. These ineradicable family feuds present the same spectacle in Corsica as the Italian cities, Florence, Bologna, Verona, Padua, and Milan, offered to the world in olden times ; but these family feuds are far more striking and terrible in Corsica, because they are carried on in such small places, in villages often possessing scarcely a thousand inhabitants, who are, moreover, indissolubly bound to one another by the bonds of blood and the rights of hospitality. At Sartené politics produced civil war ; elsewhere, this is produced by some personal injury, or by any the most trifling circumstance. For a dead goat there once died sixteen men, and a whole canton was up in arms. A young man throws a bit of bread to his dog, the dog of another man snaps it up, thence arises a war between two parishes, and the consequence is murder and death on both sides.—*Gregorovius*, p. 417.

The town of Sartené is situated in the basin of the Rizzanese ; its annals go no further back than

SAKTÉNÉ.

PLATE V.

J. BARAUD

some short way down the hill (from a spot whence a wonderfully fine picture might be made), until the sun, shining above the houses, prevented farther work. These views of Sarténé are most majestic and poetical; and, moreover, while the buildings of the town are in shadow, the commonplace nature of their details is hidden. The great isolated blocks of granite which seem thrown about on all sides on purpose to serve as foreground, the excess of wild vegetation, the silence of the deep valley or plain, and the clear lines of snow crowning all, combine to make a thousand bewitching subjects.

After 7 or 8, a walk on the other side of the city, and a long scramble among thick woods, where the ground is literally red with cyclamen, show me more of the Sarténé scenery; from the eastern side of the town you look into the quietest of profound valleys, above which the lofty line of what I suppose to be the Incudine mountain range shines crystal clear and bright against a cloudless sky. I shall certainly remain here to-morrow, at least, and try to get as many records as I can of the landscape, which is of a class rarely met with in such perfection, so fertile and so varied, so full of giant rocks, of abundant foliage, and sublime mountain forms.

But it is necessary to give M. Galloni d'Istria's letters to the Sous-préfet and to M. Vico, Sous-Inspecteur of Forests, from whom I am to gain information about the woods of Bavella, which are to be visited from the east side of the island; so I return to the town. The streets of Sarténé are not gifted with any charm of liveliness; the lofty square houses are built of blocks of rough granite, dark gray in colour, and many of them are so massive as to look more like prisons than private dwellings.

Signor Vico, a most obliging person, gives me every information about the roads. From Solenzaro, he says, my light carriage can cross the heights of Bavella, at which place I am to have an introduction to the government agent, who resides in the forest, and thence I may return by Zonza, Levie, and Tallano, to Sarténé. The whole distance across the mountains he represents as about seventy or seventy-five kilométres—forty-five miles, more or less—and provided no new fall of snow occurs, I shall find no difficulty in crossing. He confirms M. Galloni's opinion, that the Bavella forest scenery is among the finest in the island.

At 10 I am back at Fatima's hotel for breakfast. That person evidently

the sixteenth century. In 1583 it was taken by assault by Hassan, King of Algiers. About 1732 the town suffered much from the incursions of pirates, and the eleven villages depending on it were reduced to one.—*Grandchamps*, p. 28.

In the district of Sarténé are also some remains of *menhirs* and *dolmens*, those ancient mythical stones which are found in the islands of the Mediterranean and in Celtic countries. They consist of columnar stones erected in a circle, and are here called stazzone.—*Gregorovius*, p. 427.

In Sarténé (writes the Abbé Galletti, proudly), are found shops of every kind, cafés, and hotels after the fashion of the Continent —*Galletti*, p. 158.

'The poetical Gregorovius, p 414, says the streets of Sarténé are peopled with demons, and calls it a large paêse in melancholy isolation among melancholy mountains.

has regrets for her native land, and my acquaintance with the towns and villages of her early days continues to give me great interest in her eyes. She is most profuse of good things ; her wine of the best quality ; her table cleanly and carefully set out ; and her attentions unfailing. But she laments the little traffic of Sartené, and says, what must be true enough, that many articles of perishable nature cannot be kept, because so few passengers come to eat them. Her principal custom seems derived from pensionati, civilians, government officials, &c. (the officers of the garrison—for Sartené has a small garrison—go to the opposition hotel), and she makes such efforts to please all that she assuredly merits success.

At 11 I start down the hill for a walk of nine kilométres (about six miles) to get recollections of the river scenery of the Tavaria, and of the great granite boulder foregrounds. The cuckoo sings cheerily, and the cystus flowers scent the air. Up to the seventh kilométre there is comparatively little to interest ; but thenceforward, when you have passed a wayside fountain where aged and broken ilex trees and a carpet of fern make a picture, all is charming. Little, however, can be represented of this extremely beautiful scenery by the pencil alone; the colouring of the river and that of the densely-foliaged cork and ilex groves, and of the granite fragment-strewn hills—which have a sort of velvety and speckled texture or quality—are characteristics only to be given by hard study with the brush.

Returning, drew some of the great rock foregrounds. How difficult it is to give ever so slight an impression, on a small scale, of objects as full of detail as of grandeur—of those huge wrinkled Philæ-like masses of granite ; of that mingling of tall evergreen oak and rock ; that smooth bright green turf, dotted with flocks of black sheep! Worked till I was weary, and yet again, upon a view of Sartené, on my way up. The specky grayness of the hill on which the town stands is strongly contrasted with those parts that are covered with green-brown maquis.

The long ascent to Sartené—I cannot call it tedious, so varied is the scenery, so delightful at this hour the song of innumerable blackbirds, so opportune the many little rock fountains for refreshment—was accomplished by 7.15 P.M. The last look before you turn towards the street leading into the town it is difficult to cut short—to pass the bridge, without lingering to gaze down the long, long valley westward to the sea.

All through the day I have observed the civility of the passers-by, mostly bearded men in black or brown, with brown cloth caps, riding on spirited little horses, the few women with them always riding astride, and always dressed in black ; not a vestige of costume exists. Every one saluted me as I sat drawing. One called out, " We are glad you are making our Corsica known by drawing it !" Another said, " Perhaps when you foreigners know us better, you will cease to think us such savages as we are said to be !"

Fatima's reception and supper were as cheery and good as heretofore. To-morrow I shall devote the whole day to the Tavaria scenery, and all things are to be in order to start at sunrise if possible.

April 19.—At 5.30 A.M. I walk down the hill, and drawing more or less by the way, gradually reach my farthest point, the bridge over the Tavaria, a distance of some eleven kilométres, or seven miles. Such a walk here, at early morning, is unboundedly full of pleasant items; the whistle and warble of countless blackbirds, and the frequent cuckoo's note; flowers everywhere, especially the red cyclamen, blue vetch, yellow broom, tall white heath, pink cranesbill, and tiny blue veronica; the great rocks—at this hour in deep shadow—overgrown with ivy, moss, and a beautiful red lichen; the slopes of fern and cystus; all these are on each side, and below there is ever the grand valley scene. I must linger yet another day at Sartené; indeed, a week would be a short stay in these parts for an artist who really wished to study this fine order of Corsican landscape.

About the seventh kilométre the road is lively by groups of peasants going up to the town on the fête day—lively, that is by movement, not by colour, for all are gloomily black, caps, beards, and dresses—trotting on little ponies, many of which carry two riders. While I sit drawing above the Tavaria bridge, a shepherd leaves his large flock of black sheep and stands by me. At length he says, "Why are you drawing our mountains?" "Per fantasia e piacere," I reply, "for fun, and because it gives me pleasure to draw such beautiful places." "Puole," quoth he, "ma cosa siggriffica?"—"That may be, but what is the meaning of it?"—"da qualche parte d'Italia venite certo"—"You come, it is plain, from some part of Italy; do you go about mapping all our country?"—"facendo tutta la Corsica nostra dentr' una carta geografica?" But I, who cannot work and talk at the same time, tell him so, on which he says, with an air of wisdom, "Si capisce—I understand,"—and goes away apparently in the belief that I am constructing a political survey of the island.

At 11 it is time for breakfast, which G. has set, with cloaks and a folio for chair and table, below a large olive tree some way off the road; and Fatima the plentiful has outdone herself by a selection of good things, cold lamb, eggs, tunny, and Sta. Lucia di Tallano wine. I have seen few spots more full of poetical beauty than this, which, though close to the high road, would be completely a solitude but for hosts of birds, of which the woods are full, especially blackbirds, titmice, and bee-eaters, with many jays and ravens, whose home is in the crags high up on Monte Lungo. But after mid-day, all these woodland and mountain dwellers cease to sing or cry, and the bright dead silence of southern noon succeeds to the lively freshness of morning. Once only a living stream of some eighty jet black goats suddenly passes along the green sward by the little brook, sneezing and snuffling after

E

RIVER SCENERY NEAR SARTÉNÉ.

their fashion, and disappearing behind the great crags of granite, leaving silence as they had found it; little greenish lizards playing about the flat stones being now the only sign of life all around—

> " For now the noonday quiet holds the hill ;
> The lizard, with his shadow on the stone,
> Rests like a shadow."

The whole scene recalls to me many a morning in Greece, and repeats the " days that are no more," as I had not supposed they could be brought back.

Let a landscape painter, having set out from Sarténé, turn off the high road to his left, where, a little beyond the ninth kilométre from the town, he comes upon some fine detached rocks, forming a screen to an opening that leads to a vista of thick wood and noble mountain, and let him follow the winding goat tracks to the foot of the hill; there he will find on every side hundreds of foreground studies of incalculable value. The granite fragments are usually of a pale dove or slate colour, mottled with thousands of vegetable tints, green, white, yellow, orange, and black lichen, tufts of a red kind of stonecrop, moss, and ivy ; and of such masses of rock with a portion of the background to make a picture, he will find enough work for months of artist-life.

One more pause before setting out townward, to draw by the river where the wood overhangs the cliffs and masses of granite, and where the clear water reflects the delicate hues of the pallid hill above it. Then as the sun sinks lower (for it is 4.30 P.M.), while the light and shadow on the rocks in the valley and on the exquisite mountain is constantly changing, and silvering the high crags and gilding the tufted trees, I go reluctantly. Since I made drawings at

BADOUREAU

SCENERY NEAR SARTÉNÉ.

PLATE VI.

Mount Athos, in 1856, I have seen no heights so poetically wild, so good in form, and so covered with thick wood ; and, altogether, as a wild mountain scene this has few rivals. A shepherd tells me they call the chief hill here Monte Lungo. (*See* Plate 6.)

The ancient Coliseum sack is packed, and I set off on my return. Here, at the seventh kilométre, are twenty Corsicans on just ten horses, no more— a by no means ordinary spectacle—riding back from Sarténé.

On the way up the long ascent I am met by the landlord of the Hôtel de l'Univers at Sarténé ; he says he had heard that my worship was coming, by a message from the Secretary-general, and "had not the son of that woman at Olmeto been so cunning as to seize your honour first, by artfully coming down the hill, you would have come to my hotel, which is wholly the best at Sarténé, and most fit for you to have gone to ;" to which I can only reply by regrets, and by assuring my host of the Universe that Fatima's inn is as comfortable as need be.

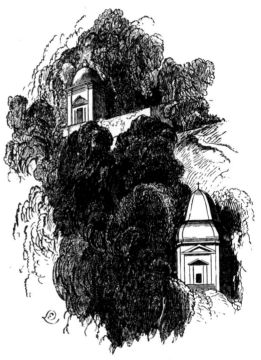

TOMBS AT SARTÉNÉ.

Many a spot on the way up to the town has a charm at this hour which it does not possess earlier in the day, for now the sun has set, the contrast of the almost black ilex against the pallor of the fading blue mountains is lovely and wondrous ; so, by reason of lingering to make notes and memoranda, I do not reach Sarténé till 7.45.

April 20, 5.30 A.M.—The first part of the day is passed in completing drawings of the town and valley already commenced, and in making other small sketches characteristic of a place I may perhaps never revisit, at least with leisure for drawing. One or two of these sketches are of the mortuary chapels or sepulchral monuments, which are very numerous and conspicuous about the

neighbourhood of Sarténé, and are often exceedingly picturesque, some high up peeping from thick woods of wild olive and cork, others in positions close to the road

Then I pay a visit to M. Peretti, one of the Sous-préfets of the department, who was away when I came here first, a very agreeable and kindly person. To his inquiries as to what I thought of and how I liked Corsica I made a reply which savoured certainly more of the artist than the politician, namely, that I regretted extremely to find no Corsican costume in the island. " Vous voulez donc, Monsieur, recommencer avec la nationalité Corse ? " " Do you wish to re-establish Corsican nationality ? " he asked, laughing. Of the present condition of the island he speaks as having absolutely no affinity with that in existence at the commencement of this century, or rather up to the year 1852, when the general disarmament of the population took place— " robbery, banditism, vendetta, all beyond that period belongs to the past, and are exchanged in the present day for security and tranquillity."

After visit to M. Vico, it becomes requisite to practise letter-writing and resignation indoors, for, cloudy all the morning, it now rains in torrents ; the weather, however, has been very propitious for drawing in Sarténé, and even this downfall may presage a clear day for to-morrow.

4.30 P.M.—The mists roll up from the higher mountains, and disclosing bright paths of coming sunset, enable me to go out once more to make some last sketches. All about the Cappuccini—a small convent just outside the town—there are beautiful bits of landscape ; but they are not easily attainable, because there is an inconvenient custom here of building up high stone walls, enclosing nothing at all; probably they mark divisions of property; at the same time they interfere much with the researches of painters not gifted with kid-like activity. Nevertheless there is hardly a path round Sarténé that does not lead to some surpassingly fine bit of landscape, and excepting Civitella and Olevano, I have known no such place for study combining so many features of grandeur and beauty. Perhaps in the finest parts of Calabria there is more analogy to the class of scenery here, but in that part of Italy there is a greater amount of culture and less variety of unbroken wildness. As the sun goes down, a band of golden light beams along the Gulf of Valinco, and a last shower breaks over the misty gray olive woods and the huge lichen-grown rocks ; so at 6.30 I return to the Hôtel d'Italie.

I ask my hostess about the mourning which every one seems to wear here. She says, for a parent or a child you mourn for life, as also for brothers, sisters, husbands, and wives, unless you marry (or re-marry) after their death, on which event you cease to mourn, and a new life is supposed to commence. " Allora, il matrimonio taglia il duol—then marriage cuts the grief." For an uncle or aunt you mourn ten years, and for a cousin seven, so that it is not wonderful that the world is so mournful as to dress in these parts. On the hostess

asking my opinion on various matters regarding Corsican inns, and on my gently suggesting that somewhat more cleanliness and attention in the matter of floors, stairs, &c. (for, indeed, the state of these contrasts strangely with that of the very clean linen, table service, &c.), would be very likely to have beneficial effect on the recommendation of English visitors, Fatima says excitedly: "Come posso far tutto? How can I do all things? In Corsica there are no servants; they consider service a dishonour, and will starve sooner than work." Yet she promises to do something for the unwashed floors. "Can I," she says, "prevent those who come to my hotel, and through whom chiefly I am able to keep it up, from bringing their dogs, and throwing all the bones and broken fragments of meat on the ground for them? Cosa volete che faccio?" Finally she hits on an ingenious compromise: "So béne che vi dev' essere la pulizia, ma qui in Sarténé non é possibile—I know well that it is proper that things should be clean, but here cleanliness is impossible—Dunque, voglio colorire con color' oscuro tutt' il fondo delle camere; cosi appunto non si scoprirà le sporcherie! —Therefore I will colour with a dark tint the floors of all the rooms, and so nobody will be able to see the dirt!"

Peter the coachman, who has already asked for two supplies of money, comes for more, and it begins to be suspected that the horses do not altogether benefit by this so much as they should in the shape of orzo or barley.

CHAPTER III.

April 21, 6 A.M.—After drawing an outline of the mountains, I am picked up by Peter, G., and the trap. After three days' stay (and I could willingly remain here for as many weeks ; for what have I seen of the upper valley or the opposite hills ?) I leave Sarténé, and can bear witness to the good fare, moderate charges, and constant wish to oblige of Fatima, padroná of the Hôtel d'Italie. Poor Fatima, rumour says, is forsaken by her husband, and " dwells alone upon the hill of storms," as in the literal sense of the expression Sarténé must certainly be, for it is exposed to all the winds of heaven, and from its great elevation must needs be bitterly cold in winter.

Just above the town, where the high road to Bonifacio passes the Capuchin convent, there is the finest view of Sarténé and the mountains ; the whole town stands out in a grand mass from the valley and heights, and there is something rough and feudal in its dark houses that places its architecture far above that of Ajaccio in a picturesque sense. (*See* Plate 7.) But to halt for drawing now is not to be thought of, inasmuch as this day's journey to Bonifacio is not only a long one, but because in the whole distance (some fifty-three kilométres, or thirty-two miles) there is only a single wayside house, where the horses are to bait, yet where humanity, expecting food, would be severely disappointed. Hearing which, the Suliot has taken care to pack the old Coliseum sack with food for the day.

SARTÉNÉ.

PLATE VII.

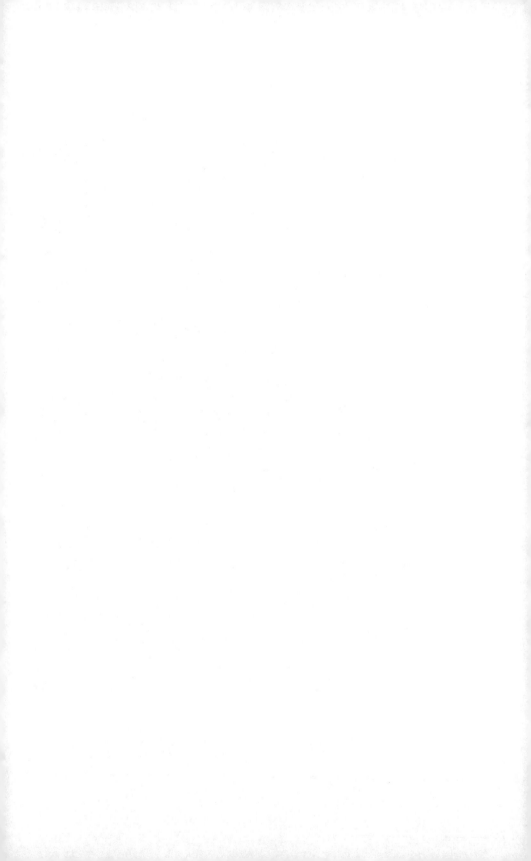

How grand at this hour is the broad light and shade of these mountains and valleys ! (notwithstanding that such as leave their houses at ten or eleven A.M. complain of "want of chiaroscuro in the south.") How curious are the chapel-tombs, so oddly and picturesquely placed, and frequently so tasteful in design, gleaming among the rocks and hanging woods ! At first, after leaving Sarténé, the road passes through splendid woods of clustering ilex, and then begins to descend by opener country, shallower green vales and scattered granite tors or boulders, here and there passing plots of cultivation, and ever farther away from the high central mountains of the island. Now the distance sweeps down to lower hills, all clothed in deep green "maquis," and at every curve of the road are endless pictures of gray granite rocks and wild olive.([1])

While I am thinking how pleasant it would be to get studies of this very peculiar scenery, by living at Sarténé, and walking seven or eight miles daily, Peter suddenly halts below the village of Giunchetto, which stands high above the road. "What is the matter ?" says G.; but Peter only points to the village and crosses himself, and looks round at me. "What has happened ?" I repeat. Peter whispers, "In that village a priest has lately died, and without confessing himself." In the midst of visions of landscape—"What," as Charles XII. said to his secretary, "What has this bomb to do with what I am dictating ?"

Farther on, near the eleventh kilométre, are some enormous granite blocks, with two or three stone huts by the road-side, and then follows a steep descent to the valley of the Ortola ; looking back, you see

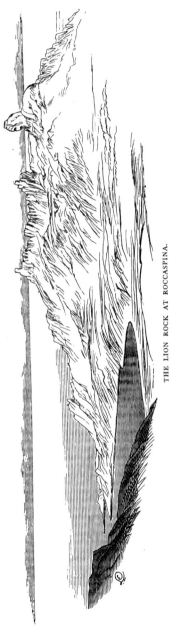

THE LION ROCK AT ROCCASPINA.

([1]) A rich waved country, with some few interruptions, reaches along the east and south coasts to Bonifacio. —*Boswell.*

a world of mist-folded mountains in the north-east, while ahead are "maquis," and cystus carpets, sown with myriads of star-twinkling white flowers, broom, and purple lavender. The descent to the Ortola valley abounds with beauty, and by its verdure reminds me of more than one Yorkshire dale—here, instead of the oak or ash, depths of aged evergreen oak and gray-branched cork-trees, shading pastures and fern.

At 8, the river, a shallow stream, is crossed by a three-arched bridge · and here, near a solitary stone hut, are a few cattle and some peculiarly hideous pigs—the only living things seen since I left Sarténé. Then, at the eighteenth kilométre, an ascent on the south side of the valley brings me in sight of the long point and tower of Cape Roccaspina and of the broad sea, above which I halt at 9 A.M., for the great Lion of Roccaspina may not be passed without getting a sketch of it. And, truly, it is a remarkable object— an immense mass of granite perfectly resembling a crowned lion, placed on a lofty ledge of the promontory, and surrounded by bare and rugged rocks. (¹) (See Vignette, p. 55.)

The road now becomes a regular còrnice coast-way, alternately descending and rising, always broad and good, and well protected by parapets ; long spurs of rock jut out into the sea beyond odorous slopes of myrtle and cystus, while in some parts enormous blocks and walls of granite form the left side of the picture. Presently the road diverges more inland, and is carried through wild and lonely tracts of "maquis," varied by patches of corn at intervals, and recalling the valleys of Philistia when you begin to ascend towards the Judæan hills from the plains near Eleutheropolis. Two flocks of goats— of course, black—and a few black sheep and pigs, who emulate the appearance of wild boars, with one man and one boy, are the living objects which a distant hamlet (I think Monaccia) contributes to the life of the scene. Occasionally glimpses of the distant sea occur ; but, as far as eye can reach, the wild green unbroken "maquis" spreads away on every side.

At 10.30 "half our mournful task is done," and the mid-day halt at a house (one of some six or seven by the wayside) is reached. The appearance of these dwellings is very poor and wretched ; and a gendarme informs me

(¹) Not far from the mouth of the Ortoli stands a solitary post-house, and opposite it a ledge of rock, on which the tower of Roccaspina stands. An oddly-shaped block of stone rises near it on the sharp edge of rock ; it bears a striking resemblance to a colossal crowned lion, and the common people call it "Il leone coronato." We proceeded along the coast, which is interrupted by arms of the sea, and melancholy. Small rivers creep through morasses into the sea, upon the coast cliffs of which gray towers hold guard. The air is foul and unhealthy. I saw a few small hamlets on the side of the hill, and was told that they were empty, for that the inmates do not return to them from the mountains till the month of September. . . Two small gulfs, that of Figari and that of Ventilegne, resemble fiords, &c —*Gregorovius*, p. 430.

Failing the long-promised road from Ajaccio to Bonifacio, the sea twice bars your onward way to that city. As the shore is steep, it is necessary to go a good way out into the Gulf of Ventilegne to find a shallow ford, and thus you gallop, very poetically, but with no small discomfort, in the middle of the waves.—*Valery*, i., p. 229.

that from the end of May till November they are all deserted, so unwhole-
some is the air of this district ; and that the few peasants at present here
go up at that season to the villages of Piannattoli or Caldarello—small
clusters of houses higher up on the hill-side. How little cheerful the aspect
of this part of the island must be then, one may imagine from what it is
even in its inhabited condition.

On a rising ground close by are some of those vast isolated rocks which
characterise this southern coast of Corsica—a good spot whereat to halt for
Fatima's breakfast. Looking southward, green lines of campagna stretch
out into what is the first semblance of a plain that I have seen in this island,
and which is exceedingly like portions of Syrian landscape. It was worth
while to get a drawing of this, and I would willingly have stayed longer, but
at I P.M. it is time to start again.

The road continues across comparatively low ground by undulating
inequalities, through wide "maquis"-dotted tracts, where here and there the
tall giant-hemlock is a new feature in the more moist parts of the ground.
Twice we descend to the sea at inlets or small creeks—Figari and Ventilegne—
in each case passing the stream which they receive by a bridge, and at these
points marshes and "still salt pools" show the malarious nature of the district.
Nor does the landscape painter fail to rejoice that he has chosen this method of
"seeing all Corsica," and that he is able to drive rapidly over this part of it,
where there is no need of halt for drawing, for the higher mountains are far away
from the south of the island, and the hills nearer the coast stretch seaward
with a persistent and impracticable length of line not to be reduced to agree-
able pictorial proportion. Once only, at 3 P.M., about seven kilométres from
Bonifacio, I stop to draw, more to obtain a record of the topographic character
of the south-west coast than for the sake of any beauty of scenery, of which
the long spiky promontories hereabouts possess but little, although there is
a certain grace in some of those slender points running far out into the blue
water, and, though far inland, you may at times catch a glimpse of some
heights of varied form ; yet, be your drawing never so long or narrow, the
length of the whole scene is with difficulty to be compressed within its
limits.

At 3.30 I send on Peter and the trap to Bonifacio, and walk, for so
many hours of sitting still in a carriage cramps limbs and head. As the hills,
from the ascent to which I had made my last drawing, are left behind, Boni-
facio, the Pisan or Genoese city, becomes visible ; extreme whiteness, cliffs as
chalky as those of Dover, and a sort of Maltese look of fortified lines are the
apparent characters at this distance of a city so full of interest and history.
Opposite, towards the south, a thick haze continues to hide the coast of
Sardinia, and this has been no light drawback to the day's journey, since the
sight of remote mountains and the blue straits would have gone far to relieve

the "maquis" monotony, driving through which has occupied so much of the time passed between Sartené and Bonifacio.([1])

Meanwhile a space of three or four miles has to be done on foot, shut out from all distant view, as well as very uninteresting in its chalky white dryness of road, about which the only features are walls, with olives all bent to the north-east, and eloquently speaking of the force of the south-west wind along this coast. But at 4.30 P.M. fields of tall corn and long-armed olives replace this ugliness, and the road descends to a deep winding gorge or valley, closely sheltered and full of luxuriant vegetation, olive, almond, and fig. After the boulders and crags of granite, which up to this time have been the foregrounds in my Corsican journey, a new world seems to be entered on coming to this deep hollow (where a stream apparently should run, but does not), for its sides are high cliffs of cretaceous formation, pale, crenelated, and with cavernous ledges, and loaded with vegetation.

At 5 P.M. the road abruptly reaches the remarkable port of Bonifacio, which forms one of the most delightful and striking pictures possible. Terminating a winding and narrow arm of the sea, or channel, the nearer part of which you see between overhanging cliffs of the strangest form, it is completely shut in on all sides, that opposite the road by which alone you can reach it being formed by the great rock on which the old fortress and city are built, and which to the south is a sheer precipice to the sea, or rather (even in some parts of it visible from the harbour) actually projecting above it. At the foot of this fort-rock lies a semicircle of suburban buildings at the water's edge, with a church, and a broad flight of shallow steps leading up to the top of this curious peninsular stronghold ; all these combine in a most perfect little scene, now lit up by the rays of the afternoon sun, and which I lose no time in drawing.([2]) (*See* Plate 8.)

A broad and good carriage road leads up to the city, huge grim walls enclose it, and before you enter them you become aware how narrow is the

([1]) Crossing the last point of land in Corsica towards the south-west, namely, Santa Trinità—the tongue which ends in Capo di Feno—the white chalk cliffs of Bonifacio come into view, and this most southern and most original town of the island, itself snow-white like the coast, placed high up on the rocks ; a surprising prospect in the midst of the wide and depressing solitude.—*Gregorovius*, p. 430.

The territory of the town of Bonifacio, built at the southern extremity of Corsica, is carefully cultivated and covered with olive groves. The inhabitants, by toil and perseverance, have made their stony soil fertile, although it is devastated perpetually by terrible winds. As you approach the upper part of the territory of Bonifacio, you observe that all the trees are bent in an easterly direction by the prevailing winds, and their horizontal branches follow the same. These winds, prevailing from the west to the east, are produced by the central mountain mass of Corsica ; they are extremely violent at Cap Corso, and in the straits of Bonifacio, where navigation is often dangerous. Less strong at Calvi, they are unfelt at Ajaccio and Propriano ; they begin to prevail at Figari, and become very violent at Bonifacio.—*Grandchamps*, p. 29.

([2]) The position of Bonifacio is extraordinary, and perhaps unique. On a calcareous rock, horizontal at its summit, almost perpendicular at its sides, and pierced with vast caves ; its little peaceful port, an oval basin formed by nature ; its marvellous sea-grottoes ; its fortifications ; all these together make Bonifacio the most curious city in Corsica ; and to see it alone, the voyage thither would be worth

PORT OF BONIFACIO.

PLATE VII

little isthmus that joins the rock-site of Bonifacio to the main land; from a small level space close below the fort you see the opposite coast of Sardinia, and you look down perpendicularly into the blue straits which divide the two islands. Very narrow streets conduct from the fortifications to the inner town; the houses are lofty and crowded, and Bonifacio evidently possesses the full share of inconveniences natural to garrison towns of limited extent, with somewhat of the neglected and unprepossessing look of many southern streets and habitations. There was no difficulty in finding the Widow Carreghi's hotel, but its exterior and entrance were, it must be owned, not a little dismal, and the staircase, steep, narrow, wooden, dark, dirty, and difficult, leading to the inn rooms on the third floor, was such as a climbing South American monkey might have rejoiced in. Nevertheless, once safe at the top of this ladder-like climb there are several little and very tolerably habitable rooms; and, as seems to be invariably the rule as to Corsican hostesses, the two here are very obliging and anxious to please.

There was yet time to walk through the town, which I was surprised to find so extensive and populous. Some of the churches are ancient, and near the end of the rock (though the lateness of the hour, together with a powder magazine and obstructive sentry, prevented my getting quite to its extremity) a considerable plateau with barracks and other public buildings exists, and I can well imagine some days might be spent with great interest in this ancient place. As it was, I could but make a slight drawing from the edge of the precipice looking up to the harbour or sea-inlet, but from such examination it was evident that the most characteristic view of this singular and picturesque place must be made from the opposite side of the narrow channel, though it does not appear how, except by boat, such a point can be reached. Bonifacio is doubtless a most striking place and full of subjects for painting; the bright chalky white of the rocks on which it stands, the deep green vegetation, and the dark gulf below it, add surprising contrasts of colour to the general effect of its remarkable position and outline.

undertaking. And you may add to all this interest, those of old and heroic associations, of ancient MSS., and, above all, of the quiet and good population, which, unlike that of the rest of the island, has never carried arms, nor has it been a prey to "Vendetta." Bonifacio, indeed, which had its own laws and coined its own money, was rather a confederate republic than a subject of Genoa. One of the oldest cities in Corsica, it owes its foundation to the illustrious Boniface, the Pisan lord, Marquis of Tuscany, Count of Corsica, Governor for the Emperors, &c. Boniface landed on this coast A.D. 833, and built the castle. . . At the entrance of the town, opposite the street called Pizzalunga, is the house in which Charles V. lodged in 1541; the door is decorated with an arabesque on marble of elegant design. When Charles V. left the city, his host, Philip Cattacciolo, shot the horse the emperor had used, saying that after him no one else was worthy to mount him. . . In the same street, and nearly opposite, I was shown a room occupied by Napoleon I. . . The great tower (Torrione), now a powder-magazine, was the old castle, and the only fortress of the town at the time of the arrival of the Genoese colony in 1195. La Manichella is the point nearest to Sardinia, from which it is but three leagues.—*Valery*, i., p. 234.—[Valery gives many details of the life of Buonaparte while residing here for eight months as second commandant under M. Quenza—E.L.]

In order to conceal the famine which menaced them during the siege of the city by Alfonso of

Returning to the Widow Carreghi's hotel, confusion prevailed throughout that establishment, owing to its being crowded at this hour by, not only the officers of the garrison, who take their food there, but an additional host of official civilians, gendarmerie, &c., to-morrow being a day of great excitement, on account of the conscription taking place, in consequence of which event the Sous-préfet is here from Sartené, with numerous other dignitaries. It was not wonderful that the two obliging women, who seemed joint hostesses, were somewhat "dazed" by the unbounded noise in the small and overfull rooms; nevertheless, they got a very good supper for me and my man, only apologising continually that "le circonstanze" of the full house, and of the late hour at which I had arrived, prevented their offering more food and in greater comfort and quiet. Everybody seemed to be aware that I was a travelling painter, and all proffered to show me this or that; the Sous-préfet, they said, had gone out to meet me, and the Mayor, for whom I have left a card and a letter from M. Galloni d'Istria (he lives in the Carreghi house), would come and see me to-morrow. Another of the persons at the table gave me his address at Casabianda, and begged that, if I should come there, he might show me the ruins of Aleria. The whole party, "continentals" and "insulaires," were full of civility.

All night long there was singing and great noise in the streets, so that in spite of my camp-bed very little sleep was attainable.

April 22.—How to obtain the best illustrations of Bonifacio? and in a single day?—that is to say, all that can be got upon dry land; for though I am aware that the grottoes here are considered as some of the finest known, I have resolved not to go into any of them, for they are all situated outside the channel, in the cliffs on the open sea, and I mentally decide to relinquish whatever of seeing Corsica depends on entering a boat.

Arragon in 1441, and which afterwards became so horrible, the Bonifazini threw loaves over the walls, and the women actually sent to Alphonso a fresh cheese made of their own milk. Hunger soon made the trait of the Roman daughters' filial piety common enough, for these intrepid and tender women ran, in the midst of dangers, to suckle the exhausted combatants, and there was not one of those who during the siege had not been revived by the generous draught. . At last, after four months of dreadful sufferings, the Genoese galleys brought relief.—*Valery*, i., 246.—[Valery's details of the history of Bonifacio are full of interest.—E. L.]

The churches of Bonifacio attest its ancient importance, its manners, riches, and civilisation. S. M. Majeure, an elegant church of Pisan construction, &c. St. Dominique, the old church of the Templars, of a light Gothic, with an octangular tower, is also very remarkable, and is the largest in Corsica. . . St. Francis dates from 1398, &c.—*Valery*, i., p. 239.

The rock on which Bonifazio is built is connected with the land; on two sides it is lashed by the surges of the straits; on the third it is washed by a narrow arm of the sea, which forms gulf, harbour, and fortifying moat at the-same time, and is enclosed by most precipitous, indeed, inaccessible hills. The force of the water has crumbled away the shores all round, and produced the most grotesque forms. Seen from below, that is, from the sea, which in many places has no edging of shore at all, this rock, rising quite precipitously from the waves, is most awe-inspiring.

Bonifacio was founded by the Tuscan Marquis whose name it bears, in the year 833, after a naval victory over the Saracens, to oppose a dam to their piratical incursions, as they were wont

The attentive Carreghi hostesses bring me coffee at 5, in a tumbler, which, it seems, is the mode in South Corsican households, and they give as a reason for doing so, that the coffee keeps hotter in glass than earthenware, which I do not deny; though at this early hour the unexpected feeling suggested by this practice—to wit, of your being about to drink a glass of porter—is objectionable. It is not possible to praise this hotel for its cleanliness, and yet it does not seem fair to judge Corsican inns, as some do, as if they were in Lombardy or Tuscany, constantly frequented by strangers. Take any part of Italy or France, away from the routine line of travellers, and you will find the inns hardly as good as those here.

6 A.M.—The first work of to-day is to complete the drawings begun yesterday at the head of the port—rather a long task, as much accurate detail is necessary. It is not easy to realise that the sea is on the further side of the fortress as well as on this. The harbour is really beautiful at this hour, when everything is reflected in the water, and the Genoese tower, which commands a view far up the channel, stands picturesquely in the foreground.

While I work there comes down the hill a large party of what G. calls μεγάλοι ἄνθρωποι—great people—to wit, M. le Sous-préfet, Dr. Montepagano the Maire, with others of the local notables and clergy, and on their arrival at where I sit, introductions, with much lifting of hats, ensue. The mayor seems a particularly agreeable man, and the whole party give an impression of being well-bred and pleasant, nor did they long interrupt my labours; every one offered to show me some portion of the city, or aid me in some way, but from the limited time at my disposal, I could only venture to name the convent of Sta. Trinità as a place I should like to visit, on account of its commanding a distant view of Bonifacio, and it was agreed that Dr. Montepagano should take me there at 2 P.M.

The next thing was to procure a view from the side of the channel opposite the city, and to this end I began, with G., an examination of paths

to land from Spain, Africa, and Sardinia, on this side of the island. Of the fortifications erected by the Marquis, the great old tower, called Torrione, is still standing. Three other towers besides are erected upon the rock ; Bonifacio carries them all in her armorial bearings. The town, as well as the island, subsequently came under the Pisans ; but the Genoese deprived them of Bonifacio as early as the year 1193. A Bonifazine, Murzolaccio, wrote a separate history of his town in the year 1625 ; it was published at Bologna, and is extremely rare. The memorable siege of the town by Alfonso of Arragon, is related by Peter Cyrnæus.—*Gregorovius*, p. 432.

The town of Bonifacio was founded towards the year 833 by Boniface, Count of Corsica. This town became a commune in the beginning of the eleventh century, and became subject to the republic of Pisa about the end of it. In 1195 the Genoese took Bonifacio, and massacred its population. Early in the sixteenth century the town withstood Alfonso of Arragon in a remarkable siege. In 1553 it was taken by the Turks.—*Grandchamps*, p. 30.

Bonifacio repulsed Alfonso, King of Arragon, and the Corsicans of Vincitello d'Istria in 1421. Later, in 1551, in the time of Sampiero, the Turks and French allied under Henry II., and, led by the famous Dragut, took the city by stratagem, after a long and memorable siege. . . In the suburbs of Bonifacio stands a long aqueduct, built by the Pisans, which furnishes water in abundance to that part of the city.—*Galletti*, p. 163.

and valleys in that direction, though the heat, and the contrast of the glaringly white soil with the dark vegetation, made the search as uncomfortable as at first it was profitless; for, pursuing a line parallel to the inlet, we diverged at times towards the water, but as often got entangled among vineyards and walls; till growing weary with climbing steep paths that led me no nearer to the point desired, and half blinded with the dazzling and hot white pathways, I was giving up the task. The Suliot, however, persevered, saying, " ἐντροπὴ εἶναι νὰ πᾶμ' ὀπίσω'—it is a shame to go back," and left me to return in half an hour, having discovered a dell leading down to the water, where a ledge at the end of the rocks seemed to command a view of the other side of the channel. And so it turned out to be, though the path along the cliff edge was so narrow and precipitous, and so giddily overhanging the water, that even with assistance I could hardly manage to arrive at the required height.

From this point there is a perfect view of this curious and interesting old Corsican city, and I know of no scene of the kind more strikingly beautiful. The exceedingly deep colour of the quiet narrow channel contrasts wondrously with the pale hues of the rocks and buildings, and the strange lonely character of the fort, and of the projecting cliffs rising perpendicularly from the water's edge, and striped with long ledges of singular form, is most impressive. A solitary cormorant flitting by is the only sign of life, and a complete silence adds to the charm of this wild spot, so full of memories of the sufferings of the Bonifacio people. I would gladly linger some days to explore more fully the position of this historic mediæval city, so unique in appearance and site. When the wind lashes this inland channel, how grandly the foaming waves must beat against the sides and hollows of these cliffs, wrinkled and worn by long buffeting! (*See* Plate 9.)

While I am drawing, the stillness is broken by two boats, which, from the distant harbour come down the channel, those who are in them singing " O pescator dell' onde;"[1] at first the sound is feeble, but gradually swells into a loud chorus over the calm water and among the great caverns of the echoing cliffs. The boats steer for the cove near which I am sitting, and twenty individuals land on a ledge of rock just below me, where they place a barrel of wine and provisions, and prepare to pass the day. These are conscripts, chosen as soldiers only yesterday, and this their farewell fête before leaving their native Bonifacio, a place so peculiar in itself, and so remote from the outer world, that the attachment its inhabitants are said to bear towards it is easily understood.

Leaving the cormorant perch or ledge, where I have made my drawing, I return to the town, and after a hot climb, first through the dells near the channel, choked with foliage, airless and stifling, and then by the blinding white stair-paths, reach Mdme. Carreghi's hotel before noon.

[1] The fishing-boats began to sail with their lights, and the fishermen to sing the beautiful fishing song, "O pescator dell' onde."—*Gregorovius*, p. 134.

PLATE IX.

BONIFACIO.

Fresh red mullet, lobster (or rather crawfish), good fowl, and other dishes more numerous than necessary, were ample proof that the good people of the house were in earnest last night when they promised better fare; and now that the rooms are less noisy and crowded, I look upon the inn as a very tolerable place of sojourn. The Widow Carreghi, like Fatima of Sarténé, is also anxious to improve her house, though with very decidedly conservative opinions as to some of its shortcomings, for, to her inquiry, " Come credete che posso far meglio nostra povera casa ?—What do you think can be done to improve our poor house ? " I suggest a cleaning of the remarkably dirty entrance and stairs by way of a commencement. But to this Widow Carreghi gives a flat negative in the most positive manner, " Signore, qui non e mai uso di polir le scale; le scale non si pulisce mai !—Here, sir, it is never the custom to clean stairs ; stairs are never cleaned, never ! " So I was silent.

At 2 comes Dr. Montepagano, and walks with me through a part of the town, showing me several points of interest, such as the house where the Emperor Charles V. lived in 1510, a small abode, and very unimperial in appearance, and that in which Buonaparte resided in 1793. The worthy doctor had insisted, much against my will, that we should use the carriage of one of his friends, but when we arrived at the port, where the vehicle in question awaited us, it was found to carry only one besides the driver, whereon I had to send G. up to the town for Peter and my own trap ; and, until its arrival, the doctor and myself sat by a fountain close to the harbour, which is celebrated for the excellence of its water, discoursing on some peculiarities in the ornithology of the district.

Then we drive up by the white cliffs and green hollow, down which I came yesterday on entering the town, and along the bald road, where stand the scanty wind-bent olives, till we come to the foot of the hills of La Trinità. A footpath leads to the great granite rocks, in a nook among which a small Franciscan monastery has now succeeded to the hermitage mentioned by Valery in 1835. The view from the convent garden is very remarkable, and as the day is clear, the north coast of Sardinia is perfectly seen in all its length and detail, in which there is much beauty, though, in some respects, it is rather disappointing, the height of the mountains beyond the straits being inconsiderable compared with those of Corsica, and the long line of hills seem wanting in grandeur. Now that I am acquainted with the position of Bonifacio, I perceive that from here its peculiar character cannot in the least be indicated, as the narrow arm or inlet of the sea is completely hidden by the higher ground on this side of it ; consequently, the city seems to stand on a part of the broad level on its western side, instead of rising, as it really does, from a rock platform, almost entirely surrounded by water. Nevertheless, this Santa Trinità view—the monastery itself has nothing picturesque to recommend it—is one very curious and impressive. You feel, as it were, at

the end of the world, as you look at the far white fortress through the stems of the large olives growing among great boulders in the convent garden; beyond it is nothing but the wide sea, and the low line of Sardinia on the horizon. At 6 we drove back to the town.([1])

Dr. Montepagano, the Maire, says that two years ago there were two Englishmen here, one of them Mr. C., the name of the other he cannot remember, but will show me his photograph to-morrow. The Maire's acquaintance has been well worth making; he is a most friendly and well-informed gentleman.

April 23.—At 6 A.M. an early visit from M. Trani, to whom I had brought an introductory letter from M. Merimée, but who was absent from the city yesterday. The Corsicans seem most anxious to show every attention to strangers, and I regretted that I could not see more of this gentleman, who was very agreeable, and who evidently entertained a warm recollection of my introducer. Dr. Montepagano also called and brought the promised photograph. Behold, it was of my friend J. B. H.! I was not aware he had ever visited this island.

At 7 I left Bonifacio and its kindly inhabitants, with more regret than is usually felt after so short a stay in any place. It is full of an indefinable romance and interest not shared by either Ajaccio or Sarténé ; a kind of wild and solemn classic grandeur prevails about its lofty fortress walls and in the views from them, either towards the screens of steep rock rising from the deep and narrow channel, or seaward to the strange pale cliffs and the long line of Sardinian hills. The port scene is a little gem, and I feel sure that there are many more beauties in the narrow valley running eastward among the hills, and from the coast towards the lighthouse.([2])

The peasantry about Bonifacio seem of a small stature, and not as well looking as those in other parts of Corsica ; among the women I did not see even one tolerably pretty face. All dress in dark brown. As a

([1]) The oratory of La Trinité, three miles from Bonifacio, and one mile from the port of Paraguano presumed to be the site of the Palla—is worth a visit.—*Valery*, p. 253.

([2]) In the isles of San Bainzo, Cavallo, and Lavezzi, are old quarries of granite used by the Romans, and enormous remains of half-sculptured columns, &c., &c. Some interesting details are given of the remains of the works of antiquity in these islets.—*Valery*, p. 256.

The isles of Cavallo, Lavezzi, and S. Bainzo, and many others, which form the archipelago of the Bouches de Bonifacio, make the passage very dangerous for vessels. These rocks have caused innumerable disasters ; in 1855 the frigate " La Semillante," carrying troops and munitions for the army in the Crimea, was shipwrecked there, and no soul was saved. In these islets, and particularly in that of S. Bainzo, great columns and other blocks of granite hewn by the Romans may be seen ; traces left by fire on the virgin rock, too, are there, as well as charred wood about the forges which were used in these quarries.—*Galletti*, p. 167.

The grottoes of St. Anthony, Saint Barthélémy, le Dragonale, their magnificent extent and stalactites, peopled with seals and pigeons, are described by Valery, pp. 249, 250

[In Gregorovius the chapter about the siege of Bonifacio in 1421, and, indeed, all he has written on the subject of Bonifacio, its histories, legends, and scenery, and of the great caves, which I did not visit, are most charming (pp. 327 to 456, &c. &c.).—E. L.]

set-off, the people of Bonifacio are said to be, as their character has been always represented, quiet and well conducted ; nor was the savage Vendetta ever known in the territory, which was, indeed, separated from all the rest of Corsica, not more by its isolated position than by the habits and circumstances of its inhabitants. The race of donkeys, of which there seem to be many used, are the smallest I have seen in the island.(¹)

The road to my next halting-place, Porto Vecchio, to which I set out at 7 A.M., is, for a short way, the same as that by which alone Bonifacio can be entered ; but it soon strikes off to the east, and, after passing through beautiful sheltered groves of rich olives, the white chalky soil is quitted, and once more the familiar granite rocks appear, interspersed with slopes of turf, cultivated undulations, and spaces gay with flowers—may or black-thorn in full bloom, and a wilderness of vegetation. The road does not run near the sea—once or twice only are there glimpses of it between heights clothed with high and dense "maquis"—but mostly along a rather flat vale or small plain, half covered with underwood and cork-trees, and lying between low granite hills on the left, and a similar but lower ridge on the right. And such is the route for nearly three hours, when, after a dip down to a small bay (the Gulf of Sta. Giulia), and a pull up on the opposite side, the valley of the Stabiaccia, the stream flowing into the Gulf of Porto Vecchio is reached. Hereabouts is the only bad bit of road encountered since leaving Ajaccio—a causeway in process of being raised across some marshy ground, and not as yet complete.(²)

A good way ahead, the town of Porto Vecchio appears on a hill above the Gulf, in the midst of what is characteristic of all the surrounding country, excessively abundant vegetation ; in parts a regular jungle, with unhealthy looking marshes and pieces of water at intervals, in the neighbourhood of

(¹) Near the road from Bonifacio to Porto Vecchio, by the hamlet of Sota, are the ruins of the Castle of Campana, ancient stronghold of the infamous tyrant, Ors' Alamanno.—*Valery*, p. 258.

(²) Porto Vecchio is a spacious haven, capable of containing a very large fleet. It is five miles long, above a mile and a half broad, has a great depth of water and a good bottom, and, being land-locked on every side, is well sheltered from storms. . . Porto Vecchio may vie with the most distinguished harbours in Europe.—*Boswell*, p. 20.

Diodorus Siculus celebrates Corsica for the excellence of its harbours. " Αὕτη δὲ ἡ νῆσος εὐπροσόρμιστος οὖσα, κάλλιστον ἔχει λιμένα τὸν ὀνομαζόμενον Συρακούσιον—The island being of very easy access has a most beautiful port, called the Syracusian." This, anciently called the Syracusian, has now the name of Porto Vecchio.—*Boswell*, p. 19.

Porto Vecchio, a calm and sheltered harbour, is one of those insalubrious and abandoned positions which may one day undergo the most vast changes. S. Florent on the side of France, Porto Vecchio on that of Italy, may become useful and magnificent stations. At present, this considerable town, which contains 1,700 inhabitants, is forsaken during the summer for the mountains. A thick vegetation of olives surrounds it. The salt works are susceptible of great improvement, for they are well situated, though not paved, and might be turned to good account.—*Valery*, p. 259.

This little town on the east coast of the island is quite fallen from its earlier splendour. It is girt with walls, and appears from a distance to be an important town. Alas, what an illusion for the traveller who enters it !—*Galletti*, p. 168.

Porto Vecchio is a vast gulf, 3,000 mètres long and as many broad.; and by improvement, its port,

which small midges and loud frogs proclaim, even at this early season of the
year, a dangerous atmosphere. But apart from its unhealthiness, the wildness
of the scenery has a great charm, the more that towards the west, finely
formed hills stand forth with a stern beauty, so that I could not resist sending
on Peter and the trap, and stopping to draw till 11 A.M. Every shrub and
thicket seems alive with the invisible nightingale, whose song

> "Fills the soul
> Of that waste place with joy."

Porto Vecchio, about which I make an exploring ramble before entering
it, is a place of forlorn appearance, with no little picturesqueness in its old
gray walls and towers, but joined to a general look of decay, more agreeable
to a painter's eye than indicative of the inhabitants' prosperity. Nor did the
interior offer any greater signs of vitality—unfinished houses, heaps of stones,
shattery wooden outer stairs and galleries, with much dirt and a large supply
of idle loiterers. On one side of a small piazza is a row of somewhat better
buildings, among which the "hotel"—kept by the widow Gianelli, an old woman
like one of Michael Angelo's Fates—resembles some others I have seen in its
very bad and dirty stair entrance, but also in its tolerably decent little apart-
ments ; a small public salle à manger (the diligence from Bonifacio to Bastia
stops here for refreshment), with sofas that do duty for beds, two small bed-
rooms, by good luck unoccupied, and a sort of kitchen used by the family,
complete the hotel arrangements ; but no part of it is as tidy or well-furnished
as the inns of Grosseto or Sarténé.

While Madame Gianelli produces breakfast, M. Quenza, the Maire of
Porto Vecchio, to whom I have forwarded a letter from M. Galloni d'Istria,
comes to visit me—a genial and intelligent person, who offers me his com-
pany, to show me some of the best points for making drawings of the town,
and who talks of the great pine forests of Spedale, which M. Merimée had par-
ticularly recommended me to visit ; they are within a few hours' drive, and a
good road of the second-class, or route forestiére, leads to them, so that this
fact begins to tempt me to remain a second day here for the sake of making
the excursion. M. Quenza departs, and Mdme. Gianelli, bringing coffee in a
tumbler, asks if I will dine at 5.30 with the "continentali ?"—" Tutti monshieu,"
is her expression—government employés here, the director of the telegraph,

from every point of view, military or commercial, may become the finest in the Mediterranean. Its
situation is magnificent ; the territories of the two basins which open out into it are of great fertility ; the
port, vast and safe, is sheltered by the mountains which surround it. Of all the points of the island, it is
that most adapted to the formation of a maritime arsenal. The marshes round the gulf, and the bad air
which prevails during the summer, the choking of the harbour by sand, are all evils within the remedies
of science and labour ; &c. Its great military importance and its commercial influence would extend
from the Gulf of Santa Manza to Fiumorbo, for there is no port on the east side from Porto Vecchio to
Bastia.—*Grandchamps*, pp. 34, 35.

[Numerous details and plans are given in M. Grandchamps' book of the gulf and harbour of Porto
Vecchio, a site which is spoken of as one admitting no doubt of its future greatness.—E. L.]

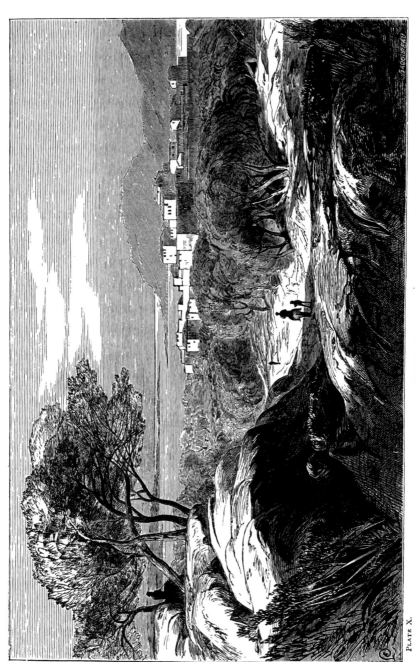

PORTO VECCHIO.

PLATE X.

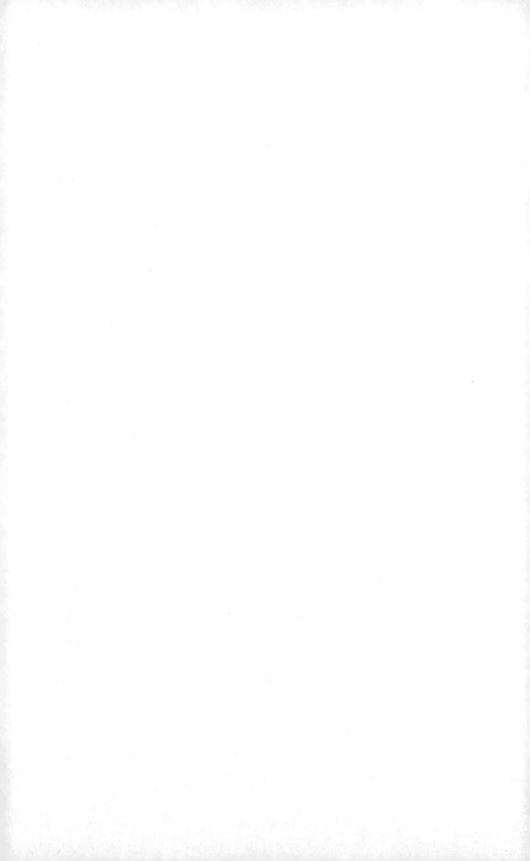

the agent of salt works, &c.; but I decline tying myself to return at a certain hour, for there may be work to do till sunset.

Next follows a return visit to M. le Maire. M. Quenza lives in a large house, with an unpleasant entrance, and all but impossible stairs, landing you in a very large and lofty room altogether out of character with the approach to it. M. Quenza, however, was out, and finding only Madame, a baby, and the room very much in deshabille, I apologise, and retreat to a height outside this sad and ruinous-looking village—in better days a comparatively flourishing town. Here, overlooking the flat shore and the salt pans at the foot of the hill, the calm gulf, and the generally unhealthy look of crowded vegetation characterising the neighbourhood, I make a drawing, until joined by M. Quenza, who has been delayed by having to preside as maire at a "civil marriage." Porto Vecchio must be a warm place during winter; sheltered from all cold westerly winds, its climate is vaunted, and I should think justly, as the warmest in Corsica; the conditions which make it so unfit as a residence in summer, rendering it precisely the reverse in winter.

The Maire takes me up to a knoll on the north-west side of the town, and there I pass most of the rest of the day, for it commands the best view of the town and gulf. (*See* Plate 10.) A tone of sadness broods over the scene, owing to the aged and forsaken look of the thinly-populated Porto Vecchio, and to the absence of dwellings round it; but the quiet gulf, like a lake, nearly landlocked by the low hills, the beautiful colour and texture given to the landscape by its extensive cork forests and olive woods, communicate to this scenery a great charm of calm softness, and though possessed of no magnificence, it has great attractions for a painter through a certain mournful wildness and an air of antiquity. Somewhat it reminds me of Santa Maura, especially as to its extent of desolate flat ground near the salt works by the sea.

Later I passed an hour at the Maire's house, where I made the acquaintance of Madame Quenza, a ladylike and good-looking woman, and a small Quenza, a sharp little fellow, with Napoleonic eyes. I was shown a large collection of letters, written by the first Emperor Napoleon, and by General Paoli, to the great-grandfather of M. Quenza. Those of the former are on coarse paper and coarsely written, chiefly, I think, in the year 1794 or 1795. There is an orderly-book, too, with enough signatures of Buonaparte to make the fortune of an autograph seller; heaps, and bundles too, of Paoli's correspondence, whether ever used or not as materials for his life I am ignorant.[1]

Lastly, as the sun set, I came again to the great rocks whence I had made my drawing, and sat in a world of gray silence. Thus far in my Corsican tour several things surprise me. First, the excellence of the roads; secondly, the

[1] There are also very interesting old manuscripts in the possession of an old man of 80, M. Jean Baptiste Quenza, who in 1793 commanded the battalion of national Liamone volunteers, and under whom Buonaparte served as second captain.—*Valery*, p. 231.

sense of extreme security in town and country ; thirdly, the good breeding of the lower class of people, who are, without any exception, respectful and obliging, and always leave me undisturbed to my artistic devices ; fourthly, the decent accommódation and good fare at these small country inns, which are far better relatively to the larger or town hotels than I have known to be the case in other countries, Italy, Sicily, &c. All this I was unprepared for ; and I confess that Corsica, to which I came without any great interest, gives me daily a desire to see more of itself.

Mdme. Gianelli, whose face would make a wonderful, if not beautiful study, sends in for supper some soup and " manzo," or boiled beef, capital fish (denticé), and lobster, a steak, with potatoes and salad, and broccio ; at many large Italian towns you would not fare better.

M. Quenza tells me that there is literally no winter here ; and I believe that for purposes of study and climate, this half-dead verdant place might well serve for a painter's home through the winter. It might be wished, however, that the neglected and dirty state of the exterior of Porto Vecchio did not extend to the interior of its dwellings, as it undoubtedly does.

I have decided to start at 5 to-morrow to the forests, and Madame Q. guarantees the early appearance of her husband.

April 24.—At 5 A.M., Peter the coachman, trap and ponies, G. with folio, cloaks, and provision for the day, are ready ; and presently M. Quenza joining me, also with a full basket, we start for the mountain, soon leaving the main road and passing through an extensive cork forest, around which the soft pleasant character of the Porto Vecchio scenery is very charming. These cork woods, too, are beautiful in colour and in the texture of their thickly clustering foliage, and from their deep red stems where the bark has been removed. M. Quenza tells me that he possesses 4,000 trees in this wood, each averaging a produce of ten sous annually.

Reaching the foot of the hills, at present covered with mist, we now begin to ascend towards the forests, and the road, one of the second class, called in Corsica, Routes Forestières, is henceforth carried, curving and winding with a steep ascent, up the face of the mountain ; and though it is a good one, yet it has no parapet, and the fact of seeing mules pulling up a cart, the wheels of which are not more than an inch from the precipice's edge, by no means makes me more at ease in the carriage, from which I dismount, and thenceforth walk. My companion, the Maire, is full of cheery fun, and stories innumerable. Presently we pass a wild and singular looking individual tending two or three goats, who waves his hand to M. Quenza with an air of lordly patronage, quite unlike the respectful obeisance I observe paid to him by other peasants. " But this poor fellow," says M. Quenza, " is a harmless lunatic, and his present delusion is that he is king of Sardinia, which explains his magnificent manner."

A short time since the poor fellow was persuaded of a far less agreeable fact, for he believed that he had swallowed two gendarmes, and that the only remedy for this mishap was to eat nothing, in order to starve the intruders, which resolution he rigidly adhered to, till his own life was nearly sacrificed. When all but gone, however, he exclaimed, "Ecco, tutti due son morti di fame!—both of them have died of hunger!"—and thereupon he resumed eating and work with joy.

M. Quenza also tells many stories of the too-famous Colomba,([1]) who was his aunt by marriage; she died only four years ago, and one of her sisters is still living. Among his anecdotes of that surprising female, he recounts

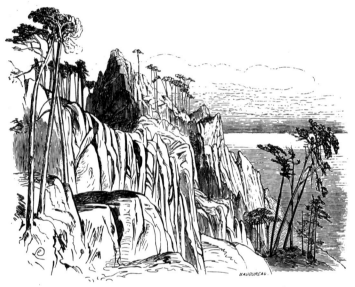

SCENERY IN SPEDALE FOREST.

that at one time the family who were in Vendetta with her own in their town Fozzano, wished to build a tower, which would have commanded that of their antagonists. Colomba, therefore, improvised a party of her own people, who sate down to play at cards on the ground opposite the tower, and when they were settled she went out and joined them, as if observing the game, always dancing and dandling her baby at the same time. But in the dress of the child she had concealed a loaded pistol, and, watching her opportunity, suddenly shot one of the masons on the tower, replacing the pistol in the child's girdle under a shawl. The wildest confusion ensued; but the card players had their hands full of cards, and their guns all lying by their sides, while Mdme. Colomba, with both hands, was pacifying the screaming child, so

([1]) [This lady, mentioned by M. Valery and others, was a celebrated leader in the Vendetta-wars at Fozzano, and is supposed to be the heroine of M. Merimée's beautiful tale of the same name.—E. L.]

that the party seemed guiltless, and a false direction was given to suspicion. This feat Colomba is said to have performed on two more of the builders, till the raising of the tower was deferred *sine die*.

M. Quenza says that there are pheasants on the eastern side of the island ; and, speaking of the immense multitude of blackbirds produced by the "maquis," he says that those of Sari (of Fiumorbo) are esteemed before all others on account of some peculiarity in their food.([1])

At 6.30 the mists begin to lift, but it is not a day for clearness of distance ; the road, now that we are fairly high on the mountain, winds along deep gullies, whence far-stretching ilex woods are seen on all sides ; a few cantonniers, or road menders, and now and then woodcutters, are met from time to time. Crags half lost in cloud, and pines growing as it were in air, or groups of evergreen oak, often tempted me to stop and draw, but I postponed doing so until the distance should be more distinct, now that on this lofty ascent all the Gulf of Porto Vecchio with Sardinia beyond was widening out at each zig-zag turn. We pass Spedale, a house inhabited by cantonniers, that has been long in sight, as well as a ruined chapel close to it, and some of the masses of rock and wood near here are wonderfully beautiful, yet the feeling that two or three hours' study is necessary to do them any justice in a drawing, besides the necessity of getting up to the top, prevents my lingering. At the twenty-first kilométre from Porto Vecchio the plateau, or summit of the mountain, is reached.

Here there is a new world, one all of pines, and, to my thinking, a gloomy one, for just now the clouds are low on these lofty regions, and the vistas of gray stems towering up to masses of darker foliage seem rather monotonous than cheerful.

A little onwards much of the ground is cleared, and in a bare space encircled by lofty trees, stands a large double dwelling, with gardens adjoining ; here the families of two foresters or guardiani live, by one of whom I am taken a little distance off to see some of the largest pine-trees— giants of twenty-five métres in height and upwards. But these forests are on level ground, and command no distance of any sort, and, except on account of their magnitude, fail to interest me ; gladly would I exchange all the magnificent monotony of these tall straight mountain trees for one glimpse of the beautiful *Pinus maritima* bending over the rocks by the sea at Kakiskali or Mount Athos, which places, indeed, the poetical sighing

([1]) One hundred thousand blackbirds are annually exported from Ajaccio alone. . . They sell there for three and four sous each.—*Campbell.*

It is barbarous to destroy, for the mere luxury of the table, birds which make such fine musick ; surely their melody affords more enjoyment than what can be had from eating them.—*Boswell,* p. 44.

Sari (of Fiumorbo), a village standing well in sight, has but a population of 200. The ruins of two castles belonging to the rich and powerful Renuccio are near it. Near Sari you remark some traces of the Roman way—the only one discovered in Corsica—which, starting from Mariana, passed by Aleria, and ended in Palla.—*Valéry,* p. 263.

of these vast woods of Spedale in some measure recalls. And so I go to the guardiano's house, doubting if, after all, I shall get much drawing to-day, and glad meantime of a thick cloak, on account of the cold, and to attack M. Quenza's substantial breakfast and not unwelcome wine gourds.

The only memorandum I could procure of this part of the mountain was by going a little later with the forester to a "massif," as they term the groups of trees, growing among great rocks on the plateau; these are of great size, and stand up majestically against the mountain side. To the forester, a grim tall fellow, who watched the progress of my sketch, I offer one of my pencils, on the nature of which he made some remarks; whereupon he only says, "There are enough in my house, but I will take it —ne ho basta in casa, ma lo prendo"—which was not gracious on the part of Don Guglielmo di Roccaserra, for so they called him; then, leaving M. Quenza, who was tired, to follow in the carriage, I came away from the level recesses of the forest, and began to descend the mountain. At 1.30 P.M., as I come down the zig-zags above the house named Spedale, the distance and Sardinia on the horizon are hidden by mist; the groups of immense ilex, with pines and crags, are all shadeless—opposite the afternoon sun—so that in the end I walked down the mountain without getting another record of its scenery. As a pictorial gain, the excursion of to-day has certainly been a failure; had I walked up alone, many effects of light and shade at different points in these beautiful woods could have been secured; whereas, fearing to inconvenience M. Quenza by a succession of fidgety halts, I did nothing at all, beyond illustrating my theory that study is next to impossible if you join a companion. Nor have I felt very enthusiastic admiration during this my first visit to a Corsican forest; perhaps others I may see will have finer qualities, and the day may be less cloudy and cold. At 4.30, M. Quenza, who does not appear fully to understand my mania for walking, picks me up; we drive across the cork woods, golden in the afternoon sun, and reach Porto Vecchio by 6 P.M.

A visit to the Maire's house closed the day's work. The sharp-eyed small Quenza, a little fellow not six years old, exhibits a curiously retentive memory, and should turn out a naturalist, for he knew the name of every animal depicted in Buffon, though showing most partiality for the monkey tribe. Every one of those apes, which nearly half a century ago I used to copy so carefully from the well-known volumes at home, this little man knew at sight, shouting out, " c'est le Talapoin," "c'est le Carcajou," &c. These would be pleasant people to know, should one ever take a fit of wintering in Corsica, and make Porto Vecchio head-quarters. I am told, too, that the country round is so famed for the variety of its entomology, especially of Lepidoptera, that many naturalists from France and Germany pass some time here on that account, and that one of these, a M. Reveillier, whose acquaintance I was sorry not to have had the

pleasure of making, has resided here for several years; moreover, two diligences to and from Ajaccio pass in every twenty-four hours, so one would not be quite shut out from the outer world.

After dinner at the hotel, supplied as usual with that wish to oblige which I begin to recognise as an eminent Corsican trait, the friendly M. Quenza comes, bringing me a lot of pine-cones which I had asked for, and a letter to one of his relatives at Quenza,([1]) in case I should go there, that being the name of the village high up towards the plain of Coscione, near Mount Incudine, to which the whole population of Porto Vecchio migrate in summer. During the vintage they come to and fro, but as a rule, the town is entirely deserted after the end of May until November.([2])

To-day I am grieved to have worked so little ; possibly I may see finer forest scenery in Corsica, but hardly any that can look down on so fair a scene of sea and distance as is commanded by the south-eastern side of the mountain I ascended, towards the wooded plain, the old town of Porto Vecchio and its olives, the gulf, and the Island of Sardinia beyond. Some of the groups of rock and foliage, too, were striking and beautiful, and yet I have not found it possible to bring away more than a few jottings.

April 25.—Either Solenzaro, or Ghisonaccio, or Migliacciara, is to be my halting place for to-night, but it is not easy to decide this question beforehand, or to obtain very clear information as to the distances; from what I gather it may be forty kilomètres to the first named place, and some twenty beyond to either of the others

Leaving forlorn Porto Vecchio at 6 A.M., the road on the eastern side of the island runs a good way inland, and seldom approaches the sea. The scenery partakes of the grave character of Corsican landscape; yet in this district I observe some qualities not noticed hitherto, owing to the mists which seem to linger about these wooded regions, and over the low grounds near the gulf. For a time, in passing through the cork wood, the varied

([1]) Quenza is the most loftily situated village in Corsica ; it is of old date, very healthy, and contains only 200 inhabitants. The vine cannot grow there ; the water is fresh, abundant, and exquisite. Quenza is principally composed of country houses, occupied only in summer, and badly kept enough, confirming the Corsican proverb, " Che due case tiene una ne piove—who has two houses will find the rain come in to one of them." The old church of the village, where mass is celebrated only once a year, was built A.D. 1000 by the Pisans.—*Valery*, i., p. 217.

([2]) Coscione, a plateau of vast extent of turf or pasturage, is the best in Corsica, and one of the most beautiful in the world. Watered by limpid fountains, and traversed by delightful streamlets, the Coscione becomes during summer the resort of all the inhabitants of Quenza and its neighbourhood. The Coscione is then alive with a multitude of horses and cattle ; the latter, small, lean, active, and almost wild, gallop about it like horses. Speaking of the want of cattle-sheds or stables in this part of Corsica, which are much needed, it occurred once that a skilful agriculturist, sent by the munificence of M. Pozzo di Borgo to the island, said to the peasants, "Why do you not get rid of the stones in your fields, and use them in making little sheds for your cattle?" "Do you take us for ambassadors?" was the contemptuous reply of these enemies of rational progress.—*Valery*, i., p. 219.

line of the gulf hills gives the landscape great interest ; the lovely morning
light falling on the dark red and silvery-gray cork stems, and the change-
fully clouded mountains inland are full of beauty ; while, on the right,
gleams of bright water are seen through rich undulations of wild green
forest.([1])

At 7, low hills shut out the gulf, "maquis" and cork woods are on
each side, and on the left an amphitheatre of far mountains, all soberly
green, with a world of detachéd granite masses. Two or three sets of
wayside houses enliven the scene, some plots of corn, some goats, and a
few people.

The torrent dell' Oso is passed, a trivial stream at present, but two long
bridges over which the road is carried show that water is not always so
scarce as now. And a sort of feverish chill appears to me to prevail in
these low marshy tracts, however lovely to look at the jungle or underwood
hereabouts may be, so rich in variety of vegetation—laurustinum and arbutus,
wild olive and sloe-tree, hawthorn, hemlock, bramble and bryony, ilex and
cork, myrtle, broom, high heath, clematis, cystus, and reeds, with here and
there a fine pine glittering with a silvery dotting of *Processionary Bombyx*
sacs. (*See* Notes at the end of the Volume.) And only where there is a
break in this wilderness, or where a carpet of red and white cystus occurs,
does the pale asphodel peep above this many-foliaged confusion. Long
tracts of such vegetation succeed each other with little change as we drive
along a level road ; and there is little to be done except drowsily writing
up notes, while Peter the coachman hums faintly, like a drowning fly.

Wondrous to say, at 7.30 A.M., there is a roadside village, perhaps con-
taining twenty houses : it is Santa Lucia di Porta Vecchio ; beyond it the
road crosses a clear and pretty river of the same name, flowing to the sea
near the Gulf of Pinarello ; and then we relapse into cork and "maquis,"
"maquis" and cork.

After 8 o'clock there is more variety in the drive, nearing the sea by the
tower and Punto della Fautea ; after passing which, and another stream
and good bridge, the road becomes a cornice, running above the shore, where
the exquisite vegetation is delightful—the superb yellow hemlock, brown
and purple lavender, rose and white cystus, in gorgeous masses of colour,
wild olive draped with festoons of wild vine, and now and then patches of
blue flax, and silver spots of tall white amaryllis. The sameness of these

([1]) Gregorovius, who traversed this district in summer, says :—On the whole journey I met not a
living creature ; not a single hamlet is passed, and only here and there a village is seen afar off on the
mountains. There only stand solitary abandoned houses on the sea shore, at such points as possess a
small seaport, a cala or landing-place, such as Porto Favone, the place to which the old Roman road
led, Fautea, Cala di Tarco, Cala di Canelle, &c. . . Here also stand Genoese watch-towers. .
All these houses were abandoned, and their windows and doors shut ; for the air is bad along the whole
coast. . . It is a strada morta. — *Gregorovius*, p. 459.

parts of the coast of Corsica is atoned for by such banks and dells, full of blazing colour, and crowded with warbling birds, besides an occasional hoopoe, or bee-eater. Nowhere do I remember to have seen such slopes of splendid tints, so complete and lively a clothing of flowers. At 9 the Tarco is crossed by a three-arched bridge, and, beyond that, the loftier summits of the southern portion of the great snowy mountains, or central chain, begin to be seen.([1])

All at once (9.30) a pretty little bay—the Porto Favone—opens, and is irresistible to the landscape painter, who halts to draw it. The compact Cala or Marina is a perfect picture, its background the mountain range near the Incudine, towering high above the velvet "maquis"-covered hills, and clear as glass; its foreground a few small houses edging the white sandy shore, drawn up on which are two or three boats, and beyond them a river and its bridge. A dozen or so of goats, and one or two raging dogs, are all the life vouchsafed to this spot, besides an ancient and crusty Corsican, who proclaims from an upper window to the inquiring Peter, that these dwellings contain no barley or horse food of any sort. Peter the coachman has been given of late to disagreeable ways; almost mute for the first days of this tour, he has latterly taken to swear at his horses with a frightful volubility and a selection of oaths which denote, if nothing else, an inventive imagination of great power; this habit, and that of beating the animals on their heads, I object to and rebuke, and for the time the evil is stopped.

After passing along more cornice road and wild gardens, it is 11.30 before Solenzaro appears ahead on the coast, and we reach it at noon, the last part of the way being along hill-sides covered with vineyards; it is a village consisting of one long straggling street, with some outlying, large, tall-chimneyed buildings, a French metallurgic establishment, and a good many more extensive dwellings or warehouses, and on the whole presenting a more general appearance of life than Corsican villages are wont to display.

I am directed to a poor little house as the best hotel, kept, according to what seems frequent custom in Corsica, by yet another widow—la Vedova Orsola. But, although I may have the pleasure of inhabiting her house on my return here two days hence, it is not requisite to do so now, as I have prudently provided breakfast at Porto Vecchio, and there is nothing to be done at Solenzaro but to rest the horses and become acquainted with the distances and halting places of the onward road; for I am anxious, if possible, to get

([1]) On the coast are many picturesque forsaken towers; one is at the little port of Favone, looked down on by high mountains. These towers on the coasts of Corsica, some fifty in all, were built in the sixteenth century by the Genoese, at the request of the inhabitants, who, as subjects of the republic, were exposed to ravages from the barbarous nations with whom Genoa was at war. The garrison of each tower ordinarily consisted of three soldiers, a corporal, and a guardian or governor. At the approach of an enemy's boat, they lit a fire, which, seen and repeated by the guardians of all the neighbour-towers, alarmed the whole coast of the island, and allowed time to prepare for defence.— *Valery*, i., p. 261.

to Casabianda and to see the site of Aleria, the ancient colony of Sylla, in this trip ; because, should I be prevented from going there till late in my stay in the island, the eastern plain is said to be then so rife with malaria that one risks fever by sleeping in it. If, therefore, I can manage to accomplish this now, I may return here and cross the forests of Bavella, according to M. Vico's itinerary, and so rejoin the road to Ajaccio at Sarténé.

What information I require is soon gained from a party who are sitting at breakfast at the door of a house opposite, magnificently labelled, and with a prophetic boldness, " Hôtel de Chemin de Fer." All these persons very good-naturedly volunteer particulars about the road, especially one, Signor Poli, who says Migliacciara is sixteen kilométres from this place, that it stands a little way off the main Bastia road upon that leading to the baths at Pie-trapola, and that I shall find a good inn there ; that Casabianda, the great Penitencier Agricole, is sixteen kilométres farther beyond Migliacciara, and close to Aleria ; and that from Solenzaro—to which I must of necessity return —it is thirty kilométres to the top of the Bavella pass, and the village of Zonza again is eighteen other kilométres beyond it. Just then there comes up another " continental," who says M. Vico, the Sous-inspecteur of Forests, has written to him to say I am on my way here ; this gentleman is M. Mathieu, the agent or head manager connected with part of the great Bavella forests, and he tells me that he is shortly about to go there himself, and that meantime he has directed the guardiano at the Casa Forestiére to house and feed me, "for you may get some bread," he says, "and possibly some potatoes." All this is very obliging, and it seems I can have but little trouble throughout ; on which I thank my informants, and leave them to their breakfast.

Some spot at hand, combining two qualifications, is now to be sought— namely, first, quiet ; secondly, some scenery to draw during the mid-day halt— for in or near such wayside houses as there appear to be in this village, where noise and dirt are plentiful, it is by no means agreeable to eat if one can avoid doing so, and it is a great thing if a sketch can be combined with a two hours' stay at some picturesque resting-place. G., however, has already found a place, to which the Coliseum-sack is taken, where, on turning round the point of a low hill, just beyond the village, a beautiful picture is seen ; a little chapel, which stands, backed by a group of pines, on the banks of a wide stream, with the snow heights near the grand Monte Incudine above, and all the middle distance of the scene composed of those deep green " maquis "-clothed velvety hills, the delight of Corsican landscape. At this river side also nightingales abound in incredible numbers, and their exquisite music fills the air.

The halt of this morning is thus in every way a pleasure, and no slight additional satisfaction is it to recall what one has seen in the earlier part of the day, which, after the cork woods and " maquis " had been left behind, was a wonder and a delight from hour to hour—a border of glorious flowers by the

still blue seaside. Now, all at once, the landscape has become noble and majestic, and I cannot help feeling, even after seeing so little as I yet have of this island, that it would be an endless field of study to a painter resident in it.

Afterwards I draw upon the bridge above the river, whence the stream and its picturesque banks, with the lofty shadowy mountains, make a beautiful scene, till it is time to send back G. for Peter and the trap. Peter has applied again here for money for the horses ; but it seems that for every advance he gives them less barley and more beating, and it is dimly becoming a sort of fixed idea with me that Miss C. was right, and that I had better have hired her man and horses, even at a greater expense.

CHAPEL NEAR SOLENZARO.

At 4 P.M., once more onward along the high road, meeting, soon after starting, the Bastia diligence which is to reach Bonifacio to-morrow morning, and Ajaccio on the succeeding day at noon—a dreary penance of shut-up shaking I am thankful to have escaped. The high central mountains, as seen from this eastern side of Corsica, stand far away beyond a wide plain, and their bases are hidden by low hills ; yet, as a snowy range, they are truly a splendid sight ; and the change from the spiky promontories of the west coast, the ins and outs, and curves and corners of the sea wall, or the close vales of " maquis " shut out from all distance, to this broad landscape, is most marked and delightful.

Give me the beauty and glory of open plains, with a distance of hill or sea! Here they are both ; and yet the lines of this mountain wall are not

easy to draw, and rather require a morning light;
nor are the undulations of rich dwarf foliage, thus
crested by snowy Alpine heights, without their
difficulties. The wide level of unvaried rich
green which stretches from the shore to the very
foot of these heights is something the like of
which I have never before seen, nor have I met
with any representation of it. Nearly at 5 the
river Travo([1]) is passed by a long and fine
bridge, and looking up this broad and beautiful
stream, the landscape is wonderfully fine, but
time does not allow of stopping to draw it. At
the fiftieth kilométre from Porto Vecchio the
plain is really unique in beauty, and more re-
sembling some parts of Thessaly than any place
I can compare it to, but that Thessaly wants the
deep full green of the Corsican "maquis" clothing.

A few roadside houses grouped together near
the river Travo are all the habitations seen on
this extended campagna, till after passing another
bridge (Ponte Palo or Londano ?) over the Vabo-

([1]) We crossed the river Travo. From thence commences
the series of lagoons, beginning with the long narrow Stagno di
Palo ; there are in succession the Stagno di Graduggini, the
lagoon of Urbino, of Siglione, del Sale, and the fine one of
Diana, which has retained its name from the Roman times.
Sandbanks separate these fish-swarming lagoons from the sea,
but most have an entrance. Their fish are celebrated ; eels, &c.

Far northwards from the Travo extends the most glorious
pianura, which is the Fiumorbo or Canton Prunelli. Crossed
by rivers, and bounded by the lagoons and the sea, as
seen from the distance, an endless luxuriant garden by the
sea-shore. There is room here for at least two populous towns
of 50,000 inhabitants, but there is hardly the scantiest arable
land to be discovered, only boundless plains covered by ferns.
Colonies of industrious cultivators and artisans would convert
the whole district into a garden ; canals would destroy the
morasses, and make the air healthy. The climate is
more sunny and milder than that of southern Tuscany ; it would
bear even the sugar-cane, and corn would yield a hundredfold.

The entire west of the island is a continuous formation of
parallel valleys ; the mountain chains there descend into the sea,
ending in capes, and encircling the magnificent gulfs. The
east has not this prominent valley formation, and the land sinks
down into levels. The west of Corsica is romantic, picturesque,
and grand ; the east gentle, monotonous, melancholy. The eye
here roves over plains many miles in extent, seeking for villages,
men, and life, and discovers nothing but heaths, with wild shrubs,
and morasses and lagoons ex*ending along the sea, and filling
the land with melancholy.—*Gregorovius*, p. 459.

PLAINS OF FIUMORBO.

lesco, a broad and clear river, we reached the road to Pietrapola at 6.30. Before this, the dark green verdure of the plain had given way to plains of asphodel and half cultivated tracts of ground, latterly to fields of corn, and as the sun goes down behind the long western mountain wall, Peter drives up to a single large dwelling by the roadside, and says, "Ecco l'Hotel di Migliacciara."[1]

The hotel, indeed (built originally, I imagine, by the French Agricultural Company mentioned by Valery), is in itself the whole of the village of Migliacciara, excepting a large group of farm-like buildings on the opposite site of the road, the whole appearing what in the Roman campagna one would call a tenuta. And at this season and hour the position of this place seems delightful, when the scent of the hawthorn, the song of the nightingale, the voices of sheep and cattle, the greenness of the country round, and the grandeur of the mountain range, but a short distance away, all seem to fill it with rural charms—it is hard to believe that in a month or two hence the whole district becomes pestilential.

The interior of the so-called "hotel," is unlike any I have yet seen in Corsica ; the large building has rambling corridors and chambers, like those in many a wayside inn in the Neapolitan states of old days, or those of anti-Italian-Rome of these, and I was surprised as well as glad to secure a lofty and quiet apartment. Presently the Bastia diligence arrived ; supper or dinner was suddenly announced, and the company—to wit, the conductor and one passenger, myself and servant—sat down to a meal, of which it may be said that better as well as worse might be essayed.

The conductor, who is a "continental," and was a soldier in the Crimea, speaks highly of the baths of Pietrapola not far from here, and says that rheumatic complaints are completely removed by the use of their waters. He himself, he adds, after the Russian war, had rheumatic fever to a degree that lost him the use of both his arms, until, through the means of the Pietrapola hot baths, he was restored to health.

It would be pleasant to see these baths of Pietrapola ; they are in a neighbouring valley ; and perhaps after Aleria has been visited, time may yet allow of my reaching them.[2]

[1] The Migliacciara, a vast domain of ten square leagues, in the best soil of Fiumorbo, or even of all Corsica, which stretches from the shore to the mountains, and through which passed the old way, belonged formerly to the Fieschi family of Genoa.—*Valery*, i., p. 266.

[2] The Baths of Pietrapola, in a rural nook in the midst of high mountains, have but few houses ; at present they are like a camp for invalids, who run to and from their tents in nightcaps, bare-legged, and wrapped up in cloaks or blankets. The mineral waters of Corsica are not like many of those on the Continent, slow and uncertain in their effects ; their season is very short, but their effect is speedy. One might say that their waters partake of the decided and powerful character of the inhabitants. The heat of the baths of Pietrapola equals that of the waters of Tunis, and is forty-six degrees at the source. Their efficacy has been recognised by medical men, both Italian and French, who have analysed them, and from the sixteenth century they have been resorted to for maladies of the nerves, head, and ears ; in our day they are regarded as most useful in chronic complaints, paralysis, rheumatism, and cutaneous diseases.—*Valery*, i., p. 269.

CHAPTER IV.

April 26.—At 5.30 A.M. I start for Aleria ; the more delay in going there, the
greater risk of fever ; so once more I am on the Bastia road. How like is
this to the old days of Roman campagna life, its early hours, the fresh air,
and the outspread plain and distant mountains ! To me this is the most
delightful of Corsican scenery ; perhaps, indeed, partly from old associations ;
and none the less so that it is unexpectedly beautiful. The river Fiumorbo,([1])
which gives its name to the canton, is soon passed, and at 6 Ghisonaccio is
reached—a sprinkling of tall houses by the road-side, many of them unfinished,
all ugly and forlorn to look at—children abound, mingled with pigs, and men
sit in idleness on the walls and door-steps. Nor does any one take notice of

([1]) The Fiumorbo district owes its name to the torrent, which, shut in by mountains, rolls on as if
by chance, till its uncertain course ends in the sea, and thus it has been poetically named the blind river.
This part of Corsica, so wild in appearance, was formerly not less so as to the manners of its peasantry,
who were proverbial for the grossness of their habits, their superstitions, their independence, and their
obstinate opposition to all improvement. The following was related to me as the speech of a curé of
Poggio di Nazza, on his first arrival at the parish church. "I know," said he, to the peasants, "that
you are bad Christians, and that you care little for your priests ; but I have brought with me what may
be strong arguments in favour of the three persons you ought to believe in. This (said he, placing his
gun against the wall) is my Padre Santo ; this (laying his pistol on the altar) is the Figlio ; and, if these
are not enough, this (drawing a dagger) is the Spirito Santo." This novel illustration of the Trinity
was so convincing to his parishioners, that they lived always on the best terms with their curé. But this
was in past times, and for twenty years the Fiumorbo has been completely civilised.—*Valery,* i., p. 271.
 Near the bridge is Ghisonaccie, peopled by inhabitants of Ghisoni (a large village in the mountains),
who, being compelled to gather their harvests in this part, have built houses, that have gradually grown
into a village, recently made a commune.—*Galletti,* p. 172.

the passers-by, except one man, who, holding a live hare, says, " Achetez,
M'sieu ?" Ghisonaccio is not a prepossessing place. Just beyond it, on the
left of the road, is a tomb of classical shape, in memory of an overseer of road-
works, murdered here some years back. On the right the plain is lost in
marsh and great étangs or salt pools, while towards the snowy mountains it
seems one immense green carpet of fern and lentisk up to their very base,
varied only in a few places by lines of purple or almost of black, marking the
place where the " maquis " has been burned. And as clouds are rising, I fear
to lose my mountain outline, and devote some time to a drawing of these wild
fern plains and green levels. Peter the coachman about this time, I being
on foot, and he somewhat ahead, gets himself into disgrace, by reason of
beating one of his horses unmercifully when it stumbled, I and my man being
unable to prevent him, far less to moderate the astonishing current of oaths
with which, in these paroxysms of fury, he accompanies his blows. But on
overtaking him, I tell him that patience may have an end, and that if he
persists in disorderly behaviour, I will telegraph to Ajaccio for a new coach-
man, and leave him here. Whereon he says, ·" Una cosa certa é che l'uomo
deve sempre aver pazienza ; quest' é una delle prime regole della vita.
—one thing is certain, that a man should always be patient ; and this, indeed,
is one of the first rules of life !"

The plain becomes much more undulating as Casabianda is approached,
it stands on high ground, not far from the site of ancient Aleria—both
places overlooking the Tavignano and the whole eastern plain, and consists
in a group of large new buildings, not over picturesque, notwithstanding
that at a distance it has something of the air of Castel Guibilei, or similar
places on the Roman campagna. In the vicinity of this important estab-
lishment, fern, myrtle, and cystus disappear, and give way to corn, lupines,
and other vegetables more useful if not so poetical ; labour takes the place
of neglect ; and, instead of a green desert, there is flourishing cultivation.
Carts and cattle are met, and groups of the convicts (of which there are
about a thousand in the Penitencier) going out to work. A road strikes
off on the right to the reclaimed ground, near the great marshes now under-
going drainage, close to the sea, and to the left it is continued to the principal
buildings of the establishment, which I reach at 9.([1])

Fortunately for me (for, not having expected to come here when I left
Ajaccio, I had had no note or recommendation from M. Galloni d'Istria),
M. Benielli, the young clerk who, at Bonifacio, had volunteered to show me

([1]) The plain of Aleria, nearly thirty leagues long by three or four in breadth, and one of the
most fertile in the world, might produce food for more than 100,000 inhabitants. Its soft climate,
where winter is unknown, would permit even tropical plants to be cultivated. This superb plain along
the sea-shore is bordered with high mountains, and varied by light undulations which preserve it from
the dull uniformity of many plains. On seeing it, its characteristics impress you at once as those
peculiar to the site of an ancient and powerful city.— *Valery*, p. 278.

the lions of Aleria, happened to be at that moment at the entrance of the open space before the prisons, otherwise I could have made but little progress, owing to the sentinels and gendarmes, who naturally are on all sides in a place devoted to convict labour. M. Benielli greeted me heartily, and offered, conjointly with several other young employés, to show me all over Aleria. I was to see the new drainage, the prisons, the remains—here of a wall, there of an amphitheatre; in a word, nothing was to be left unseen. My object, however, being to procure one or two good views of the place, and to avoid giving up much time to what was not of immediate interest to my topographical work, I had little inclination to take long walks in the heat of the day; and, moreover, I had already discerned the point from which the plain of the Tavignano must be best represented. It requires all a man's available tact and politeness to intimate to fourteen or fifteen amiable individuals, without giving them offence, that you do not want their company, and would far rather be alone ; but it is necessary for me to choose on the one hand between companionship and time lost, and the chance of making a good drawing on the other.

> " Let us alone ; time driveth onward fast,
> And in a little while our lips are dumb,"

and our hands useless; so I beg my new acquaintances to allow me to go my own way, to which they most good-naturedly assent, being only hospitably obstinate on the point of my returning to breakfast with them at 11. Then, having accepted the offer of an obliging M. Liberati (who was on the point of going to the fort and village of Aleria) to show me a short cut across some fields towards the site of the old city, I set off, not without fear that the clouds, which are rapidly covering the snowy range, may prevent my getting their outline.([1])

([1]) The ruins of Aleria are the only ruins of Roman times in Corsica, besides those of Mariana. The few and detached remains consist in portions of a prætorial building—a sort of circus—some traces of the walls, &c. The salt lake of Diana, blocked up by sand, appears to have served as a port to Aleria, as indeed the large iron rings fixed on its edge still indicate. In our day it is noted for its oysters, of extraordinary size and exquisite flavour. So late as the end of the thirteenth century, Aleria was not entirely destroyed, for the bishop of the see resided there, as well as the family of Catinco, one of the most powerful of the island.—*Valery*, i., p. 277.

The city of Aleria was built on an elevation, which on the north side rises to a height of over fifty mètres above the level of the ground, and which slopes gradually towards the east. To the south-west it presents an undulating surface, and displays to the traveller who stands among its ruins one of the most imposing and magnificent panoramas. The beautiful prospect includes an immense and fertile, but little cultivated plain ; a large and deep river whose crystal waters rise in the high mountains of Niolo, and winding below the site of Aleria, fall into the sea exactly opposite the mouth of the Tiber ; a great expanse of blue sea, that on its further side breaks on the shores of the Roman campagna, and against the great ruins of the cities of Ostia, Porto, and Nettuno, which seem to send back to these silent plains of Aleria the echo of their decay.—*Galletti*, p. 174.

The port of Aleria was formed by an arm of the sea, which in our day comes up to half a league from its ruins. Near the mouth of this port is a charmingly picturesque islet, several mètres high above the level of the water, and in various parts of it are the remains of a wall which served as a quay. Further on, at the spot called Santa Agata, are ruins of a wall, in which portions of iron are fixed, and jars

It was at Aleria that Theodore, afterwards king of Corsica, first landed—a character so remarkable, that I subjoin some account of his most romantic life, extracted from Boswell and Gregorovius, in both of whose writings will be found much interesting information on the subject, one intimately con-nected with the history of Corsicans during their rebellion against Genoa in the early part of the last century.([1])

Several pieces of Roman brickwork, clearly denoting the antiquity of the spot, are scattered about the bluff or headland to which I went, and which may have been an outpost or fort of the old Roman colony, or even the citadel of Sylla's city, the site of which is evidently well chosen, and commanding a very glorious view on all sides—northward, along the flat plain which melts into the horizon near Cervione; westward, towards Monte Rotondo, the gorge of the Tavignano, and the course of that river to the foot of the Alerian hills; eastward, over the plain, and the broad marshes, and salt lakes, or étangs, to the sea; and, southward, to the whole chain of snowy heights, from Mont Renoso to Mont Incudine, with its remarkable outline, and the hills which at Solenzaro close the view in that direction. The long line of white snow against the blue sky is not unlike that of the Alps as seen from Turin; and, while I remained on this eminence, I wished to make another drawing, combining the buildings of Casabianda with the mountain wall beyond the plain; but clouds gradually blot out all their forms, and finally oblige me to give up the attempt. While I am drawing, G. brings me two specimens of the Mygale, or trap-spider, so common in Corfù, called there the Κεφαλάμια, and apparently abundant hereabouts.

are in some places built into it. The waters of Diana (which produce excellent oysters) occupy a space of 570 mètres, and their depth is ten or eleven. With small expense, the lagoon of Diana might be made one of the finest ports, as well as one of the safest in the Mediterranean.—*Galletti*, p. 15.

Aleria seems to have been an unlucky spot for many of its visitors; poor M. Valery became suddenly blind there, and Gregorovius's experience, on reaching it, was far from agreeable; for, in spite of "sniffing at camphor," he ran great risk of illness from being unable to procure any shelter. This is his description of the vicinity of the fort of Aleria, to which at length he was admitted. "The scenery around seemed to me truly Sullanic; a night as still as the grave; a barren plain full of feverish air at our feet; dark, night-shrouded mountains behind the fort, and the horizon reddened as with the glow of burning towns, for the thickets were on fire all around. The poor soldiers went out with their dogs to the lagoon of Diana, to be on the watch for smugglers. Their service is a dangerous one; they are changed every fifteen days, as they would otherwise succumb to the fever. . . I lay down on the floor of the room, and tried to sleep, but the sultriness was dreadful. . . It was a diabolical night, and I sighed more than once, 'Aleria! Aleria! chi non amazza vituperia!' the lampoon current in Corsica, 'Aleria, whom thou killlest not abuses thee.'"—*Gregorovius*, p. 463.

([1]) J. Baron Newhoff, in the county of La Marc, in Westphalia, was the personage who aspired to the sovereignty of Corsica. He had his education in the French service. He afterwards went to Spain, where he received some marks of regard from the Duke of Riperda, and Cardinal Alberoni. But being of a strange, unsettled, projecting disposition, he quitted Spain, and went and travelled into Italy, England, and Holland, ever in search of some new adventure. He at last fixed his attention on Corsica, and formed a scheme of making himself a king.

He was a man of considerable abilities and address; and after having fully informed himself of everything relating to the island, he went to Tunis, where he fell upon means to procure some money and arms; and then came to Leghorn, from whence he wrote a letter to the Corsican chiefs, Giafferi

At 11, return to Casabianda, where M. Benièlli meets me, and a good breakfast is most welcome after the morning's work, for even now the heat is great in these exposed plains. Whatever may be the privations of modern, compared with those of ancient, Aleria, the want of a good table is certainly not one, as sea-fish of several sorts, fresh river trout, wild-boar steaks and stew, hare and partridge, amply testified ; though the foreign visitor, however willing and able to appreciate such variety, could hardly help putting the friendly and simple hospitality of his French acquaintance as the highest item in the bill of fare. It seems that wild boars are very numerous here in the low underwood about the marshy districts near the sea, and the pursuit of them is a favourite amusement. M. Benielli tells me that from here to Corte is a ride only of six hours, and that on the way they pass Ghisoni, and near that place he says there is a gorge or chasm in the hills, called the *Inseca,* which he strongly urges me to see, as well as the forest of Marmano in that neighbourhood, where there exists a summer station for the Penitencier establishment. But how can I see "*all* Corsica" in ten weeks? At noon I took leave of my kindly entertainers, who, besides all the morning's attentions, pressed me warmly to stay with them two or three days.

Alas for the tops of the mountains ! they are invisible ; nevertheless, the one great peculiarity of this plain is ever before me ; namely, that it spreads darkly green to the very roots of the hill-range rising directly out of it—a single pale blue wall, silver tipped. Meanwhile the day is hot, and progress slow, which is no evil at all, compared with my hard task in preventing Peter from beating his horses, and from swearing after a fashion which becomes unendurable when you must needs sit still and hear it.

and Hyacinth Paoli, offering considerable assistance to the nation if they would elect him as their sovereign. This letter was addressed to Count Domenico Rivarola, who acted as Corsican plenipotentiary in Tuscany, and he gave for answer, that if Theodore brought the assistance he promised to the Corsicans, they would very willingly make him their king. Upon this, without loss of time, he set sail, and landed in the spring of 1736. He was a man of very stately appearance, and the Turkish dress which he wore added to the dignity of his mien. He had a few attendants with him. His manners were so engaging, and his offers so plausible, that he was proclaimed king of Corsica before Count Rivarola's despatches arrived to inform the chiefs of the terms upon which he had agreed. He brought with him about 1,000 zechins of Tunis, besides some arms and ammunition, and made magnificent promises of foreign assistance, so that the Corsicans, who were glad of any support, willingly gave in to his schemes. Theodore assumed every mark of royal dignity. He had his guards and his officers of state. He conferred titles of honour, and he struck money, both of silver and copper. The silver pieces were few in number, and can now hardly be met with. I have one of his copper coins ; on one side of it is "T. R. (Theodorus Rex), King Theodore," with a double branch crossed, and round it this inscription, " Pro bono publico Re. Co. (Regni Corsicæ), For the public good of the Kingdom of Corsica." On the other side is the value of the piece, " cinque soldi. five sous." There was such a curiosity over all Europe to have King Theodore's coins, that his silver pieces were sold at four zechins each ; and when the genuine ones were exhausted, imitations of them were made at Naples, and, like the imitations of antiques, were bought up at a high price, and carefully preserved in the cabinets of the virtuosi. Theodore immediately blocked up the Genoese fortified towns ; and he used to be sometimes at one siege, sometimes at another, standing with a telescope in his hand, as if he spied the assistance which he said he expected. He used also the artifice of making large packets be continually brought to him from the continent, which he gave out to be from the different sovereigns of Europe, acknowledging his authority, and promising to befriend him. The Genoese were not a little confounded with this unexpected adventurer.

Even in a carriage drive "to see all Corsica," there is still room for some variety, and such may be counted the frequent walking of red-legged partridges across the road, and the sitting of bee-eaters on the telegraph wires. If possible, I shall revisit Casabianda on my way to Bastia, for not only is the spot historically interesting in more than one way, but the scenery of the east side of Corsica can be illustrated from it more advantageously than from any other point ; perhaps on a second visit the distance may be less clouded, and if I cannot return, it will at least be something to have seen this side of the island, which is less easy to become acquainted with than the western.

The untidy Ghisonaccio is repassed, and the bridge over the Fiumorbo river, at 2.15 P.M. ; and at 4 the road to Pietrapola is reached, when I send on Peter to the inn, and take a short cut across the fields towards the entrance of the gorge in the hills, at the head of which are the village and the baths of Pietrapola, which perhaps there may yet be time to reach. In this walk, low down by the river Vabolesco, all is delightful, and strongly contrasted with the hot unsheltered Aleria ; great chestnut trees, here nearly in leaf, stand on grassy levels, or among fern four or five feet in height; all along the pleasant valley the hawthorn blooms, the blackbird and nightingale sing, and

They published a violent manifesto against Theodore, treating him with great contempt, but at the same time showing that they were alarmed at his appearance. Theodore replied in a manifesto with all the calmness and dignity of a monarch, expressed his indifference as to the injurious treatment of the republic, and appeared firm in the hopes of victory After having been about eight months in Corsica, Theodore perceived that the people began to cool in their affections towards him, and did not act with the same resolution as before. He therefore wisely determined to leave them for a little, and try his fortune again upon the continent. So, after having laid down a plan of administration to be observed in his absence, he quitted the island in the month of November. He went to Holland, and there he was successful enough to get credit to a great extent from several rich merchants, particularly Jews, who trusted him with cannon and other warlike stores to a great value, under the charge of a supercargo. With these he returned to Corsica, in 1739, and on his arrival he put to death the supercargo, that he might not have any trouble from demands being made upon him.

By this time the French had become so powerful in the island, that, although Theodore threw in his supply of warlike stores, he did not incline to venture his person, the Genoese having set a high price upon his head. He therefore chose to relinquish his throne, and give up his views of ambition for safety, &c., &c. . . . The Corsicans now talk differently of King Theodore. Some of them, who had most faith in his fine speeches, still extol him to the skies, to support their own judgment ; others, who looked upon him as an impostor, and never joined heartily in his measures, represent him as a kind of Wat Tyler—a king of a rabble ; but the most knowing and judicious, and the General (Paoli) himself, consider him in the moderate light in which he has now been represented, and own that he was of great service in reviving the spirit of the nation, which after a good many years of constant war, was beginning to droop, but which Theodore restored, while he rekindled the sacred fire of liberty. They, indeed, are sensible that his wretched fate has thrown a sort of ridicule on the nation, since their king was confined in a jail at London, which was actually the case of poor Theodore ; who, after experiencing the most extraordinary vicissitudes of fortune, chose to end his days in our island of liberty ; but was reduced to the wretched state of a prisoner for debt. Mr. Horace Walpole generously exerted himself for Theodore. He wrote a paper in the *World*, with great elegance and humour, soliciting a contribution for the monarch in distress, to be paid to Mr. Robert Dodsley, bookseller, as lord high treasurer. This brought him a very handsome sum. He was allowed to get out of prison. Mr. Walpole has the original deed by which Theodore made over the kingdom of Corsica in security to his creditors. He has also the great seal of his kingdom. He died very soon after he got out of prison, and was buried in St. Anne's churchyard, Westminster.—*Boswell*, pp. 106, 107.

The shore occupied by Marius and Scylla was later the burlesque theatre of two disembarkations

gravelly paths lead on by the side of the clear running stream, between clumps of lentisk and cool verdure. Rejoining the road—a route forestière—which leads to the baths, it enters the pass of Pietrapola, a winding woody valley scene almost exactly like one in Derbyshire or Devonshire. The road runs at a considerable height above the beautifully clear rivulet that foams and dashes over rocks and white boulders, and only the presence of large ilex instead of ash or oak forbids an Englishman to suppose he is in his own country. But there is not time to pursue this leafy valley very far, for it is 5.30 P.M., and I turn back towards Migliacciara without having reached the baths, though the walk even so far up the picturesque and narrowing vale in the enjoyable quiet of this cool evening has its agreeable memories.

On the way back to Migliacciara by the upper road, glimpses of the plain are caught now and then from pleasant lanes, where the hedges are alive with bird-melody. There are a few fine cattle (not an ordinary sight in Corsica) here and there, some scattered cottages, all with an accompaniment of pigs, which seem more common on this than on the other side of the island, and now and then a few peasants are met, on their return home to their villages, black and brown garmented as usual, their horses carrying

and one departure of that Westphalian baron, Neuhoff—called king Theodore—crowned adventurer, friend of Law, lover of pomp and luxury, able speaker, libertine, shut up for debt in Holland, dying at length in a garret in London, and figuring in the "Supper of Six Kings" of Candide at Venice, the Libretto of Casti, and the music of Paisiello.—*Valery*, i., p. 278.

It was at Aleria that Theodore of Neuhoff landed on the 12th of March, 1736, says Gregorovius, at the commencement of a very interesting chapter on the subject, and quoting from an unpublished Genoese manuscript of the year 1739, "Accinelli's Historical, Geographical, and Political Memorabilia of the Kingdom of Corsica," embellished by the motto in no wise complimentary to the people of the island, "a perverse and erring people, beasts, and all brutes." (This MS. contains a portrait of King Theodore, in Moorish costume, &c.; and a second representation of him is given in an old German book, printed in Frankfort, 1736, published by Giovanni di San Forenzo. Theodore's appearance in Corsica, and his romantic election to be king of the island, then engaged the attention of all the world, and the account of his landing is given in this book on the authority of letters from Bastia.) "*April 5.*—At the port of Aleria arrived lately an English ship said to belong to the consul of that nation at Tunis, and in this a very exalted personage, &c. His costume is after the manner of the Christians who travel in Turkey, and consists of a long scarlet-lined coat, a perruque and hat, as well as a stick and sword. He has a suite of two officers, a secretary, a priest, a lord-steward, a steward, a head cook, three slaves, and six lacqueys with him; also, he has disembarked ten cannon, above 7,000 muskets, 2,000 pairs of shoes, and a great lot of all kinds of stores, among which are 7,000 sacks of flour, likewise several chests of gold and silver specie, one of which is a strong lead-cornered one with silver handles, full of whole and half sequins from Barbary, and the treasure is reckoned at two millions of pieces of eight. The Corsican leaders have received him with great demonstrations of reverence, and conferred upon him the title of "Your Excellency," and of Viceroy; whereupon he then appointed four of the Corsican colonels, with a monthly salary of a hundred pieces of eight; he next created twenty companies, and caused a gun, a pair of shoes, and a sequin, to be given to each common soldier; but a captain receives henceforth eleven pieces of eight every month, &c. . . He has taken up his residence at the episcopal palace at Campo Loro, before which house 400 men with two cannon keep guard; . . . he is going to repair to Casinca, . . . and he awaits more large ships of war which are to arrive about the 15th of this month, to assail the Genoese with all his force by land and sea. . . We are assured that he has been deputed by some Catholic European potentates, who will second his enterprise in every way; wherefore the Genoese are thrown into the extreme of alarm, and regard their cause in the island as good as lost. Some more recent accounts add that the above-mentioned foreigner is appointing his court with greater and greater magnificence,

double. But the event of the evening lay in meeting an equéstrian party, two of whom, good-looking damsels, were running a race, and others with their male friends all following in a body and encouraging the bold and fair, the like of which departure from the gravities I had not before seen in this island. Near the Migliacciara farm are immense flocks of black sheep, soon, I am told, to leave the plains for the upper mountain pastures.

The Bastia Diligence had just arrived at the hotel, and as it was pretty full, the party at supper were numerous; the repast, more remarkable for the rapidity with which it was consumed than for the quality of the food, was chiefly distinguished by the large supplies of capital asparagus, and for a pyramid of oysters from the étang, or salt-water lake, at Aleria; these are of immense size, but, to my taste, wanting in delicacy. The Diligence company included some who were very amusing; the conductor, who constantly reminded his charge that time was precious, and urged fast eating; a young and merry priest, a continental, who joked and smoked; two naturalists, one a lively youth from Dresden, the other an elderly Austrian savant, who had met by chance at Bastia on their way to collect entomological novelties at Porto Vecchio; and three or four others. In these round-table meetings there is a good deal of hurry and noise; the Migliacciara Hebe—she is like an Arab girl, with her head so muffled up as to allow as little as possible of her very brown face to be seen—sets the various dishes, or rather throws them, with great vigour and audacity at no particular point on the table, and snatches up the plates, with clashing and no small tumult, from those who have accomplished the disappearance of a portion of food; everybody helps everybody else to wine, and himself to food; and conversation becomes general and loud.

To-night it happens to be full of amusement, till M. le conducteur, having

and is always attended by a guard from one church to another, and has appointed one named Hyacinthus Paoli to be his treasurer, &c., &c."

Theodore von Neuhoff was born at Altena, a small town in Westphalia. His father was a captain of the body-guard of the Bishop of Münster. . . When he was ten years old he was entered at the Jesuits' College at Münster. He killed a rival for some lady's love in a duel. All that transpired of the life of Theodore before he came to Corsica, displays him to us as one of the most prominent and successful of the series of adventurers of the eighteenth century. It is related that he became a page to the celebrated Duchess of Orleans, and was educated into a finished and dexterous courtier. His Protean nature drew him into the most contradictory careers. In Paris, the Marquis de Courçillon procured an officer's commission for him. He became a desperate gambler; then he fled to Sweden, to save himself from his creditors, to Baron von Görst, and by turns formed connections with the adventurous and intriguing ministers of that age, with Ripperda, Alberoni, and lastly with Law, who all more or less transferred to political life the character of soldiers of fortune. Theodore became an intimate of Alberoni's, and gained such influence in Spain that he amassed a considerable fortune. After Alberoni's fall, he clove to Ripperda, and married a maid of honour to the Queen of Spain—a Spanish lady of English or Irish descent, a relation of the Duke of Ormond. She appears not to have been a paragon of beauty. Theodore abandoned her; not without taking possession of her jewels, and other treasures. He went to Paris, where he was connected with the schemes of Law; and, moving about through all countries of the world, tried everything in turn, in England and particularly in Holland, where he set speculations on foot, gambled, and made debts. Theodore came to Genoa, formed connections with the

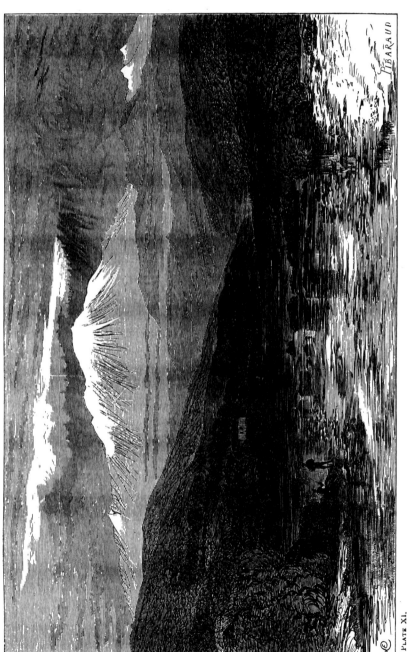

TIBARAUD

PLATE XI.

several times vainly essayed to move the party, rises, and saying with authority, "Messieurs! soyez raisonnables! Il faut que vous partiez," breaks up the sitting.

April 27.—Off at 6 from the wide-meadowed and rural Migliacciara—a place that calls up many a memory of farms on the Campagna di Roma—and along the Bastia and Bonifacio road back to Solenzaro ; this is my only plan, for there is no possibility of getting to Bavella in one day from here, and, more-over, the weather is cloudy and threatens rain, ill prospect for high mountain passes. And now the whole beautiful line of snowy heights, so great a compensation for the long straight high road, is altogether invisible, and the drive has but slender charms ; soon even the rarely occurring houses, the lazy people and the pigs, the fields of asphodel and carpet of fern, are all shut out by hard rain for a couple of hours.

At 8 the weather clears as I reach the bridge over the Travo ; and since the chief necessity of this day consists in keeping clear of the village inn at Solenzaro as long as possible, I determine to make what studies I can about the river, and anyhow to stay out of doors till near sunset. G., besides breakfast and folio, has a plentiful supply of cloaks, so come rain or sunshine, Peter is sent on, and the horses, who may perhaps have a hard day's work at Bavella to-morrow, will have a long rest to-day.

Drawing thrives ill, for the day is sunless and heavy, yet I venture by snatches to secure the nearer parts of this beautiful river scene ; and when rain falls, sitting below a thick myrtle and lentisk grove and writing up journal notes ekes out the hours. Days of Cumberland and of Devonshire Lydford seem to return as I sit by the clear and noisy river. At intervals the snowy heights appear, and then again are hidden in the most tantalising fashion,

exiled Corsicans there and at Leghorn, took up the idea of becoming King of Corsica, and went to Tunis. In Barbary he was taken prisoner, wherefore he subsequently included a chain on his royal coat of arms. From Corsica he wrote to his Westphalian cousin, M. de Drost (the letter, which, with other information, is in the Genoese MSS. of Accinelli, is printed as authentic in the third volume of "Cambiaggi"), announcing his election (April 15, 1736) to the sovereignty of Corsica, and other par-ticulars of his life.

No sooner had the election of Theodore become known than the "doge, governors, and procurators of the republic of Genoa," published a manifesto, describing the new king "very odiously." It com-mences, "On the receipt of the news that at the port of Aleria, in our kingdom of Corsica, the English Captain Dick's small merchant ship has landed stores of war, and a certain person, who has unaccount-ably succeeded in rendering himself popular, &c." . . and goes on to exhibit his past life and character in the blackest colours, dwelling, among other matters, on his continual change of name, Baron von Naxaer, von Snichner, von Nissen, von Smithberg ; of his perpetual change of residence, of his frauds on all sorts of people, his desertion of his wife, &c., &c., and concludes by threatening all who followed the said Baron of Neuhoff with penalties, &c. (May 9, 1736).

Theodore then published as answer a counter-manifesto to the Genoese decree, "given in the camp before Bastia, July 10, 1736," a letter of the most haughty and violent nature, and which must have enraged the republic beyond all limits of patience.

The new King set up his court at Cervione ; he founded orders, coined money, &c., &c.

After a vain attempt to regain his crown in 1739, he retired to England. He left behind him a

happily beaming out brightly for an hour later in the day, so that, in the end, I can procure their outline correctly. (*See* Plate 11.) •

One human being only is seen through all the morning, to wit, a half frightened little boy, to whom I give the empty wine-bottle after breakfast; but he supposes I want it filled with water, and although on his return to the place where I was sitting he finds me no longer there, I meet him, seeking for me everywhere, a full hour afterwards, and still carrying the full water bottle—a degree of patient virtue meriting all that remains of the unfinished breakfast.

The rest of the day's work consists in slowly walking to Solenzaro, getting one or two memoranda of the positive black-purple line of burnt "maquis" all across the plain, and watching the vast crags of the Incudine range gradually glooming out through mist and thunder-cloud as I reach the village at 7 P.M.

A very queer little hotel indeed seems this of the Widow Orsola; from its ground floor a ladder leads to an upper set of apartments, including three small rooms, all occupied, besides an open platform landing or common passage, the only place in Solenzaro where a night's rest can be got. "Διὰ μίαν νύκτα—only for one night"—says the Suliot, as he puts up my camp-bed in a corner, gets the room swept, and gradually contrives to change the confusion of the place into something like order. I decline the offer of one of the French employés, who good-naturedly begs to vacate his own room for me; and finally two tables are introduced, one to serve for supper, the other for my

wonderful life-dream, in which he had seen himself on a wild island, with a crown on his head, and a sceptre in his hand, surrounded by marquises, earls, barons, knights, chancellors, and keepers of the great seal. He now sat beggared and sad in a London debtor's prison, into which he had been cast by his creditors. He died in the year 1756. Walpole opened a subscription for the benefit of the poor Corsican king, and delivered him from imprisonment, in gratitude for which Theodore made him a present of the great seal of his kingdom. He was buried in the cemetery of Westminster.—*Gregorovius*, pp. 466—483.

Gregorovius appends this note :—" He was buried in an obscure corner among the paupers in the churchyard of St. Anne's, Soho." (*Athenæum*, No. 1427, March, 1855.)

We find a neat mural tablet fixed against the exterior wall of the Church of St. Anne's, Soho, at the west end, on which, surmounted by a coronet, is inscribed the following epitaph, written by H. Walpole :—

> " Near this place is interred
> Theodore, King of Corsica,
> Who died in this parish,
> Dec. 11, 1756,
> Immediately after leaving the
> King's Bench prison,
> By the benefit of the Act of Insolvency ;
> In consequence of which,
> He registered his kingdom of Corsica
> For the use of his creditors."

> " The grave, great teacher, to a level brings,
> Heroes and beggars, galley slaves and kings ;
> But Theodore this moral learned ere dead :
> Fate poured his lesson on his living head ;
> Bestowed a kingdom, and denied him bread."—*Forester*.

man to sleep on, and the evening meal is set forth in such space as has been cleared of boxes, barrels, and sacks.

The dinner, with a curious inconsistency that I am now beginning to recognise as a regular part of Corsican travel, is quite a contrast to the rude discomfort of the room—good soup and boiled meat, trout which might do credit to a table at Ambleside, capital roast mutton and salad, with the red Tallano wine, famous in these parts. Moreover, the quiet and obliging ways of the Corsicans who administer these rustic roadside inns is beyond praise, and after two weeks' sojourn in the island, I am coming to think that a more unpretendingly civil and attentive set of people to a stranger who brings them very little profit, can hardly be found.

Meanwhile, in the opposite room beyond the ladder-entrance, various people employed in the metal or wood interests are supping, among them the young Dresden naturalist, who had broken down in the long Diligence journey, and is going on to Porto Vecchio by slow instalments. Later, I converse with some of the "continentals," and learn the details of what I hope is to be my to-morrow's journey to the Bavella forest. The Maison de l'Alza (or Maison Forestière), the principal forest lodge, is, says M. Mathieu, twenty-three kilomètres from Solenzaro, and thence it is five or six more up to the Bocca di Bavella, or head of the pass, beyond which there are twelve or fourteen more kilomètres to Zonza. Provisions must be taken for the whole route, as none are likely to be found on it. Some to whom I speak, say boldly that they think there is no chance of my trap, owing to its weight and the smallness of its horses, ever arriving even at the top of the first pass, for there are two; others opine that the ascent may be accomplished with care, and as I and G. shall always walk, I do not doubt that I may get there. To-day, however, I shall only endeavour to reach the Maison de l'Alza, drawing as much as I can by the way. And it has rained so hard in the mountains all day that a clear morrow may, I think, be hoped for.

April 28.—At 5 A.M. the weather is cloudy, but yet giving sufficient promise of clearing to allow of a start on this cross-country expedition. The obliging Widow Orsola, besides recommending thin slices of toast with the morning cup of coffee, superintends the arrangements for carrying food for at least two days, in the shape of bread and cheese, a large piece of meat, twenty-five eggs, cold trout, and three bottles of wine, for all which, besides yesterday's lodging and supper, ten francs is the charge.

We are off at six, and ascending immediately behind the little chapel I had drawn three days ago, turn out of the main road into the Route Forestière, which, like that on the hills of Spedale, is broad and in good order, but without parapets. The views become finer at every turn in the steep ascent; immense tracts of wood and "maquis" stretch away to the north; before me,

towards the south-west, rise the huge crags of the Bavélla Pass, their summits hidden in mist, and far below rolls the river through underwood and among rocks, with pines growing close to the water's edge. (*See* Plate 12.)

At 7.30 a stoppage occurs from meeting the first timber carts I have seen in these lands, loaded each with a single tree-trunk a hundred feet or upwards in length, and drawn by from ten to fifteen mules. From a distance, these cars seem like giant serpents or megalosauri slowly winding down the mountain, and it is as well to perceive their coming beforehand, so as to draw up by the inner side of the road ; for, although guided behind by two men with a sort of helm, they are dangerously unwieldy neighbours if encountered unexpectedly at any of the sharp turns of the road, the mules when going down hill being stopped with difficulty.

About 8 a small white house of refuge in time of snow or storm is passed ; outside it is a forno, or oven for baking bread. A long string of mules comes down the mountain laden with wine from Tallano ; and, later, M. Mathieu, the agent or head forester, passes on horseback, and says that he shall be at the Maison de l'Alza to receive me—we are a long way off that yet, however. The pass here is very grand, and I obtain many a memorandum of it as the carriage goes slowly up the hill. The pines are much larger than those lower down, and grow wildly among the detached masses of granite, among which the river foams and dashes.

At 9.45, being at the eleventh kilométre, half the way is accomplished, and hitherto I see no reason to despair of getting in good time to the desired halt, if only Peter can be induced to leave his horses alone ; while they toil up slowly and regularly, stopping from time to time, things go on well, but when he bursts into one of his vicious paroxysms, he beats them—if I or my man are not near enough to prevent him—till they back nearly to the edge of the precipice ; once or twice a very ugly sight.

Meanwhile the pass becomes constantly finer and more interesting ; the immense crags in front—the hightest of this part of the lofty central range, and very close to the Mónt Incudine—are wrapped in cloud, and are awfully mysterious, and somewhat resembling the great pillars of Gebel Serbal, in the peninsula of Sinai. The pines are exquisitely beautiful, and unlike any I have ever seen ; perfectly bare and straight to a great height, they seem to rise like giant needles from the "deep blue gloom" of the abyss below. Granite rocks of splendid forms are on every side, the spaces between them cushioned with fern, and the tall spires of the *Pinus maritima* shooting out from their sides and crevices. Springs by the road-side are frequent and welcome, for the way is exceedingly steep, and Giorgio has to work hard in pushing the carriage behind, which the poor little horses, willing, but ill-fed and ill-treated, find it difficult to pull up.

11 A.M.—At the fourteenth kilométre, where there is another little forest

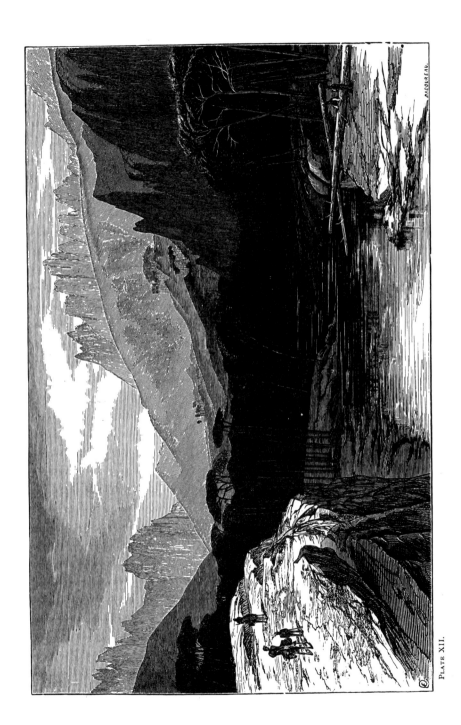

JACQUEREAU.

PLATE XII.

house or refuge (the spot is called Rocca Pinsuta, a wondrous scene of fine crags and pines), we halt for breakfast and to remain at least till 1 o'clock. May the heavy clouds now gathering and throwing a deeper gloom over the depths and tremendous heights around, not turn to violent storm and rain! for

there are still three kilo-
métres (two miles) to the
bocca, or top of the pass ;
two gendarmes, however,
who come down the hill,
say that the road ahead is
less worn and not quite so
steep as along the part we
have come up.

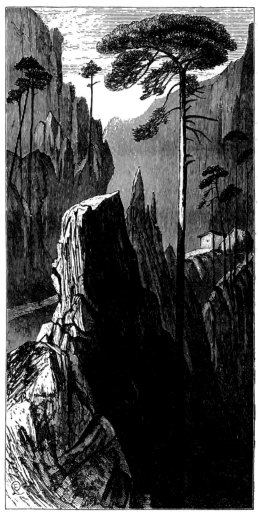

Leaving G. to oversee
Peter and the horses, I
wander on alone with my
note - book and pencil.
The colour here is more
beautiful than in most
mountain passes I have
seen, owing to the great
variety of underwood
foliage and the thick cloth-
ing of herbs ; forms, too, of
granite rocks seem to me
more individually interest-
ing than those of other
formations ; and the sin-
gular grace and beauty of
the pine-trees has a pe-
culiar charm — their tall
stems apparently so slen-
der, and so delicate the
proportions of the tuft of
foliage crowning them.
The whole of this profound
gorge, at the very edge of
which the road runs, is full

FOREST OF BAVELLA.

of mountain scenes of the
utmost splendour, and would furnish pictures by the score to a painter who could remain for a lengthened sojourn. Sometimes ivory-white, needle-spiry pine stems, dead and leafless, break the dark yawning chasm of some black abyss far

below with a line as of a silver thread; now a great space of gray mist in the distant hollow depth is crossed by lines of black burned stems; anon the high trunk of a solitary tufted tree looks like a kind of giant flower on a tall stalk; and ever above are delicate myriads of far pines "pluming the craggy ledge," their stems drawn like fine hair against the sky.

At 3 the top of the pass, or Bocca di Larone, is reached; and here the real forest of Bavella commences, lying in a deep cup-like hollow between this and the opposite ridge, the north and south side of the valley being formed by the tremendous columns and peaks of granite (or porphyry?), the summits of which are seen above the hills from Sarténé, and which stand up like two gigantic portions of a vast amphitheatre, the whole centre of which is filled with a thick forest of pine. These crags, often as I have drawn their upper outline from the pass I have been ascending to-day, are doubly awful and magnificent now that one is close to them, and, excepting the heights of Serbal and Sinai, they exceed in grandeur anything of the kind I have ever seen, the more so that at present the distance is half hidden with dark cloud, heavily curtaining all this singular valley; and the tops of the huge rock buttresses being hidden, they seem as if they connected heaven and earth. At times the mist is suddenly lifted like a veil, and discloses the whole forest—as it were in the pit of an immense theatre confined between towering rock-wall, and filling up with its thousands of pines all the great hollow (for it is hardly to be called a valley in the ordinary sense of the term) between those two screens of stupendous precipices. As I contemplate the glory of this astonishing amphitheatre, I decide to stay at least another day within its limits, and I confess that a journey to Corsica is worth any amount of expense and trouble, if but to look on this scene alone. At length I have seen that of which I have heard so much—a Corsican forest. (See Plate 13.)

The road leads down from the Bocca di Larone to the bottom of the hollow, and, crossing it, mounts the further side, half way up which, a small white speck, is the Maison de l'Alza, and the end of my day's journey. All along the descent there are no words for the majesty and wonder of this scenery; the tremendous mystery of those cloud-piercing towers and pillars, their sides riven and wrinkled in thousands of chasms, with pines growing in all their crevices and on all their ledges and pinnacles; the waves of the forest, so to speak, stretching from side to side of the vale; the groups of ilex, mixed with pine, in innumerable pictures, massive or slender, bare stemmed or creeper-hung, flourishing in life, or dead glittering and white.

At the end of the descent stand two small foresters' houses on the short space of level ground between the four sides of this vale of Bavella; but here, at the twentieth kilométre from Solenzaro, the clouds burst, and violent torrents of rain make shelter welcome. Yet when the storm ceases for a

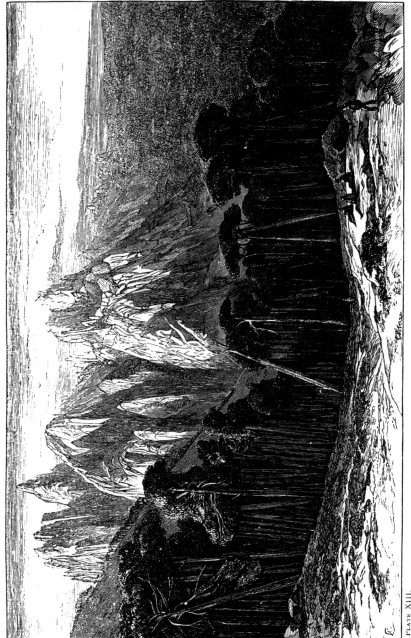

PLATE XIII.

FOREST OF RAV

time, and the sun gleams out through cloud, the whole scene is lighted up in a thousand splendid ways, and becomes more than ever astonishing, a changeful golden haze illumes the tops of the mighty peaks, a vast gloom below, resulting from the masses of black solemn pines standing out in deepest shadow from pale granite cliffs dazzling in the sunlight, torrents of water streaming down between walls and gates of granite, giant forms of trees in dusky recesses below perpendicular crags; no frenzy of the wildest dreams of a landscape painter could shape out ideal scenes of more magnificence and wonder.

From the twenty-first kilométre the road again begins to wind steeply upwards between tall walls of spectre pines, half seen through a dim mist and thickly falling rain ; and at times I am glad to take shelter below some of the rocks, till complete wet-throughness renders any further care unnecessary. There is now no longer any fear of precipices, for the road here has a natural parapet of rock ; and G. has worked hard in superintending the progress of the carriage from behind, while the tired horses creep slowly up; for in this last stage of their discomfort, Peter the merciless is not to be suffered to beat them—a shutting up of one valve which only occasions his anger to escape more violently by another. So that when there is a pause of a few minutes he occupies them in the most ferocious cursing, often so ridiculous, that it ceases even to be shocking, as he introduces into his maledictions a multitude of novel and definite detail quite surprising. Once, when the horses had stopped, and I prohibited their being touched, Peter's volubility ceased from sheer want of power to continue; "for," said he, "I have no more breath, and besides I have sworn at everything, and there's nothing left to 'bestemmiare,' —to curse." But at that moment the upraised voice of several cuckoos, who seemed rather than not to rejoice in the rain, was heard, and gave him a fresh impetus, for, with a poetical ingenuity worthy a better cause, he exclaimed, "May all the parliament of heaven be so full of these nasty cuckoo birds that the saints and apostles will not be able to hear themselves or each other speak ; and may every drop of rain turn into a million of snakes on its way from the sky downwards !" Assuredly Peter is a most unpleasant coachman.

The Maison de l'Alza, close to the twenty-fourth kilométre, was reached at 5.30 P.M. ; a neat tidy house of two storeys, standing in a space cleared from trees and looking directly across the valley to the Bocca di Larone. Here M. Mathieu came out, and received me most amiably, giving me and my servant rooms ; and, after putting on dry clothes, most welcome were a good fire and a hot basin of soup, not to speak of trout, pork and potatoes, and an omelette with morelles—a production of my host's—with plenty of good wine. A double-kerchiefed old woman and an old guardiano waited at table, and the house in the woods was a treasure after the day's work and walk. So also was a sound sleep in the camp-bed ; but, before that happened, I had already resolved to remain here all to-morrow.

April 29, 4.45 A.M., wake with a strong impression that it is needful to work extra hard all day, in order to secure as many records as possible of the scenery I walked through in the afternoon of yesterday, anything approaching to the magnificence of which, as forest landscape, I have never seen ; yet,

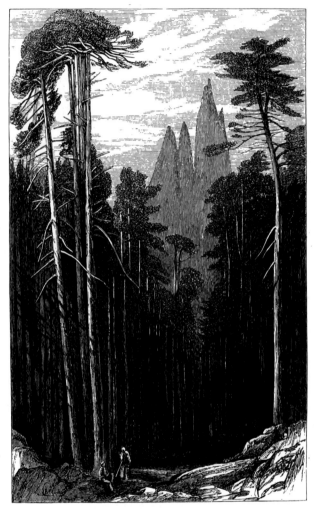

FOREST OF BAVELLA.

owing to the perfect clearness of to-day, there cannot be that wealth of effect produced yesterday by the passing and lifting of clouds across the enormous crags—sublime and continually changing—and that infinite variety of light and shadow thrown over the pines and all the foliage of the deep hollow valley.

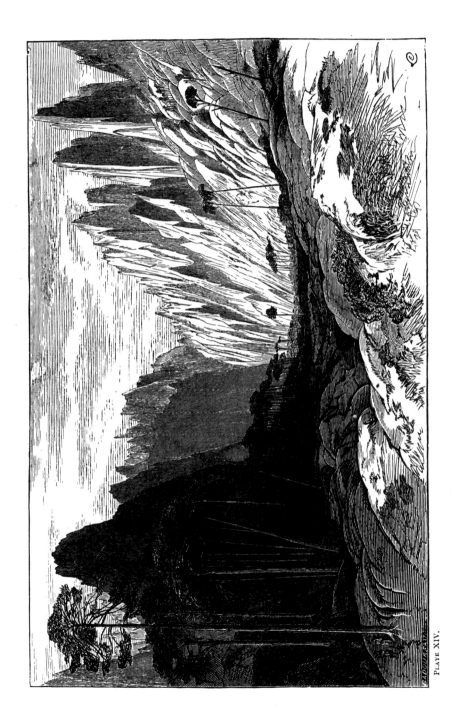

PLATE XIV.

The sun rises cloudlessly over the world of pines, and presently forms new and glorious pictures, as point after point of the western side of the valley is lighted up, while all the eastern part of the forest is as yet in dark and solemn shadow, below the giant crags—long streams of gold and bronze widening out gradually into masses of luminous green, and a flood of glory spreading slowly up the immense granite buttresses. I set off at 5.30 A.M. down to the bottom of the valley, and crossing it, go up as far as the Bocca di Larone, M. Mathieu, on his return to Solenzaro, overtaking me by the way, of whom I took leave, with thanks, for his good-natured hospitality.

Thenceforth, all the rest of the day went in hard work, only interrupted at 11, after Giorgio's announcement, " ἕτοιμον τὸ πρόγευμα, κύριε—Sir, break-fast is ready"—and by walking from one part to another of this never-to-be-forgotten beautiful forest, not the least of its charms being the profound silence, broken only by the cuckoo's notes echoing from the crags, and from the fulness of melody chanted by thousands of blackbirds. Other forests in Corsica are much larger than this, but surely none can surpass it in certain qualities. For, remarkable as the valley of Bavella undoubtedly is as a whole, by reason of its intense solemnity, and for the double range of apparently perpendicular barriers which close it entirely from the outer world, and admit no prospect whatever beyond its limits, it is not less so for the exquisite detail of its scenery, the brushwood or " maquis "—particularly the arbutus and great heath—being throughout of the most perfect béauty. In some spots, too, groups of large evergreen oaks standing on slopes of green sward or fresh fern, and at others, masses of isolated granite, form pictures hardly to be exceeded in grandeur.

A slowly moving black and orange lizard is a noticeable inhabitant of the forest ; he waddles gravely across the road, and frequently gets crushed by the wheels of the great timber carts. For, above the Maison de l'Alza great havoc goes on amongst the stately pines, and these enormous trees, peeled and cut angularly, are carried down to the valley depth, and thence up to the Bocca di Larone, and all the way to the shore at Solenzaro—often, as I have before observed, very unpleasant loads if met at sharp turns of the road. Some of these giant trees are six feet in diameter, and require fourteen or sixteen mules to drag them up to the Bocca.

After a hard day's drawing I come up to the Maison de l'Alza before sun-set. Although the wrapping mists of yesterday's cloud and storm are blown away, and what seemed the fathomless hollows and immeasurable summits are now plainly understood ; yet, in spite of this, parts of the forest are still truly extraordinary, the greatest novelty of the scenery being that the great granite columns are so near to you, that here and there some of them appear literally overhead, while every imaginable beauty of detail adorns their surface ; and, again, one remarks how, sometimes, multitudes of tall needle-like pine stems

shine brightly off the deep-shadowed chasms in the crags, or cluster in lines of jetty black against the pallid granite.

Some of the scenes at the foot of the ascent to the Maison de l'Alza, and close to the great precipices, occupy me two or three hours—one, a narrow gorge with a perspective of spires, leading, as it were, into the very inmost heart of the mountain ; another, of bold crags (*see* Plates 14 and 15), dark against the sunset sky, and rising out of the most profuse vegetation—both scenes grand beyond expression in words. Nor, indeed, except by very careful study, could many of the greatest and wildest beauties of this forest be represented in a sketch, and to attempt to do so seems like endeavouring in one day to make satisfactory notes from the contents of a whole library, full of all sorts of literature. Nevertheless, I have succeeded in obtaining a few striking points of this wonderful landscape.

The wife of the guardiano did her best to procure us a dinner, though the materials of it were only potatoes in various forms ; happily the Solenzaro larder was far from exhausted. A painter, however, might and should endure anything short of starvation, to see what I have seen of Bavella.

April 30.—Before the red sun glows over the eastern sea, and while yet the grand forest is in deep shade, I have risen, and having paid the expenses of Madame Guardiano, and secured a lot of pine cones and seeds for Stratton and various other English places, I leave G. to follow with disagreeable Peter and the trap, and walk on alone ; strict injunctions previously given that the horses are to take their own time, since there are but six more kilométres to the top, and we shall there make a long halt.

The silence and majesty of these pine forests at this hour! the deep obscurity in dim untrodden dells ! the touches of gold high up on the loftiest branches and foliage !—And as the road mounts steeply upward, how beautiful are the cushions of green, the topmost verdure of the thousands of trees on which, far below, you look down !—Generally speaking, the Corsican pine has but little lateral foliage, but sometimes on the outskirts of the forest, you meet with trees that have broad arms and dark lines of flat spreading leafage, exactly resembling some in Martin's pictures. To make small memoranda as I walk up is all I can do, though in reality there are great pictures on every side, but such as require a long time to portray.

At 9 A.M., a little beyond the twenty-ninth kilomètre, the last forest house, called Maison de Bavella, is reached, and here is to be the two hours' halt. The position of this little building is bewitching, for it overlooks every part of the valley, and being considerably higher than the opposite Bocca di Larone, has a most extended horizon in that direction ; some of the tallest and finest formed trees stand near, serving as frames for the scene below, and between their stems, far away on the eastern sea, appears the island of Elba (so at

FOREST OF BAVELLA.

PLATE XV.

least say the people at the forest house, though by its situation I should have thought it Monte Cristo); and beyond that the Italian coast appears perfectly clear. An hour or more is passed in drawing at some distance from the high road. How pure at this height is the air! what stately trees around! how perfect and beautiful are·these scenes! and yet, though the last two days have considerably altered my opinion about pine-forest scenery, I would rather live among palms than pines.

After breakfast, by the side of a delicious spring, on the last of the food prudently secured at Solenzaro, I wander on still upwards. All about the slopes above and around the Bavella forest-house, stand numerous little houses, or rather huts of stone; these, says the woman at the Maison Forestiére, are all occupied in the summer by the people of Zonza, the next village westward; the whole of the inhabitants of that place coming, as it were, up-stairs, and passing three months in the forest. "Everybody comes," says the guardianessa, "the maire, the doctor, the priest;" but how they exist in such miserable dwellings it is not easy to understand, the rude buildings being made of masses of granite put together in the most cyclopean fashion, with wooden roofs, and heavy stones to keep the planks in their places. Inside there are shelves to do duty as beds, and in some there are tables, all of the roughest description. I counted more than eighty of these "mountain homes;" as many more are fallen down, and are simply heaps of stones, while others are very unsafe and ready to collapse with the next heavy snow or violent wind. The turf-slopes and whispering tall pines about this high eastern ridge of Bavella are delightful; and, doubtless, in the summer, when the temperature is always settled, an out-door life on this mountain top must have charms that atone for the want of comfort these unsatisfactory domiciles must present. By noon I reach the Bocca di Bavella, or top of the pass, where pines flattened and bent tell of the fury of the south-west tempests; and here I look back for the last time on one of the most beautiful and wonderful dream-scenes of forest landscape it has been my lot to see. Farewell, Bavella!

After a short space of level, the road winds downward still through forests, which on this side of the mountain belong to the commune of Zonza, and are in many parts very magnificent, unfolding views of great extent and grandeur; but in no wise comparable to that in the centre or valley of Bavella, inasmuch as the accompaniment of the perpendicular crags which wall in the hollow forest there is wanting. After 1 P.M. the road passes another Maison Forestiére, and now again for a space there are tall, majestic trees, and folds of innumerable pines stretch around the western sides of the mountain range, the higher points of which increase in picturesqueness as they are more remote. Farther down the trees are more mixed in species—a tangled wood of ilex and oak—and the scene is enlivened by a greater amount of animal life—orioles, chaffinches, and robins; birds, of which in the depths of the forest but few are seen. By

H

degrees the pine ceases, and opener views succeed, gradually breaking up into plots of turf with the familiar detached masses of granite ; then, little by little, groups of chesnut trees and cultivation of corn follow, and presently I halt to draw the Incudine heights towering on the eastern side of the landscape and ribbed with snow.

3 P.M.—Zonza is reached unexpectedly, for, till a close approach, it is hidden by trees—a picturesque village, with a snow-white new campanile ; and, to give the horses a rest, I order Peter to pick me up later at a spot where,

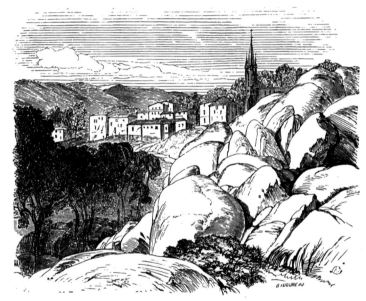

ZONZA.

among vast boulders of granite, the village composes prettily with the near rocks and far mountain, and masses of fine though still leafless chesnut. Below Zonza the road passes much beautiful landscape, some, indeed, of the most graceful I have seen in Corsica, very unlike the stern wild splendour of the Bavella scenery, but full of delicate and lovely Claude-like views, bosky dells, and a curving river, wooded distances, and good lines of far hill, among which I would there were more time to linger. Ever descending, the road at 3.45 passes another village, San Gavino : except as they combine with other objects, these Corsican dwellings are rarely attractive, either from their form or colour ; but, adjoining this group of hamlets, there are very beautiful pastures and chesnut groves. After San Gavino is left, there is less of the picturesque and more of cultivation.

At 5 P.M. I reach Levié, (¹) the road being always carried high up on the northern side of the great valley that runs in a south-westerly direction from the Incudine range; and had I found the scenery remarkable for beauty, I had thought of stopping here for the night, since, although there is no sort of inn in the place, I have a letter of introduction from Signor Galloni d'Istria to the maire. But Levié, a large village, with detached houses along both sides of the main road, presents no inducement to remain, the buildings being ugly,

(¹) Levié, a quiet and lonely village, and which has had no "Vendetta" since 1826, was troubled on the day I came through it by a fearful accident. A man had perished on account of a fowl, escaped from a courtyard, and which one woman had endeavoured to get back from another, her neighbour; the latter, still pretending that the fowl was her's, consented at length to restore it, on the advice of a priest who stood by. The first woman, displeased at this manner of restitution, instantly wrung the neck of the fowl, and, throwing the dead bird at the head of her rival, exclaimed, "Since you persist in saying the fowl is yours—eat it !" On this, some men joined in the fray, and being armed, the issue was fatal to one youth, against whom one of the opposite party had some previous grudge. The disasters which anciently arose from the carriage of arms were well pointed out by Limperani, and by the naïve and pathetic sensibility of Filippini, who terminates his history at the year 1591 by this passage :—"The suppression of arms was ordered by Genoa in 1715, and the official reports of that time show that in the thirty-two preceding years 28,715 homicides had been committed, *i.e.*, 897 annually." The permission to bear fire-arms is one of the calamities which still continues to afflict Corsica ; it flatters the idleness of the peasant, who believes himself somebody when he walks about with his gun; and the suppression or limit of this habit is one of the first measures that should be taken to give peace to the island.—*Valery*, i., p. 213.

To Levié belongs San Gavino de' Carbini, a place mentioned in Corsican history as being the chief seat of that extraordinary sect, the Giovannali ; those ancient Corsican communists, who made such rapid progress on the island, and were, in a manner, forerunners of the St. Simonists and the Mormons, &c.—*Gregorovius*, p. 428.

[Of the tenets of the Giovannali, Valery and the Abbé Galletti give the following account, which, in face of facts established as historical concerning the destruction of Waldenses in Piedmont, Protestants in France, and Jews in Spian, may be received with caution. Those who, in the name of the Most High, confounded murder with righteousness, would hardly have scrupled at falsehood, had it served their purpose.—E. L.]

Carbini, a little village near Levié, once celebrated and flourishing, has been ruined through false doctrines and bad ways. It was the cradle and the theatre of the excesses of the politico-religious sect of the Giovannali, a sort of Corsican Saint-Simonians of the fourteenth century. The Giovannali were remarkable for the strangeness of their costume, and the mystic rules of their lives ; already they had preached to an agitated and disquieted society the division of property, association of humanity into a single family, and absolute obedience to one and the same rule ; and they united to vague and chimerical projects of reform the most anti-social and cynical theories, such as of a community of women, &c. After having made rapid strides, and having counted among their proselytes the powerful Signori Henri and Paul d'Attala, they were excommunicated by Innocent VI. Menaced and pursued without pity by the populace, who execrated them, and by the zealous Papal Commissioner, who came to Corsica with troops, the Giovannali, in spite of their pacific principles, took up arms, and, instead of sinking into obscurity, as did their Parisian successors, the whole of them were massacred.—*Valery*, i., p. 214.

Carbini is the place where, towards the end of the fourteenth century, the execrable society of the Giovannali arose, which professed a sort of St. Simonianism, and the most exaggerated communistic opinions. Paul and Henri d'Attala, bastard brothers of Guglielminaccio d'Attala, were the creators of this religious sect, which was excommunicated by Innocent VI., and pitilessly persecuted by the Corsicans, headed by the Commissioners of the Pope ; finally the faction was extirpated by a massacre in the Piève or Canton of Alessani. The Giovannali probably took their name from the Church of St. John of Carbini, where their proselytes often assembled ; they only recognised the Gospel of St. John, which they interpreted after their own fashion. Community of goods, whether money, land, or women, was one of their doctrines, and in their churches after service, the lights were extinguished, and they gave way to monstrous orgies. Carbini, become deserted by the destruction of the Giovannali, was re-peopled by families sent from Sarténé. —*Galletti*, p. 159.

separately and collectively, and in a situation commanding no views remarkable for beauty. Gardens abound in the neighbourhood, and in no place in Corsica have I seen greater abundance of fruit trees of various kinds — almond, cherry, pear, &c.; these, and the ilex and oak interspersed among the dwellings, remind me of Mezzovo, in Albania, though here, in the street and on doorsteps, are groups of idlers such as industrious Mezzovo containeth not.

5.30 P.M.—A tedious ascent follows; the road crossing the ridge that divides this deep and long valley from that of Santa Lucia di Tallano, a group of communes, which I have heard spoken of as famous for the production of some of the best wines in the island, and for its advancement in agriculture. All this part of to-day's journey has but little beauty to recommend it, nor, until the road dips into the next valley, is the scenery interesting, either as to general outline or nearer detail; one village only (Mera) appears to me in passing to offer any attraction for the pencil. All down these long hill drives, and from village to village, but few people are met with; three or four drivers, two timber-carts from the forest, with their long team of mules, besides half a dozen peasants, are the utmost signs of human life seen throughout this day's journey.

On approaching Santa Lucia di Tallano the landscape becomes every minute more pleasing; the principal village is compactly built on a little hill, and is picturesque from the presence of a good campanile and an old convent close by. Everywhere there is foliage and abundant streams of water, and below—for Santa Lucia stands very high—you see the valley of Tallano, almost a little plain, and full of cultivated undulating ground; a long range of hills separates this — the valley of the Tavaria — from that of Olmeto or the Boracci, which runs into the gulf of Valinco. There seem to be some very large and good houses in Santa Lucia di Tallano, and I rejoice at not having stopped at Levié.

Sometimes, however, a man may be thankful too soon; for, on driving into the little town, and enquiring of a gendarme for the "best hotel," I am directed to a house, the entrance and interior of which is so unclean and uncomfortable, that with reluctance I decide on not risking a sleepless night there. Other hotel, they assure me, there is none; and, as I have an introductory letter to Don Giacomo Giacomone, the principal proprietor of the place, I cause myself to be shown to his dwelling—a spacious house beyond the piazza. Unfortunately, Don Giacomo is from home, and, although the Signora, his wife, sends down a message begging me to remain, I do not like, at the late hour it now is, to intrude suddenly as claimant of a night's lodging; and, consequently, return to the hotel with small prospect of comfort. Luckily, meanwhile, the landlord has had the offer of a room in another building, where it is possible to get housed; this has, at least, the negative merit of being less dirty than his own, and is, before long, by

Giorgio's arrangements, made tolerably available. It is but just to say that the innkeeper did all in his power to oblige, bringing in some supper —such as it was—from the hotel, and making apologies without end for being so taken by surprise as to be unable to procure any eatables except eggs, salad, and pickled tunny. In no instance as yet have I met in Corsica anything but civility; and when a traveller encounters discomfort it seems to be to these worthy people a cause of real regret.

After supper, Don Giacomo Giacomone came in, much distressed at not having been at home when I called at his house, to which he even now

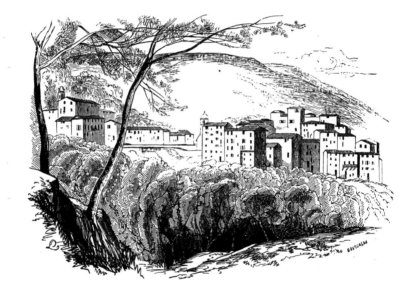

SANTA LUCIA DI TALLANO

proposes I should go. Eventually it is arranged that at sunrise I should be shown all that is to be seen in and around Santa Lucia di Tallano, and that I should breakfast with him at 10.

It seems that Dr. Bennet, of Mentône, has been staying with M. Giacomone for three days, and only left this morning.

May 1.—Waking, a vivid impression of Bavella and its wondrous trees and precipices—that strange oasis of glory, which is yet fresh and bright to memory—haunts the landscape painter, who, since days passed in the pine woods in Euboea, has seen nothing of the sort so beautiful.

At 5 A.M. I get coffee at the "hotel"—alas, for the state of the floors thereof!—and then meet Don Giacomo Giacomone, who awaits me with a cousin

in the piazza, a square, neither small nor of undistinguished appearance, for it contains several good houses, and it seems strange that so well-looking a town should be so ill off for accommodation. My first occupation is to get a drawing of Santa Lucia, from a point to which Don Giacomo takes me, whence the view, though wanting in variety, is very pleasing; and this is followed by a walk along a new road my guide is making (to join that leading to Zicavo), traced along the higher part of the valley, and commanding views up and down it both extensive and beautiful, towards Zicavo on one side, and on the other towards Sarténé, a portion of which is just visible from one point of it. Don Giacomo, who is a great landowner here, and a most energetic improver of his property, is full of enthusiasm, and justly so, concerning the valley of Tallano, a canton or district containing several communes. The cultivation of the vine is one of its principal interests ; the fertility of the soil, the richness of vegetation, abundance of fruit, and facility of transport by road to Sarténé and Ajaccio, justify the eulogies of my wealthy companion, who is as free from ostentation as he is full of hospitality.

Our next move, after returning to Santa Lucia, is to visit the two old churches mentioned by Valery,([1]) and the ancient convent of Pisan times, now abandoned, and belonging, apparently, like everything else here, to M. Giacomone, who is evidently the Marquis de Carabas of Santa Lucia di Tallano. This convent, my guide suggests, might be made into a hotel for the use of such English visitors to Ajaccio as having wintered there do not wish to return for the summer to England or Switzerland ; but if this design be ever carried out in Corsica, it seems to me that a more lofty situation would be preferable.

M. Giacomone proposes at 9 to go to his house, which, after the fashion of houses in Corsica, is better than its entrance or exterior promises, and contains a good suite of well-furnished rooms on the second floor ; the little bed-room which was shown me as that where I was to have slept had I arrived suffi-ciently early was perfect in its arrangement and cleanliness, and might have been in Paris.

([1]) At Santa Lucia de Tallano, a village of 700 inhabitants, I tried twice, but without success, to find in the ancient convent of the Franciscans the curious picture of Rinuccio della Rocca, the last of the great feudal lords of Corsica, represented as in the act of administering justice to the people, with his Genoese wife by his side. One part of the convent is now the quarters of the gendarmerie ; the rest of the building, let to peasants, is used as cellars. This part, it is said, was the Hall of Justice of Rinuccio, and the fresco was on the roof.—*Valery*, i., p. 206.

The magnificent convent built at Tallano by Rinnuccio della Rocca is still in good condition. *Galletti*, p. 159.

Of the orbicular granite found in the neighbourhood of Tallano, and of other sorts of marble, M. Valery says :—These coloured, clouded, or sparkling rocks, are like the vegetation and the flowers, ornaments of the wild mountains of the island. Independently of their beauty, they have also some sort of productiveness, for many of the granites produce in abundance a certain lichen, from which chemistry in England extracts a splendid and unchangeable crimson dye ; this is manufactured only by one Glasgow house, and the exportation of this lichen amounts to the value of 100,000 francs.— *Valery*, i., p. 208.

In the reception-room were Madame Giacomone and her eldest daughter —more like sisters than parent and child—dressed plainly in black, both good-looking, and singularly graceful and pleasant. Unlike some days in former travels through Abruzzo and Calabria, when the difficulty of discourse used to be well-nigh unconquerable, conversation is here, easy and agreeable, for both these ladies, though they have never been out of their native island, are well educated, and full of information about their own country, as well as of interest regarding others.

Then we all went down-stairs, where a table was laid for eight or ten, exhibiting an aspect of great plenty and propriety. To each person's plate there were not less than six glasses, so that the Scotch minister—of whom it is recorded that he adapted his form of grace to what he thought the probable conditions of the banquet—commencing, when there were only beer glasses on the table, with "Bless the food of these puir miserable creatures!" and, on the contrary, if champagne glasses were visible, beginning in a loud and joyful tone with "Bountifully shower down all Thy blessings on these thy excellent servants!"—might have appropriately asked the latter bene-diction on my hosts at Tallano, even though their wines were of home growth. For, starting with bread and butter of the first quality, olives, and other etcetera, and proceeding with eels and trout, through a course of stews and ragouts, to plain roast fowl and mutton, and ending in creams and broccio ; all these, with many kinds of vegetables and fruits, were simply excellent, and, moreover, all derived from the possessions of these wealthy and hospitable people. As for the wines, they were supplied rather more "bountifully" than I liked : this, a white vintage, was to be tried ; that of red must not be neglected ; and, had I any previous doubt on the subject, I should have been convinced by the experience of this morning of the eminently good qualities of the Corsican wines.[1] Several of these are not unlike Burgundy, and, unless mixed with a large portion of water, are too strong for ordinary use ; the very best are made largely by M. Giacomone, and "vino di Tallano" is proverbial on the west side of the island for its excellence.

Two younger children, Amalia and Catarina, were of the family party, which is really pleasant and friendly ; the two ladies are sensible and well-bred, and Don Giacomo, fluent on the topic of his possessions, and on the prospective commercial value of Tallano to England, is hearty and jovial.

[1] In the morning I returned to breakfast at Morato with Signor Barbaggi, and had chocolate ; and at dinner we had no less than twelve well-drest dishes, served on Dresden china, with a dessert, different sorts of wine, and a liqueur, all the produce of Corsica.—*Boswell*, p. 280.

At Ajaccio, a delicate white wine made in the neighbourhood, which we thought resembled Chablis.—*Forester.*

M. Giacomone tells me that his prices are—2 fr. 50 c. the litre, or quart, for the wine of 1860 ; 2 fr. 25 c. for that of 1861 ; and 2 fr. for that of 1862, in the wood.—*Bennet*, p. 260.

Coffee was given up-stairs, and an hour passed in drawing pictures for the children. Barrabattoli, as they called butterflies, were most in favour; but their glee was immense at all the nonsense I scribbled for them in the shape of birds carrying parasols, fishes smoking pipes, &c.

Act the last was to ascend a tower or belvedere, thence to contemplate the whole of the village and my host's property. Santa Lucia is in all respects well placed; yet, as a landscape painter, I should prefer to live amid the ruder but more picturesque scenery of Sarténé, in spite of the reputation Tallano is said to have of excelling all other valleys in Corsica for its cultivation.

At noon, after vain attempts to resist polite offers to accompany me to the hotel, I took leave of the friendly M. Giacomone and his family, and set off for Sarténé. Notwithstanding the elevation at which Santa Lucia is placed, it is not very picturesque from any point except that from which I drew it this morning. Scattered hamlets, fertile slopes, gay with the pleasant green of corn and vineyard, fields of blooming flax—which seen from above have the beautiful effect of sheets of water reflecting the blue sky—chesnut groves, and general woody richness, these are the characteristics of the Tallano valley, walled in on each side by rather monotonous hill forms, unbroken by detail, and somewhat wanting in interest.

For an hour and a half the winding road descends towards the river Tavaria, by whose banks are large flocks of diminutive black sheep, and broad fields of pearly-bloomed asphodel. At 2 P.M. the valley is left, the high road to Ajaccio reached, and once more I am going slowly up the well-known ascent to Sarténé.

The beauty of foreground as well as of distance, in this part of Corsica, appear to me more remarkable than ever now that I revisit it; and I gladly walk up the hill to enjoy the variety of picturesqueness on all sides, as well as to avoid hearing the cursing of the unpleasant Peter, who shall certainly go no farther with me than the next two days' journeys. Even my taciturn servant Giorgio is moved, in one of P.'s frightful paroxysms, to say, "If you swear so and never stop, you should provide some cotton for my master's ears and mine;" to which Peter says, "Vero è: l'uomo deve esser sempre paziente; ci vuol sempre pazienza—it is true : man should be always patient; patience is necessary."

There yet remained time before going into Sarténé to make a drawing (see Plate 7) from above the Capuchin convent, and another by the bridge, of the wide view westward that takes in all the landscape from the snow white Incudine heights, in gradations of wood and hill down to the sea; afterwards I made visits to M. le Sous-Préfet and M. Vico, and then went to the Hôtel d'Italia.

Fatima of Sarténé, out of respect to my suggestion about cleanliness, has actually had the whole of her room floors coloured red, and wax-polished; and

is delighted with my commendation of her experiments in the way of pro-
gress. Nor, in this, my second visit here, was other fault to be found than in
the over-abundance of her dinner—soup, trout, and lobster, boiled beef and
artichokes, stewed veal, mutton, and olives, roast lamb and salad, cucumbers,
butter, &c.—an oppressive amount of good things, sending away any of
which untouched sorely vexed the good landlady. My return to her hotel
instead of going to the other inn greatly pleases poor Fatima, and she
volunteers conversation and confidence to a degree at once surprising and
mournful.

"Did you not," said she, enumerating one by one the hotels I had been
to, "at Grosseto, at Olmeto, at Bonifacio, Porto Vecchio, and Solenzaro, find
that all the hotels were kept by widows?"

"Yes," said I.

"Have you written down this fact?"

"I have."

"Then," said the unhappy Fatima, "write me down, too, a widow, and not
only a widow, but mille volte più infelice che tutte vedove—a thousand times
more unhappy than all widows!"——

Whereon there followed a tremendous burst of tragic eloquence in the
highest tones, and with gestures to match, telling how, after seventeen years
of marriage, in which she had never given her husband the smallest cause for
discontent—la minima cagione di scontento—he had forsaken her, faithlessly
carrying off her servant girl, and settling in Sardinia under a changed name
in a new hotel, had left the unfortunate Fatima, like the Ossianic heroine
before alluded to, "alone, upon the hill of storms."

Fatima's opinion about the state of the culinary science in the other hotel
at Sartené was sufficiently sweeping, the cook there being, according to
her, "un disgraziato vecchio, chi forse settanta anni fà, sapeva far una frittura,
—mai più di ciò; ed ora nemmeno tanto—a miserable old man, who per-
haps seventy years ago knew how to make an omelette, never anything more;
and now not even that."

May 2.—At sunrise the completion of the drawing above the town occu-
pied me till 7 A.M., when I joined the trap at the bridge, and left beautiful
Sartené with regret.

To-day's journey will be over no new ground. Passing the charming
river scenes, where I spent the 18th and 19th of April, I reached the unhealthy
village of Propriano at 8, and having made the ascent from the shore to
Olmeto on foot, reached that place at 10.15. The walk up from the sea, six
and a half kilomètres—a steep and hot pull—is pleasant from the extreme
beauty of the landscape—much of which cloud and bad weather had prevented
my seeing on the 16th ultimo—where graceful olives and luxuriant green

vegetation, flowers now in greater profusion than ever, and the universal melody of nightingales filling the hill sides and deep valley, are all truly delightful. The horses have a long day's work to-day, but though I and my servant almost always walk, it is not certain that they are better off on account of having less weight to pull, for when I am in the carriage I can prevent Peter from beating them, which he never neglects to do, if I give him an opportunity by lingering behind. At present he is to rest at least two hours at Olmeto, a place that seems fuller of idle people than at my first visit.

On inquiring for Mr. B., I found that he had become much worse than when I was here on the 17th of April, and I went up to see him. It does not seem to me possible that he can live much longer, and this, by a message he begged me to take to his father in England, is evidently his own impression. Although he has with him an attendant who takes every care of him, and although he appears to have made friends among the people of Olmeto, yet nothing could be more sad than to see so young a man dying in so lonely and desolate a manner in this remote Corsican village.

At 11.30, after a walk nearly to the top of the hill above Olmeto, where groups of large trees, seldom lacking in Corsica, are plentiful, a spot is easily found—favourable alike as a place for a sketch and for the despatch of poor Fatima's bountiful breakfast—surrounded by bushes peopled with nightingales, robins, and blackbirds, and infinitely lovely with wild flowers.

At 12.45 P.M. I go on, and at Casalabriva await the trap and the ever-swearing Peter. All the landscape, hidden by rain and cloud at the time I first passed here, is now a grand outspread of "maquis"-covered hills, green down to the very last point and deepest dell of the valley of the Taravo, and up to the high wall of snow and long lines of Mont Renoso in the north and east; but in all this extent there is no particular spot tempting me to linger and draw.

Just beyond the village of Casalabriva a wonderful spectacle strikes the eye, namely, a carriage with two horses, a lady and her maid therein, going, like the landscape painter, to "see all Corsica." It is Miss C., who is on her way to Sartène and Bonifacio. We stop and discourse, the cheery nature of this pleasant lady being a happy set-off to the sad scene I had left at the sick man's house in Olmeto. I recommend the lonely Fatima to Miss C.'s notice, but, unluckily, she has already written to secure rooms at the other inn ; and so, as in the words of the song—

> " Too soon we part with pain,
> To drive o'er dusty roads again,——"

Miss C. continuing to profess herself incredulous as to the safety of my luggage, and still predicting that some indefinite woe will befall me on account

of my employing Peter, of whom, now that I am experienced as to his
character, certainly very little good may be expected.

The descent of Bicchisano follows, and that village is reached at 2.40.
Some of the ilex-grown dells on the way are indeed beautiful, but in the great
valley of the Taravo, though it is full of innumerable studies, few views of
general interest can be selected, and the landscape is of a nature exacting
long term of study for individual detail. Towards the bridge over the Taravo
there are many lovely pictures which would delight the eye, and give work
for the pencil of Creswick, who (so it seems to me) is the best portrayer
(after Turner) of river and wood scenery combined. A walk along this stream
is one succession of park landscapes, and the thick foliaged white-armed
ilex-trees, so mingled with granite rocks and the foaming river, would even
be more beautiful were there snow on the hills to form a contrast with the
dark bosky hollows.([1])

Once only during the afternoon, at a place where two or three houses
(called by Peter, Bagni di Surbalaconi), combine with the fine bridge and the
high road to indicate the vicinity of man, do I see any human life; here there
is a little boy tending some goats. Peter, who is somewhat ahead, having
dropped the apron of the carriage, the small boy picks it up, runs after the
trap to give it him, and returns to his goats ; whereon I offer him the super-
fluity of Fatima's breakfast—to wit, two loaves of bread. But these are
rejected with a solemn and decided shake of the head by the child ; who,
however, on my telling him that though white, they are really good bread, takes
them after a time gravely, and thenceforth appears to think that he ought to
do something in return. " Perhaps," says he, " you might be pleased to know
the names of my goats : one is Black-nose, another Silver-spot, that is Grey-
foot, and this is Cippo. Cippo is quite the best goat in these parts, and likes
to be talked to—come un Cristiano—just like a Christian—perhaps, even if
you stand still, she may let you scratch the end of her nose, and I will call her
at once if you choose to try." After which gratifying information the small
boy prattles about the state of the corn, and the good it has gained from the
last rains, with a quiet intelligence, and at the same time with a want of
vivacity peculiar to Corsican life; until at a by-lane he says, " The goats must
go down here ; so addio !"—and exit.

At 6.30 P.M. I am once more at the little Hôtel des Amis, kept by the
Widow Lionardi (*see* page 37), at Grosseto ; the village, with its houses half
hidden among large trees, has a quiet, rural character that greatly charms me,
and the inn is by no means an unwelcome place of rest. Just after I arrive, a
sudden confusion takes place, which, thirty years ago, would doubtless have
occasioned a Vendetta ; a little boy throws a large stone at a little girl with

([1]) In Corsica the ilex, or evergreen oak, is very common, and gives the country a cheerful look,
even in the depth of winter.—*Boswell*, p. 45.

whom he quarrels, and knocks out her two front teeth, besides disfiguring her face ; screams resound, the mother of the girl pursues the boy, the neighbours join in the clamour, and there is every prospect of a fight (worthy of the Henrietta-street colony at the back of my London rooms), when gendarmes interfere, and forcibly wind up the commotion ; as a "moral" or finale to which, the mother of the injured girl inflicts a violent chastisement on her small daughter, either to teach her a better choice of companions, or to impress her with the fact that the saying, "misfortunes never come single," is a solemn truth.

The Widow Lionardi, to her dinner of stewed veal, trout, and roast lamb, adds a dish of "fiardoni," or cakes made of pastry and broccio—in other words, cheesecakes, or as they are called in Crete, Κρητικὰ Μισιθρόπιτε.

CHAPTER V.

May 3.—The Hôtel des Amis, Widow Lionardi's unpretending little inn, is so good and comfortable that it would be a capital central head-quarters for study to a landscape painter. Leaving it at sunrise, and sending on Peter to the Bocco, or Col San Giorgio, I made a drawing of the village from a little way up the hill; the top of the church tower is golden in the rising sun, and all the brown and shadowy depths of ilex—as beautiful a feature in the foreground of this valley as are the green splendour and softness of the distance below the farthest range of the hills near Bicchisano—are particularly delightful at this calm, early hour ; a world of quiet, save for the song of nightingales and the fresh sound of running streamlets. (*See* Vignette, p. 110.)

By 7.40 A.M. the top of the col San Giorgio is reached, and the wayside inn at Cauro by 8.30, where three hours are allotted for baiting the horses and breakfast. After I have been down the hill as far as Barraconi to make a drawing there, which I could not get on the cloudy evening of April 15th, I shall go on to Bastelica for the night, and back to Ajaccio to-morrow.

At 9.30, having terminated my Barraconi drawing, I am once again at Mdme. Angela Paoloni's hotel, where there are still some of the party of officials who were here at the time of my first visit ; I have now, however, been long enough in Corsica to avoid mistakes. These gentlemen give me several valuable hints as to parts of the island to which I have not yet been. M. Chauton, a "continental," has, they say, a great establishment for cutting and transport of trees at Valdoniello, and they recommend me to procure an introduction to him in order to see what they affirm is the most magnificent of

all Corsican forests (though secretly I believe there can be none so fine as
Bavella). A carriage road, I am told, leads to Aïtone and Valdoniello from
Evisa, either by way of Porto or Vico.

Mdme. Paoloni's breakfast of trout and beefsteak, brains and caper-sauce,
Irish-stew, broccio, &c., good in quality and profuse in quantity, is, as usual, a
curious contrast to the stairs and entry of her hotel, and is accompanied by

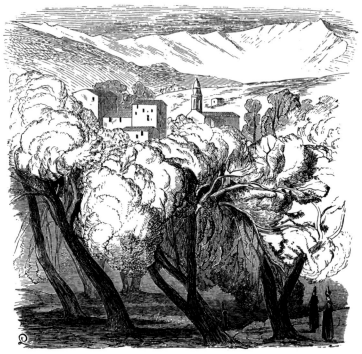

GROSSETO.

the usual careful and obliging manners of Corsican innkeepers. When I leave
the house the hostess says, "Do not pay me now, but stop as you return, and
pay then."

"But, not so," I reply, "for who can tell what may happen ? Suppose I
should die at Bastelica ; you would then lose your money."

"In that case," says Mdme. Paoloni, "although we are poor, and should
miss your money, we should not feel the loss so much, because our sorrow for
your death would be greater."

Shortly after noon I went on towards Bastelica, which is twenty kilomètres
distant. Peter the oathful, who this morning has had some very bad fits of
swearing and beating, but who is at present in a comparatively placid mood,

says, " At these villages I am very often asked who you are, and I always say you are the Ministro delle Finanze—the Finance Minister of England."

" But why," said I, " do you say such a thing ? "

" Oh, partly because you wear spectacles, and have an air of extreme wisdom, and partly because one must say something or other."

A Minister of Finance seems to be grim Peter's beau idéal of earthly grandeur, and he has frequently spoken of having accompanied the illustrious M. Abbattucci, late Minister of Finance, to the country residence of that personage at Zicavo. Now, as I was particularly in want of information concerning the road thither, I asked him one day, " Did M. Abbattucci make the journey by Sta. Maria Zicché, or by the village of Bicchisano ? "

" He went by Grosseto to Sta. Maria," was the reply.

" But," said I, " as the way from Ajaccio to Zicavo is long, where did the minister stop, at Grosseto, or is there any other midway inn ? "

" By no means," said Peter, " non si fermò punto, andava a giorno e notte——he stopped nowhere, but travelled day and night. Era mortissimo—he was quite dead—that Minister of Finance—e non era che sue cenere che si portava—it was only his ashes that I took to Zicavo."

Long ascents, varied by portions of level ground, lead along the hill sides ; the road is good and broad, but like other " Routes Forestières," without a parapet on the sides towards the valley, up which, clothed luxuriantly with " maquis" and larger trees, the eye looks to the snowy heights at the end of it, immediately above the village of Bastelica ; as a whole, the picture is grand and beautiful, but possessing no particular beauty of detail. I walk up the ascent, to give the brutal Peter as little excuse as possible for maltreating his horses, who go on slowly, but regularly, if left to themselves. It is a pleasure to think that to-morrow I shall get rid of this man, and, meanwhile, though I or my servant are generally able to prevent his inhuman treatment, this is not always possible, as, accompanying the act with torrents of maledictions, he will sometimes, quite unexpectedly, strike the horses so fiercely as to make them back three or four paces.

About 1.40 the valley grows somewhat narrower ; bright streams of water fall from the hill side to join the river below, the tall heath, full of white blossom, reminds me of the shores of Albania, near Porto Tre Scoglie, and all along the route the clothing of these Corsican mountains never ceases to be a charm and a wonder, for there are spreading woods of ilex, and a thick carpet of " maquis" right and left. The top of the first ascent is reached about 3, at the tenth kilomètre, when a level bit of road succeeds. The only life seen since leaving Cauro is in a group of charcoal burners, not to speak of twenty pigs revelling in a shallow pool of water. The charcoal burners talk with a vivacity very singular for Corsicans ; but forthwith I find them to be Italians from the neighbourhood of Lucca.

At kilomètre eleven and a half is a neat little forest house and a mill. The guardiano and his family, sitting outside their dwelling, make a picture, combined with groups of trees and the beautiful river, here close below the highway, and dashing foamily over its worn stones. Beyond this point the road makes a sharp turn, and for the moment Peter is lost sight of. Latterly his swearing has been so horrible, and his cruelty so odious, that I have thought at times that he is not quite sane ; consequently, I have walked nearer the carriage, and it was only by the accident of my having stopped a little while at the forest house, to make some inquiries about the distance, that he had got considerably ahead, for here the ascent is not steep.

But on turning the corner of the road just mentioned there was a shocking sight, and one that became more so at each moment. Taking this opportunity of being alone Peter had given way to a burst of rage and violent blows with his whip handle on the poor beasts' heads. In vain did both I and Giorgio shout, running forward. Even then the carriage stood at right angles to the side of the road, and not far from the edge of it, above the river, while at every blow the poor horses backed nearer to the ravine.

One more blow—carriage and horses are quite at the side of the· precipice !——

Yet one more blow, struck with an infernal scream from bad Peter, and the horses back for the last time ! And then————————————

Down, down, go all into the ravine !

Nothing was left on the road but the abominable old fellow, kneeling, and wailing to the Madonna and all the saints, whom a minute before he had been blaspheming.

I ran back to the corner of the road, whence I could see the forest house, to alarm the inhabitants ; and, directly, they set off on the way up to help. Meanwhile, the Suliot was already down the steep. Happily, the hill side at this spot, the twelfth kilomètre, is not nearly so precipitous as it is at a few yards distance either way, and a cluster of large chesnut trees had stopped the carriage and horses from rolling downward to the stream. One of the poor beasts was, notwithstanding, killed on the spot ; the other, which G. had managed to extricate, was dreadfully lacerated by a sharp rock. The carriage, as may be supposed, was broken in pieces, and the luggage—literally fulfilling Miss C.'s prediction—had rolled further down, among the rocks and fern.

The zeal with which the forester, his son, and friends, worked to get up the " roba " and the remaining horse, was most praiseworthy; and seeing so much energy where I had expected apathy, I internally resolved to be less hasty in future in characterising Corsicans as lazy, on account of their being undemonstrative. By 4 all the " roba " had been carried up, and was in a pile by the road-side, as were the splintered portions of the vehicle ; but what was now to

be done? At Bastelica, still eight kilomètres ahead, they say that a car may
be got; and to send on the forester's son (a lad of sixteen or seventeen)
at once seems the best plan, so that he may bring a car—or, if none can
be obtained, mules—that I may then either go on to Bastelica, or back to
Cauro, as circumstances may direct. The youth, Domenico Casanova, there-
fore sets off running; and later I resolve to walk on to Bastelica, for if
that should not prove a place in which there is much work for my pencil,
then I can return here with the mule-cart, or, if otherwise, pass the night
there; the luggage, meanwhile, and the ruins of the carriage, will be well
cared for by Giorgio, and by the good people who have been helping me
so energetically.

From the thirteenth kilomètre, which I passed at 4.15, the road up the
valley commands views of a fine solitude of pine woods and far snowy heights,
and at the eighteenth kilomètre I am able to make a sketch of the village,
which stands very high, and is seen from the midst of luxuriant chesnut
groves. Bastelica, in the summer time must, indeed, be a delightful place,
embosomed, as it is, in foliage below its lofty mountain amphitheatre. ([1])

On reaching the village before 6, by a steep ascent at the nineteenth and
a half kilomètre from Cauro, I found three mules being put to one of the long
carts used by the peasantry, and the forester's son actively hastening the
operation. And as I had ascertained that I could do little so far as regards
making a view of the very straggling village of Bastelica beyond what I
had already done, and as a clear full moon is shining, I decide on returning
in the jolting-car to the forest-house, and perhaps to get on as far as Cauro
to-night, which place the diligence passes at 7 A.M. to-morrow. Bastelica, I
perceive, should be seen when the chesnut-tree is in full leaf, for without that
its principal characteristic is wanting.

While Domenico went to get some eggs and wine (as it is by no means
certain that his father's house contains eatables), I talk with the villagers, a
large number of whom crowded round me. The propriety of conduct in
these rustics strikes me very forcibly; the absence of all clamour and
rudeness, and the good sense of their observations on my replying to their
questions concerning the accident, are as remarkable as the intelligence
which is in all their countenances. Every one of the children, too, of whom

([1]) Bastelica, which reckons 2,400 inhabitants, passes for the most considerable village in Corsica.
At Domenicacce, a hamlet close by, is the house called the Tower of Ṣampiero, with the date, 1546.—
Valery, i., p. 187.

Farther to the north of Cauro lies the great canton of Bastelica, which is separated by a mountain
chain from that of Zicavo. This rugged mountain land is the native place of Sampiero. In
Bastelica, or rather in the small hamlet of Dominicaccia, they still show the black gloomy house where
he was born; for his own house was pulled down by the Genoese under Stephen Doria. All the people
of this valley are distinguished by a strong build and martial physiognomy; they are principally herds-
men; rugged men, with the iron manners of their forefathers, and quite unaffected by culture.—
Gregorovius, p. 411.

there are many, is well conducted. I find they are taught French as well as Italian, and that the more advanced could read and write in both languages ; so grave and well-bred a lot of little fellows one would not expect to find in such a remote place.

Pasquale, the driver of the mule-cart, was ready to start at 6.30, but I walked down the hill as far as a cottage, where there was a halt, "in order," said the man of Bastelica, "to take up something he had to convey to Cauro." This something proved to be two immense bags, which, when lifted on to the narrow car, occupied more than half its space, though that was not of such importance as the fact that they tainted the air with the most horrible odours, proceeding, as I soon found, from the contents, which were old rags. This episode occasioned some delay, for I would neither have the rags nor the owner, and I was compelled, before the matter was settled, to tell the driver that our bargain was at an end, unless I could have the car to myself. And when the rag-bags were finally ejected, the anger of the rag-man was exceedingly funny. "It is plain," he said, "that you know nothing of Corsica. Probably you never heard that Napoleon Buonaparte, the greatest man in all the world, was born here. The oldest and dirtiest rags are honourable here, and you should be grateful for smelling and touching them !"

This delay made it 7 P.M before we were off, but the car jolted rapidly down the hill, and the moon gave a light like day ; by 8 we were at the ill-fated twelfth kilomètre, where there was nothing now left but splinters of the carriage, and shortly afterwards arrived at the forest lodge, to which all the "roba" had been removed. Here, for I had had enough of jolting and walking for one day, I decided on remaining the night, and to go on as early as I could to-morrow to Ajaccio ; so the camp-bed was put up, and the eggs, and bread and wine were the dinner, to which the good-natured forester added some onions and broccio, after frying the eggs with alacrity.

The guardiano, Stefano Casanova, is a civil and pleasant fellow, and his wife a good, bustling, tidy body ; they are from Evisa, about which place they give me various information, and declare that the pines of Aïtone are the most surprising in the world, "so much so," says M. Casanova, by a powerful metaphor, "that the only possible way to see their tops is to lie down flat on your back and look up into the sky." More obliging people I could not have chanced to meet with ; how hard they worked with G. to get up the "roba" and horse ! how quickly their son Domenico had gone to Bastelica, and how busily, while constantly worrying the slow Pasquale to bestir himself, he had managed to get the car and mules ready !

I should be glad, were it possible, to return to Bastelica before leaving Corsica ; its position, in a kind of cul-de-sac, below some of the highest moun-tains, is fine, and although, owing to its form—being a very scattered village—

it does not appear to contain many houses, it is in reality one of the largest in the island

May 4, 4.30 A.M.—The rushing river below this little forest-house reminds me of many nights' lodgings in Switzerland, particularly of one by the falls of the Aar; and, doubtless, had I not had my invaluable camp-bed here, other and livelier objects of similarity would not be wanting.

I went up the hill to the scene of yesterday's catastrophe; except the trampled bushes and splinters of broken wheels, &c. there is little sign of what took place—the last struggle of the poor falling horses will not be so easily effaced from my memory. As I returned to the forest-house the odious Peter, who has hitherto carefully kept out of my way, accidentally met me, and to him I delivered a short moral discourse on the general impropriety of anger, and the particular evil of profane swearing, in reply to which that impish individual only said, " Oh, mi lasci! mi lasci! ci vuol sempre la pazienza; la più buona cosa è la pazienza—leave me! leave me! patience is always necessary; the best of all things is patience." So I did leave him, and I truly hope I may never again see his unpleasant face.

At 5.30 Pasquale and the jolt-car were ready, and G. had packed all the "roba" on it, so, having given the worthy Casanova couple some money for their boy Domenico to buy what he liked with, jolting began forthwith, and in two hours Cauro was reached, Madame Angela Paoloni gazing from her window in extreme surprise at my third appearance, as I passed her door in a travelling guise so different to that of my two former visits. At Barraconi there was a halt of half an hour to bait the mules, a time I employed in looking about the beautiful valley of Suarella (*see* vignette, page 32), so historically interesting as the scene of the death of Sampiero. The Campo di Loro, clouded and obscured when I had passed it on April 15, seemed to me now most beautiful, the broad green meadows and tall poplars harmonising well with the distant snowy range beyond. By 11 Ajaccio was reached, the ungainly mule-car and its driver paid and dismissed, and Ottavi's hotel once more made head-quarters. And thus ends the first "fytte" of Corsican travel.[1]

There were letters to read and to write, and in the afternoon a drawing to finish on the delightful hill beyond the grotto. Now that all the ridges and hollows on the southern part of those opposite mountains are familiar to me, with what a different interest is this scene, so charming even before, invested !

[1] Between the pretty and picturesque villages of Suarella and Eccica, a well-grounded tradition indicates the spot where Sampiero perished, January 17, 1567. One arrives at the place where his death occurred by a wild path along the banks of a torrent. Near at hand are the ruins, mingled with olive and ilex trees, of the castle of Giglio, where Sampiero had passed the night, and where he had questioned and caused to be put to death a peasant convicted of intelligence with the Genoese. — *Valery*, p. 185.

On a rock in the vicinity are seen the ruins of the castle of Giglio, where Sampiero had passed the night before he met his death. I looked about in vain for any monument to remind the traveller that in this awful place the greatest of all Corsican heroes fell. — *Gregorovius*, p. 407.

There, high up the hill, is Cauro, there to the left of it is the pass to Col San Giorgio, and there, across the ridge, are the high snow hills beyond Grosseto; there, too, are the heights of Bastelica.

May 5.—Soon after sunrise, I am drawing at the grotto hill, overlooking garden and shrubbery, down to the calm gulf and silver-topped mountains; and on so lovely a morning as this it seems to me that imagination could picture no scene more beautiful.

Later, on calling at Dr. Ribton's, I find that my friends the j. S.'s are not only gone, but that they have been heard of from Pisa ; their transit from this side of the island to the other having been of the unluckiest, in a fierce storm of rain and wind, and with the addition of their carriage having been upset before reaching Corte.

Nor are the chances very favourable for my own progress in seeing the rest of Corsica; for, first, M. Galloni d'Istria, who had so ably and kindly helped me with introductions in my first tour, has gone to Italy ; and, secondly, although the Préfet, M. Géry, has returned from France, he has met with a bad accident in leaving the steamer, and is laid up ; and, thirdly, my servant Giorgio has a fit of fever, possibly owing to chill after the hard work in the Bastelica ravine two days ago. As a set-off against all this, I make the acquaintance of M. Lambert (the commandant of gendarmerie in the arrondissement of Ajaccio), who dines in the rooms of the Ottavi hotel. This gentleman most ably enters into my plans of seeing more of the island, and offers me letters should I go to the western side—to Carghésé, and to the agent of M. Chauton at the great forests of Aïtone and Valdoniello ; or, if I go to Bastia, to Bocognano and other places. This may remedy my two first grievances, the absence of M. Galloni, and of the Préfet ; patience and quinine may bring back the Suliot to working condition. Nor do I myself neglect to take some preventive and precautionary quinine, for after the air of the high mountains, this of Ajaccio seems warm and relaxing.

Writing letters filled up the rest of this day.

May 6.—An early walk along the shore to the cemetery. In spite of all the beauty of colour, and the gaiety of flowers, broom, honeysuckle, and rose cystus, and of the immense luxuriance of vegetation and elegance of foliage, a grave melancholy seems to me to be ever the character of Ajaccio scenery. Those circling snow-topped hills at the head of the gulf, that long barrier line on its southern side, and the absence of much life or movement either on land or water, all contribute to this impression, and tinge the landscape, lovely as beyond doubt it is, with somewhat of the mournful.

At mid-day, on calling at the Prefecture, to learn how M. Géry is going on, his daughter, a most fascinating little girl—who speaks English well, owing to

having been under the care of an English lady, her governess, from a child—comes into the hall to say that her father, though suffering much and unable to leave a sofa, wishes to see me. Had I expected to find the Governor of the island—of the Departement de la Corse—a formidable official, I should have been much deceived ; but I had previously heard of M. Géry as a person not less known for his ability and for the high positions he has filled than for the kindness of his disposition and for the charm of his conversation. He enters with warmth into all the details concerning that portion of the island I have already seen, sketches out a second and third tour for me, promises me abundance of letters to places guiltless of inns, and finally invites me to dine at the Préfecture to-morrow. Thus, I return to the hotel with a new source of thanks to M. Merimée, whose good-nature procured me an introduction of such value.

In the course of to-day Miss C. returns from her southern trip to Sartené and Bonifacio, and triumphs, though far from ill-naturedly, at the fulfilment of her predictions about my carriage. We quite agree about the fine qualities of the scenery we have both visited ; Miss C. has been up to Zicavo, and through the forests of Marmano and Sorba, whereas, although I have not seen these, I have been to Bavella, which she has not, and I steadfastly declare that, Bavella unseen, she has seen nothing—less than nothing.

G.'s fever is not much better to-day; but as I have long been an expert fever-doctor, I believe that two or three days will bring him round. Miss C. and Dr. R. stop their ears when I venture to speak of fever ; yet sickness is a fact, and there are moments when my servant's illness, added to the difficulty I find in procuring another carriage and horses for my next start, makes a gloomy side to the picture, and half inclines me to return by next Saturday's boat to Nice, leaving the remainder of Corsica to be portrayed in that far off indefinite time when I may wind up my journeys in Crete, Palestine, Syria, and other only-in-part-visited places.

May 7.—All the morning is rainy—propitious time for letter-writing—and the day is passed in making calls, and in searching for a carriage and horses, &c., till at 6 P.M. dining at the Préfecture adds another to the pleasant memories already afforded me by Corsica. Miss C. was there, as well as several other persons, and the excellence of M. le Préfet's table is as distinguished as the friendly and social character of the party and the pleasant conversation of the guests. Afterwards, other persons, mostly in official positions, came in, and a collection of photographs of the chief or most interesting places of Corsica was exhibited. Some of these photographs were of the finest I have seen ; but it is not easy to procure copies of them, as only three perfect sets, for the Emperor, Prince Napoleon, and the Préfet, were struck off,

when the photographer, owing to some pique, withdrew the whole from public circulation.

May 8.—The mountains here have taken to invisible ways, and refuse to appear.

The search for a carriage continues, and Giovanni Carburo the Vaudois, who lets out vehicles, and is recommended by Miss C., shows me, besides other traps heavier and more expensive, a sort of double-seated car for two horses, which I may have for seventeen francs a day, and am to try later in the morning. It proves, however, far too shaky, and is rejected, so that the matter of vehicles is once more in *nubibus*.

Passed the afternoon on the hill near the grotto drawing cactus; the warbling of nightingales is truly delightful, till gendarme target practice, with infantry bugling and drumming commence—then

> " The nightingale said, ' I have sung many songs,
> But never ' "——

will I sing any more if this horrid hubbub continues—and thenceforth the voices of birds were hushed. My work, too, is stopped by rain, and the landscape painter becomes indisposed for further Corsican travel, and resolves at length to leave further decision till to-morrow. One thing is certain, that a good trap and horses are a *sine quâ non* if I am to visit the rest of the island. " *Nà κάμῃς ὄνειρον, Κύριε,*" says the Suliot, whose fever is departing—"decide by dreaming, Sir."

In the evening the pleasant M. Lambert, who has many remembrances of Zante and Cerigo, Milo and Cyprus, brings a letter of introduction which he has written for me to a friend at Casabianda; but I think it will be best to visit all the western side of Corsica first, and M. Lambert promises letters to-morrow, should I procure a carriage, to facilitate my visit to the great forests, where, without some personal recommendation, little can be done. If I succeed in completing my tours in the west of the island I can proceed across it to Bastia, and go back to Nice from that port, if time does not allow of a third visit to Ajaccio.

May 9.—The morning is hot and misty, and the mountains hidden in clouds prophetic of rain.

The first thing to be attended to to-day is an examination of such carriages as are on hire, as I have finally resolved to go if possible to the great forests of Aïtone and Valdoniello, and Vico, a tour which I hear can be very well managed in a week, the longest space of time I can give to it. And after looking at several vehicles, all more or less unsuitable, and the owners of which manifest a great carelessness as to whether they are employed or not, I hire the only one left, belonging to the Vaudois Jean, a roomy, good trap, which I am to have at twenty francs a day, all expenses of the driver included.

Next, I call on M. Lambert, who, in spite of all his busy occupation, has found time to write a note to the Chef de Gendarmerie at Carghésé. M. Chauton, the lessee of part of the great government forest of Valdoniello, who has an establishment both there and near the coast at Porto, is unluckily away from Ajaccio at present, but, says M. Lambert, a nephew of one of the gendarmes at Carghésé is M. Chauton's agent at Porto, and will send me on to the upper station.

At 9 A.M. Jean Vaudois comes to see that all is in order for my new start ; the ponies seem good and the carriage comfortable, the luggage well fastened behind and carefully covered, only, the box-seat being now filled up with sacks of barley—an improvement which Miss C. does not fail to remark, and which at least indicates more care for the horses than was shown by swearing Peter—my man has to sit inside. The new driver is a Corsican youth named Domenico, of Napoleonic and grave aspect, and the party is completed by a small spotty dog of amiable and watchful deportment, called Flora, who examines the carriage and luggage with an evident expression of certainty that she is the head and moving spring of the whole arrangement. Miss C., who is looking out of Ottavi's window, begs me to send word as to progress or success, and as we set off, Giovanni Vaudois suggests that if I do not care to go as far as Carghésé to-night I may sleep at Sagona.

The way lies through Ajaccio and past the Villa Bacciocchi as far as the southern road to Sarténé and Bonifacio, when the highway to Corte and Bastia is followed to the fifth kilomètre, there the road to Vico strikes off to the left, and shortly beyond it another way to that place leads on the right hand through Sari. Almost up to the commencement of the Vico road, where a fine many-arched aqueduct is a picturesque addition to the landscape, the neighbourhood of Ajaccio is a continued garden of cherry and mulberry plantations, but afterwards such cultivation becomes more rare as the road winds away among pleasant, rounded, low hills, where the familiar fern, white blossomed cystus, and asphodel, gradually take the place of fruit trees and corn-fields. The great precipitous heights which show so finely from the end of the Gulf of Ajaccio are passed on the right as you climb a hill range, and after a dip down to a green valley, a long and steep ascent follows to Bocca San Sebastiano, which is reached at noon, the road thither being carried very high along the side of the lofty hills, which are cultivated in patches, and not remarkable for beauty of form.

At the Bocca, or summit, where there is a single roadside house, nothing is to be seen to-day, owing to the thick misty weather, except a vast indication of mountains mostly hidden by rolling clouds, and it seems to me that even had the landscape been visible, its extent would have been too great to allow of its being drawn as a whole. Lower down, however, on the other side of the pass, the Gulf of Sagona, with abundance of those long points and capes

so characteristic of Corsican west coast scenery, would have been worth a halt had the morning been fine; on one of these promontories Carghésé, already seen from the sea on April 9, is pointed out.

The winding descent towards the gulf from Bocca San Sebastiano is beautiful, all the more so from some showers of rain and effects of cloud shadows. The village of Calcatoggio stands above the road, and from it all is vineyard and garden, fig, pear, and cherry orchard, nearly down to the sea, where against the rocks of white granite that border the little bay of Liscia, the quiet waves beat lazily along the lonely shore.(¹) Here, 1.15 P.M., about the twenty-ninth kilomètre from Ajaccio, at a small wayside house, is to be the mid-day halt for two hours, for the not over-clean " Repos des Voyageurs," as the hut is labelled, is avoided for a spot more fitted for drawing and breakfast among the boulders and cystus-growth a little way up the hill, whence the view of the gulf, widespread towards the west, is grand and solitary.

Beyond the little bay of Liscia and the tower-crowned promontory on its northern side, whence Carghésé is now clearly seen, the road descends into the valley or small plain of the river Liamone, a considerable stream, flowing from the western base of Monte Rotondo and the neighbourhood of Guagno.(²) The valley of the Liamone is a level of green corn as far as eye can see to the foot of the hills; and the river, crossed by a good bridge, reaches the sea through marshes gay with yellow iris. Beyond it the road leads through what resemble "cuttings" of wrinkled cretaceous rock, crowned with wind-bent lentisk or schinos, now and then passing quiet coves of pure sand edged with granite rocks, whence you look down on to the wide solemn gulf beyond, till one more Genoese tower is left behind, and Sagona, the port of Vico, is reached at 4 P.M.(³) Whatever may have been the condition of this place in the days when it was the seat of a bishopric, and possessed a cathedral, few traces of its former state remain now, some six or eight square buildings, like warehouses, and one " boat on the bay," being all its present signs of life.

(¹) Concerning Calcatoggio there is an ancient saying,

> Calcatoggio, Calcatoggio,
> Mala cena e peggio alloggio !
> (Calcatoggio, travellers' curse,
> Supper bad and lodging worse !)
> *Galleti.*

(²) Between Arbori, a village of 400 inhabitants, and the river of Liamone, stood the castle of the illustrious Jean Paul de Leca. This historic building, placed on a rock, still preserves its cisterns and drawbridge.—*Valery*, i., p. 112.

One has to ford the River Liamone, a torrent, &c.—*Valery*, i., p. 108.

(³) The Gulf of Sagona is magnificent. Formerly, the town was splendid, and there are still some remains of the palace and of the ancient cathedral, of which the sacristy still exists, and serves as a shelter to peasants.—*Valery*, i., p. 107.

I looked for some trace of the ruins of the ancient town of Sagona, but in vain—all has disappeared from the soil, and the small ruined church which exists belongs to the middle ages. Nevertheless, the town of Sagona did flourish at the end of this fine gulf, and though it has long ceased to exist, it always preserved the title of the episcopal city of the island until 1801, when the whole of Corsica was included in a single bishopric.—*Galletti*, p. 136.

The highway, now a winding road, follows the shore from point to point, till it climbs the last hills before you reach the promontory of the Greek colony. Here cultivation increases, and the view over the broad placid gulf of Sagona is very fine; so I send on Domenico to the village hotel, and stop for an hour to draw. The hills around, of no great height, are well formed, and covered with corn and olive growth quite to the sea. Over all this Carghésé coast broods a kind of lonely classic grandeur, which the usual scarcity of life in Corsica gives full leisure for contemplating—the promontory and little bay, with coves of white sand, and "curving lines of creamy spray," then the broad gulf, and beyond that, the long line of hills forming the northern side of the gulf of Ajaccio, "all barred with long white clouds the scornful crags," at half their height throughout.

Carghésé, which you come upon all at once by a sudden turn of the road, is a larger place than I had expected to see, and is built with regular streets at right angles to each other. Several scattered houses, among them the hotel and the old Greek church are by the side of the high road, which here crosses the cape of Carghésé; but the chief part of the village stands lower down, facing the south; the Latin church, and a second Greek building, large and unfinished, are in the farther part of the settlement, nearer the end of the promontory, and the whole forms a singular and picturesque scene, greatly interesting to me from what I had heard of the migration of these Greek settlers from the Morea, and of the persecution which had at one time made their adopted land little less undesirable than their own.([1])

I had told my Suliot servant not to speak Greek at first, by way of having some merriment when our knowledge of their language came to be suddenly known; but this plan fell through by my own inattention; for from a window of one of the first houses I pass, there looks out a Greek priest with a venerable beard and the well-known cap, who makes me a bow and waves his hand, to which salute I unthinkingly reply, "Καλὴ σας ἡμέρα!—good morning!" and naturally elicit "Πῶς! ὁμιλεῖτε Ρωμαϊκὰ?—what! do you speak Romaic?" for, in the days when these Greeks came to Corsica, 'η Ἑλληνικὴ γλῶσσα was unknown as such.

([9]) Carghésé, says Valery, writing in 1833, is an agreeable village, built regularly in an amphitheatrical form above the sea, and planted with fine mulberry trees. It was founded by M. de Marbœuf, and peopled by the Greek colony which had, about 1676, sought refuge in Corsica. In this village of 600 souls they speak at once good Greek, Italian, and French. The chief of the colony was called Constantin Stephanópoulos; some of his descendants still inhabit Carghésé and Ajaccio, and rank among the first families of the island. The fugitive Greeks found in a foreign land, from their jealous neighbours the mountaineers of Niolo and the labourers of Vico, somewhat of the violent oppression and spoliation which they would have had to encounter in their own country. Twice they were compelled to forsake Carghésé, in order to seek an asylum in Ajaccio, and in 1814 they again lost a part of their property. These Greeks, independently of their language, have retained their habits and religious rites; but the national costume which they had formerly preserved has disappeared, and the trace of their Greek origin is found alone in their eyes and countenances. The contrast of Greek civilisation, careful, industrious, and active, by the side of the Corsican roughness and indifference, is

The hotel at Carghésé is a homely and tolerably comfortable second-floor apartment, with a certain appearance of cleanliness about its staircase and rooms, the latter having dark raftered ceilings; an elderly woman and her very good-looking daughter, with a second young woman, also pretty, receives me, and are greatly amused and pleased by my speaking Greek, which the landlady both understands and speaks well; of the two young damsels one only knew the commonest Romaic words, and the other none at all, for, said the daughter, "questa è Franca—she is a Frank." After a visit from the long-bearded Papa who had spoken to me from the window, and who promises to come in again in the evening, there is still time for a ramble in the village, the right-angled streets of which, and an air of care and cleanliness about the houses, give it a novel interest to a Corsican tourist. All round the village the *Cactus opuntia* is largely grown, and (as says Valery) there is a briskness and order here contrasting not a little with the apathy I had seen in other parts of the island. It was very amusing to talk Romaic with the people here and there—that is, with the elders, for they alone seemed to understand it; one woman at a fountain spoke as if an Athenian; and with characteristic Greek curiosity inquired, "Ἀλλὰ διατί ἦλθ᾽ ἡ Εὐγενέια σας ἐδῶ—*Why* did your honour come here?"

On returning to the hotel an excellent dinner was provided—soup, a dish of pilaf (the first seen in Corsica), roast lamb, &c., and very tolerable wine, but the priest, who came to pay his promised visit, brought a bottle of far better quality. The colony, according to him, came to Corsica under Genoese protection, about 1626, and consisted of 600 or 700 Greeks from Vittolo in Maina, and he says that now the population of the village is 1,200, but much crossed by marriage with the islanders, and that even some Corsicans by descent are counted in that number. He describes the site of Paomia—the first settlement of these Spartan Moreotes, and burned some thirty years after their coming—as being distant about an hour's walk from here. After its destruction the colonies took refuge in Ajaccio for fifty years. They preserve their old ritual, but are all "united Greeks," or, in other words, Papists. The priests, he says, may marry, and at first did so, but do not now. Long since they have disused all national costume, and very generally the use of the Greek language, which intermarriage and the settling of the islanders amongst them are fast obliterating, and it is evident that they seek to separate themselves as little as possible from Corsicans. Thus, in two or three more generations their family names will be the only remaining proof of their nationality. My acquaintance, Papa Michele, seems to have been superseded, unjustly, according to his own account, by the Bishop of

singularly striking at Carghésé, surrounded as it is by some of the most barbarous villages in the island. Nevertheless, for some years past these refugees form alliances with the indigenous families, and Corsican blood even begins to preponderate.—*Valery*, i., p. 104.

Ajaccio, who has given his place to a curate from the Piana de' Greci, in Sicily. "Perhaps," says he, "the Préfet may one day do me justice—νομίζω αὐτὸν, ἔπειτα τὸν Θεὸν, ἦναι ὁ Ηατήρ μου καὶ πρῶτος ἀνθρώπων.—He, after the Lord, is (in my opinion) my father, and the first of men."([1])

May 10.—At 5 A.M., coffee-au-tumbler having been obligingly brought at

([1]) During this period of oppression, there happened a remarkable event, which was the establishment of a colony of Greeks in Corsica. . . The Turks having got possession of Candia in 1669, came by sea, and became masters of Maina, and reduced the unfortunate posterity of the Spartans to a state little better than slavery. But among those who dwelt at Porto Vitilo were some who, despairing to see any change in their dejected country, came to the resolution of abandoning it altogether, and of seeking an establishment somewhere else. In 1676, about 1,000 souls left Greece, the family of Stefanopoli conducting the whole enterprise, and they arrived at Genoa in January, 1677, and remained till March. . . . They also brought with them some religious of the order of St. Basil, the only order in their church, who established a convent in a wild and romantic valley. But the Genoese did not approve of these fathers, and in a short time their convent was shut up. The Greeks found themselves very easy and happy for a good many years. By their industry and activity they beautified and enriched their possessions, and built very good houses, doing everything with a taste altogether new in Corsica. But their neighbours, the natives of the island, did not live in great harmony with them. Perhaps in this envy may have had some share ; for their vines and their olives, their herds and their flocks, were, by care and skill, much superior to those of the Corsicans. But, besides, the islanders looked upon the Greeks as auxiliaries of the Genoese, to whom indeed they, from time to time, swore fidelity, and were ever ready to give their assistance. They also knew that the Greeks were well supplied with arms, and therefore there were frequent skirmishes between them and the peasants of the province of Vico, of which their territories had formerly made a part ; and in the year 1729, when the nation rose against the Genoese, the Greeks were seriously attacked ; and many a desperate action they fought with great bravery. The Genoese formed three regular companies of them, to whom they gave pay, and they were always employed in the most difficult enterprises. In particular, they were detached to attempt taking the castle of Corte from the patriots ; on which occasion they were sorely defeated, and a great number of them were killed. After various struggles the Greeks were forced to leave their possessions, and retire to Ajaccio, where they now support themselves tolerably by their labour. . This colony has been sober, virtuous, and industrious ; and if they have acted in a hostile manner against the nation, it was from a good principle, from the fidelity which they owed to the republic that had granted them an asylum, which fidelity they would ever have preserved had not the republic included them in the general oppression. I must observe of this colony, that it hath had the honour of producing an excellent physician, Signor Giovanni Stefanópoli, the first who hath had the wisdom and the spirit to bring inoculation into Corsica, by which he preserves multitudes of lives, and may, therefore, be justly reckoned a distinguished benefactor.—*Boswell*, pp. 88—90.

The emigration of Moreote Greeks to Corsica took place on October 3, 1675, and the emigrants, 730 in number, arrived at Genoa in January, 1675. Jean Stephanópoli, when the Laconians had decided on leaving Greece, had previously visited Sicily in order to find some spot whereon to settle beyond the power of the Mussulman ; but ultimately had been permitted by the Genoese republic to choose a site in Corsica. A second emigration, consisting of 400 persons, left the Morea soon after the first, but were overtaken by the Turkish fleet, and massacred. The treaty signed at Genoa, January 18, 1676, assured the colony the possession of Paomia on the following conditions:—

Article 1.—The emigrants must recognise the Roman pontiff as spiritual chief, and they must profess the Greek rites as they are exercised in the pontifical states.

2.—The bishops and other ecclesiastics of the colony must receive their investiture from the Holy See.

3.—They oblige themselves to construct on their arrival at Paomia churches and dwellings for their own use, on condition of recognising the sovereignty of the Most Serene Republic, to which they must swear fidelity ; and they engage to serve it by land or sea, as it may require them to do, and also to pay exactly every established tax.

4.—The colonists must be subordinate to the authority of the Latin bishop of the diocese.

5.—The domains of Paomia, Rovida, and Salogna, which the Republic gives up, à titre emphyteotique, must be divided between the different colonists ; the lot of each at his decease must be equally subdivided between his children without distinction of sex ;

a still earlier hour, I am busy drawing the village of the Mainotes from a height on its east side, whence the whole locality is visible, besides a broad expanse of Mediterranean ; but thick mists cover all the farther distance, and at times descend even lower than the little chapel close above the village. Below me are groves of fruit trees, resounding with hundreds of nightingales, and looking either towards the shore, or inland to the hills, all the land is cultivated, and unites with clouds above and cloud shadows far away on the sea, to make a pretty picture enough. (*See* Plate 16.)

Descending, I draw on the other side of the village till 10.30. There is a look of cheerfulness about Carghésé not observable in any of the places I have hitherto seen in Corsica ; the scattered and rural Grosseto ; the wooded and secluded Olmeto ; Sarténé, the grand and solemn ; Bonifacio, walled and isolated ; Porto Vecchio, the decayed ; all have their special characteristic, but among them cheerfulness is not. Here, on the contrary, the entire open-ness of the position of the village is in itself a cheery feature ; standing, as it does, away from rocks or trees, or overhanging height, at the end of a pro-montory with sea on all sides but one, so that from the southern face of the

and the property of any colonist who dies without descendants must return to the Republic.

7.—It is permitted to the colonists to build stoves and mills ; to possess cattle of all kinds ; and to have arms, with the exception of those the carriage of which is prohibited.

8.—They may exercise commerce freely, on condition of paying *patente*.

9.—They may arm rebels against the Turks, but only under the flag of the Republic.

10.—The government of Genoa engages to furnish the means of transport from Genoa to Paomia gratuitously ; but the colonists must repay the Republic the sum of 1,000 piastres which has been advanced, either for the purpose of defraying the expenses of the captain of the vessel in which they came from Greece, or for that of providing for their maintenance before their departure for Corsica.

11.—The Republic of Genoa engages to maintain at its own charge an ecclesiastic knowing the literal Greek language to instruct the children of the colony, in order to preserve in it the language and the Græco-Catholic rite ; and further, binds itself to maintain at its own expense two pupils at the Propaganda Fide at Rome.

The colony arrrived in Corsica, March 14, 1676. Among the colonists was a bishop named Parthenius, but the Republic of Genoa ruled that no future bishop should replace him after his death, and that the young Greek ecclesiastics should thenceforth receive ordination at the hands of the Græco-Catholic bishop residing at Rome. The Greek colony became extremely flourishing, but its happiness only lasted from 1676 to 1729, the period when the Corsican revolution against Genoa burst out in the Terra de' Communi, and which continued down to 1769.

In these circumstances, the Greeks, out of gratitude to the Genoese Government, took no part in the revolution, and when the adjoining villages claimed their arms they refused to give them up, and assumed an attitude of defence ; then they were accused as partisans of the Genoese, and assailed on every side, their lands were devastated, their flocks driven away or destroyed. The Genoese government being no longer in a position to help the Greeks, it counselled them to abandon Paomia, and to take refuge in Ajaccio ; and the Greeks, having sent their families thither in boats, endeavoured for some time longer to defend themselves, but, harassed on all sides, they were soon reduced to the cruel necessity of forsaking their villages, and, with great difficulty, to save themselves in the town of Ajaccio. This event happened in the month of April, 1731. Transplanted to that city, they were allowed, for the exercise of their worship a chapel situated not far from Ajaccio, named La Madonna del Carmine, which was thenceforth called La Capella de' Greci. Up to this time they had preserved their national dress, but a sanguinary feud between them and the inhabitants of Mezzana led them to adopt the same

CARGHÉSE.

PLATE XVI.

hill you overlook the whole settlement at once. The light colour of the stone of which the houses are built, in regular lines, and the gardens that surround many of them, have none of the usual gloomy Corsican aspect, and there is a novelty in the wide extent of the Indian fig or cactus which stretches below the village on the north side, and along the edge of which pigs are tied to stakes, leading a life of order and propriety, instead of dirtily rambling all over the settlement. Many a trim village scene of industrious and lively Greece is recalled by Carghésé. And had the shores of the opposite side of the Gulf of Sagona been clear, the view looking that way must needs be of great beauty; the indentations of the coast line and the lower hills show thus much, though the higher summits are just now hopelessly hidden by mist.

11 A.M.—Return to the inn, passing the large building which is so conspicuous in all the views of Carghésé, and which they tell me is the new Greek church; it is a mere shell, standing unfinished for want of funds, and I suppose is the same edifice towards the completion of which M. Valery was so amusingly entreated to subscribe in 1835. The original chapel used by

dress as that of the population of Ajaccio, because the men of Mezzana, whenever they saw any one dressed as a Greek, killed him without mercy. And by this time the poor Greeks had discovered that want of pity and bloodthirstiness are not more characteristic of the worshippers of Mahomet than of those who adore Christ.

During the time the Greeks lived in the town of Ajaccio they contributed greatly to the improvement of the cultivation of the beautiful territories which that city possesses; and the Genoese government also gained by them in their supplying the republic with many good soldiers.

The Germans who came to Corsica in aid of the Genoese republic could not inspire the Greeks with sufficient confidence to induce them to return to their possessions in Paomia, and hardly had the imperialists quitted the island than new troubles broke out. It was then that Genoa applied to France as mediator.

France, become mistress of Corsica in 1769, resolved at once to reinstate the Greek colony in its former position; but by this time all the dwellings were utterly destroyed, and their lands, once so well cultivated, had again resumed their natural savage appearance.

Thus, after forty-three years of exile, they were re-established, A.D. 1774, in a spot west of Paomia, and a new domain was given to them on the promontory named Pontiglione, which separates the Gulf of Sagona from that of Pero, and this new establishment was called Carghésé, and raised to a marquisate under the protection of the Count de Marbœuf. This village or little town is placed like an amphitheatre above the sea-shore; erected at the expense of the French government, all the houses were from the first built of the same height, and arranged in streets at right angles.

The Count de Marbœuf caused a fine castle to be raised at Carghésé, and often went there to pass some days in admiring the progress and industry of the Greeks.

The colonists continued to enjoy peace till the commencement of the French revolution. At that period the ancient animosities of the surrounding villagers again burst forth, war soon followed, and the Greeks, unable to offer resistance, were again obliged to abandon Carghésé, a great part of which was burned, and the castle of Count de Marbœuf was destroyed. The colonists re-entered the town of Ajaccio reduced to the utmost misery. It was then that several families allied themselves with Corsicans, and when order was restored, and the Greeks were able to return to their possessions, many of them preferred to remain in the town of Ajaccio.

Since that period (1814) tranquillity has not been disturbed; alliances with the islanders have become more and more frequent; the Corsican dialect is even spoken by all the Greeks, though they have always preserved their own language among themselves. The marriages of Corsicans and Greeks have made it necessary in our own time to erect two new churches at Carghésé, one consecrated to the Latin rite, the other to that of the United Greek Catholics.—*Galletti*, pp. 131—136.

the Greeks stands on the main road. I could linger willingly in Carghésé for two or three days, but, according to the scale which my limited stay in Corsica compels me to adopt, more than this one morning cannot be spared for the Mainote village, and I shall reach my next halting-place, La Piana, this evening. Meanwhile the people of the inn tell me some of the names of the Carghésé families—Stephanópoulos, Papaláki, Pietroláki, Dhrimaláki, Frangoláki, Zannitáki ; the priest is Michele Mendouráki ; and, oddly enough, that of the landlord of the hotel Polyméros Korfiótti.

After breakfast, which, though very good, was, excepting its conclusion of roast lamb, quite marine in its character—to wit, lobster soup, fried mullet, lobster boiled, and lobster salad—I went out to see the "Greek church," so called ; it is very small, and differing only from similar places of worship, in its having a crucifix above the altar; a fact sufficiently demonstrating that the Catholic had superseded the Orthodox in the religious system of Carghésé.

After this there was a visit to pay, for on my arrival last night I had sent M. Lambert's letter to the Chef de gendarmerie, who had called, begging I would take coffee with him next day, when he would give me a letter to the agent of M. Chauton, at the forest of Valdoniello; and so, after some very good tumbler-coffee and biscuits, in the neat clean room of M. Ceccaldi and his colleague, whose daughter is married to the agent at Porto, I gained much information as to my onward route. From Carghésé to La Piana, they say are twenty kilomètres, and beyond it twelve more to Porto, along a coast road cited as wonderful for precipices and fine scenery ; from Porto up to the mountain to Evisa are twenty kilomètres farther; but as to the forests higher up my informants are not sure—seven or eight kilomètres of a bad and steep road they believe to be about the distance. From Evisa to Vico there are twenty kilomètres, and thence down to Sagona on the main Ajaccio road other fourteen. At Evisa they recommend the Maison Carrara as a halting-place.

The trap is ordered at 2.30 P.M., so there is yet time to add somewhat to my sketch of the distant mountains, which are gradually clearing. Looking across the Gulf of Sagona, and away from the wide western sea, how clearly much of the history of Corsica is explained ; of days when the people in its valleys, closed in by their own barrier mountain walls—hardly even in much communication with that next to them, and quite divided from the rest of the island—spent their energies in quarrels with their neighbours.

Either there is little curiosity or much good breeding in Carghésé, for no one comes near or otherwise molests me while drawing, which is as pleasant as singular. Children in Corsica, as far as I have seen, are a race unique for good behaviour; no throwing of stones, as at Naples or in Greece ; no shouting or teasing, and yet never is there any sign of timidity; in fact, for the sake of their quiet intelligence, I have already quite forgiven all Corsican children their habits of swarming up Ajaccio stairs.

Papa Mendoúrias Michéle Stephanópoulos comes to pay me a parting visit, and writes me down a Greek song from memory, promising me others if I will send him some from Fauriel's book; at present I can only repeat him the single verse of one sent me by M. Merimée—

'Εδῶ ἡμεῖς δὲν ἤλθαμεν
Καλὸ κρασὶ νὰ πιῶμεν.

He says that when M. Merimée was here, about 1843, a Greek costume, now quite disused, was pretty generally worn by the elder women. My clerical acquaintance imputes many changes at Carghésé to a "fuggasco" Latin priest from Syra, in the time of Leo XII. Papa Michéle is not, however, wholly to be relied on, for in maintaining that their religious ritual is unaltered, he declares that the Athanasian Creed is used in the Orthodox Oriental churches, which most certainly and happily is not the case. He also says there exists a MS., date 1650, written by one of their priests, detailing all their early tribulations, but does not inform me where it is.(1)

2.45 P.M.—Flora, Domenico, and Co. are ready, and so farewell to the Greek colony of Carghésé; a wind is rising, and a clearing of all hill-tops ensues. Soon, leaving the shore of the little Gulf di Pero and that of Chiomi,

(1) [The Greek characters of Papa Mendourias were not easy to decipher, but a friend thus writes to me on sending me back the old song with a translation, "By the help of a magnifying-glass I have leapt over the wall of illegibility, though the first line cannot be made out. I take it to be some old refrain like 'The leaves grow rarely,' or 'The birk blows bonny,' &c. of a Scotch ballad."—E. L.]

'Ανὰ βροδαὶς βροδίου καὶ ἀπὼ βραδὴ βραδιάζει,
Εὐγίνε ἡ φούστα ἡ Φραγγικὴ, καὶ ἡ Τουρκικὴ γαλιότα
Καὶ ἐπιάσαν ἕνα νεὸ καλλὸ, ἕνα καλλὸ στρατηότ',
Μάνα δὲν εἶχε νὰ τὸ κλάει, κύρι νὰ τὸ λιπόται

Μον' εἶχε μία ἀγαπητικὴ πολλὰ μακρὰ 'στὰ ξένα
Καὶ ἐκείνη κ' ὅπου τ' ἄκουσε, κ' ὅπου εἶχε τ' ἀγρικώση,
Καὶ βὰζει τὰ σκοῦδα στηνπωδιὰ, καὶ τὰ φλουρία 'στὴν ζώση,
Καὶ ἐπείρε τὸ στρατὴ στρατὴ, τὸ ριὸ τὸ μονοπάτη.

.

There went out a Frankish vessel, and a Turkish galley,
And they took a fine young man, a fine soldier.
He had no mother to weep for him, no lady to grieve for him.

He had only a love far away in a foreign land.
And she, when she had heard of it, and listened to it,
She put her shoes on her feet, and her florins in her girdle,
And took the road, the road, the way trodden in a single path.

[Among other notices of Corsica which M. Prosper Merimée most kindly sent me before I left Cannes is one relating to Carghésé, in which he says, "I was struck with their pronunciation, which is, I am told, much like that of the Cretans. For instance they would pronounce λαγήνι as a Frenchman would *lajini*, χέρι as *chéri*, κεφ'αλη as *tchefáli*. I remember one of their songs, a very foolish one, that will give you, perhaps, an idea of their dialect—

"'Ημεῖς ἐπᾶ δὲν ἤλθαμεν
Καλὸ κρασὶ νὰ πιοῦμεν
ὁ σύντροφός μου σ' ἀγαπῶ
Καὶ ἤλθαμεν νὰ σ' ἰδοῦμεν.'"

As M. Merimée says, the pronunciation of the Carghésé Greeks is precisely like that of the natives of Crete, in which island I spent some months in 1864.—E. L.]

the road runs inland among pleasant green fields, up a bright vale joyous
with corn ; there are poplars by a stream, dazzling yellow blooming rape,
and eastward a wall of mountains at the valley head, with corn everywhere,
up to the very tops of the nearer hills. But as the way begins to wind up
a long and steep ascent in a narrowing gorge, the well-known "maquis"
encroaches gradually on the merry food-fields, gay with sunlight, and striped
with cloud shades—for

> "A light wind blew from the gates of the sun,
> And waves of shadow went over the corn."

4.20.—Beautiful views of the far-away Carghésé promontory and a clear
fountain are good excuses for five minutes' rest. Henceforth the road is
tolerably level, as leaving the valley of Chiomi it takes a more northerly
direction, parallel to the craggy-fronted barriers, towards which I have been
climbing, not without observing the good driving of the new Jehu Domenico,
and the eminent qualities of his two ponies. Coasting the mountains, as it
were, the head of another seaward valley is passed, woodier and more beautiful
than the last, and with more picturesque mountain outlines ; then succeed
bosky ilex-woods at intervals, and some enclosures of cherry trees, while not
unfrequently a couple of red-legged partridges trot leisurely across the road.

Shortly the ridge terminating in Capo Rosso is crossed, and at a sharp
turn of the road, a vast and striking picture of mountain, cliff, sea, and the
village of La Piana, starts suddenly, as it were, into life : never again shall I
say, as I have said more than once, that there is no remarkable coast scenery
in Corsica, for, doubtless, this may claim comparison with that of most
countries for grandeur. Indeed, I cannot remember any view of the kind
so magnificent, except that of Assos in Cephalonia and the coast near Amalfi,
but in both those places a high snowy range like that of the Corsican Alps is
wanting. Below that silver range of peaks, the great heights opposite are, at
this hour, covered with the loveliest velvety gray-green, furrowed and fretted
with infinite lines, and beautifully mysterious with floating clouds and misty
"scumblings ;" in the middle distance is a line of pink granite or porphyry
rocks, and nearer still a crest of immense crags above the village of La Piana,
in itself more picturesque than most I have seen in Corsica ; placed among
slopes of green gardens and groups of chesnut trees, and looking seaward to a
stretch of exceedingly grand coast cliffs, running, from what I suppose is the
bay or gulf of Porto, to Punt 'alla Scopa and Rossa. (*See* Plate 17.)

Sending on Flora and Co., I worked hard till 6.30 P.M. to get a drawing of
this scene—a task that seemed to have no end, as higher snow peaks were
suddenly unfolded from wreaths of cloud, and the crimsoning lights and purple
shades on the mountains rapidly varied as the sun set.[1]

[1] I landed on the rocks at the point called Fiscaiola. The ascent to Piana is horribly steep.
Piana, a pretty village of 700 souls, well situated and modern—for the fear of the Barbary corsairs has

Plate XVII.

LA PIANA.

7.15.—Reach La Piana, a pleasant looking country village, loftily placed amid this glorious scenery, and possessing a Piazza or Place, where Domenico is waiting to point out the hotel, a little house with ladder-staircases, cleaner than usual, leading to two tiny rooms unexpectedly snug and clean. The landlord, with that obliging manner and homely good breeding so constantly observable in this island, after a short apology for "our poor and rustic dwelling, where you must not expect much," prepares the little table for dinner, which is served up by a bustling country girl; and in this remote village inn, where the slenderest accommodation might have been looked for not only were the clean cloth and napkins and silver spoons such as you might expect at town hotels, but the fare was all good, and well cooked. Corsican country inns are, it is evident, surprisingly satisfactory by comparison with those of the towns.

The short journey of to-day, as well as the morning passed at Carghésé, have left plenty of pleasant memories ; and the air here is so fresh and bracing that G., who, thanks to quinine, has had no fresh attack of fever, will now I think escape that enemy. Altogether this second " fytte " of Corsican travel seems to have commenced prosperously.

long kept this part of the island uninhabited—might become a place of commerce, were there any road from Fiscaiola.

In the neigbourhood of La Piana are two ruins, or rather two remembrances, which are associated with the ancient times of the island history—the castle of Guinepro, near the tower of Porto, and that of Jean Paul de Leca, the first and most indefatigable movers of that perpetual insurrection of Corsica against the Genoese, which lasted four centuries, and only closed with Paoli. — *Valery*, i., pp. 100, 101.

CHAPTER VI.

Glorious Scenery—Leave La Piana—Extraordinary Pass among Rocks—Descent to Gulf of Porto
—Finest Portion of Corsican Coast Landscape—Tower of Porto—Great Timber Works of
M. Chauton—M. and Madame Ceccaldi—Superb Scenery of the Valley of Otta—Grasshopper-
Pigs—The Gorge or Pass below Evisa ; exceeding Grandeur of Views—Evisa—Unsatisfactory
"Hotel"—Beautiful Scenery beyond Evisa—Great Forest of Aïtone—Bombyx Processionaria—
Vast and magnificent Forest Scenery—Variety of Trees—Reach the Forest of Valdoniello—Valley
of Niolo—Enormous Pines—Descent to M. Chauton's Establishment—Pine Forest Scenery in
perfection—Hospitable reception by M. and Madame Ruelle—Pleasant Evening and agreeable
Company—A Day in Valdoniello—Effects of Sunrise in the Forest—Gigantic Trees—Cloud and
Rain—Leave Valdoniello and return by Aïtone to Evisa—Madame Carrara's excellent little Hotel
and good Breakfast — Drive from Evisa to Cristinaccie—Great Ilex and Chesnut Woods—
Domenico the Coachman's Music — Beautiful Drive ; ever delightful greenness of Corsican
Landscape—Walks in the Valley of Vico—Great Extent of Chesnut Woods—Vico—Picturesque-
ness cum Dirt—Leave Vico and descend to Sagona—Mid-day Halt by the Seaside—Flora's
exemplary Conduct—Jelly-Fish and Amaryllises—Return to Ajaccio.

May 11.—It is necessary to rise early to get an outline of the topmost
peaks of the mountains above La Piana, about which the clouds soon gather
and hide them; but this does not prevent the good folk of the house from
getting coffee ready before 4 A.M., so that I could complete a drawing near the
village by 6. Sky, earth, and sea are all clear as crystal, and this view of La
Piana and the west coast of Corsica is alone worth coming a long way to see.

Leaving G. to pay, and to follow with Flora and C°· I take leave of the
tidy and obliging people at the little hotel, and walk on alone. And shortly
are reached the great precipices that form so prominent a part of the view
I had drawn of La Piana, standing apparently immediately behind the village,
but in reality distant some half-mile, sloping down in jagged and dreadful
array to the sea. (*See* Plate 18.) What beautiful variety of form and colouring
in these granite—or are they porphyry?—pillars and crags, so brilliant and
gay in comparison with the sober pallid hues of limestone rocks! The
carriage road—a very good one, and with a parapet throughout on the side
towards the sea—is cut for a considerable distance through the heart of these
crags and peaks, along the edge of this savage coast, parts of which are truly
splendid. Groups of lofty spires, like cypresses turned into stone, shoot up
from the shadowy depths of terrible abysses, or overhang the highway, in
one place half-blocked up by a mass lately fallen from the heights above,
and as you wind among these strange and wild pinnacles, you look between
their clusters of rugged columns to the placid gulf of Porto and the beautiful
hill forms on its farther side, forming a succession of pictures, framed by the
grim foreground above and below you. This part of Corsican coast scenery
somewhat resembles the cornice road, near Capo di Noli; but though the

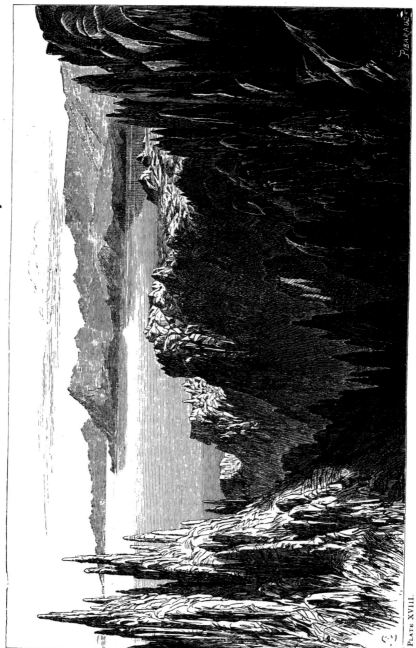

PIBARAUD

COAST NEAR LA PIANA.

Plate XVIII.

mountain wall is much higher there, the Piana and Porto rocks are far more beautiful on account of their colour, in some places almost rosy, and reminding me not a little of portions of Petra.

At 7.30 I walk on, having made fewer memoranda than I could wish of these remarkable coast scenes, partly that there is a long day's work ahead, partly from there being more coldness than is agreeable among the shadows of this weird region of peakedness, and its gulfs of dim gloom, strange and silent as death.

As in the song of the autumn garden of Alfred Tennyson, one may imagine that a spirit haunts the place, and "listening earnestly," one may hear him say, "Enough that you have destroyed the solitude and quiet of my mountain fastnesses by a high road : pass on, nor linger among my stony palaces!"([1])

Broad and beautiful views open out after the last of the precipices is passed, when the descent commences to the gulf and tower of Porto, at the entrance of the valley leading up to Aïtone. From the great height at which this fine road is carried through the pass from La Piana, it winds snakily down the hill side to the sea, with a series of curves at the edge of precipices, by no means conveying pleasure to those who dislike giddy heights ; Domenico, however, drives well and steadily the whole way down, allowing time to observe some of the finest scenes I have yet seen in this island. At every turn there are new and fine combinations of beauty — round-headed pines rising above the dense vegetation that clothes the whole of the middle dis tance, backed by immense mountains above, and with the deep green gulf lying like a mirror below. (*See* Plate 19.)

On reaching the shore the road leaves the sea and turns up the valley of Otta, and at 8.30 A.M. I am at the timber works or establishment of M. Chauton, a large group of wooden houses, with mills, chimneys, bridges, &c., pine trunks in great piles, sawpits, mules, men and women, and abundant children—a busy spot, appearing to contain more life than one has seen on the whole route from Ajaccio, Carghésé and La Piana excepted. The buildings stand not far from the mouth of the river, a torrent which flows from the high mountains above Evisa into the Gulf of Porto, the lower part of its course being through what is now nearly a dry channel, with marshy ground on each side, unhealthy in appearance, as, according to all accounts, it is in reality.

M. Martin Ceccaldi, the resident agent, to whom his cousin the gendarme at Carghésé had given me an introduction, received me with the gravity so characteristic of Corsicans, who, it seems to me, are little given to compliment or gaiety, and with his wife, an extremely pretty person, genial in manners, ask me to stay breakfast, promising a letter to M. Ruelle, M. Chauton's

([1]) [This is the finest portion of coast scenery I saw in Corsica. What must the pathway from Porto to La Piana have been in the days of M. Valery?—E. L.]

principal agent at Valdoniello. The establishment there is about twenty-three kilomètres from Evisa, and that place is about as many from Porto, a steep up-hill drive all the way, whereby, says Domenico, I ought to start hence at mid-day.

There is little employment for the pencil at Porto besides the Genoese tower at the mouth of the valley and a sketch of the bridge and mountains moreover, there was a sensation of feverish damp, which instinctively led me to prefer sitting in M. Ceccaldi's house. Within-doors, however, time passed pleasantly, not only in discussing a breakfast doubly welcome from its excellence and from the kindliness of my hosts, but in conversation on various subjects. Much is said about the Hon. Mrs. A. B., who, with the Duc de B. and others, have lately been here ; her beauty seems to have

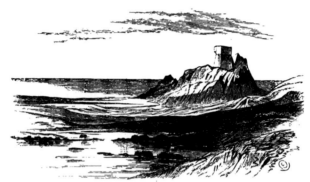

TOWER OF PORTO.

struck my host and hostess with extreme admiration. We discourse, too, on the goodness of Corsican roads ; on the perfect security now existing in all parts of the island ; and of the contrast in this respect between its present condition and that of even thirty years ago ; of Otta, the native village of M. Ceccaldi, a place four kilomètres ahead, and which I am to observe as I go up to the forests ; of the fertile subject of Vendetta ; and of how Ceccaldi's own father was assassinated at Otta, because, when maire, he had asked a doctor to examine the hands of a man who had been drawn as a conscript, but who shammed having lame fingers ; of silkworms, and of how Madame Ceccaldi, when at school, kept so many with the "élèves" at Ajaccio, that they were able to buy an harmonium with the proceeds of the silk ; and of the wrongs inflicted on Corsica by the Genoese ; &c. All this, playing withal with little Leo, the elder of two small Ceccaldi children, passed the morning easily.

Domenico, says Giorgio, having volunteered that this house is "ὡσὰν

PIBARAUD

PLATE XIX.

GULF OF PORTO.

ξενοδοχεῖον—all the same as an inn," I endeavour to settle the account, but find I have made a mistake, and that I can nowise induce my entertainer to accept any money. Nor can I without difficulty find an opportunity of giving a trifling sum to the female servant, whose face speaks bitterly of fever suffered, and reminds me of many I used to see in days of Pontine Marsh malarious wanderings. So, Flora and C⁰· being ready, I promise to send a "Book of Nonsense" to Leo, and take leave of my good hosts at 11.30, with a pleasant recollection of this visit to Porto.

Recrossing the torrent by the bridge I had passed in coming from La Piana, the road leads up the great valley which ascends towards the heights of Mount Artica, and the lofty ridges west of the Niolo, keeping near the bed of the stream where masses of granite are worn by the water into most grotesque

GRASSHOPPER-PIGS.

forms. The north side of this vast gorge, on which lies the property of the village of Otta, is much cultivated, olives, corn, and vineyards hanging on its steep terraced declivities([1]); on the opposite side of the pass, that along which the route forestière is carried, another and wilder world prevails ; depths and groves of chesnuts, now full of young leaf in all the green beauty of spring, and waving above fern and foxglove and patches of cyclamen, where "here and there a milky-belled amaryllis blew." As you proceed to the ascent, the views into the heart of the great mountains through some of the lateral openings from this valley of Otta are exceedingly remarkable, the more that the lower part of the gorge is not particularly distinguished from many similar fine mountain scenes ; some of these bursts of stupendously fine landscapes higher

([1]) [The pigs in this part of Corsica, in order to prevent them from straying in garden or vineyard, are furnished with an extraordinary apparatus of two long pieces of wood fastened above and below their heads, and having the appearance of huge horns ; at a distance they look like vast grasshoppers.—E. L.]

up in the pass are really startling, and unlike any I have seen elsewhere. Huge
pyramidal crags stand above you, isolated, and rising from rich green groves
of great chesnut trees ; their riven peaks and towering masses magnified by
floating mists, pierce the clear sky, and it is difficult to exaggerate the extra-
ordinary grandeur of their effect, though varied as they are every moment
by passing clouds at times hiding or displaying them, it is not easy to seize
distinct records of such fleeting magic day-dreams. (*See* Plate 20.) The
whole pass is thickly covered with wood, chesnut, and ilex, and no part of it

SCENERY NEAR EVISA.

is more romantic than about the fourth kilomètre, where the village of Otta is
seen perched up on the opposite side of the gorge, below tremendous heights,
which seem to threaten it with destruction, especially one enormous mass of
rock poised, apparently, immediately above the village.([1])

Still higher up, the gorge is more contracted, and seems to close in with
immense heights and a terrible wildness of dusky gray granite and depths of

([1]) Above Otta is an enormous stone which overhangs and seems perpetually to threaten the village
below. There are legends told regarding this great rock, and it is said that formerly the superstitious
inhabitants went at certain times of the year to tie the huge mass with cords, and sprinkle it with oil,
that it might thus be prevented from falling on the village.—*Galletti*, p. 130.

PLATE XX.

SCENERY NEAR PORTO.

awful gloom; ·grand as are the scenes, the great scale of their proportions hardly allow them to be favourably represented. · 3 P.M., the road skirts hollows in the hill side, and runs disagreeably by the edge of parapetless precipices, then crosses to the opposite face of the valley, high up at the head of which you see Cristinaccie and other villages, while fruit gardens mark the vicinity of habitations; finally, at 4, the top of the pass being nearly reached, I send on Flora and C to Evisa, and linger on the edge of the great gorge

EVISA.

for the sake of getting some memoranda of its sublime scenery, here visible down the whole of the valley of Otta to the gulf of Porto. It would take, however, far longer than the half hour I can spare for it to portray the infinitesimal detail of its wild and gloomy precipices. ([1])

At 5.15 P.M. reach Evisa, one of the highest villages in Corsica, apparently a considerable place, stretching on the east side down to groves of chesnut

([1]) Evisa offers a charming distant view of mountains and forests. These gay mountains, detached and distinct, almost recall the hopping hills of Scripture. . . . Near Evisa, on the road to Otta, is the chapel of St. Cyprien · · · the altar is destroyed, and the building is now used as a cemetery for the inhabitants of Evisa.—*Valery*, i., p. 117.

not yet fully in leaf, while seaward are the great mountain crags in the valley of Otta. Although there seem to be several very tolerable houses in the village, that at the door of which Domenico is cleaning the ponies is not at all prepossessing, and betokens no pleasant night's rest. " Is there no better hotel ?" No, he knows of none ; has already placed the "roba" inside, and has bespoken dinner, so, as the Suliot says, " δὲν εἶναι ἰατρικὰ—there is no help for it." A room opening from the road—there is here at least no ladder-stair to complain of—seems used as a common osteria as well as kitchen and family dwelling ; beyond it is the tiniest of squalid chambers, in which G. with difficulty makes up my camp-bed, himself being promised a mattress on the table in the osteria when—an unknown future—that establishment may be empty. The host and his wife—he is a Milanese, who tells me he came from Italy hither on account of "circonstanze" many years back—are obliging, and do their best to provide a supper, though that best is very feeble. Nor did it prove to be eatable, even after a long walk ; one of the items, an astonishingly nasty compound of eggs, parsley, sugar, and garlic, was indeed wholly otherwise, a matter, however, soon remedied by G.'s taking the culinary department into his own hands, and turning out a dish of plain fried eggs, which, with bread and cheese and good wine, did well enough.

This day, however, though not ending pleasantly as to lodgings, has its own valuable memories ; in the morning, those of the strange rock scenery of La Piana, and later of the pass from Porto, where the vast and sublime masses of precipitous rock made new dream landscapes at every step, with magnificent alternations of light and shadow.

May 12, 5 A.M.—The morning is delightfully fine and the air exquisite ; nor, among other good things, should an excellent tumbler of coffee be forgotten, such as one would hardly have expected to find on the top of a mountain in remote Corsica ; here, as elsewhere, the good people exhibit great anxiety to compensate for what they know to be their deficiencies.

While Flora and C⁰· are getting ready I discourse with Casanova, a brother of the guardiano at the forest house near the twelfth kilomètre on the Bastelica road—scene of the memorable downfall of the carriage and horses of Peter the profane—and then set off to make a drawing of Evisa, looking towards the crags of the Porto pass. Notwithstanding M. Valery's raptures, and the "bondants collines de la Sainte Ecriture — Why hop ye so ye hills ?" to which he likens this scenery, I had not found it so attractive as I had expected on entering Evisa by the west side ; but from the east the view is far more beautiful, and as you go up the hill from the village the Porto crags are immensely majestic. (*See* Vignette, page 135.)

Just beyond the twenty-third kilomètre, from the sea, the road—a route forestière—divides ; one branch to the right leads by Cristinaccie to Vico, the

other through the forest of Aïtone, up the great valley or basin of that name, to the ridge which separates it from the district or canton of Niolo, and then down the other side, through the forest of Valdoniello, as far as the establishment of M. Chauton.

In a short time the skirts of the forest are reached, and as far as eye can see is a world of pines, filling up the depths of the wide vale, and clothing the sides of it far up the mountains on either hand, a space greatly exceeding the hollow of Bavella in size, but less novel and beautiful in its aspect, owing to the unbroken wall-like character of the heights here, and the absence of the detached and varied forms of rock which are the glory of the Bavella scenery.([1]) The trees near the entrance of the forest are not of great height, and for some distance inward are mostly more or less covered with a multitude of the bright white sacs or nests of the larvæ of that remarkable insect, the *Bombyx pro-*

([1]) The pine (*Pinus lariccio*) is the chief occupant of Corsican forests, frequently reaching to the height of from 100 to 120 feet. The branches of the *Pinus lariccio* are mostly confined to its top, while the trunk appears one broken column. Spread over large tracts of country, with foliage interlaced so as to be almost impervious to the sun, the pines convey the idea of a magnificent temple, the intercolumned perspective of which the traveller attempts in vain to penetrate.—*Benson,* p. 20.

(Benson gives an extract from Theophrastus on the pines of Corsica, and on the ship carrying fifty sails built of them by the Romans.—*Hist. Plant.,* l. 5, c. 8, Edit. Stackhouse.)

The superb Lariccio pines of Corsica have not degenerated from their ancestors of two thousand years ago, when praised by Theophrastus, who observed that the pines of Latium could not be compared to them. The forests of Corsica, to the number of forty or fifty, of which two only are turned to account, would supply more than the wants of our navy. The Genoese, wiser than we, imported all their wood from Corsica, and this explains the importance they attached to possessing the island. These forests, the first in Europe, instead of extending monotonously in long plains, plunge into deep valleys, or wind along the sides of high mountains, not wrapped in heavy and gloomy clouds like the forests of the north ; a splendid sun illumines them, and they present immense and magnificent prospects. The forest of Aïtone, one of the two which are being utilised, passes for the most vast and the most beautiful of all in the island. I admired its gigantic Lariccio pines, their trunks slender and smooth, towering, exhaling a powerful perfume of resin, branchless up to a height of above 100 feet, and crowned by a magnificent tuft of foliage, waving and sonorous in the breeze.—*Valery,* i., pp. 118—120.

The forests belonging to the state have in Corsica a superficies of about 40,000 hectares ; these forests will be utilised by means of thirteen routes forestières.—*Grandchamps.*

The forest of Aïtone, the most classical of Corsica, contains more than 700,000 trees of fir and larix pine, of large girth and height. The utilisation of this forest by the Genoese in the seventeenth century lasted fifty years. Its superficies is 1,360 hectares ; on one of its sides it approaches the sea along the torrent of Porto, on the other, climbing the mountain, it joins the great forest of Valdoniello, which contains more than 500,000 trees.—*Galletti,* p. 139.

The forests are of pine trees, principally of two species, *Pinus maritima,* generally called pinaster, which is chiefly useful as yielding great quantities of turpentine, but whose wood is not durable ; and the famous Corsican pine, which supplies some of the most valuable timber in Europe. . . . Mr. Hawker, speaking of the confusion existing between this tree and larch, says, There are two trees, whose scientific names are—1. *Pinus larix,* which we call larch, and the French *Melèse,* or rarely *larix;* 2. *Pinus laricio,* which we call Corsican pine, and the French *Pin larice.* No one who has ever seen the Corsican pine could possibly mistake it for a larch, as the tree is an evergreen, and resembles a Scotch fir ; and, moreover, I do not believe that there is a single specimen of a larch in the island.—*Hawker,* "Alpine Journal," May, 1869.

The tallest *Pinus maritima* that we measured was 116 feet high, and the largest *Pinus laricio* was close to the path on our way up ; it was 136 feet high and twenty-four round, but there were many larger in the forest. A baulk of *laricio* timber was exhibited at the Ajaccio exhibition (1865), for which a prize was deservedly given, as the labour of getting it out of the forest must have been enormous. It measured, when properly squared, eight feet square, and was over 160 feet long.—*Hawker,* "Alpine Journal," p. 297.

cessionalis,(?) my first acquaintance with which I had made in the woods round Cannes. Here, in Aïtone, the smooth satin-like surface of these nests, shining like silver among the tall dark green pines, has a most curious effect ; and not less strange, from time to time, are the long strings or processions —some of them ten or fifteen feet in length—of this extraordinary cater-pillar crawling along the road, now parallel with its edge, now crossing it in unbroken file. In other parts, below trees more than commonly full of their nests, are great heaps, some of them as large as a half-bushel basket, of these creatures, apparently in a state of torpor, or only in motion towards the point from which their " follow my leader " institution is about to take place. Now and then, in passing under trees loaded with these bombyx bags, the thought that one may plump into one's face is not agreeable, for the hairs which come from these animals on the slightest touch occasion excessive and even dangerous irritation.

But the questions arise, on seeing such myriads of these wonderful little brutes—do the nests fall down by their own weight, owing to the increasing size of the caterpillars ? Or do the inmates at a certain time open their nests and fall down "spontaneous " to commence their linear expeditions ? Do they, as some maintain, migrate in order to procure fresh food ? It seems to me not so from what I have noticed of their habits ; for though I have continually discovered them coming *down* the trunk of a pine-tree, I have never seen any going *up*. Rather is not all this movement preliminary to burrowing in the earth (as, indeed, the peasants about Cannes say they do) previously to their transformation into chrysalides ? Anyhow, they are a singularly curious, though not a pleasant lot of creatures, and their most strange habits are well worth observing. (*See* Notes relating to this species of Bombyx at the end of the Volume.)

The walk through the forest of Aïtone, one of the largest in Corsica, is full of interest. The carriage-road which winds along the southern side of the basin or valley is not very steep, and generally in good condition ; but at present, on account of the deep ruts made by the heavy timber cars, I send on Flora and C⁰· with the letter to M. Ruelle, and prefer doing the day's work on foot. Having passed beyond a tract, partially cleared for charcoal burning, and where there are other buildings belonging to M. Chauton, the forest becomes excessively dense, and although it is always more and more apparent as you proceed, that in subjects of pictorial beauty the immense expanse of these woods is inferior to those of Bavella, owing to the want of the unique background of crags that completes the scenery there, yet Aïtone may boast of a greater variety in its foliage—beech, spruce fir, and, high up in the pass, birch, being mingled in the most exquisite luxuriance with the *Pinus maritima* and *Pinus lariccio*—so that at every step you are struck by fresh " bits " for study, though, so to speak, the sea of forest baffles any attempt to portray it as a

PLATE XXI.

FOREST OF AÏTONE.

whole. All the way up the pass numberless charms arrest your attention—the sunlight twinkling and glittering through the young yellow leaves of the great beech trees, or glancing on their tall silvery stems, here black with moss, there with long floating tresses of pale green lichen waving from their branches. You look up to the highest summits above the pass, where masses of pine contrast darkly with cushions of gold-green beech-wood ; lingering in shady hollows you mark the chequered lights on the road, or on the pure white snow, which higher up is lying in wreaths along the banks by the wayside. Nowhere is there any lack of the beautiful throughout.

Halting here and there to make memoranda, or to rest by the delicious streams which are frequent in these high mountains, it is ten before I reach the bocca or level space that at the top of the pass divides the two great forests, and where that of Aïtone abruptly ceases as you leave the hollow basin in which it grows. Here, among the last pines crowning the topmost edge of the valley, I sit and look down on the vast scene, the deep and broad gulf between two mountain walls, thousands of pine and beech trees filling up all the intervening space, stretching down in shadowy blue gradations towards the sea, and climbing up the barrier ridges on each side ; the sense of magnitude and solitude is profoundly impressive, and all I have heard of Corsican forest scenery seems little compared with the plenitude of reality before me, a scene wanting possibly in elegance of form, but in splendour of extent and variety of colour certainly far beyond what I had expected to find.[1] (*See* Plate 21.)

A few minutes' walk suffices to cross the ridge, and to bring me on the opposite side of it to the descent leading through the forest of Valdoniello, into the great basin of the Niolo, which, from the point I now stand on, is seen below in its whole breadth and length to the north-east—Niolo, the heart of Corsican romance and liberty—its long lines of hill fading away into palest blue on the horizon.[2] All the landscape here is on a greater scale than that I have left ; the lofty Monte Artica on the south, and Monte Cinto (the highest summit in the island) on the north, tower above the head of this deep and wide valley of the Golo in snowy magnificence, enclosing it as it were with gigantic wings ; and less lofty heights bar away the outer world from this compactly delineated canton throughout its whole extent.

[1] Many pines in the Aïtone and Valdoniello forests are 120 feet in height ; one in the latter forest is twenty-six feet in girth at three feet three inches from the ground, and 150 feet high. *Forester*, p. 186.

At the top of the valley of the Golo, the forest of Valdoniello, which crests it, is perhaps superior to that of Aïtone by its site and extent, the variety of its trees, and its rich vegetation. Many of the pines in it are thirty mètres high and eight in girth.—*Valéry*, i., p. 119.

[2] Some few heathen usages have been retained in Corsica, especially among the herdsmen of Niolc. The most remarkable is the divination from bones. The diviner takes the shoulder-blade of a goat or sheep, polishes it, and reads from it the destinies of the person in question. It must, however, be the left shoulder-blade, because by the old proverb, *La distra spalla falla.*—*Gregorovius.*

The great forest of Valdoniello, commencing immediately from the bocca or ridge I have crossed, clothes the slopes of the mountains on its eastern, as that of Aïtone does its western side; but the proportions of the surrounding scenery are here so much more vast that the space covered by the pines seems less at a first glance than that in the pass from Porto; it is only when you begin the descent through Valdoniello that you perceive how widely in each direction the limits of this grand forest stretch out, and that the trees here are of the greatest size, though dwarfed by the huge mountain forms above them into apparently less importance. Two or three woodmen point out a direct path down the hill to M. Chauton's great establishment; but I prefer descending by the longer carriage route, first breakfasting—for it is now nearly noon—and then making a drawing of this magnificent scene, where, unlike Bavella, there is no mystery, but all is spread out in one broad picture, from the high snowy Artica and the long lines of dark pines feathering its sides, down to the farthest limits of the Niolo, a valley that may indeed rather be called a small plain, the features of which, however dear to the memory of Corsican days of liberty, do not make me regret that I shall not have time to visit it; at least, from this height it has a somewhat bare and bleak aspect.([1]) (*See* Plate 22.)

Much of the upper part of this forest is beginning to show the ravages of M. Chauton's hatchets; here and there on the hillside are pale patches of cleared ground, with piles of cut and barked pines; and you pass at times a spot where giant trees lie prostrate; or you see a car with many mules drawing up its ponderous burden to the bocca, whence it is carried down to Porto or to Sagona.

> "They came, they cut away my tallest pines,
> My dark tall pines, that plumed the craggy ledge."

As I descend slowly, commencing drawings which are to be returned to on the morrow, my first impressions as to the difficulty of procuring

([1]) The Niolo, a large and populous valley, is, from its situation and its shepherd inhabitants, one of the most curious and interesting parts of the island. The valley, of a regular form—a sort of theatre closed in by mountains—has an extraordinary aspect; its four entrances, two at each end, might be defended by a few men against numbers. Small fields, separated by low walls of stones piled up together, serve as pasture-grounds throughout its extent. The height, strength, and good looks of the men of Niolo, who are almost all shepherds, are remarkable, and their intelligence is extreme; it is difficult to give an idea of how neatly and with what facility they express themselves on their own affairs and the interests of their valley. This normal population is about 3,300 in number, among which there are not thirty artisans or merchants; poetry and song are familiar to these rude Arcadians of Corsica. . . . The ravages committed in the valley of the Niolo by the Genoese in 1503 is one of the most horrible memories connected with their rule; the inhabitants were hunted down, the houses destroyed, &c. &c. . . . Calacuccia, the chief place of the canton, contains more than 600 inhabitants. The period of the annual cattle fair, September 8, is the best time to visit the Niolo and to see the population of the valley in its most picturesque phase. The women are the only ones left in the island who preserve their ancient costume, a costly but durable dress which may be 130 francs in price. A cap of black velvet, bordered by their hair in two tresses, is the head-dress; a chemise buttoned up to the chin serves for a handkerchief; the dress is of blue cloth, open at the throat, and bordered with velvet. Nevertheless,

TIBARAUD

PLATE XXII.

FOREST OF VALDONIELLO.

subjects in Valdoniello are a good deal modified. At Bavella, I had said
the precipices are absolutely close at hand; while here the great heights
are far away; vast slopes of pines in masses, with a bare valley, Niolo,
beyond—a scene too large to be reducible to a drawing. Yet, on advancing,
I perceive that here the pines are larger and more spreading, and more
apt by their detached manner of growth to combine gracefully and grandly
with the mountains above; and it must be confessed that the very thinning
of Valdoniello, which is preluding its downfall, has its advantages in providing
space for light and shadow, for which there was no room in the close dense
masses of wood before the work of destruction began.

 Heavy showers of rain fall as I get further down the hill, an inconvenience
atoned for by the beautiful effects which follow; folds of mist are drawn
like gauze curtains across parts of the forest, while others are black in cloud
shade; the more open portion, where trees have been cut away, disclose
vistas and depths of inner scenery, and multitudes of stately pillar-like stems;
and within these recesses, deeper and farther away from daylight, all, as well
as their lateral branches relieved, light off the solid wall of pines behind.
None of these beautiful effects were to be seen in Bavella, nor was there
there, as here, an undergrowth of silvery birch, suddenly recalling Coolhurst
or Cumberland. (*See* Plate 23.)

 At 4 P.M., always descending, I reach the cleared level space in which
stands the principal establishment of M. Chauton—a busy little world, in
great contrast with the scenery around it, and reminding me of Robinson
Crusoe's settlement as represented in beautiful Stothard drawings, those
exquisite creations of landscape which first made me, when a child, long to
see similar realities. A large building made of bright pale pine-wood—the
house of M. Ruelle, the agent—is encircled by grounds divided from the
forest by palisades, and containing gardens and houses for workmen, and

this costume is now much left off by the younger girls, who have the bad taste to dress themselves "à la
mode."—*Valery*, i., pp. 122, 123.
 To the right lies the shepherd-region of Niolo, the modern canton of Calacuccia, a remarkable
district, enclosed by the highest mountains, in which the two lakes Ino and Creno are situated. This
district is a natural stronghold, opening out only at four points, towards Vico, Venaco, Calvi, and Corte.
In this district live the strongest men in Corsica, patriarchal shepherds, who have faithfully preserved
the manners of their forefathers.—*Gregorovius*, p. 316.
 The people of the Niolo are a nomade tribe, who occupy a wild and cold valley on the banks and at
the source of the Golo. The winter drives them from their villages for eight months in the year, when
they come down to the plains, to the gates of Bastia, Ajaccio, Corte, and Rousse.—*Grandchamps*, p. 22.
 Every road into the Niolo presents inconveniences; that which leads thither from the Ponte
Fraucardo goes to the bridge of Castirla, and follows the course of the Golo to the ladder or stair of
Santa Regina, once a place of great danger, and one where so many men and animals have perished,
now rendered sufficiently safe even for travellers on horseback. In following the road by the course of
the Tavignano, the grotto of the Fugitives (Refugiés) is seen, the place where the mother of Napoleon
I. passed a night—one of storms—when, after the catastrophe of Ponte Nuovo, she and other com-
panions of misfortune fled to the highest mountains. After leaving the Tavignano, the path leads to the
forest of Alberato di Melo and Mount Pascio, thence to Campo-Tile and the lakes of Ino and Creno.—
Galletti, pp. 210, 211.

stables for mules. One hundred and fifty men are employed on the spot, mostly from Lucca or Modena, and in many instances accompanied by their families—in fact, one sees a small village in the centre of a forest, the appearance of the whole betokening extreme order and cleanliness.

The demure Domenico—little Flora having long since espied and come to

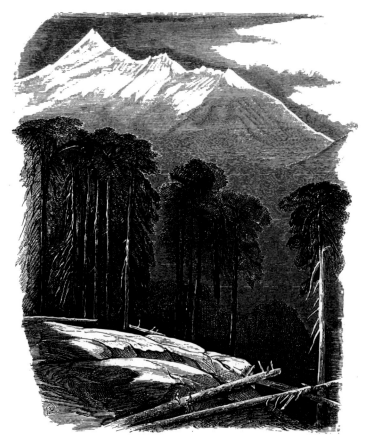

FOREST OF VALDONIELLO.

meet me—shows me the way through a formidable array of dogs to M. Ruelle's door, where that gentleman receives me with the greatest cordiality—"rooms for me and my servant are all ready, would I have some refreshment now?" No ; for as the weather is once more clear and fine, I will go out, and return later. "Then you must be here punctually at 6, for at that hour I and my wife dine, whether you return or not, because directly afterwards I have to

see to the men's supper." M. Ruelle is a "continental," and adds to friendliness and hospitality that vivacity which is so pleasant in the cheery Frenchman.

I drew on among those tall trees till 5.30 ; the whispering of their foliage, so high in air, is heard but faintly. Go ever so little away from the cleared space, and you may fancy yourself miles distant in the heart of this sadly grand forest—silent, silent ; darkening, darkening, as the sun sinks lower ; a lonely and majestic phase of nature, and one by no means painless or free from a strange melancholy.

5.30.—In the wooden palace of Valdoniello M. Ruelle is ready to show me a spacious room and comfortable bed up-stairs, everything above and around being odorous of fresh pine-wood ; and then, after a glass of absinthe, dinner was served in the neatest of rooms, clean and well-furnished, after a pine-wood log-house fashion. Madame Ruelle, a pleasant, homely little lady, joined us, and a tame pigeon and a cat were all the party besides ; my man G., whom they kindly ask to join it, having again a fit of fever. The dinner is excellent, and, as I remark to my hosts, the effect of the whole house and entertainment is as if Robinson Crusoe had found the Trois Frères Restaurant on his desolate island ; nor, I think, in any place, can the contrasts of life be stronger, or events more inverted, than in Corsica ; here, for instance, in the heart of a remote mountain forest, where the most ordinary fare would have been thankfully met with, is a small palace and a first-rate cuisine ; while at cities like Bonifacio or Sarténé your comfort is doubtful. My lively and intelligent acquaintance are full of pleasant conversation ; they have lived four years at Moscow and Novgorod, and after dinner show me an interesting collection of Russian photographs ; of their stay in Russia and of the people they knew there they speak with regret and affection. As to my praise of Valdoniello, there seems to be to that, as to all questions, two sides ; for in winter they are sometimes quite blocked up by snow for two or three months ; nor is the responsibility of managing so large a number of operatives in so lonely a place without its cares.

My plan of going down to Evisa to-morrow afternoon is first heard with dismay, and then utterly repudiated ; and their request that I will stay another day with them is urged with so much warmth and heartiness that I accept the invitation, the rather that doing so will enable me to complete much more work than I could accomplish otherwise. So we pass a pleasant evening, talking chiefly of Corsica and Russia ; nor do my two French riddles fail to secure their usual brilliant popularity—"Quand est ce que vos souliers font vingt-cinq ?—Quand ils sont neuf et treize et trois (neufs et très étroits) ;" and " Pourquoi dois tu cherir la chicorée ?—Parceque c'est amère (ta mère)."

.At 9 to sleep in the wooden room of the wooden house, a perfectly comfortable chamber, and where one may fancy one's self in an Australian or backwood loghouse.

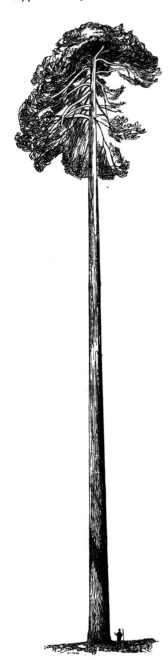

PINUS LARICCIO.

May 13.—4.30 A.M., looking from the window, the red sunlight glancing on the thousands of pine stems of the forest, recalls the crimson lights on the palms in many a Nile sunrise. At 5 I am on my way up the hill, G. carrying a particularly abundant load for breakfast, for it had been arranged by my hospitable host and hostess that I was to pass the day in the forest, so as not to lose time by returning ; and, said M. Ruelle, who busied himself in seeing the eatables packed, "Voilà un gigot d'agneau, des truites, du pain, et du fromage et du vin ; est-ce qu'on mange bien au milieu d'un forêt ?"

The day passed in hard work about the two forests, until towards 3 P.M., when the clouds, which, as yesterday, had added much to the beauty of the scenery, ceased to be either pleasant or useful, and dissolved in rain, so that it became difficult to make any more drawings requiring continued attention. While in Aïtone I was convinced, as on my first passing through that forest, of the im-practicability of giving an idea of the whole scene. Several of those groups of gigantic trees were, however, wonderful to look at, and especially some which, dead, and white as ivory, shoot up out of the purply gloom of the deep forest, their antler-like heads looking like silver as they caught gleams of sunshine.

In Valdoniello, where at 11 breakfast was arranged by a clear stream—possibly one of the sources of the Golo—no portion of this sublime forest landscape is more striking than the flat tops of some of the singularly Turneresque or Martinesque pines, relieving almost positively black against the great dis-tance beyond, an effect which is not seen among the more crowded trees ; and, moreover, I should say that these Valdoniello pines ex-ceed any I have seen both in girth and height. Unlike Bavella, so delightfully full of birds,

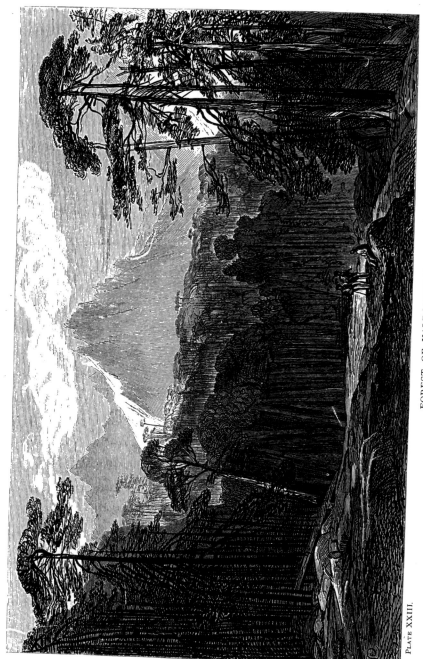

PLATE XXIII.

FOREST OF VALDONIELLO.

the forest here seems very destitute of animal life, hardly a note being heard
from hour to hour, a deficiency with which probably the constant sound of
the hatchet and frequent passage of timber carts may have somewhat to do.

While at breakfast, two gendarmes passing asked me why, at Evisa, I
had gone to the inn of Constantino Colombi, an Italian refugee, instead of
to the Hôtel Carrara ; so that it seems after all there is really some better
abode at the village than that I was taken to by coachman Domenico ;
and now that the name is mentioned it recalls to me that the gendarme at
Carghésé spoke to me about the Carrara house.

Late in the afternoon rain-showers prevented all work, except rapidly
noting down flying effects of cloud and mist, or making memoranda of the
fine masses of pines mixed with groups of birch trees ; and as a little book
sufficed for this, I sent G., still suffering more or less from fever, down to the
house. After all, at this great elevation, and so early in the summer, it is a
matter of congratulation that I have not had more bad weather to hinder
my tour ; nor, in quite clear days can this broad open forest be nearly so
beautiful as now, when it is varied by cloud and light.

At the hospitable Maison Ruelle the evening passed cheerfully with these
amiable and sensible people. Before dinner we visited the little gardens,
bordered neatly with wooden palings. Assuredly, " Lo, we found it in the
wood," if a scriptural motto were desired, would be the one most suitable for
this Valdoniello palace.

May 14.—The morning is glorious. M. Ruelle, followed by great watch-
dogs and innumerable puppydom, greets me at sunrise with coffee. At 5.30
I send Flora and C$^{o.}$ to wait at the foot of the Aïtone pass near Evisa. The
passage of the heavy timber carts along these roads after rain makes them far
from pleasant to drive over, besides that on foot I can better study the
immense hollow of Aïtone forest, with its multitudinous glories, chaos of pine
below, and gold-cushioned beech woods above. I take leave of the hospitable
M. Ruelle, and begin to ascend the ridge by the short steep winding path
among the pines ; G., who by dint of quinine is better, follows, but Flora, who
knows that her primary sphere of obedience is to stick to the carriage, and yet
who has now come to believe that she should not lose sight of me, is puzzled,
and sees before her a divided duty, finally rushing to the road to resume her
old habits of life. Perhaps the finest scene of all here is about half way up
the ridge, whence you look down on a stern line of giant pines standing out
sharply and wall-like against the clear distance and voluminous folds of forest
which fringe the edges of snowy Mount Artica ; this morning, bright and
cloudless, would not, however, have admitted of my making any drawing
opposite the sunrise, so that I have been lucky in the clouds of yesterday.
(*See* Plate 22.)

K

At 8, having rejoined the trap, Flora and C⁰·, M. Chauton's charcoal station is passed, and thenceforth is Bombyx-land, the white caterpillar sacs high upon the trees shining like silvery Abou-Jerdánns on Nile palms. All the pines that I observe so infested are thin and not strong looking; whether being diseased they attract settlements of Bombyx, or whether the insects are the origin of the decay of the tree, I know not, but, certainly, in the interior of the forest, where the trees are so magnificent, the Bombyx prevails not. At Valdoniello I scarcely saw an instance of it. At 9 the forest is fairly left; the careful Domenico, who, unlike swearing Peter, never loses an opportunity of well-treating his horses, stops for some minutes at a fountain; and then on to Evisa by 9.30 A.M.

Here the Hôtel Carrara, on the second floor of a very tidy little house, is a surprise, from its absolute cleanliness and neatness. Domenico's excuse for not having gone there on our way from Porto, is that the mistress does not receive any one unless they bring a recommendation from some known person, and this may be really the case, because the taciturn landlady, on my saying, " You must have many guests with such a nice clean house," replies, " Si riceve pochi; commandanti, colonelli, gente chi come voi conoscono Mons. Chauton; gli altri si mand' à basso—few are received here; officers and such as, like yourself, know M. Chauton; the rest are sent down "— " basso " meaning the dirty pothouse where I slept two nights ago, and which is nearly opposite, lower in the road.

The perfect propriety of the two little bed-rooms here, and of the plain well-furnished sitting-room, could not be surpassed in even a Dutch country inn; nor could the most fastidious have found fault with the breakfast of omelette, supported by ham and olives, mutton with Lazagne-pasta, first-rate trout—generally, they say, to be had here all through the year—broccio, walnuts, Vico raisins, and excellent wine, served, as they were, by the neat mistress of the house and her daughter, the prettiest girl I have seen in these Corsican travels, with light blue eyes and long black eyelashes. Both mother and daughter are dressed in the short black silk spencer and coloured cotton gown, and the double head handkerchief worn in this part of the island. They tell me that in the winter there are frequently three or four feet of snow here for months together. Who, in a remote mountain village of Corsica, would have looked for such a locanda—faultless in point of cleanliness, good fare, and homely civility, and with a charge, too, of only two and a half francs a head for breakfast? It is something at least to have seen life in Evisa from two distinct points of view.

Off at 11, and soon leaving the forest road to Aïtone on the left, drive to the village of Cristinaccie, a small hamlet containing some tolerably good houses, at the head of the valley; thence crossing by a good and large bridge the torrent which runs by the pass of Otta to Porto, the road commences a

steep ascent, occupying more than an hour. The first part of it is very interesting and beautiful, from the noble ilex groves through which it passes, and from the fine woods of mixed ilex and chesnut you look down on in the deep vale above which you are rising. Sheets of white mayflower contrast with bright green or yellow brown foliage of the two sorts of trees, and glitter among the bare gray arms and moss-grown trunks of the dark evergreen oaks, immense in size, and feathering the mountain sides down into far depths of shade. Farther up, these woods are left behind, as loftier heights are neared, where there are crowns and cushions of brilliant yellow beech among granite cliffs, and dusky hued smooth rocks shining and sparkling with streaks of white snow and streams of running water.

At 12.30, winding along the edge of precipices, guarded here by good parapets, three or four of the monstrous timber-laden carriages are passed. Quite across the valley, Evisa is seen, compact above its massive chesnut groves ; far below is the little village of Cristinaccie. Coachman Domenico, who never hastens his horses up hill—they obey with a word,—"fate osservazione, Signore, come ubbidiscono !"—seizes on these opportunities to indulge in ebullitions assumed to be of a vocal character, if that may be so called which is rather a succession of mildly dismal moans in a minor key, sadly slow and monotonous. No cheerful air have I yet heard hummed or whistled by any Corsican, male or female ; the women, instead of singing those far-sounding and beautiful melodies so often listened to in days of Italian life, walk mutely. Corsican gravity is continually noticeable. "Tout est grave," says M. Merimée, "en Corse."

At 1 P.M., after rest for the horses at a fountain, the bocca or top of the pass is reached. A perspective of road succeeds to the hill-climb, descending always towards the valley of Vico, and offering, as it recedes from the higher mountains, finer views in the direction of the great ranges towards Monte Artica and Monte Rotondo, where darkening clouds tell that rain storms, as yesterday, are in full play. All the drive is remarkable for beauty, and of that kind so characteristic of woody Corsica ; extreme greenness, ilex trees in detached groups or crowded into dells, slopes of fern and asphodel, distances of pure blue towards the sea, and snow-topped hills lost in cloud inland, where a road leads to Guagno and its baths at the foot of Monte Rotondo.

At 1.30 the town of Vico([1]) is visible among vineyards and cultivation, in

([1]) Vico, a small town, the chief place of the canton of that name, formerly possessed a tribunal, and was always the head of the old province of Vico. The Bishop of Sagona resided there. Among the communes composing the canton is Renno, where that widow was born who, during the government of General Paoli, devoted her two sons to their country. Having received the news that the eldest had been killed in battle, she hastily armed the other and accompanied him (to Sollacarò) in order to present him to the General, whom the incident moved to tears. —*Galletti*, p. 139.

On the way from Vico to Guagno, between Musso and Boccasorro, are the ruins of the castle of La Zurlina, occupied in 1488 by Rinuccio de Leca, relative and confederate of the illustrious Jean Paul. The sulphur baths of Guagno, efficacious against rheumatism and cutaneous maladies, are the least ill-

the hollow of a deep valley ; and not far off on the right stands its detached convent, greatly praised for its position. So I send on Flora and C⁰· to the hotel, of which Domenico somewhat proudly reports, " E' all 'uso d'Ajaccio ; Vico è città—the inn is after the fashion of Ajaccio, for Vico is a city," and I walk on, taking, at a junction of three roads, that which leads to Ajaccio through Sari, the other two being those to Sagona and to Guagno, by Vico.

It is hardly possible to visit a more beautiful scene of mixed cultivation and wild distance than that which opens from the Vico convent, where, after passing through a small ancient-looking hamlet, with very dark black-brown houses, I soon arrived. Leafiness is the general characteristic of Corsica, but here it is more observable than ever, so completely clothed is every part of the landscape with luxuriant foliage, except at the very tops of the mountains. Everywhere a profusion of olives and walnut and fig trees, with much vineyard and corn, give a cheery air to the nearer scenery, while all the parts less culti- vated are carpeted with fern and shaded by noble chesnut groves, and though the valley is quite surrounded by mountains, yet it is sufficiently spacious to be free from any look of confinement or gloom. In the middle of all this basin of tufted greenery stands the town of Vico, a compact cluster of dwellings, backed by a tall and not unpicturesque campanile, completing the picture, doubtless one of the most beautiful in Corsica. (*See* Plate 24.)

It was 6 P.M. before—having finished the drawings I had commenced on the convent side of the town—I went on to Vico. But I regret to say that the place was much lessened in my esteem by becoming more nearly acquainted with it ; the particularly unclean streets, the appalling odours on all sides, and the hotel, "all' uso d'Ajaccio," not appearing at all prepos- sessing after the perfect little inn at Evisa, or even those of Carghésé and La Piana, albeit those are comparatively unfrequented localities, while Vico is a place to which a diligence runs daily from the capital, and which at one time was a Sous-préfecture.

Before dusk there is still time to see the farther side of the town, but a walk through it, and for some way along the Guagno road, shows me—luckily, since my time is limited—that there will be no necessity to make drawings in

kept and the most frequented in Corsica ; there is even an inn and a chapel there, and the number of bathers is as great as 600 or 800 annually. . . Guagno is in repute for the purity of its Italian. Vico, it is said, has the same merit. The French language in Corsica is not at all corrupted, and bears no resemblance to the barbarous patois of many of our own provinces ; it is singular that these moun- taineer islanders speak the Italian of Rome, and the French of Paris, for the dialect of Corsica is the least corrupt of Italian dialects, and infinitely more intelligible than the jargon of Naples, Genoa, Bologna, or Milan. Vico, a small industrious old town, which has nearly 1,400 inhabitants, is one of the Sous-Préfectures suppressed under the empire.—*Valery*, i., p. 11.

Guagno, the most populous village of the canton of Soccia, is one of which the inhabitants are nearly all shepherds or agriculturists, and they possess large flocks of sheep and goats. Their cheese is of the best quality ; and they cultivate some tobacco, *Nicotina rustica.—Galletti*, p. 140.

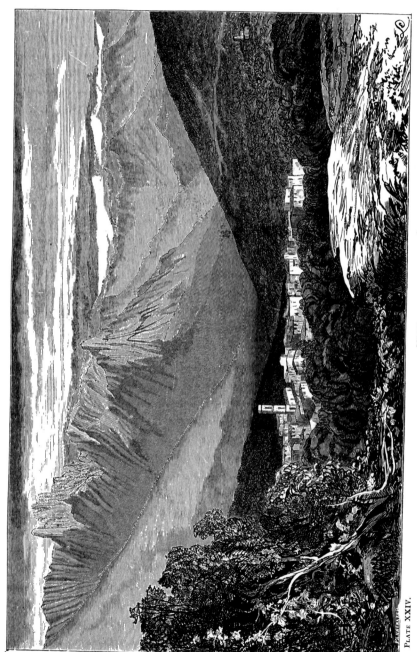

VICO.

PLATE XXIV.

that direction, and I return to the hotel as the gray hues of evening are falling on all this beautiful valley scenery.

Meanwhile, on the arrival of the diligence, dinner is announced—a *table d'hôte* meal, hastily and ill served, though of tolerable quality. Three travellers by the vehicle assist at the function, besides the conducteur, myself and servant ; and the courteous and pleasant manners of the Corsicans soon went far to atone for the impressions made by the rough *service d'hôtel*, unwashed and offensively-smelling floors, and other disagreeable etcetera. Of the three travellers, two seem Government employés ; they discourse chiefly on local

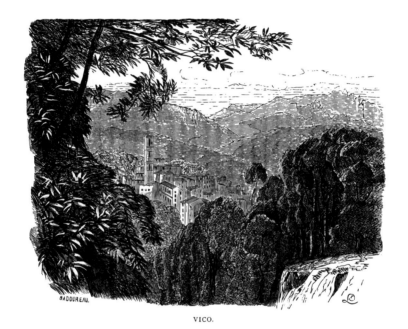

VICO.

matters, also on fevers, and on the principal places in Corsica infested by malaria. The east side of Ajaccio, in summer time, they unite in condemning.

May 15.—I leave the hotel at Vico before 5 A.M., but carry with me no pleasant memories. Till 7 I draw the town once more, and then go to the Evisa road junction, or Τρίοδος, to wait for the trap, D., G., and Flora. As I sit by a little chapel conspicuous for its singularly ugly architecture— the absence in Corsica of the numerous pretty chapels and shrines that so adorn Italian landscapes is to be regretted—the view all around is very beautiful ; the convent hill side is absolutely one dense mass of chesnut foliage, and everywhere the extreme greenness is delightful. The blue

mountain heights and parts of the foreground remind me a good deal of Subiaco; here, however, all is richer in covering, and the scenery of a more open character. Most charming and complete are the valley of Vico and its fresh verdure, and the recollections of their great beauty are a good set-off to those of its town and hotel.

The diligence road down to Sagona, broad and furnished with parapets, runs along the side of a valley, gradually descending to the shore, and the drive occupies little more than an hour from the junction of the Evisa and Sari roads. In the upper part of the vale there is much cultivation, particularly of the vine—the village of Balogna, close to Vico, being famous for its vintage—but the hills are not remarkable for beauty, nor does the rest of the way present any novelty; fern, red and white cystus, foxglove, and other wild flowers are plentiful and lovely near the road; chesnut and ilex groves below it—all constant accompaniments in Corsican journeying. Certain objects, which look like wheelless and bottomless cars, or decayed wheel-barrows of large dimensions, puzzle me by their frequent occurrence by Corsican waysides, and are explained by Domenico to be measures for broken stone used for road-mending by cantonniers, and are called "casci di roccaglie." The stone-breakers and road-menders in the island, unlike the woodmen and cultivators, are all natives.

Towards the sea the valley broadens, and the familiar "maquis" resumes its place in the landscape; the few forlorn houses representing the ancient Sagona and the Porte de Sagone are reached shortly after 8 A.M. Then follows the pleasant shore drive, and the beautiful vale of the Liamone with its fields of corn and its gay yellow iris marshes, after which there is nothing more worth noting, except the number of bee-eaters on the telegraph wires, and that a large snake crosses the road at the Liamone mouth. And thus Teucchia, and the wayside "Repos des Voyageurs," is reached at 9 A.M. Here they tell me Miss C. is expected on her way to the forests of Aïtone and Valdoniello; the untiring zeal of this lady may be of great use to many hereafter, if she will publish her observations, which are sure to be many and shrewd.

It is too soon yet for breakfast, but there are many very calm and "shadowed coves by a sunny shore" hereabouts, and a sketch of the granite rocks and the distant gulf hills well passes the time. Long points—à la Corse—stretch out and form a tranquil little bay, where scarcely a plash of sea is heard. Later, G. presents a breakfast of cold hare and snow-white cheese, assuring me, as the head of the former is wanting, that he had previously examined it at the hotel, and that its long ears precluded any fear of its belonging to the genus *felis*. The judicious Flora comes to assist at the polishing of bones, running every other minute to inspect the carriage and luggage, and to bark at imaginary marauders. She returns, when breakfast is over, to her post at

the trap, I to my drawing, the Suliot to the gathering of marine bobolia, and the examination of blue jelly-fish, which, as he truly says, abound here as they do on the long breezy sands of storm-beaten Askalon, or on the shore at Eleutheropolis, opposite Saloniki, where I was once detained in idleness and semi-starvation for three days on account of contrary winds. But the white amaryllis of these lands was wanting there.

At 11 Domenico, who has been investing in crawfish and other marine edibles, is ready with his capital little ponies, always well kept and well driven, and away I go back to Ajaccio. I pass the fig gardens and vineyards of the village of Calcatoggio at noon, stopping now and then to take a look, or a memorandum, of Carghésé, the Mainote settlement, on its long and solitary promontory ; or admiring the sheets of rose-coloured cystus-bloom amongst the wide tracts of "maquis ;" and thus, by a walk up the hill, reach the Bocca di S. Sebastiano (vide page 119) by 12.30 P.M. Miss C. not having been met with, Domenico opines that the lady has gone round to Vico by Sari, and with Corsican shrewdness, remarks, " Quella vuol veder tutta l'Isola e quando vi sono due strade andar e ritornar, non si contenta con una—that lady wishes to see all Corsica, and when there are two roads to come and go by, she uses both."

The way back is well and rapidly got over, the rather that, as is its custom of an afternoon, it begins to rain. How invariably, on perceiving some little white building a long way ahead, does one find it, on drawing near, to be no Italian shrine, no picturesque Greek chapel, but a mere box-like house. In Corsica one must not look for architectural graces, except, perhaps, among the tombs.

2.30 P.M.—At Ajaccio once more. Letters and papers, and a pleasant welcome at the Ottavi hotel, and from M. le Commandant Lambert. And, as usual, the high slanting wall by the barracks is blackened with swarming children.

This, the second tour in Corsica, has been all that could be desired as to carriage, horses, and driver, the young man Domenico being a careful whip and kind master to his cattle. But he wants to know if I can certainly start for Corte on Monday morning, a decision which as yet I cannot arrive at, as it must depend on weather, among other things.

CHAPTER VII.

May 16.—Rain has fallen in torrents through the whole day, holding up only
towards evening, in timely allowance for a walk by the seaside. Before this
walk becomes as much frequented by those flocks of English, whom hope—
that springs eternal in the human breast—forcibly pictures to certain minds as
making a new "Promenade des Anglais" on these shores, may the drainage be
remodelled! for at present the nasal sense is much disturbed by its condition.

But the hours bring plenty of work—abundant writing of letters, among
others one to Olmeto, from which place I hear by a note that Mr. B.
continues to get worse; a call at the Préfecture, where I find the amiable
Préfet recovering slowly from the effects of his accident. Taking great
interest in my journeys through the island, he promises letters of intro-
duction for various places on the eastern and northern sides, where hotels
do not always exist. Zicavo, Ghisoni, and the forests of Sorba and
Marmáno, are among the places he recommends me to see, but I doubt
my being able to accomplish the whole programme he draws up for my next
and last tour. After all, counting the chances of bad weather, and other
possible causes of interruption, a tour of two months, let an artist work as hard
as he may, very barely suffices to give an idea of the scenery of so large an
island as this—one hundred and fifteen miles long, by fifty or sixty broad;
nevertheless some twenty or more views of the most strikingly characteristic
portions of its landscape may serve to give home-stayers a tolerably correct
notion of Corsica, perhaps even to induce some of the migratory to visit it.

The unlucky Miss C. is supposed to have only succeeded in getting as far
as Vico, and to be there imprisoned, because the violent rains will without

doubt have made the mountain roads impassable. Meanwhile, my good fortune in seeing the forests so easily is a matter of congratulation.

The Ottavi talk to me of the larger hotel they hope to establish next winter; and I hope they may do so, for they are sure to prosper. Madame Ottavi's coffee—she learned to make it in Algeria—is alone worth much, not to speak of care and obliging ways, cleanliness, and good cookery, besides the assiduous sweepings of the waiter Bonifazio.

To-morrow I hope to see Mellili, formerly the country house of the Buonapartes; to get a drawing of the St. Antoine scenery; and on the following day to start for Corte and Bastia.

Late in the day comes a budget of letters-introductory from M. Géry. M. Prosper Merimée, who promised little, did much in being the cause of my receiving these letters, which will be extremely useful

May 17.—The day, cloudy and wet early, clears at noon; the trap and ponies come, driven by their master Jean the Vaudois, Jehu Domenico and Flora having set off yesterday to Corte, where there is some particular fête. Jean discourses on the great security of the Corsican roads in our days, and of the vice versâ-ness of those in Sardinia; also on the advantages of climate here, which had restored him to health, after he had been getting worse year by year at his native Luzerna in the Vaudois hills.

The drive is a pleasant one, and all things are brighter than when I was here on April 14; the vines out in full leaf, and all the verdure of cultivation— now the characteristic of these hills, which but a few years back were so bare— fresh and vivid, and resounding with the voices of multitudes of quails. There are two large penal establishments or penitenciers on these hills; the lower, whence a road (*see* page 29) goes on to St. Antonio and some villages beyond, is used as a farming depôt for cattle, horses, sheep, &c.; the land around both this and the building higher up the hill is being brought into cultivation by the convicts, who are all French, and mostly youths sentenced for venial offences to various terms of imprisonment. All wear a prison costume, and are attended by armed guardiani.

A steep pull leads to Castelluccio, the upper or chief penitencier, which stands very high, and commands a magnificent lake-like view over the head of the gulf of Ajaccio and the central mountains. The place gives an impression of that order and good administration for which the French are so justly credited, and the convicts, who, I am told, really like their life here, have, or seem to have, a look of comfort and cheerfulness, while turning the wilderness into a garden. In the grounds about the establishment I observe specimens of the Australian Eucalyptus or gum-tree, now so frequently planted and flourishing at Cannes and Golf Jouan.

Beyond the Penitencier, the road, skirting the hill-sides towards the east

among slopes of rich "olives hoary to the wind," dives downward, and ends among several villas half hidden in foliage, and as Jean Vaudois has no idea of the position of Mellili, it is some time before I find the path to it; there exists, however, a short cut leading directly down to the house from Castelluccio, not far below which is the site of this very interesting spot.

Mellili is one of the places that has left with me a stronger impression than most I have visited. The house, always inhabited in the early days of Napoleon by his father and Madame Letitia Buonaparte, is now neglected.

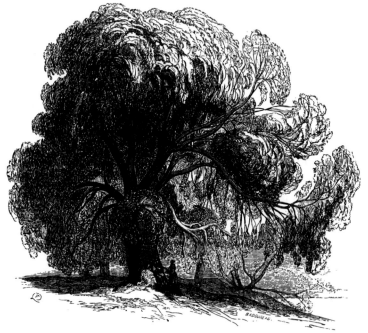

THE ILEX TREE OF MELLILI.

Bequeathed by Cardinal Fesch to the municipality of Ajaccio, it is let to peasants, who keep sheep and pigs in the once probably well-cared-for grounds. The building, apparently an ordinary farmhouse or villa, tall, small-windowed, and with a forlorn look, presents nothing remarkable to the observer; many large gray rounded granite rocks are scattered near it; great growth of cactus, and long-armed thin-foliaged olive-trees with moss-grown stems. You pass beyond the house through a wilderness of vegetation, and find a level space covered with a tangle of cystus mixed with long grass and lupines, among which a few sheep are feeding; and at the edge of this sort of platform stands the great ilex tree—truly, as Valery says,

"un arbre historique," for its shade was the favourite retreat of Napoleon the First.

This celebrated ilex tree—a large portion of which has been broken off by time or storms—is of great size, and stretches its venerable branches droopingly above the verdure and the stone seat it overshadows. Its tufted and thick foliage, almost yellow in colour, contrasts strongly with the green below and with the gray olives on every side; beyond its dark black-brown stem and deep gray branches the blue gulf·and hills gleam; and there is no sound to break the sad quiet of this once gay spot but the voice of the wild pigeon and the sweet harmony of many nightingales. Yet the undying spirit of the past seems to pierce the dim veil of years and neglect, to colour with life all this impressive and solitary place, and to people Mellili with visions of beauty and history connected with the family who, as children, played here unnoticed, but who grew up to be the most prominent objects in the sight of a wondering world. Madame Letitia, her five sons, four of them to sit in after years on thrones; and her three daughters, two of them to be queens. The boy Napoleon reading below the great oak, or pacing about what was then the garden, looking to those majestic mountains beyond the sea; in after days (1790) meditating on the fierce Buttafuoco letter (it is dated from Mellili), or on the whirlwind of change so soon to astonish Europe; ten years later, visiting once more, and for the last time, his favourite haunts, when the fortunes of Corsica were beginning to seem insignificant among those of so many states, and mainly of France.

Like the talking oak of the poet, could the aged tree but answer our questions, and be "—— garrulously given,
 A babbler in the land,"

what might he not tell us of the days when Elise, Caroline, and Pauline Buonaparte sported in its shade, undreaming of the crowns of Tuscany and Naples and the princely Borghese halls; when Joseph, Lucien, Louis, and Jerome played, and Napoleon paced and meditated below its branches. Melancholy Mellili, well does the repose of the neglected garden and the beautiful scenery around suit such memories! (¹)

After making some studies of the great tree, I left the place and climbed up the short steep path to Castelluccio; from thence you look over the great slope of olive grounds down almost to the gulf, and mark where a good way

(¹) Mellili, a garden of olives on a height, formerly belonging to the Jesuits and to the family Buonaparte, was the favourite spot of Napoleon's youth. Here he wrote his letter to Count Matthew Buttafuoco. By an unquestioned tradition, Buonaparte often meditated in the shade of an ancient ilex tree planted near the house; there he gave himself up at twenty years of age to dreams full of hope and confidence in the future—dreams that nevertheless could not equal the reality of his history. The Mellili gardens were visited for the last time by Buonaparte on his return from Egypt, ten years after the date of his popular letter to Count Buttafuoco. He passed one day there.—*Valery*, i., p. 175.

[The letter to Count Buttafuoco is given in full at page 370 of Gregorovius. It is dated "From my cabinet of Mellili, January 23, Year Two."—E. L.]

beyond the old house, and conspicuous by its greenness in the midst of the sea of gray foliage stands the vast evergreen oak of Mellili—a mournful place, and one which cannot fail to engrave on some minds its outline and beauty in fixed characters.

At 3 P.M., having driven down to the lower penitencier, I walked to the rocks of St. Antoine, and, until 5, made a drawing of that wild, strange scene; the multitude of granite masses, piled up and thrown hither and thither, make a fine contrast with the·delicate South-down-like turf below, dotted with patches of cystus and lentisk; but the scene is by no means an easy one to represent. (*See* Plate 3.)

At 6.30 back to Ajaccio. Poor Miss C. has returned from Vico, having seen nothing of the forests she has taken so much trouble to visit; for, as was foreseen, the roads through them are quite impassable, owing to the late rains.

All things are arranged for a start to-morrow on my third and last journey in Corsica.

May 18.—There are heavy clouds on the mountains; but, as in Cretan travels in May, 1864, what avails it to wait for clear weather? Just twenty days remain to June 6, when the fortnightly steamer leaves Ajaccio for Nice, and as that must be the date of my exit from Corsica, this journey to the centre and north of the island must be put in practice at once—even at the risk of bad weather preventing the pass of Vivario being visible—or not at all. Off, therefore, once more at 6.30 A.M., with the same carriage and first-rate ponies, but minus Flora and Domenico, one Vicenzo being the new driver until Corte is reached.

Freshness of gardens and mulberry plantations near Ajaccio, with melody of nightingales, are the accompaniments of morning on each side of the road (which, as far as the turning to Vico, I have already gone over,) and the exten-sive views as one advances nearer to the mountains must be very fine in clear weather; now, however, ever-thickening clouds hide the pass to Vivario and Corte, so well seen from above Ajaccio (*see* Plate 1), and by degrees efface all the distant landscape. Observation, therefore, is strictly limited to the foreground, to sheets of white cystus, and here and there to a few peasants, whose dark dresses subtract nothing from the gray gloom of the scene.

At the twelfth kilomètre—to me an ominous number in Corsican carriage life—an incident occurs to break the monotony of the drive; the seat by the driver being occupied by sacks of barley, G. is obliged to sit in the carriage, and, consequently, the proceedings of the new Jehu cannot be watched with satisfactory caution, nor did we know that he had gone fast asleep, and that the reins had fallen from his hand, until the ponies suddenly turned off at right angles to the road into a path which led straight to a sort of quarry,

over the edge of which, in ten paces more, we should have executed a second
Bastelica somersault, had not Jehu awoke in time.

8 A.M.—The river Gravona, coming from the high ridge between the Monti
Renoso and d'Oro, runs between the sides of a great basin or gorge, after-
wards widening out into a spacious valley to the little plain to the east of
Ajaccio, where it falls into the sea.

Up this valley lies the road to Corte. The way to Vico by Sariola and
Sari is on the left, that to Corte keeps always in the valley of the Gravone
through a green and beautiful country, much cultivated with corn, and with
groups of olives growing among detached masses of granite. Beyond a single
wayside house—where there are two mounted gendarmes, and two on foot,
with a captured deserter from Castelluccio—the road enters the hills, and the
valley narrows considerably, near what is, if I remember rightly, the Ponte
d'Ucciani, the village of that name, as well as Tavaro and others, peering
through clouds high up on the wooded hills far above. Vincenzo points out
Ucciani thus: " In that village lives the father of the other coachman,
Domenico," and thereby plainly shows that he is not a Corsican, for a native
would first have related that it was at Ucciani that the first Napoleon was
sheltered when he so narrowly escaped being destroyed at Bocognano. The
Gravona, here a foaming and clear broad river, runs between fringes of foliage ;
the wild hills around are covered with cystus growth and " maquis ; " and
granite heights, now deeply purple with cloud shade, all combine to show that
this would be fine scenery for walking excursions in propitious weather. At a
turn of the road hereabouts two of the great timber carts are suddenly encoun-
tered—no pleasant neighbours when you are driving near a precipice-edge to
which there is no parapet, for where the descent is steep it is not easy to stop
the mules.

Gardens, corn-fields, and chestnuts, now vary the wilder scenery, and at 9.15
the hamlet of Castellano (?) with a roadside diligence house is reached ; here
is to be the mid-day halt, a pleasant quiet spot near the river, below chestnut
trees which grow among grass and fern, and close to a stream abounding in
watercresses, serving well for breakfast. High up on the north side of the
valley, a black and desolate tract—the forest of Vero, burned not long since—
stretches away like a dark curtain ; and it matters little that showers of rain
prevent drawing, for the grim sad skeleton trees of the burned forest would
make but a mournful landscape. At 10.45 it is time to move on.

All the scenery of the valley of the Gravona seems of a fine and pic-
turesque character, but increasing mists hid much of it towards noon.
The good and broad Route Impériale, constantly ascends, and in parts
steeply, at a considerable height above the river ; fields of green fern and
gleaming spaces of blooming asphodel, their pale bright flowers shining
starrily off dark foliage ; large masses of chestnut wood ; these are what I see ;

but the opposite side of the picture, the Monte d'Oro, which must give so
much character to the pass, is lost in thick cloud, and always unseen. After
1 P.M. I send on the trap to Bocognano, a rash act soon repented of, as hard
rain begins in earnest, and tree shelter is often necessary ; from time to time
there are glimpses of the Gravona through the world of chestnut trees along
which I pass, and at 3, when the steepest part of the ascent is overcome, the
road, now level, reaches the great hollow or semicircle below Mont Renoso, on
the side of which the villages of Bocognano are situated among the folds of
thick wood, almost entirely chestnut, which clothe all this region. Bocognano
is not, as I had imagined, a single town or village, but a collection of several
hamlets scattered among the woods, some of them being only discoverable
by the curling smoke from their houses. One tall campanile alone is seen :
in Corsica churches are not very numerous.

The chief hamlet of Bocognano([1]), the first reached from Ajaccio, from
which it is distant forty kilomètres, is not in itself picturesque. The main
road forms the high street, the houses of which it consists being nearly all of
an ordinary kind, white-washed, with dark wooden window shutters and roofs,
very rustic, and with much of that sombre dull look common to most Corsican
buildings. Detached buildings are built above and below the village, as well as
beyond it on the road to Corte, all more or less hidden by the luxuriant ches-
nut trees which grow on every side. Half-way through the hamlet, on the
left hand, is a humble Locanda, called Café des Amis, and here, again, the
interior, as is so frequently noticeable in this island, is far better than the out-
side promises, the "hotel" consisting of two very decent and clean bed-rooms,
and a rather bare sitting-room, the latter adorned with representations of the
life of Napoleon I., the former with a few prints of a religious character. Of
the two dormitories I choose the least and worst furnished, because it looks out
over the magnificent valley of chestnut woods towards Monte d'Oro, so that if
to-morrow's sunrise should prove fine, I have my work immediately before
me. Meanwhile, pouring rain continuing to fall, a change of clothes, rest,
and writing up journal till 5 P.M., are the order of the day for the present.

5.30 P.M.—M. Berlandi calls—the Maréchal de Logis de Gendarmerie—to

([1]) At Bocognano I came upon the same road I had formerly travelled from Corte.—*Boswell*, p. 358.
Bocognano is at the foot of Monte d'Oro, and consists of ten hamlets, or knots of houses, embosomed
in a forest of chesnut-trees of surprising size and of the most picturesque forms. These hamlets are
scattered very capriciously ; the houses are built of unwrought stone, and do not exceed two storeys.—
Bennet, p. 15.
Bocognano has some factories of coarse Corsican cloth, called pelone. The appearance of these
rustic houses causes a satisfaction not inspired by more majestic buildings, when one reflects on the
custom which exists here and in some other villages of the island. If an inhabitant builds a house,
the neighbours on each Sunday, on coming from mass, carry him one load of stones, a voluntary and
mutual tax.—*Valery*, i., p. 149.
Bocognano, near the entrance of the wild defile of Vizzavona. It is surrounded by dark mountains
covered with wood, and having snow-clad summits ; and the whole district bears a solemn grandiose
character.—*Gregorovius*, p. 343.

PLATE XXV.

MONTE D'ORO.

whom M. le Commandant Lambert has given me a note which I had forwarded
on arriving ; a polite and pleasant fellow, who offers me any assistance I may
require. I beg that to-morrow he will show me the house from which the
first Napoleon escaped, but require nothing else now that I have found a
lodging—about my doing which M. Lambert was in doubt, since sometimes in
these places the only inn happens to be full, and then your letter to any one
in authority is of great use. M. Berlandi tells me that he was away when I
arrived, searching, with nearly all the people of the Bocognano villages, for a
poor half-witted youth, who has now been missing for four days. He says
that every year deaths occur in these mountains from children or old persons
losing their way in the thick "maquis," or from being caught, high up in the
hills, by snow storms. Last autumn two little girls strayed from their home,
only to be found (or rather their skeletons) when the snow melted, a month or
two ago.

Dinner follows, and by no means a bad one for a little roadside inn ; very
decent soup, eggs and ham, good stewed mutton, a dish of excellent trout,
broccio, and good wine. Might not a man live here very tolerably for ever
so long a summer ?

This evening a fire is welcome, for Bocognano stands at a great height
above the sea, and the weather is damp and chilly. At 6 P.M. the mist clears
somewhat, and as it sails away, shows, as if by a curtain being partly drawn
up, vast depths and breadths of grand gloom.

Later, the sky clears suddenly and completely, and most astonishing is the
spectacle of the immense Monte d'Oro, all at once, as if by magic, unveiled
from base to summit in all its magnificence of rock and snow ; and where a
minute before nothing was to be seen but a pale white mist, now rises a vast
mountain, purple in the last shades of evening. I drew till 7.30, when darkness
stopped me. I think no mountain scene has ever so much impressed me, except
the view of the Jungfrau from the Wengern Alp, which this of Monte d'Oro,
from its proximity and position, somewhat resembles. Here, however, there
are few pastures, but everywhere grand forests of chesnut. (*See* Plate 25.)

May 19.—Up by earliest daylight to draw the sublime scene from my
window, Monte d'Oro and the villages of this singular place, so beautifully
nestled among the wide chesnut woods. The weather seems to have become
perfectly fine, which in these high mountains is more than I had looked for.

5.30 A.M. I go out to obtain, if possible, a general view of the village. Fresh
and pleasant as is the air, and charming the glistening chesnut foliage, it is
yet a trifle too damp by the roadside below the trees, where, in order to draw,
I am obliged to take up my position. This Bocognano scenery is quite a
change from what I have seen in Corsica hitherto. The great extent of ches-
nut woods, mistily or distinctly seen through the blue filmy smoke rising from

the distant hamlets, lit up by the sun, or overshadowed by cloud ; then the village, not very interesting in its forms, but having a tolerable variety of tints, brown, ochre, and gray, or its older houses, which have rich brown-madder roofs and white chimneys ; and lastly, above village and woods, the vast heights of Monte Renoso—streaked with snow, and appearing or vanishing as driving clouds pass over them—form hundreds of beautiful pictures. Bocognano, to those who wish to represent such scenes of mountain grandeur, with few accessories of distance, or, to such as desire to become thoroughly acquainted with the characteristics of chesnut foliage, would be a first-rate place for summer study.

As I sit close to the village, I have at least the advantage of seeing all who come out of it on this side ; but, alas, for the joyous singing of Italy ! and for the gay dresses and beautiful laughing faces of Italian mountain girls as they leave the town for their work in the country ! here all things are triste and mute ; mopy men in black, their hands in their pockets, lead out a single black goat to some pasture, the rope fastened to their arm ; women in black dresses, and black kerchiefed, and with grave though not unpleasing faces, and grave manners, also lead forth one goat apiece. Slowly and lazily walk the men, slowly the women—mournful Corsican mountain homes and inhabitants. But on the other hand I am allowed to draw quite unmolested ; two or three boys on their way to school stop to look at my work, and make intelligent remarks on it, but avoid giving me the least annoyance, some of them rebuking others if they stand ever so little in my way ; and when, on more of them gathering round me, I suggest that it would be better they should go to school, one of the children says, quietly, " E vero, sarebbe meglio, andiam —It is true, it *would* be better, let us go"—and away they all walk. I never was in any country where so little trouble was given me by bystanders.

A walk through and beyond the village next occupied me ; on the whole an air of neatness and tranquillity pervades it. Children are numerous but not idle, for one and all carry books, and are on their way to school. There are many pigs, too, for it is a land of chesnuts, and the hams and sausages of the chesnut-fed are famous. As I returned, M. Berlandi joined me, and took me to see the house from which Napoleon I. so narrowly escaped with life in 1780, when pursued by his enemies of the Pozzo di Borgo faction. The building is now the caserne of the gendarmerie, and near one of the windows there formerly grew a tree, by the aid of whose branches the young Napoleon was enabled to leave the house at night and to fly to Ucciani, a village not far off, where the family Poggiani protected him. My informants state that at the death of the first emperor several persons of Ucciani received legacies of 5,000 and 6,000 francs, and that their descendants are still much favoured by Napoleon III.

[1] In Ucciani, the family of Poggiani, named in the will of Napoleon I.-- *Galletti.*

PLATE XXVI.

7.15.—It is time to begin the day's journey, which is to be as far as Vivario at least. Of Paolo Mufraggi, landlord of the little Café des Amis, at Bocognano, it may be noted that his charges for yesterday's board and lodging and a substantial breakfast for to-day are extremely moderate, and that he himself is most civil and obliging.

As you pass out of the woody amphitheatre which half circles Bocognano there are beautiful views looking back to the church and villages.([1])　After passing the last hamlet the ascent is steep, the road winding up always in face

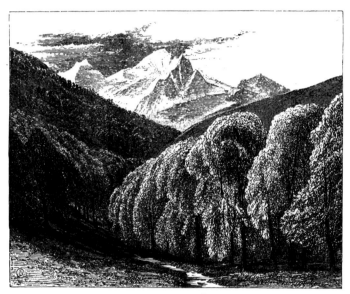

PASS OF MONTE D'ORO.

of the huge Monte d'Oro, divided from it by a deep hollow, narrower and clothed less with chesnut and more with "maquis" as you mount higher. The scenery of this wild pass is of a vast impressive character, but not very drawable, at least without longer time for study ; on the left, the heights of Monte d'Oro are bleak and savage ; on the right through a lateral gorge are seen grand glimpses of the snowy Renoso ; looking westward down the pass there are beautiful views of the valley of the Gravona, intricate folds of hill, and windings of river.　And now, at 9 A.M., great beech-woods are reached— green, shady, delightful, silver-stemmed, their feathering foliage contrasting

([1]) Ascending the hill, the view back towards Bocognano was enchanting ; lofty snow-topped mountains, extensive groves, rocks, and torrents, all of the wildest kind, were the chief objects. The smoke of the village rising among the chesnuts was almost the only thing that associated man with the scene.—*Benson*, p. 18.

beautifully with the pearly lilac hills of Ajaccio. And down the pass from the Bocca comes a long train of six of the huge timber-carts, each drawn by ten or twelve mules, descending at a pace that would not be without risk to a carriage happening to meet them abruptly at one of the many sharp turns of the pass before there was time to halt the animals.

At 9.15 reach the top of the pass or Bocca (at the forty-ninth kilomètre from Ajaccio), a ridge, from which on one side the water flows westward to the gulf of Ajaccio, and on the other into the Tavignano to Aleria on the east coast. (¹) At this height the air is sufficiently cold to make a cloak welcome. I linger to make a drawing below a ruined house or tower, and then, sending on Vincenzo and the trap to Vivario, twelve or thirteen kilomètres ahead, commence the descent through the great forest of Vizzavona.

The scenery of the whole of this walk does not, it seems to me, rival that of the three forests I have previously seen ; the upper part of it is all beech of great beauty, but the distance is much hidden by the trees, and this is the case also on reaching the pines, of which, at least near the road, I see no specimens equalling those of Bavella, Aïtone, or Valdoniello. And, after having stopped at noon to breakfast by a streamlet, at a grassy space purpled with violets, the lower part of this great Vizzavona forest is extremely disappointing in its appearance, for it was ravaged a few years ago by a very destructive conflagration. The black charred trunks of the tall pines make but a melancholy foreground to the distance, which now opens out more widely towards the range of Monte Rotondo and remoter blue hills beyond a deep valley, above which the eastern side of Monte d'Oro is clothed with fine forest ; and in all the descent I find neither scope for the pencil nor great subject for admiration. The forest of Vizzavona, lying on the direct road from Bastia to Ajaccio, is more known and talked of than any other in the island, so that my expectations had been, perhaps, unreasonable as to its magnificence ; moreover, it has been the scene of many of the stories of bandits, of whom but four years ago some of the last were hunted from these wild and dark heights, where, if report speaks truly, some, harmless to the traveller, are still living, the precise locality of their abode known but to a faithful few.

At 1 P.M. I come to the end of the burned forest, and gladly, for it only presents the deplorable spectacle of a harsh dead world of naked pine trunks and bristling brown branches. An old cantonnier—the only living being I have seen since leaving Bocognano, except the muleteers who accompanied the timber-carts—says the fire here took place in 1866, and burned for three days, and that all the Vizzavona forest would have been destroyed had

(¹) There is a small guard-house, in a wild and lonely situation in the mountain of Vivario. The great valley of the Tavignano closes in here, and an elevated ridge forms the water-shed between it and the Gravona, which flows in the opposite direction, south-west to Ajaccio.—*Gregorovius*, p. 342.

not the population of the surrounding villages worked hard to prevent its spread by cutting down trees beyond its limits.

Two carriages now appear—strange sight in these lonely woods ! One contains the Bishop of Ajaccio returning from the fête at Corte ; the second is that I came in to Bocognano ; at Vivario (says Vincenzo) Flora and Cᵒ· are waiting for me. At 3 the house roofs of that village are seen, deep and far below the steep zig-zags which I am descending ; little, however, am I tempted to stop for drawing, so vast and so full of multitudinous detail are the great mountain buttresses of Monte d'Oro and Monte Rotondo, filling up all the picture, and defying any attempt to give an idea of their bulky magnificence. Small were the hills, Latin or Sabine, edging the Roman campagna —small the delicate distances of Argos or Bassæ ; but all were refined and beautiful. To me these Corsican Alps, like their Swiss brethren, seem generally more awful than lovely.

Vivario, situated at the foot of these great mountains, is a compact little village, and a picturesque scene might be made of it with ample time for studying the gigantic details around it ; to-day, however, the heights are quite cloud-capped on all sides, and as in any case I must return thus far on my way back to Ajaccio, it is a question whether getting on to Serraggio for to-night is not my best policy for the present. The latter village is seen clearly from here, as well as much of the road to Corte, running along the flanks of Monte Rotondo, and ascending to the woods of Santa Maria di Venaco.

Flora, espying me from a long way off, comes to greet me at the entrance of Vivario.(¹) This village, which is distant sixty-two kilomètres from Ajaccio, is not so prepossessing in its interior as externally. In the piazza is a fountain with a statue, but the rustic houses are not in very exact keeping with this embellishment. Domenico shows me the hotel of Vivario, standing in a queer little alley, but some people, of whom there are plenty lounging about, inform me that it is quite full ; and this, combined with increasing cloud and the prospect of passing the afternoon here to no purpose, finally decides me on going on now, and taking the chance of better fortune on my return.

3.30 P.M.—Off to Serraggio, and perhaps even on as far as Corte ; it is impossible in this kind of journey to be sure as to one's halting place beforehand. The road runs immediately below the great Monte Rotondo, and at certain points passes some magnificent scenes, especially one at the bridge over the river Vecchio(²)—it runs from the forest of Vizzavona to the

(¹) Vivario, poor, rustic, and peaceful, has 800 inhabitants. On the threshold of the church, an old mortuary stone, with an escutcheon but no name, has these words in large characters — " Maledictus qui percussit clàm proximum suum, et dicat omnis populus, Amen." A mysterious anathema, which has been so effective, that for more than a century and a half no murder has been committed in the town.— *Valéry*, i., p. 167.

(²) Soon after we left Vivario we came to a torrent, over which is a wooden bridge called Ponte

Tavignano—which I must return to draw. So far from Vivario the way is level or down hill, but beyond the bridge the ascent commences that continues to S. Pietro di Venaco. The scenery is more cheerful than that of the great passes in the centre of the island ; the hills on the right hand which shut in the valley of Ghisoni gradually opening out into views of the more distant and smiling valleys towards the Tavignano and the sea.

Unusual liveliness, too, for Corsica, is added to the road by a good many cars being met with, containing people returning from the Corte fête, though hardly any colour brightens their dark and gloomy costume.

By 4.20 we have rattled up the hill at a great rate, and Serraggio is reached —a considerable village, standing among chesnut groves under the great heights of Monte Rotondo, and with beautiful views looking back to Vivario, and eastward towards the sea. There is, says Domenico, a hotel here ; but as Corte is now so near I resolve to go on at once to Paoli's former capital, and leave whatever is to be done hereabouts till my return. Only I halt to inquire for the Moufflon, of which Miss C. tells me they have a very fine living specimen, taken in the course of last winter, now in the village. That animal, however, I find, has been taken to be exhibited at Corte.

A little beyond Serraggio is a smaller village, Lugo, at which the abundance of children seemed the most observable characteristic ; thence the road winds steeply up to Sta. Maria di Venaco, a village on the highest point of the road between Vivario and Corte.(¹) All the scenery about here is doubtless beautiful ; the chesnut woods are noble, and at times a sunny gleam lights up the farther hills towards the coast, but heavy rain begins to fall, and forthwith clouds blot out the landscape, which, nevertheless, it has been easy to perceive is among the most interesting in the island.

The rain ceases during the descent to the valley of the Tavignano, so that the approach to the old Corsican stronghold is well seen.(²) There, backed by the lofty mountains which divide this district and its fortress city from all the western side of the island, stands Corte—Corte so rich in associations of the

del Vecchio. It was in this neighbourhood that Paoli bade adieu to his followers when the French first conquered the island in 1769.—*Benson*, p. 26.

(¹) In the midst of the ruins of the chapel of St. Pierre, at Serraggio, near Vivario, is an apple-tree, the fruit of which has angles pointing to those of the church, architectural delicacies which the village children pluck before they are ripe, from devotion, say the villagers, though possibly from greediness.

Venaco, once illustrious as the dwelling of Bel Messer, is now in credit for producing the best cheese in the island. Bel Messer, one of the signori of the tenth century, was, like Henry IV., beloved by the people, and, like him, died assassinated. Great was the grief of all Corsica at the tidings of his death ; and it became a tradition that a voice was heard in the air, crying, "Bel Messer is dead ; unhappy Corsica, hope no more for any good ! "—*Valery*, i., p. 146.

Nothing can be brighter and more cheerful than the landscape of the canton of Serraggio, which was the former pième of Venaco. On the green hills of Venaco nine ghosts are often seen wandering by night ; these are the ghosts of Bel Messere, his wife, and the seven poor children who were drowned in the little lake of the seven bowls.—*Gregorovius*, p. 341.

(²) In the centre of the island stands Corte, which is properly its capital, and will undoubtedly be one day a city of eminence, &c. It is situated part at the foot, and part at the declivity of a rock,

history of Corsica, its capital under the rule of General Paoli, and the focus of all the national liberty for centuries. Even from the distance at which I now stand from it, it is evidently an imposingly situated and highly picturesque place, and stands—a pyramid of buildings crowned by a citadel—but a short way from the base of the high mountain wall, whence, from the heights Mounts Artica and Rotondo ([1]) issue forth the rivers Restonica and Tavignano by two gorges, uniting just below the city, to flow through what is thenceforth called the valley of the Tavignano, but which is, in the vicinity of Corte, almost a little plain, with a boundary of low hills stretching towards the eastern sea.

in a plain surrounded by prodigious high mountains, and at the conflux of two rivers, &c. It hath a great deal of rich country about it, and a wonderful natural strength, being hemmed in by almost impassable mountains, and narrow defiles, which may be defended with a handful of men against very large armies. Upon a point of the rock, prominent above the rest, and on every side perpendicular, stands the castle or citadel. It is at the back of the town, and is almost impregnable, there being only one winding passage to climb up to it, and that not capable of admitting more than two persons abreast, &c.—*Boswell*, p. 30.

Corte, which at present counts 33,000 inhabitants, was the favourite city of Paoli, and the capital of his rising state. It might well, indeed, by its position, become the key of the island in time of war, by intercepting communications, and by being able to despatch troops to any point in forty-eight hours. The citadel—an old castle built in the early part of the fifteenth century by the brilliant and unfortunate Viceroy of Corsica, Vincitello d'Istria—is close to the barracks. On the west side of it is an abyss where, at the foot of perpendicular rocks, rushes the Tavignano, and it is by this terrible descent that Corsicans detained in the citadel have sometimes escaped from it—creeping to a rock close below the parapet, and then sliding down boldly to the bottom. The Gaffori family and their adherents, seventeen in number, escaped thus in the night by means of cords. After the palace of Paoli, I visited the house of Gaffori, which is riddled by the balls fired by the Genoese whom Gaffori besieged there in 1745. His child, given up by its nurse to the besieged, had been exposed by them in the breach in order to stop the firing, but Gaffori, unmoved by this, ordered the cannonade to continue, saying, "I was a citizen before I was a father"—a heroism well rewarded, for the citadel was taken, and the child was not hurt. The Gaffori, originally of Corte, still possess their family house, and religiously preserve the Genoese bullets, &c. This house of Gaffori was inhabited in 1868 by Madame Letitia, and her husband Charles Buonaparte.—*Valery*, i., p. 132.

Corte is truly the national city of Corsica; a stronghold of the Saracens in the ninth century, it was taken from the Genoese in 1419, to fall again into their hands in 1456. De Thermes took it in 1553; in 1564, during the war of Sampiero, they were expelled from it by the Corsicans, but retook it after a bloody and murderous siege; in 1734 the place was carried by the French, and the national (Corsican) army only retook it in 1745. In 1762 the deputies from the pièves assembled there; and in 1768 Paoli convoked there his last assembly. The French took it after the battle of Ponte Nuovo. At first sight it would seem that Corte, almost in the centre of Corsica, satisfies the double conditions of relations with the interior on one part, and on the other with France and the continent. The outer civilisation has very imperfectly penetrated Corte, and its manners have remained what they were when Paoli made it the capital of the island. It was then in truth the feudal capital of Corsica, with its girdle of gorges, ravines, and mountains, its fortress built on a pointed rock at the confluence of the Tavignano and Restonica. But its place as the first city of Corsica would require that the produce of all the principal valleys should be concentrated there with equal facility, which cannot be well looked for.— *Grandchamps*, pp. 45, 46.

([1]) From the Monte Rotondo assuredly one of the finest views in Europe is to be seen, including the whole of Corsica, with the exception of the charming Balagna, which is hidden by the Monte Cinto; the coast of France and Italy from Nice to Civita Vecchia, the Alps, the Apennines, and the islands of Sardinia, Elba, Capraija, and Monte Cristo. The ascent of the mountain requires two days; you must sleep at a shepherd's hut, where the mules can rest till the next day, and then at dawn you must climb to the summit without loss of time in order to arrive there before the morning clouds efface the horizon.

The mountain of Campotile contains two lakes, differently interesting, and not very inaccessible; the Creno, solemn, deep, moaning, mysterious, sung of in legends; the Ino, among rocks with brilliant

All round this interesting city the ground is cultivated mostly in vineyards or corn-fields, and it would be difficult to imagine a town more finely placed, at least for pictorial purposes, than Corte. Sending on Domenico to the Hôtel de l'Europe, I draw till nearly 6, from a part of the descent commanding good views of the town and spacious valley, and not far from the celebrated convent where Paoli lived, (¹) now in process of restoration, and then go onward, diverging for a little while to a sort of platform or promenade on the banks of the Tavignano, where a grove of chestnut trees bordering the stream forms a wonderfully good foreground to the city and mountains, and where I perceive plenty of work for to-morrow.

Corte is approached from the side of Ajaccio by two fine bridges, built above the two torrents, and is placed on a high rock, on the upper parts of which houses are perched and wedged in every possible vantage ground and corner, its lower space being occupied by rows of great houses, not wholly divested of the magnified domino or warehouse likeness, but far more picturesque in their combined groups than those of most Corsican towns. Altogether, Corte must be acknowledged to be a grand place as to the general aspect of its exterior.(²) (*See* Plate 27.)

cascades, is a beautiful scene, and well filled with trout. The Liamone and the Tavignano come from the Creno, the Golo from Lake Ino. The Scala di Santa Regina, leading to Corte, is not so bad as to merit the formidable name of Ladder, it is a long and stony descent easy enough to accomplish with attention to one's footsteps.—*Valery*, i., p. 124.

[There is a long and interesting chapter describing the ascent of Monte Rotondo in Gregorovius ; and the detailed narrative of his visit to the shepherds is full of poetical charm.—E. L.]

The herdsmen live dispersed in caverns or cabins, on the declivities of Monte Rotondo, up to the ridge of which their herds climb. The last herdsmen's hamlets are at a height of more than 5,000 feet above the sea-level ; their curious stations have each its peculiar name. "Fetch the *broccio*," said the herdsman, "that is the best thing we have, and you'll like it." I was curious about the *broccio*, for I had heard it praised even in Corte as the great dainty of the island, and as the flower of the herdsman's industry. Santa brought a round covered basket, which she set before me and untied ; in it lay the *broccio*, white as snow. It is a kind of sweet curdled goat's milk, which, taken with rum and sugar, is undoubtedly a dainty. The poor herdsmen sell a broccio-cake in the town for from one to two francs.—*Gregorovius*, p. 328.

[According to M. Arago, Monte Rotondo is 2,762 mètres—about 8,976 feet—above the level of the sea, and that there are seven others exceeding 2,000 mètres (6,500 feet) ; among them, Mount d'Oro, 2,653 mètres (8,622 feet). Forester says that at the end of October none but these two peaks were covered with snow, and he inclines to assign the height of 7,500 or 8,000 feet above the level of the Mediterranean as the line of perpetual snow in Corsica. In Chapter XVIII. is an interesting account of an excursion to the forest on the borders of the Niolo.—E. L.]

(¹) On the side of the hill to the south of the city there is a convent of Franciscans. Here the General lived while his palace was repairing ; and here all strangers of respect are lodged. From this convent one has the best view of the city of Corte.

The learned and ingenious Messieurs Hervey and Burnaby, when they were at this convent, were greatly struck by the romantic appearance of Corte. We could scarcely help fancying ourselves at Lacedemon, or some other ancient city, &c.

On one of the days that my ague disturbed me the least, I walked from the convent to Corte, purposely to write a letter to Mr. Samuel Johnson.—*Boswell*, p. 32.

The convent of S. Francis, close to Corte, now in ruins, was magnificent ; General Paoli had large rooms there. During the war of independence the church served as a place of assembly for the state, and the pulpit was the tribune.—*Valery*, i., p. 136.

(²) There are but really few good houses in the town ; the Duc de Padoue's is decidedly the best.

CORTE.

PLATE XXVII.

It was nearly dusk when I entered the city. Long ranges of many-windowed and very lofty houses form one side of the main road, which rises steeply to the centre and more level part of the town, and no lack is there here of bustle and life compared with the quiet of Ajaccio ; even the swarms of children seem still more abundant. Suddenly, at the opening of the high street, running at right angles to this first approach, transparencies and illuminations, bands of music, crowds of people, and universal movement, greet my astonished senses. I had thought the bitterness and noise of fêtes was over with Sunday, but, on the contrary, this, the last of the three days, is the most violent and fuss-ful of the whole time allotted to rejoicing on this occasion, that of unveiling a statue of Marshal the Duc de Padoue, one of the first Napoleon's generals, and a native of Corte.

Every place was thronged, and it was with difficulty I could get through the crowd to the Piazza, and thence to the Hôtel de l'Europe. Here all was bustle and confusion. There were no vacant rooms ; and as to where Domenico and my luggage might be found, no answer could be got ; the general festivity seemed to have turned the heads of the good people of Corte. Group after group of people to whom I applied shrugged their ignorance on the subject. Nor were the efforts of Giorgio to find our driver and roba more fortunate, and we were meditating—as at Montenegro in 1866—on the possible chance of passing the night in the street, when I remembered that M. Merimée had procured me an introduction to Signor Corteggiani, President of the Tribunals, and residing in Corte. In such a difficulty, application to one of the gendarmerie is usually the best proceeding, and had I asked M. Lambert for a letter, I could have been saved all trouble, though Corte is not in his district ; as it was, a gendarme took me to the Judge's house, though this was a step but little in advance, for M. Corteggiani was giving a dinner to the Duke, the General, and others, and the servants would not deliver my letter until next day. Meanwhile, as I remained on the staircase with the gendarme and others, that functionary, who had evidently entered fully into the festal hilarities of the day, made an absurd scene by shouting, " Proclaim your rank ! call aloud your title ! We gendarmes are the heart and beginning of all justice ! we will see everything done for you ! " till a domestic, thinking it would be wiser to end the matter at once, rushed up-stairs with the letter, and shortly brought down the Judge's secretary, with directions to show me a lodging, and to apologise for his not being able to receive me at the moment.

Accordingly, I was taken to a tiny house, with a very dirty entrance, but

The Baron Mariani's is handsome, and so is that of the Gaffori family, on the Piazza, near the Mairie. Gaffori's, marked with shot-holes, is intimately connected with Corsican history.—*Benson*, p. 30.

I had heard much of the rudeness and of the independence of the people of Corte, of its violent " Vendette," of its contempt for authority, of the party-spirit of its men, even of its children. The number of assassinations, murders, and attempts at these crimes in Corte during the twelve years from 1822 to 1834 had surpassed in number those of all the rest of the island.—*Valery*, i., p. 126.

containing one available decent bed-room, and a sort of public chamber, where they promised some supper. G. shortly joined me, with two wild-looking individuals bringing up the roba ; but these men, being in a festive and elated state, asked fabulous sums for each article, and on G. refusing to pay so much, a row ensued. The most outrageous of the "savage men" kicked a saddle-bag down-stairs, and was proceeding to further violence, when a compromise was come to by aid of the gendarme, and peace was finally restored. I had previously been told that the people of Corte had the reputation of being dirtier and more turbulent than any in the island, and, however unwilling to harbour unfavourable impressions, my first hour in this place tends to make me think the character is not undeserved.

Throughout all this hullabaloo, the people of the house—Andrei, a man and his two daughters—took no part in it, and after the savage porters had gone, were civil and kindly after their fashion, and provided a tolerable supper. G. puts up my camp-bed in the next room to the public one ; but has a less chance of a night's rest than even mine, on a chair in the salon. Already these small apartments are more than full, and others are flocking into the house. Sleep, at least during the fête of the Duc de Padoue's statue, is not to be looked for in the capital of Paoli's Corsica.([1])

([1]) It is but justice to say that on the morrow the landlord of the Hôtel de l'Europe, for whom the excitement and possibly the good cheer of the three days' fête necessitate some allowance, apologised very fully for his inattention, not to say rudeness ; and as I have heard his hotel well spoken of, I am willing to think that the nineteenth of May, 1868, was an exceptional day in his history.

- CHAPTER VIII.

May 20.—No sleep, for there was noise all night long ; this, together with having been more or less unwell yesterday, make it difficult for me to rise, but the bare prospect of passing an hour more than is absolutely necessary in this dwelling gives me energy to set off at 5.15 to the Restonica Bridge, near which I drew till 7.

Why does it seem a law established by destiny that the best points for making landscape drawings are so frequently in dangerous, uncomfortable, or filthy spots ? If your drawing is to be made in the country, why are you compelled to sit in a narrow and frequented mule-track, at the edge of a precipice, or below a crumbling rock, simply on account of the distance of a foot right or left preventing your seeing your subject owing to some intervening obstacle ? If in a town, why for a similar cause does the top of a wall, the centre of a thronged street, or the vicinity of an " immondezzaio," become your inevitable seat ? And oh, painter, if you go to Corte ever beware of " studying " below the houses thereof, lest the sudden opening of windows cause you eternal regret ! These bitter reflections are prompted by the drawing I am making from the river bank, where my only possible position in order to see what I want is on a narrow strip of ground between the torrent and a wall, and as every five minutes there comes a vexatious mule along with a wide load of wood, I am as often obliged, for fear of a concussion, to mount the wall suddenly, while G. gathers up my folio and materials. But the view is beautifully picturesque ; the rugged simplicity of Corte architecture agrees well with the proud and strong position of the citadel rock, standing out from a mountain background of the sternest sort.

Hardly able to bear up against warnings of fever, I next go to the chesnut grove beyond the junction of the two rivers, where a sort of esplanade has some benches at its borders. Few town pictures can be more

interesting than that of Corte from this spot ; the large trees grow on a slope quite down to the clear rushing water, and form a delightfully shady walk, particularly grateful now that the sun's heat is daily getting more powerful. I cannot as yet, however, from what I have seen of Corte, understand why some have thought of it as a place suited for the summer abode of invalids. Its position must be one of great heat during the summer months, as it is exposed to the sun from its first rising, and notwithstanding that the chesnut grove where I now am is pleasantly shady, yet a long and hot walk has to be accomplished to reach it ; and, excepting the public *allée* or avenue on the further side of the town, there is no other shelter. In winter, from its situation close to great mountains immediately above it, and the two windy ravines behind the town, Corte must be as subject to extreme cold as to heat in summer.([1]) (*See* Plate 28.)

At 9 I return to the high street, and finding that M. le Président Corteggiani has twice called on me, lose no time in returning his visit. At first, his nephew, a pleasant fellow, receives me, and then the Judge, a kindly gentleman, very profuse of apologies, no wise needed by me, regarding his inability to receive me last night—how he had gone to the landlord of the Europe Hotel, and had made "des sévères reproches," and how that person had acknowledged the justice of his reproof. I decline with thanks his offer of a room in his house, but accept, though very far from well, an invitation to dine with him at 6 this evening, and in the meantime M. Corteggiani promises to send some one at noon who is to show me the principal lions of Corte, such as Gaffori's house, &c. So I return to my "hotel," and devote the next three hours to quinine, and to the endeavour to get some rest—the last an unattainable blessing in this noisy little den, where some twenty people are breakfasting on one side of my room, and on the other a family of screaming children wake the echoes of all the walls.

At noon I go up the steep and narrow paved streets with a cicerone who is very Corsican and ultra-liberal in his views of things in general. He shows me the house of Gaffori, the front riddled with the balls of the Genoese (there are still members of the Gaffori family residing in it), and that of General Paoli ; but as I am too unwell to go into these, or to mount higher towards the citadel, I return to the inn by a lower route, pausing only below the rock to make a drawing of that part of the castle from which, in 1745, the famous escape of the Gaffori prisoners took place—all which lionising is effected with no slight difficulty. (*See* Vignette, p. 171.)

One more effort is to be made to complete the drawing I commenced

([1]) All the force of patriotism must surely have impelled the Abbé Galletti to write, "One sees at Corte shops full of every kind of merchandise ; luxuriously fitted up cafés, and hotels where nothing of the comfortable is wanting !"—*Galletti*, p. 209.

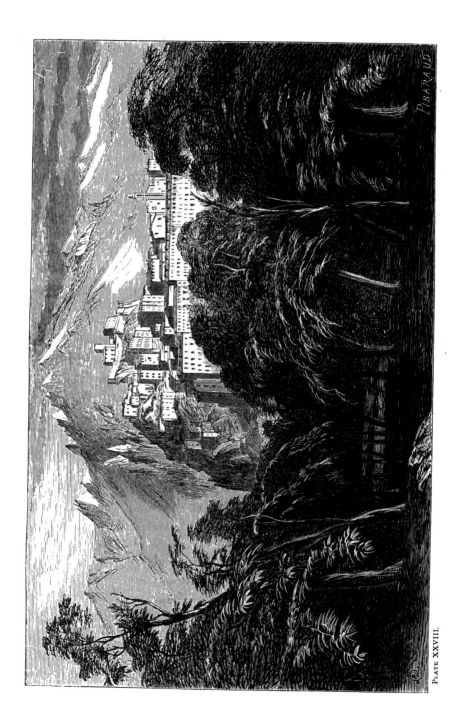

PIBARAUD

PLATE XXVIII.

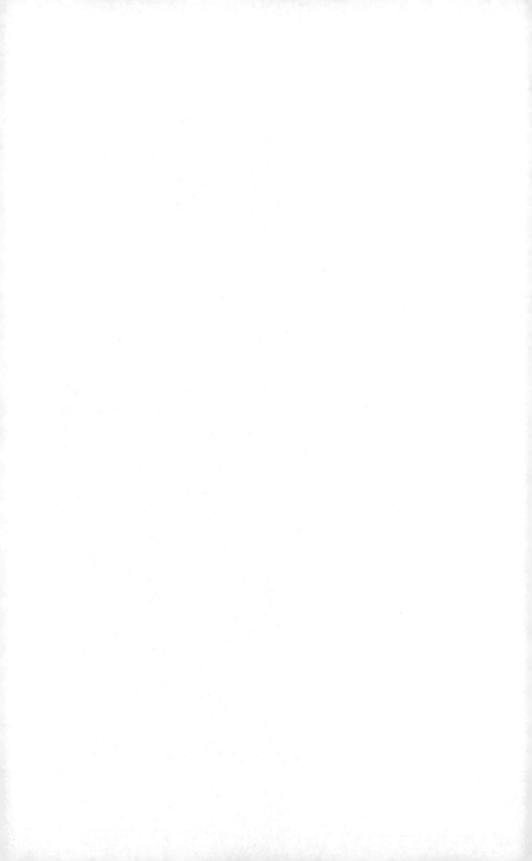

yesterday afternoon on the road leading down from Sta. Maria di Venaco; thither, therefore, I go, and return to the hotel by 4.30. In Corte the little girls are almost all pretty, and nearly without exception fair, with pale or yellow hair like English children ; they grow up darker, and get a coarser look, though on the whole there seems a good deal of female beauty

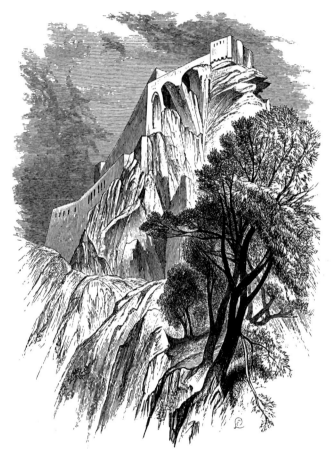

CITADEL OF CORTE.

in Corte, albeit, perhaps, of a stern rather than a genial expression. As for the boys, who are legion, they are sturdy but ugly little fellows.

At 6 P.M., much against my inclination, I go to M. Corteggiani's, making a strong effort to do so, rather than send an excuse, which my last night's misadventures might cause to be imputed to touchiness. I find M. le Président a plain, pleasant gentleman ; the only persons at the table

besides himself and me were two nephews, one of them, M. Antonio Gatta, a lively and intelligent young man, who, residing at Bastia, is well acquainted with that part of the island, and who gave me much information about distances in Cap Corse, the Balagna, &c. This last district, as well as the valley of Luri, I am counselled by no means to omit visiting. He also gives me a list of published memoirs of Paoli, and of other books on Corsica, &c., &c., which I shall probably find of use. The dinner was plentiful, good, and well served, and I thought it amiable of President Corteggiani, who had been dining or dined for four days past in all the fatigues of a noisy fête, to have invited me. The wine from his own estate, a good " ordinaire," seemed to me some of the best I have tasted in Corsica. At 8.30 I took leave, one of the nephews accompanying me to the hotel door, and now, notwithstanding the incessant noise in the next room, am glad to get to my camp-bed, which is ready for my early return.

May 21, 4 A.M.—Early rising, were it pleasant nowhere else, would be so in this hotel, where noise and other indescribable objections make egress very desirable. At a café good coffee is obtained at twenty-five centimes a head, and the sun was only rising when I was down at the esplanade drawing the picturesque town above, the cool river gleaming between the dark chesnut foliage, and standing out on its bold rock away from any overhanging mountains. Indeed, the front, so to speak, of Corte catches the whole glare of day from the moment of the sun's rising till late in the afternoon, and it is only for about an hour after sunrise (at this season) that the shadows of the buildings and rock relieve so beautifully off the fine background ; soon all is shadeless till afternoon, when the whole is in broad shade unbroken by lights. The upper part of the rock is of a dark gray-brown colour, cactus-covered at its points and crevices, and all the upper houses are similarly of dark brown or gray material, the windows bordered with white. One church only I have seen in the town, and that not at all remarkable in its appearance.

7.30.—I return through the town ; from the ascent to it the eastward view down the valley of the Tavignano has much that is graceful and pretty. Prettiness, however, is far from being the characteristic one should seek to express here, at the stern capital of Paoli, where the rugged and positive lines of scenery harmonise well with the history of the fierce struggles and bitter revenges of Corsican life. Not a part of this rock-pyramid but must have been fought over, and blood-covered ; no precipitous wall of either of the two ravines, no pinnacle of the granite heights above, but must have echoed the wild cries of victory and defeat from the Pisan and Genoese wars down to the last battle with the men of Genoa in Gaffori's time.

Before going to the inn I stroll into the Piazza, where stands a statue of Pasquale Paoli ; a tame hornless deer is walking about, and some persons

PEGARD SCULP

PLATE XXIX.

CORTE.

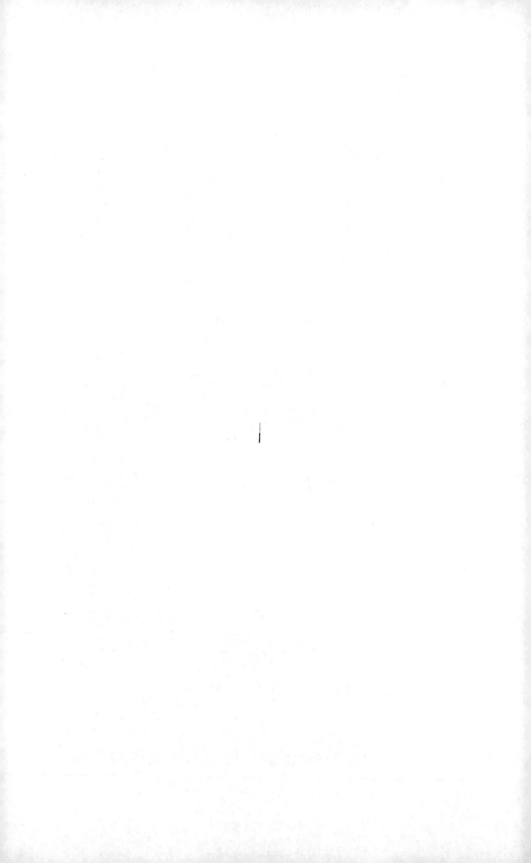

assure me that it is a small red-deer of a kind peculiar to Corsica. (¹) As for
Miss C.'s Moufflon, I again make earnest endeavours to see that remarkable
beast, who is evidently exclusive in his habits and difficult of acquaintance—
three days ago he again started on his travels to be exhibited at Bastia.

G., in wandering about yesterday, when I was too unwell to go out, dis-
covered what he says is a good view of Corte on the Bastia road, so I go
thither, and finding it to be so, draw there till 9. The whole city is beauti-
fully seen from this side, and has, from its northern approach, the most com-
manding and grand character of any town, I imagine, in Corsica ; its large
houses cluster in well-composed lines up to the barracks and citadel apex, and
the noble outline of the double mountain background makes a magnificent
finish to the picture. (*See* Plate 29.) From Bastia the entrance to Corte is
by an avenue of trees, but this "boulevard" is so frequented that it can
hardly be called a country walk. On one side of it, in a little Piazza, is
the brand-new statue of Arrighi, Duc de Padoue.

At 9.30 breakfast at Pietro Giovanni Andrei's inn ; its proprietors, a father
and two gentle and graceful daughters, are pleasant and obliging, and their
charges very moderate ; but as their tiny house is merely a locanda of the
commonest sort, and chiefly frequented by the gendarmerie and country
people, it should not be a matter of complaint that it does not come up to
the standard of comfort we northern travellers desire.(²)

At 10 all is ready (a taking of quinine pills not excepted) for the start to
my next halt at Casabianda—that place so eminently full of fever-danger as
the summer advances, yet to which I am determined to risk another visit for
the sake of getting better drawings there than I obtained on April 26. Adieu
Corte ! a crowd of whose inhabitants gaze on my departure from windows,
and a multitude of whose children collect round the trap, Flora and Cº·
Adieu, Corte ! you are picturesque, venerable, historic, liberty - loving ;

(¹) The Corsican cerf is like the red deer. Their colour is ferruginous. In size they are a little
larger than fallow deer, with a heavier body, and stronger horns, springing upright, spreading less than
any other variety, and slightly palmated.—*Forester*, p. 192.

The deer, *Cervus Corsicanus*, is, I believe, altogether peculiar to the island, and is supposed by some
to be a variety of the red deer, *Cervus elaphos ;* . the animal is much smaller and more compact
than the red deer ; but there are also differences in the colour of the fur and in the branching of the
horns.—*Hawker*, p. 306.

M. Grandchamps severely censures the want of cleanliness in certain of the towns and villages of
Corsica, from which dangerous illnesses arise. The filth of all sorts, &c.—p. 145.

(²) When one wanders now through the dead stillness of the little town, where miserable looking
Corsicans are standing about under shady elms, as if they were trying to dream away the day and the
world, one can scarcely conceive that hardly a hundred years ago, the most enlightened political
wisdom had taken up its abode in such an obscure corner of the earth.—*Gregorovius*, p. 323.

Calling at the café in the Corso, we find it as before, dirty, disorderly, and noisy.
Where, we ask ourselves, are the gentlemen of Corte ? But what has any one above the classes
who toil for a livelihood to do in Corte except to lounge the long day under the melancholy
elms in the Corso, and while away the evenings by petty gambling in its wretched cafés ?—
Forester, p. 163.

nevertheless, until your drainage is overhauled and remodelled, and until cleanliness is in a greater degree recognised as a virtue by your population, I should not wish to make any of your houses my home.

Domenico says there are seventy kilomètres to Casabianda, but I doubt if it can be so far. I propose to go from that place to Bastia in two days, if this can be easily done, as I think it may be, because the whole distance is on comparatively level road, and the ponies will have a whole day's rest at Bastia. Of the beautiful district Catinca I fear I shall see but little, if anything, for there are Cap Corse and the Balagna to visit before returning to Ajaccio; perhaps I may succeed in getting to see Cervione and Vescovato. Meanwhile, it is a relief to have left the small and dirty rooms, the bad smells, and the noise of Corte.

On the road, which for a short distance is that to Vivario, several parties are leaving the town in cars for their country abodes (after all, it must be remembered that I have seen Corte under a very exceptional state of things); among these there are hardly any one who does not carry a white umbrella, a sign that the heat, even now very considerable, is not thought lightly of by the natives.([1])

The road to the coast soon leaves that to Ajaccio, and following the course of the Tavignano as it winds among low hills, Corte is soon lost to sight; scattered cork and ilex groves are passed; and after a little while granite rocks, flowering cystus, and a line of snowy heights behind and to the right, are the features of the landscape. Presently the valley becomes deeper and narrower, and all horizon is shut out; we rattle rapidly down the good broad road, running not far above the river between low hills, covered with wild verdure, or here and there with patches of grain. One might be in Devonshire, and not in the prettiest part either.

11.30 A.M.—At the seventeenth kilomètre from Corte (we get over about twelve kilomètres the hour on the down-hill journey) the Tavignano is crossed by a three-arched bridge; near it is a little church which seems to be a structure of Pisan times, and not to sketch it occasions a moment of regret; but the day's work may be long, so we hurry on—as the poet says, "What time have I to be sad?"

Ever the road winds along the green valley, now at the edge of high cliffs, where the somewhat too rapid course of Domenico has now and then to be checked, now, at the twenty-second kilomètre, passing a wayside house or two, a few olive trees, and scanty shreds of cultivation, dovetailed into the green "maquis" and white cystus. Below flows the river, deep and fast,

([1]) The parasol is indispensable here. The man always has the zucca, or round gourd-bottle slung round him, and often a zaino or small goatskin too; and round his waist the carchera, a leathern girdle in which his cartouches are held.—*Gregorovius*, p. 111. [A portion of dress now happily no longer used.—E. L.]

often fringed with large trees, and always through a continuance of lonely but pretty scenery.

Towards the thirty-fifth kilomètre the descent becomes more gradual, and the valley, though still winding among undulations of low green hills, begins to open out on wider spaces ; the Tavignano flows on a broader and shallower stream between broken banks of red earth (for the region of granite is left behind) and waving fields of corn ; and after a halt at 1 P.M. to rest the thirsty ponies, behold once more the rich and beautiful plains of the east side of Corsica, with Casabianda on its hill. There, stretched out in long lines, beyond the last undulations of the hills as they sink towards the coast, is the wide campagna of ancient Aleria, with its many pictures and varied interest, the vast growth of "maquis" and brilliant bloom of cystus, the river and the smooth corn-fields, and the blue remote forms of the crags of Mont' Incudine — how much of all this recalls the descent to the Roman campagna from the Sabine hills, or to some bright plain of Sicily or Greece !

All along the way the flitting of gay hued bee-eaters, who make the telegraph wires their resting place, is a pretty sight enough. At 2.15 P.M. the road from Bonifacio to Bastia, and the long bridge over the Tavignano (at the forty-seventh kilomètre from Corte) below the fort of Aleria is reached ; a few warehouse-like build. ings stand near it. Here, till 3, I stop to make a drawing of the fort

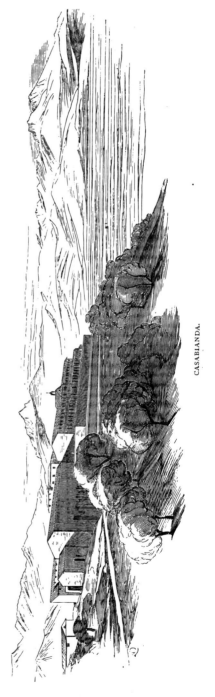

CASABIANDA.

and village, an'd the curve of the broad river, soon to be lost in the great Étang de Diane ; the work of art I have undertaken being much abridged and hastened by the discovery that my position, in strict accordance with certain rules of destiny not long since alluded to, is close to a nest of a species of hornet, magnificent fellows of purple and burnished gold, but unpleasant as near companions.([1]) At 3 I start again, passing below the fort of Aleria, which is very picturesque from this side, and thoroughly Roman-campagna like ; the road to Casabianda is but two or three kilomètres farther, and here, sending on Domenico to the establishment with M. le Préfet's letter to M. le Directeur du Penitencier Agricole de Casabianda, I make a sacrifice to duty by trudging over ploughed fields in the hot sun to complete my unfinished drawing of April 26, adding thereto the mountain chain, which is now perfectly clear.([2]) (*See* Vignette, p. 175.)

No reception could be more kindly than that I met with an hour later from M. Beurville, all the more so that Madame Beurville was only recovering from illness, nor is it easy to describe, particularly after having so recently left the roughnesses of Corte, how delightful were the pleasant and clean apartments allotted to me ; all at once, thanks to M. Merimée, it seems that I am in Paris, or, according to the Suliot's phrase, " φαίνεται παράδεισος—it appears to be paradise." The director, as well as another officer of the establishment, M. de Lahitolle, a Breton gentleman, to whom I have a letter from M. Lambert, enter at once into my plans, which they soon perceive relate rather to the far away outlines of the beautiful mountain ranges than to the internal arrangements or exterior cultivation of the establishment. Not that the most indifferent could fail to be struck with the order and good administration of this large penal settlement—which contains nearly 1,000 convicts—and with the great

([1]) This plain (of Aleria) would alone support the whole of Corsica if well cultivated, and might be easily irrigated by the Tavignano.—*Grandchamps*, p. 35.

The greatest part of the houses in the village of Aleria, as well as of the territory adjoining, belongs to the heirs of the Marchese Potenziani of Rieti, who married one of the daughters of Christophero Saliceti, the last possessor of the family.

Many interesting details in Galletti about Galeria, discoveries of inscriptions, tombs, rings, &c., Etruscan vases, coins of various dates.

The Abbé G. speaks of the ruins of Aleria, an old wall of enormous thickness, some portions still two mètres in height, but not of old Roman construction. A space enclosed by ruins of walls, and known as Sala Reale, or Royal Hall, portions of what is doubtless an amphitheatre, an oval, the circumference of which is 142 mètres, ruins of a circus capable of holding 2,000 spectators. Other scattered portions of ruin, but not of early date—vestiges of a mole or some building serving as a defence to the entry of the port. On the Island of St. Agatha, near the mouth of the port, are ruins of a thick wall, where are seen pieces of iron to hold the rings to which ropes were attached for ships. In these walls are vases, or a kind of jars. Vast and beautiful houses, says the enthusiastic Abbé Galletti, have now risen at Aleria (!)—*Galletti*, pp. 178, 180.

M. Grandchamps, who speaks with great hope and certainty as to the future of the eastern plains, does not speak so positively about the possibility of restoring the Étang lagoon of Diana to the place it occupied as port of the Roman colony.

([2]) [From the spurs of the chain between Aleria and Cervione some magnificent views must be obtainable.—E. L.]

change that in a short time has so visibly been wrought, a wide cultivation
having replaced what only a few years back was totally a wilderness. But the
view from the terrace below the Director's house, taking in the great central
mountains of Corsica, from the Incudine to Monte Rotondo, and northward
to nearly as far as the plains of ancient Mariana, is the object of greatest
interest to the wandering landscape painter, whose only desire is that he may
have coffee earlier than daylight, in order to be at work before the sun rises,
lest vapours obscure the clear mountain outline. Then, as well as now, it is
necessary, as my new acquaintance do not fail to warn me, to put on an extra
coat, as the air of Aleria is, even at this season, dangerous at early morning
and towards sunset, the chill from the great marshes on the coast contrasting
forcibly with the heat of the day.

At dinner-time, 6 o'clock, the table of my host and hostess was without
ceremony, but there was an exceedingly hearty welcome, and very good cheer;
their little girl, an intelligent and darling child, was one of the party, 'and
though not six years old, for good behaviour might have been twenty. On
my arrival, the great size of my spectacles had attracted the observant little
lady, who had whispered to her mother, "Comme il est charmant ce monsieur
avec ses beaux yeux de verre!—what a delightful gentleman with beautiful
glass eyes!"—an admiration which was at least more gracious than that of a
little girl at Chamouni some years back, who, after a long stare at me, ex-
claimed, "Ah, que vos grandes lunettes vous donnent tout à fait l'air d'un gros
hibou!—how exactly your great spectacles make you look like a big owl!"

Later, M. de Lahitolle, who has been for many years in Algeria, joined us,
and there was much discourse about Corsica, and especially about this part of
it, now in so transitional a state, owing to the treatment of it by the Emperor
Napoleon III.'s government. Only a certain portion of the plain of Aleria
belongs to the state; the family Franceschetti of Vescovato and others possess
much of the adjacent land, and that is all allowed to remain in its desert
condition, while drainage and other agricultural labour are doing their work
of civilisation at Casabianda. And it appears that by a great many Corsicans
these improvements are not looked upon with very loving eyes, though there
are, of course, many enlightened men among them who approve of, and per-
haps have suggested the measures of utility put in practice by the emperor's
government. As for the convicts, they naturally prefer labour in the open air,
with comparative freedom, to a life within prison walls in France. In June
nearly the whole establishment migrates to a Sanatorium, or mountain settle-
ment, near Ghisoni, in the pine forest of Marmáno, which I hope to visit on
my return to Ajaccio early next month.

The evening passes in making drawings for little Terése, not unenlivened
by snatches of merriment; for although I labour under the disadvantage of
speaking French very ill, I nevertheless always find French acquaintance

M

ready to help all deficiencies, and with the pleasant liveliness of their nature, to seize on any opportunity of amusement. My riddle of " Quand est ce," &c. (*see* page 143), delights my cheerful hosts; and, apropos to the appearance of potatoes at dinner, when the question is asked, " On en mange beaucoup en Angleterre, n'est ce pas, monsieur?" they are charmed by my telling them the Irishman's saying, " Only two things in this world are too serious to be jested on—to wit, potatoes and matrimony." The beauty of the Hon. Mrs. A. B. (their party was here not long since), was again, as at Porto, a theme of admiration.

At 9. M. and Madame Beurville, knowing my early hour of rising, allowed me to wish them good-night. In the sitting-room and bed-room up-stairs I seem to be transported to some English country-house, and neither the memories of ancient Aleria nor of modern Casabianda interfere with immediate sleep.

May 22.—Before 4 A.M. coffee had been brought me by one of the convict-servants of the Penitencier, and as it is not easy to move about in this necessarily much be-sentinelled and be-locked-up place, MM. Beurville and de Lahitolle were soon at hand to facilitate matters, and I was speedily down on the terrace, drawing the long chain of Corsican Alps, clear as amethyst and tipped with silver as the sun rose.

The Romans were right in making a city at Aleria, in a site so majestic in itself, so well placed for communication with the outer world, and situated in the widest and most fertile territory in the whole east coast of the island, looking, on one side, to the lofty range of snowy summits, on the other to the sea, and to the river Tavignano winding through the broad plain, this part of which is so happily awakening from its long sleep of desolation. I am well rewarded for my trouble in coming here a second time, in thus seeing one of the finest parts of Corsica in cloudless weather, and in being able to procure an accurate drawing of its distant landscape. And having completed this, there remains but one more duty here—to visit some parts of the establishment which M. Beurville wishes to show me, and which, to my eye, inexperienced in such matters, appear in all the perfection of working order; the spacious kitchen, the storehouse for food, the warehouses for clothing, &c. —nearly everything is made by the convicts on the spot, from the produce of the territory—and all seems arranged and overlooked with the greatest care. A detailed account of the condition and results of this establishment for 1,000 *condamnés* would be interesting.

7 A.M.—I take leave of my amiable hosts, and of M. Lahitolle, and set off with Flora and C°. along the road to Bastia, hoping to divide the journey thither by halting for the night at Vescovato.

Before passing the bridge over the Tavignano I stop to make a drawing of the fort of Aleria, with a distance of green plain and far mountain. If

anything were wanting to complete the exact
resemblance of this part of Corsica to the
well-beloved Campagna of Rome, it is sup-
plied just here by portions of the polygonally
paved ancient road, which formerly led from
Mariana to Aleria. So vividly Romanesque
is the scene, and so exactly reproduced are
such spots as Gabii, or similar places, that it
is hard to believe the "days that are no
more" are not returned, particularly when a
flock of goats passes leisurely and sneezingly,
after their manner, across the long-enduring
memorials of Roman dominion, wandering
about the dark gray fragments of pavement
as they might upon the old Via Appia—but
here the parallel halts. There is no goatherd
with pointed hat and peacock's feather and
Malvolio-like cross-gartered gaiters ; no little
girl with scarlet boddice, spindle and wool in
hand, and with her bright black eyes shaded
by the white squared tovaglia, as—if you never
saw the reality—you may see in the pictures of
Penry Williams. Here, the model for the "Cor-
sican Goatherd" might be safely selected from
Holborn or Whitechapel indiscriminately.

Onward at 8. There are sixty-seven kilo-
mètres to Bastia, on the direct road from
Aleria, and one hundred from Bonifacio, so
say the kilomètrical milestones. Although
this eastern side of Corsica is called and
seems "a plain," it is by no means flat, any
more than is the Roman Campagna, which
equally appears so from any height. A good
but straight road runs along it, mostly over
undulating ground, and rarely level. Sandy
or cretaceous banks border the highway ; and
in so clear and charming a morning as this
there is enough of interest to prevent the
drive being a weary one, which in dull weather
it would assuredly prove. In the depressions
or shallow dells the variety of flowers and the
richness of the "maquis" are constant sources

ALERIA.

of pleasure ; from the top of each rise in the road you may look back at the snowy heights to the south, gradually fading away, or forward to the green hills which approach the coast at Cervione ; to the right is the sea, with Monte Cristo and Elba on the horizon, and all around stretches the apparent plain over which you are passing. Rarely a human being is met ; once or twice only I remarked a hut or two, and now and then great herds of black goats filled up the road, migrating with the goatherds and their families to higher regions, above the reach of malaria. Everywhere there are characteristic and picturesque bits of Campagna-like landscape ; everywhere the cheerful bee eater abounds, sitting by pairs on the telegraph wires, and sometimes not stirring as the carriage drives by

9 A.M.—Since leaving Aleria—thirteen kilomètres—scarcely any cultiva tion has been passed ; but now, as the hill-range, at the end or corner of which Cervione stands, is approached, the scenery begins to change, and has a less deserted look ; there are a few roadside houses, with plots of grain more or less extended, and scattered patches of alder trees or of cork wood vary the "maquis" that clothes the flat ground to the sea-side. The snow-topped hills to the south recede, and are seen no more, while those ahead are of a rich velvety blue green, covered with foliage from foot to summit, one of the lower heights being crowned with a conspicuous lighthouse — the Faro d'Alistro. Beyond this, cultivation and signs of life become more frequent ; and at 10 we stop for a rest, for the day is particularly hot, and Domenico never fails when there is water to avail himself of it for the ponies. Here there is a fresh pool and a stream, shaded by alders and a single willow— "one willow over the river hung"—add also, in the interest of zoology, a very large snake, which, as I wander about the thick vegetation, glides over my feet towards the water. When first I came to Corsica I was told, "There are no snakes here;" but having pointed out four to Domenico, he now says, "There are only harmless snakes;" which may be true or not.

Off again at 10.30, and in five minutes leave the main Bastia road for a "route forestière" on the right, leading up to Cervione, where very willingly would I pass the night, could I by so doing leave time enough to see Bastia and Cap Corse, besides the Balagna, before my return to Ajaccio ; well I know that from Cervione through the Casinca district exists some of Corsica's best scenery and points of greatest interest ; and it is a matter of vexation that so much of this beautiful island must be glanced at thus slightly—so much left quite unseen.([1])

[1] [I regret extremely not having been able to see these districts of the chesnut country, called the Casinca, or Castagniccia, since they are described as among the most beautiful and interesting of the island by all who have visited them. Valery in 1834, Gregorovius in 1852 (some of his most delightful chapters—see page 216—relate to his walks among the Casinca villages), and, more recently, Forester and Dr. Bennet speak with enthusiasm of the scenery, and praise the inhabitants of some of the villages for their industry, though, in general, the population of this part of Corsica seem to have little taste for

A very pleasant lane is the pretty steep ascent from the coast road to Cervione, shaded by chesnut and ilex, bordered with·fern, and ever and anon with peeps into dells full of vineyard and walnut and cherry trees; as you mount higher the views are increasingly beautiful, overlooking all the wide plain of Aleria southward, and with Elba and the bright sea on the east. Extreme richness of foliage is the characteristic of the nearer part of the prospect down to the shore, and I am frequently reminded of the views from Massa Carrara and Pietra Santa, with the plain of Via Reggio below. Sending on Flora and C⁰·, I stop to draw for a time, and then proceed to Cervione, which stands at about seven kilomètres distant from the Bastia road on that leading to the west side of the island, or rather to the central point of Ponte della Leccia. [1]

Cervione is a good sized town (it was for a short time a Sous-préfecture), and has an imposing appearance from its high position, its lofty church tower, and massive many-windowed houses, like those of Sarténé, all of which added to some great rocks immediately above it, make a picturesque scene in combination with the rich foliage—what cherry, chesnut, and walnut trees!— on every side, and with the grand view of the plain and sea afar. Its street, too, possesses a certain air of activity and life, and on the Piazza fronting the south is the very tolerably clean little house by way of a "hotel," containing a billiard-room and café below stairs, and a large and not ill-kept apartment above, arrived at by one of the ladders that do duty for staircases in these parts.

labour. and live chiefly on chesnuts; throughout the district it is almost the universal diet, and in the canton of Alesani as many as twenty-two different kinds of dishes are said to be made from it (*Valery*, p. 308). The canton of Piedicroce of Orezza is spoken of as that where a great variety of small wares are made, and the Abbé Galletti says it is that in which the population work more than those of any other canton in Corsica, a character also given to it so far back as the days of Filippini. Much detail relating to this part of the island, including notices of some of their oldest churches, S. Michele of Morato among others, is to be found in Galletti, and there are good descriptions of the beauty of the landscape near Bevinco and Olmeta in Forester's book. The mineral waters of Orezza are celebrated (see *Bennet*, p. 264). The history of Maria Gentili—the modern Antigone (see *Gregorovius, Benson*, &c.)—of Oletta, and of Viterbi of Penta, are tales of Corsican life illustrative of this part of the island. —E. L.]

[1] Cervione, an industrious and progressing village, and counting more than 1,400 inhabitants, is one of the two suppressed préfectures.—*Valery*, i., p. 282.

I dined with the sub-préfet of Bastia; tasted a great variety of wines. I had not conceived that Corsica produced any so excellent; some were like port, strong, rough, and full bodied; some rich and sweet, so much resembling Frontignac, that they are frequently sold as such; others like Chablis; and another sort similar to the best Herefordshire perry.—*Benson*, p. 56.

All the villages of the canton of Cervione make wine, which is their greatest resource, and much esteemed in Corsica. · · · · The territories of Cervione and Corte produce a wine which is not much inferior to Bordeaux. The wines of the cantons of Sari d'Urcino, Tallano, and Sarténé, and the muscat wine of Cape Corse, may be compared with the best wines of the Continent. · · · · · The Corsicans make plenty of admirable wines, for their grapes are excellent. They make in Capo Corso two very good white wines; one of them has a great resemblance to Malaga. The other of these white wines is something like Frontignac. At Furiani they make a white wine very like Syracuse, not quite so luscious, and, upon the whole, preferable to it. In some villages they make a rich sweet wine, much resembling Tokay. At Vescovato and at Campoloro they make wine very like Burgundy; and over the whole island there are wines of different sorts.—*Galletti*, pp. 40, 182, 186, 187.

For all this, unless it could be made head-quarters for several days' study, Cervione does not in itself present enough of interest to induce me to shorten the time allotted to places so important as Bastia and the Balagna, which I must needs visit, so I decide on going for the night, if it is possible to do so easily, to Vescovato, a place I much wish to see, owing to its many associations, as well as for its reputed beauty.

Quoth Domenico, who having unexpectedly fallen in with some Ajaccio acquaintance, is moved to demur to farther progress to-day—"Vescovato is much too far." Nevertheless, on hearing some gendarmes certify the way as seven kilomètres to the high Bastia road, twenty along it, and five up to Vescovato, he acquiesces readily, and the trap is ordered to be ready at 3 P.M.— The gendarmes say there is no regular hotel at Vescovato, but they name one M. Gravie, an old "Continental," and formerly in the gendarmerie, as having a decent lodging-house.

Meanwhile, the people of the little inn here, full of obliging civility—now the well-known type of Corsican manner—produce as good a breakfast as they can on so short a notice, for, as they truly say, it is impossible to kill meat and get fish in a spirit of prophecy for persons whom they have no reason to expect. The Cervione district has a high reputation for its wine, but there was none particularly good at this locanda. As to female costume there is this change for the worse, that the women here only wear—instead of the two handkerchiefs so gracefully worn all over the west side of the island— a single one, and that simply tied round the head and knotted behind.

Once more I have to record that the small country inns of Corsica, are cleaner and better than those of the towns, generally speaking. Meanwhile, I cannot bring myself to make any drawing of Cervione, though I know I ought to do so from the farthest side of the deep hollow over against the town, where, combined with the chesnut-woods, the sea, and Elba, a picture might be made—but then, the houses are so commonplace!—and it is so far to go down there and up again !—and so hot !—and so late !— and thus I do nothing at all but wander a little way on the road leading to Orezza, a land of chesnut-woods, not alas! by me to be explored.(¹)

Starting at 3.10 P.M., the Bastia road, very straight and unpleasant to look at, is reached at 3.40 ; and we drive on until at about the twenty-sixth kilomè-

(¹) "Truly," says Gregorovius, "the traveller is sometimes weary of travelling, and passes many an object worthy of consideration with his eyes shut. I saw Cervione (Theodore's royal residence) on the hill above me, and gave it up for the sake of the ruins of Mariana,—p. 484.

[There is a chapter (p. 216) in Gregorovius very characteristic of Corsican village life in these districts, and full of interesting traits ; the hospitality of a poor and simple family, combined with the ambition which is so frequent in the island, where "the example of many allures people away from their villages ; in which one may often find in the dingiest cabin, the family portrait of senators, generals, and prefects." There is a description, too, of the view from Oreto, which has caused me to regret much, as in other instances, my not having met with Gregorovius's book before I left the island. —E, L.]

tre from Bastia it is time to enquire for a road said to turn off on the left hand
to Vescovato ; but as there are many such lanes, the directions are not very
satisfactory; and Domenico is in a land new to him. From the junction of
the Cervione road, the landscape has been full of cheerfulness—everywhere
with much cultivation, and very little of the wild Corsican vegetation, except
arbutus hedges, white and red cystus. On the left is a line of mountains,
of no great height, but of good form, with a nearer and lower range of hills
entirely covered with wood—here and there a house or two is passed, with
corn-fields and great walnut trees. At 5.30, a town not far from the road
stands on a gentle elevation crowded with foliage, and with a beautiful
picturesque campanile ; this place I suppose at first to be Vescovato, but it is
(I believe) Venzolasca (¹) ; some people—there are in this district plenty on
the road—say there is a way from it to Vescovato, but difficult for carriages.

6 P.M.—At the twenty-third kilométre from Bastia the real lane is reached,
so I send on Domenico to secure what rooms M. Gravie may have, and prefer,
after the long and hot drive, walking up slowly to the town of Filippini and
Buttafuoco, the refuge that should have been of J. J. Rousseau, and that was
so to Joachim Murat King of Naples.

Few prettier walks could be taken anywhere—at first through open
country, always approaching the hills, which are throughout completely
wooded and exceedingly beautiful, the sinking sun now edging their graceful
outlines with long streams of gold, green, and yellow, like the plumage of a
peacock or a trogon. Then, as the narrow valley of Vescovato is entered, the
way is more and more closed in by thick olive-trees growing above rocky
banks, and hedges where a profusion of blossoming honeysuckles scent the
evening air deliciously; no town, however, is to be seen ; and this leafy approach,
reminding me of the lanes near Virò in Corfu, is quite unlike any I have yet
seen in Corsica. And not less novel are the accompaniments of the ascent ;
quite a crowd is moving up to Vescovato from the plains and cultivated
territory nearer the sea, with a stir and show of population altogether dif-
ferent from the lonely and thinly peopled western side of the island. Long
strings of carts laden with hay ; horses and asses, with groups of peasants
carrying baskets, instruments of labour, &c. — one seems to have come to

(¹) The ancient convent of Franciscans at Venzolasca has a beautiful court with eighteen columns
Valery, i., p. 305.

From the plateau on which the church of Venzolasca stands there is a ravishing distant view over
the sea, and on the other side a view of the indescribably beautiful mountain basin of the Castagniccia.
Few regions of Corsica and its neighbourhood gave me so much delight as these mountains in their
connection with the sea. The Castagniccia is an imposing circle, enclosed by mountains of a beau-
tiful fresh green, and the finest forms ; they are all covered with chesnut trees to near the summit,
and have at their feet olive groves, whose silvery gray contrasts picturesquely with the deep green of
the chesnut foliage. From the midst of the foliage solitary hamlets look forth, such as Sorba, Penta,
Castellare, and Oreto, perched high among the clouds, dark, and with slender black church spires.
Gregorovius, p. 214.

a new world—and scarcely one of all these people—I counted some hun_ dreds—passed without touching their hats and saying, as did also the women, " Bonsoir."

All at once the town of Vescovato (¹) is visible, than which I never saw any more curiously befoliaged and hidden place ; nor is it till within half an hour of reaching it that it is to be seen at all, so high and so thick are the olive_ trees, and above them the chesnut, over the winding road that leads up to it. First you see two or three temple-like tombs, placed in striking and beautiful spots, Corsica fashion, and then suddenly the whole town is perceived, high up among the woods in which it is embedded, and looking down on a clear stream brawling onward over rocks to a little bridge, and dark haunts of_ shady leafiness. (*See* Plate 30.)

Nor is Vescovato a featureless array of ugly and commonplace buildings of the domino-warehouse type, but a most picturesque place both in form and colour, so much resembling such towns as Corchiano, or similar places in Central Italy, that one seems to have been transported thither, there is even a sort of palace, as a " roof or crown of things"—though of course not such as at Genazzano or Valmontone—at the highest part of the town. A

(¹) I at length set out for Bastia, and went the first night to Rostino. Next day I reached Vescovato, where I was received by Signor Buttafuoco.—*Boswell.*

Vescovato, a town of 1,000 inhabitants, is the capital of the Casinca or Castagniccia, so called from its chesnut woods. These lovely and verdant forests might give open a field of industry to the Corsican, for the chesnut is one of the best woods, and even Filippini records, that in his time they made and exported the most beautiful tables in the world. In our time, however, this tree is rather a cause of poverty than profit. Six chesnut trees and as many goats suffice for the subsistence and independence of the Corsican, who does not feel the want of any other kind of life, and who saunters about all day instead of working or cultivating the land.

It was at Vescovato that an asylum was offered, in 1764, by Count Matthew Buttafuoco to Jean Jacques Rousseau, who had expressed a strong wish to retire thither, in order to escape from his Swiss persecutors. The house of Filippini, now occupied by peasants, has been preserved out of respect for his memory ; it is now only three storeys instead of foar in height, but solidly built, and a curious model of a Corsican dwelling of the sixteenth century, for although the historian was well off, and could receive several friends in his house, it would now appear but an inconvenient abode.

The abode of the historian Ceccaldi, large and restored, still exists, and in our days this house of a historian has itself become a part of history, for it served as an asylum to Murat when he came, in 1815, to Corsica, to demand hospitality of General Franceschetti, formerly a colonel in his army. The General occupied the house still in 1834, and I paid a visit there to his wife, who was Catarina Ceccaldi. Murat, that cavalier always so well mounted and equipped, that paladin of the white plumes, which he never ceased to wear in front of the enemy, made his entrance into Vescovato on a mule, a black silk cap only on his head, a common cloak and soldier's gaiters ; his thick shoes are still preserved in this house. General Franceschetti died in 1836, ruined in consequence of Murat's residence with him, and by his having accompanied the ex-king in his expedition to Pizzo.—*Valery,* i., p. 311.

I expected to find such a place as I had seen plenty of on these mountains. So I was astonished when I saw Vescovato before me, surrounded by green hills, concealed among the chesnut-groves, oranges, vines, and fruit-trees of every kind, watered by a mountain stream, and built in original Corsican style, yet not without some elegant architecture. The place was founded by a bishop, and was in later times the residence of the bishops of the old town of Mariana, which lay in the plain below. The archdeacon (Filippini) had the custom of writing his history in his vineyard at Vescovato, which they still show. When he had ridden up from Mariana, he tied his horse to a pine-tree, and sat down to meditate or to write, protected by the high wall of his garden—for he was

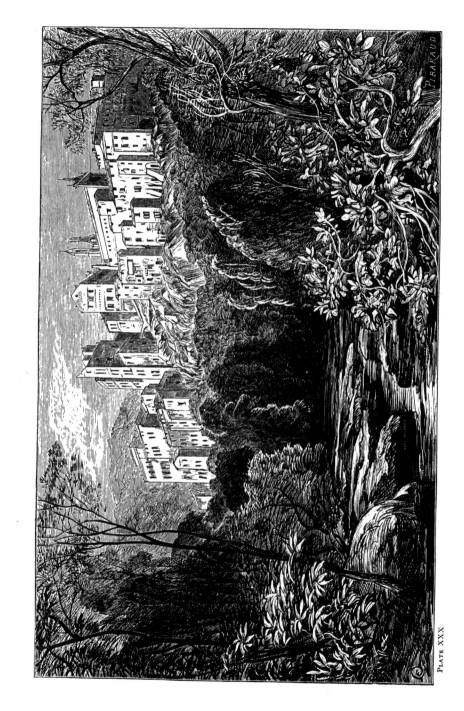

multitude of unequal windows, and all sorts of angular oddities of architecture, are crowded together, to the delight of the artistic eye, the brown, gray, and yellow tints making each of the houses a picture ; and on the whole, no place in all these Corsican journeys has so delighted me at first sight as Vescovato, which its historical associations alone would make worth a visit.

A smart ascent leads up to the town, and all along the way there are beautiful combinations of foliage and building. At the top, in a little piazza, surrounded by children, stand the trap and ponies, the luggage unpacked, and Flora looking as if all was not right, while Domenico comes forward to say that there is no possible lodging to be found. The Maire, to whom I have a letter, is ill, and I send Giorgio to find the house of M. Gravie, when two gendarmes, who are always a civil set, come and offer their assistance ; at the same time G. returns, having discovered the house which Domenico could not find, from being unable to leave the ponies. During G.'s search I was surrounded by seventy or eighty boys, who stared at me diligently, and in silence ; and I was struck by the quiet manner in which all these children dispersed on my saying to them, " Have you never before seen a stranger ? and do you think it is right to look at him as if he were a wild beast and not

never secure against the bullets of his enemies all his life through—and so he wrote the history of the Corsicans, under truly dramatic and exciting influences.—*Gregorovius*, ·p. 192.

The territory of the canton of Vescovato is the most fertile in all the island ; that part of it—the plain watered by the Golo—is well cultivated, and the part near the sea, called Prato, is prodigiously fertile. Vescovato is the birthplace of the patriot General Andrea Ceccaldi, the three historians, Monteggiani, Ceccaldi, and Filippini, of General Count de Buttafuoco, Luca de Casabianca, captain of the vessel "l'Orient," who perished at Aboukir, together with his son Giocante, twelve years of age, and of many other distinguished members of the Casabianca family, &c. The long residence of the bishops of Mariana has changed the name of Belfiorita into Vescovato.—*Galletti*, pp. 184, 185.

" I went," says G. "to the house of Count Matteo Buttafuoco, which was to have been the abode of j. J. Rousseau. It is a sightly, château-like building, the grandest in Vescovato. Paoli also invited Rousseau to the island in the year 1764, so that he might withdraw from the persecution of his enemies in Switzerland."

" I am growing old and failing," says J. J. R., in a letter declining this invitation, " my strength is leaving me ; the wish excites me, and the hope vanishes. However it be, accept yourself a present to the Paoli, my sincerest and tenderest thanks for the refuge he has deigned to offer me."

Circumstances, however, diverted Rousseau from his intention of going to Corsica, and a pity it was. He might there have put his theories to the test, for the island appears like the realised Utopia of his ideas on the normal condition of society eulogised by him, especially in the treatise " Whether the arts and sciences have been salutary to mankind." In Corsica he would have found to the full what he wished, natural men in woollen blouses, living on goats' milk and a few chesnuts ; neither science nor art ; equality, valour, hospitality, and blood-revenge at every step. I think the warlike Corsicans would have heartily laughed to see Rousseau walking about under the chestnut trees with his cat on his arm, or twining his basket-work, &c.

There is a third very memorable house at Vescovato, that of the family of Ceccaldi. .
It is now the house of General Franceschetti, or rather of his wife, Catarina Ceccaldi ; and it was here that the ill-fated king, Joachim Murat, found a hospitable reception when he landed in Corsica on his flight from Provence ; and here he formed the plan of reconquering his beautiful kingdom of Naples by a knightly *coup de main*.—*Gregorovius*, pp. 199, 200.

Gregorovius gives many details of the last days of Murat's life, taken from the Memoirs written by Franceschetti—how Murat, after he had escaped, fled to Corsica, and landed near Bastia, August 25, 1815, and hearing that General Franceschetti, who had served in his body-guard, was at Vescovato,

a man like your own people ? " " Dite vero, é vero—true, true," said many
of the little fellows, as they walked away, without a single instance of rude
words or a grimace from any one of them ; and this behaviour from a large
number of common children in a remote mountain village impressed me—who
remember various odious and howling juvenile crowds in other countries—as
not a little remarkable.

Crooked narrow flights of super-odorous and slippery stairs—dark, too,
for daylight is waning—cut in the rock, lead up to the queer little house of
M. Gravie. As usual, the interior of the tiny rooms is far better than was to
have been expected from the very rude approach, and the old landlord and
two daughters are full of civilities and apologies. But as I have been very far
from well all day, G. makes up my camp-bed at once, and I get rest till
supper is announced, at which I only "assist," for fear my not doing so may
be construed as a slight to what these good people, in their anxiety to give
satisfaction, have prepared—to wit, pease-soup, an omelette, stewed lamb,
and a roast fowl, killed on my arrival, all good and well dressed. The supper
is served by the two daughters, both of them agreeable in face and manner,
and I beg the master of the house, a well-bred old French gendarme, to sit
down in the room—which he will not do without a positive invitation more

went thither to the house of the Maire Colonna Ceccaldi ; how he presented himself to the general,
wrapped in a hooded cloak, with his head buried under a black silk cap, with the thick beard, and the
trousers, gaiters, and shoes, of a common soldier, his face emaciated with misery. In spite of all per-
suasion, it seems that he persisted madly in his scheme of returning to Naples, lingering on in Corsica
until his situation became daily more full of peril. On September 17 he went to Ajaccio, to
embark there, his journey being a sort of triumphant march, from many of his admirers joining him,
and Ajaccio, on the 23rd, declared in his favour. While in the city, offers were made him of complete
security, guaranteed by Austrian and English passports, and at one time he accepted them, but finally,
decided to proceed on his enterprise. The recital of his last days, and of his death, is full of affecting
detail, as well as that of his faithful follower Franceschetti, of his sufferings, and of the ruin his fidelity
entailed on himself and family.

Franceschetti died in the year 1836. His wife, Catarina Ceccaldi still lives (1852) at a great age in
the house where she gave a hospitable reception to King Joachim. . . She spoke of the
time when Murat lived here. " Franceschetti," said she, " represented the affair to him in the plainest
colours ; he did not shrink from telling him he was bent upon impossibilities ; but then Murat would
exclaim with bitterness, ' You too will abandon me? Ah! my Corsicans will leave me.' "—*Gregoro-
vius*, p. 212, &c.

The last representation of the warlike Corsican dance in armour, now disused, called the
" Moresca," was in 1817, but Filippini mentions Vescovato as the theatre of it, and it was frequently
performed there. The old plays of Passion Week were kept up also in Corsica till a very late period,
and in 1808 an entertainment of the kind was given at Orezza, according to Robiquet, in the presence
of 10,000 people. There were tents to represent the houses of Pilate, Herod, and Caiphas ; angels
and devils rose up from a trap-door ; Pilate's wife was acted by a young man, twenty-three years old,
with a raven black beard. The "Captain of the Guard " wore the French national-guard uniform, with
a colonel's gold and silver epaulettes ; the second commander wore an infantry uniform ; and both had
the cross of the legion of honour on the breast. Judas was represented by a priest, the curé of
Carcheto. When the play began, the spectators, from some unknown cause, got into a fray, and began
to bombard one another with pieces of rock that they tore up from the natural amphitheatre.
Hereupon Jesus, who had just entered the stage, would not play any more, and retired in a tiff from this
earthly vale of woe; but two gendarmes took him under the arms, and forcibly brought him back to the
stage, so that he had to play on.—*Gregorovius*, p. 204.

than once given—in order that I may have some talk with him, as I shall be off so early to-morrow. M. Gravie tells me he has been in Corsica forty years, and in this place twenty, having married a Corsican wife ; I am the only Englishman he has ever seen at Vescovato, with the exception that once the English Vice-consul at Bastia slept here. The life of a gendarme in this island forty years ago was, he says, indeed, one of danger, when banditism and vendetta were flourishing institutions, and if one could but have staid here some days, unlimited stores of romance might have been taken down from this old ex-official's recital.

Seeing how much pains these good folk took to please me, I was vexed that I could not eat, and therefore sat the longer to talk with this pleasant old man, in whose conversation there was something sad as well as interesting, particularly when he spoke of France. I should much like to linger here some days, but it cannot be done ; I must see Corsica hastily or not at all. Meanwhile I only just hope to escape fever while I am in the island, not at all on account of the prevalence of malaria, but because fatigue always awakes the old slumberings of an illness to which I have for years been liable.

It is past 9.30 before I get to the camp-bed.

Speaking of the Casabianca family of Vescovato, and of the spirit of family or bond of relationship so general in Corsica, M. Valery instances the three Sampieri, the three Paoli, two Abbatucci, two Cervoni, three Casabianca, two Sebastiani—as proofs of his statement.—*Valery*, i., p. 213.

CHAPTER IX.

May 23.—Quinine and a good night's rest in a quiet house are great things ;
by mistake I have risen at 3.30, an hour earlier than was necessary, when —

<div align="center">" Morn broadened on the borders of the dark."</div>

Would that I could have got some notes and ideas of that chestnut scenery
along the last few kilométres along the Bastia road ! especially of the town I
believe to have been Venzolasca, about which the beautiful effects of light and
shade were delightful ; but owing to hurry, and that the sun was low and
directly opposite the eye, drawing was not possible.

Vescovato, closely shut in between densely-wooded heights, with few
distant glimpses of the shining eastern sea, might, it seems to me, have suited
Jean Jacques, had he accepted the Buttafuoco invitation, from its peaceful
and remote position. Murat in the Franceschetti house, and Filippini in his
own, must have found the place fitted to their wants ; but it may be doubted
if Count Buttafuoco, after the celebrated letter of Napoleon Buonaparte, did
so. All these, and other names remarkable in history, stamp Vescovato as
a town of peculiar interest.

After coffee, I took leave of my landlord, M. Gravie, who said, "Je ne
crois pas, monsieur, que nous nous reverrons." On my asking him last night
if he had ever revisited France, the poor old fellow said, "Non, monsieur,
je n'ai jamais vu la France depuis que je l'ai quittée, et maintenant je ne la
reverrai plus." I do not think my worthy host was convinced that I was
not a political agent of some sort, partly because it has always been a charac-
teristic of Vescovato to mix itself up or initiate surprising political events ;
and partly that, after all, it is very difficult for these people to reconcile the
popular notion of a painter laboriously working his way from place to place

with that of an elderly traveller speaking four languages, and going about
with a carriage, luggage, and a servant. It is of no use to attempt explana-
tions—qui s'excuse s'accuse—and, therefore, "silence is golden" is the best
rule of the traveller's life in these lands.

So at 5 A.M. I came down, leaving Domenico and C⁰· to follow by the
shady lanes where Jean Jacques Rousseau should have loitered; and, till
6.30, I draw below the town, by the side of the road, which is, as last night,
all alive with peasants, now going to their work in the fields, many of them
in cars or on horseback, and all giving me a civil "Bonjour." Of costume
there is literally none hereabouts, any more than in other parts of Corsica,
unless the universal wearing of one or sometimes two gourds, many of them
very large and flat, be considered as such. As the territory of Vescovato
is all about the low lands near the sea-shore, where it is not easy to find
good water, the villagers here take a large supply with them for their day's
need.

In making a painting of Vescovato, as I hope one day to do, the
luxuriantly leafy aspect of the place should be well attended to, and the
rich broken colours of the houses, so unlike most in Corsica; especially when
the stream below the town is fuller of water than it now is, few more beautiful
subjects could be chosen. By 7 A.M. I am once more driving along the Bastia
road, Flora having politely come up the Vescovato lane to meet me, lest I
should miss seeing the carriage. At this hour the richly-wooded and almost
unbroken line of hills on the left of the highway are shadeless and glaring
in the full eastern sunshine; the time of their great beauty was that of even-
ing, when they were varied and lighted up by the long shadows and gold
gleams of western sunset.

The valley of the river Golo and its bridge is soon passed, and already
Bastia, the northern capital of Corsica, is seen, beyond what seems an inter-
minable straight wide road. On the right hand, stretching to the sea, lie the
great marsh and plain of ancient Mariana,(¹) and the wide Étang de Biguglia,

(¹) The old cathedral of Mariana, now called La Canonica, is a curious and picturesque ruin on the
sea-shore, overgrown with herbs and shrubs, its columns all standing, its roof open, and with figures of
animals sculptured on its façade.—*Valery*, i., p. 314.

The ruins of Mariana lie an hour's walk off from the road, towards the sea-coast. Here, as at
Aleria, I found extensive tracts strewn with stones of walls covering the whole ground. The ruins of
Mariana are yet more insignificant than those of Aleria. . . Two ruined churches alone attract
attention : they are the most prominent ruins of the middle age period. The first and smaller one
was a beautiful chapel, the long nave of which has been well preserved. It has a pulpit decorated
outside by six pilasters of the Corinthian order. A mile further stand the beautiful ruins of a larger
church, of which, likewise, the nave remains erect. It is called the Canonica. The building is a
basilica of three naves, with rows of pilasters of the Doric order, and a pulpit constructed like a
Gothic chapel on both sides. . . . It is in every respect like a basilica of the Pisans.—*Gregorovius*,
p. 485.

There are ruins of Roman construction still existing at Mariana, pilasters of a bridge which crossed the
Golo, those of a small octagon temple near the church La Canonica, portions of great parallel walls, &c.,

so pestilentially malarious as summer draws on. I could well have liked to get a drawing of the site of the old city, but at 8 A.M. it begins to be too hot to indulge in wanderings over a marshy district of most suspiciously unhealthy aspect. Not much of the old city, I believe, remains above ground, but there might be picturesque masses of Roman brickwork, and vegetation ; and the far hills, did circumstances allow, would combine to make a good illustration of the ruins. Borgo, Furiani, Lucciani, all villages on the left as you approach Bastia, would well have been worth a visit had it been possible to compass it.(¹)

Meanwhile, signs of life and cultivation continue to increase as I go on;

&c.; ruins of baths well paved with Roman bricks, &c. ; vestiges of a canal, &c.; Roman tiles, sarcophagi, &c., &c.—*Galletti*, p. 189.

The ruins of Mariana are less apparent than those of Aleria, being in a plain more or less cultivated, and the Abbé Galletti says that many portions of the old city have disappeared even in his own remembrance. [The Abbé makes some strictures on Marmocchi's book, it seems to me with justice. "No trace," says Marmocchi, "exists of the town of Mariana, nor can the geographer discover the exact spot occupied."—E. L.]

Biguglia, now a little village with less than 300 inhabitants, succeeded to the noble Mariana, and was the capital of the island under the protecting government of the Pisans from 1090 to 1300. Biguglia preserved its rank of capital till the year 1380, when the Genoese governor, Leonello Lomellino, driven from it by Henri de la Rocca, built further away on the sea-shore a fort, which afterwards became Bastia. The lagoon of Biguglia, three leagues long, in some places half a league broad, and which has a superficies of 3,000 hectares, is, from its insalubrity, the scourge of the neighbourhood, and its exhalations affect the public health even as far as Bastia.—*Valery.*

The exhalations that rise from the waters of this lagoon have always been the scourge of Biguglia, which is now only a small hamlet. The inhabitants of Furiani, Borgo, and Lucciana, and even of the city of Bastia, often suffer from the effects of its homicidal insalubrity.—*Galletti*, p. 17.

(¹) Furiani, where the Corsicans in a national assembly first organised their insurrection against the Genoese, and elected the prudent and intrepid Giafferi one of their leaders, with cries of "Evviva la libertà ! evviva il popolo !" Furiani, where in almost their last struggle 200 Corsicans held the fortifications long after they were a heap of ruins, and at length cut their way by night to the shore.—*Forester*, pp. 49, 95.

In the battle of Borgo, 1768, the Corsicans, under Pasquale and Clement Paoli and other chiefs, thrice repulsed the French army of 15,000 men, under Chauvelin, and forced them to retreat in disorder to Bastia. The garrison of Borgo, a force of 700 men, laid down their arms, &c.

On the slopes of the hills that extend from Bastia to the river Fiumalto, remains of antiquity are frequently discovered. In all probability Etruscans and Romans possessed country houses or villas there. An immense number of tombs containing lachrymatory vases are found there.

The sulphurous waters of Merenzana, on which the Romans had constructed baths, are at a place now called Marmorana, and the ground is full of vestiges of Roman antiquity.—*Galletti*, p. 193.

In the year 1832—sometimes the occasions of bloody feuds between two villages are very ridiculous, a dead donkey was the cause of one. In Easter week a procession going to a certain chapel stumbled upon a dead ass in the road. The sexton was angry, and began to curse those who had thrown the ass on the road, and thus shown dishonour to the holy procession. A strife immediately arose, between the people of Lucciana and those of Borgo, which parish the ass belonged to, and arms were seized forthwith, and shots exchanged ; the holy procession had suddenly converted itself into a battle. The one village cast the burthen upon the other ; each carried the ass to the other : one while they of Borgo dragged him to Lucciana, another while they of Lucciana did the same to Borgo, and this in the midst of constant shooting and wild battle cries on both sides. The men of Borgo once dragged the dead ass quite to the church of Lucciana, and threw him down at the church-door ; but those of Lucciana took him up again, and then having taken Borgo by storm, impaled him on the belfry-tower. At length . the podestà caused the *corpus delicti*—which was beaten into a pulp by its wandering, and was in a state of dissolution—to be seized and buried in peace. The poet Viale has composed a comic epic on this story.—*Gregorovius*, p. 417.

wide corn-fields, lupines, and great plantations of almond trees stretch on both
sides of the road ; there are hay-fields, too, with vulgar domestic hay-cocks,
dear to the memories of tumbling childhood ; even the wayside accompani-
ments are different from those of West Corsica, inasmuch as here there are
lines of great aloes, while, instead of fern, asphodel, arbutus and its blackbirds,
the road is edged with thistles, tipped with the familiar goldfinch. Peasants,
on foot or in cars, are numerous ; and two Diligences—to Cervione and
Bonifacio—a sprinkling of wayside houses, and a very dusty road, all unite
to exhibit a different and livelier condition of things in the neighbourhood
of Bastia than is found elsewhere in Corsica. Nor is the drive without
interest of association, apart from that of the destroyed Mariana, since, on
the hills to the left hereabouts, took place some of the greatest events
in the island history—to wit, at Borgo, Biguglia, and Furiani, villages all
perched at some height above the plain, and apparently worth a painter's
visit.

For the last hour the road has been quite near the sea, and now, at 8.30,
walled gardens, a large cemetery, and villas on the hill sides, announce the
approach to Bastia, which is reached by 9 A.M., through a populous and not
over-clean suburb, just previously to entering which there is a picturesque
view of the city, to which I shall have to return.([1])

([1]) Bastia has of a long time been reckoned the capital of Corsica. It has a stately appearance
from the sea, being built on the declivity of a hill ; though upon entering the town one is a good deal
disappointed, for the houses are in general ill-built and the streets narrow, and from the situation of the
town necessarily very steep.—*Boswell*, p. 22.

Bastia, built in an amphitheatrical form, in the middle of gardens of olive, citron, and orange trees,
may be said rather to be long than large. The port only contains fifty vessels, but might, if enlarged,
rival that of Leghorn, which improvement might be made at the expense of 1,150,000 francs ; but the
engineers doubt the possibility of such additions.

The buildings of Bastia are generally little worthy of note ; the finest is the military hospital,
anciently the convent of St. Francis. The citadel is commanded by hills covered with small
forts.

The donjon of Bastia il maschio is of the fifteenth century, and was commenced by one of the most
brilliant heroes of Corsica, Count Vincentello d'Istria. The celebrated bastion of St. Charles, seen
from the port, and constructed some time later, has given its name to the city. The Genoese raised the
fine pile of building used as the residence of their governors ; Genoese dungeons, less celebrated than
those of the rival Republic of Venice, are hardly less hideous. The old and handsome palace of the
French governors is now the Sous-prefecture, the Royal Court, and the Court of Assize ; while the
ground floor serves as barracks for the Corsican Voltigeurs. The churches, richly gilded, and orna-
mented with marble, vividly recall those of Italy ; the reflex of Italian manners, too, is very perceptible
at Bastia, a refinement wanting its new rival Ajaccio, that savage head-quarters of a department, spite of
the administrative buildings with which it has been decorated at no small expense. In the church of St.
John the Baptist is a small old picture of the miraculous draught, which seems a good work. The
cathedral, though old and fine, is not the most magnificent church of the city. At the church of La
Conception was held the first parliament of 1795, and the bust of Paoli was inaugurated with a perfidious
respect, just as he was about to be entirely put aside ; a grave error on the part of England, for only
Paoli, as viceroy, could have prevented the return of the French Republicans. . . . The pavement
of Bastia, formed of slabs of Brando stone, is superior to that of Milan, Florence, or Naples, and
worthier of flooring palaces and temples than of being laid down in streets. The markings and cloud-
ings of this stone come out after being wet by rain with a singular brilliancy.—*Valery*, i., pp. 2, 4, 14.

I cannot imagine any one staying longer than they can help in Bastia ; its only attractions are the sea

Bastia, a city containing about 20,000 inhabitants, is a complete contrast to its quiet, not to say slow, co-capital Ajaccio, where, comparatively speaking, few and far between are the walkers about. Here all is bustle and life, and

and the mountain view from the environs ; it is the most populous town in Corsica (16,000), and has the largest commerce. Bastia was the standing point from which the old division of Corsica into the "di quà" and the "di là dei monti" (the country on this side and the country on the other side of the mountains) was made. The division was by no means equal ; the country "di quà," including the present arrondissements of Bastia, Corte, and Calori ; being one-third larger than the "di là," comprising those of Ajaccio and Sarténé.—*Forester*, p. 39.

The sea passage from Leghorn is beautiful, and more entertaining than that from Leghorn to Genoa. You certainly enjoy the sight of the picturesque islands in the Tuscan channel. — *Gregorovius*, p. 99.

Bastia lies in an amphitheatre round the little harbour ; the sea forms here no gulf, but only a landing-place or cala. The town rises in terraces above the harbour, with high tower-shaped, closely crowded houses. Above the town are the green mountains, with some abandoned convents and beautiful olive-groves. Bastia has its name from the bastion built there by the Genoese. The town is not ancient ; at least neither Pliny, nor Strabo, nor Ptolemy, mention any town upon its site. Formerly there was there the little marina of the neighbouring village, Cardo. Then, in the year 1383, the Genoese governor, Lionello Lomellino, built the donjon keep, or castle, round which a division of the town, the Terra Nuova, soon clustered. The Genoese afterwards removed the seat of their Corsican Government from Biguglia to Bastia, and there resided the Fregosos, the Spinolas, the Dorias (eleven Dorias governed Corsica during more than 400 years), the Fiescos, the Cibbas, the Giustiniani, Negri, Vivaldi, Fornari, and so many other nobles of renowned Genoese families. When under French rule, Corsica was divided, in the year 1797, into two departments named after the rivers Golo and Liamone, Bastia remained the capital of the department of Golo. In the year 1811 the two divisions were again united, and the smaller town of Ajaccio became the capital of the island. Bastia cannot yet get over her vexation at having sunk into a sub-préfecture, but in industry, commerce, and intelligence she is, without doubt, the leading town of Corsica. The mutual jealousy of the Bastinese and the citizens of Ajaccio is almost absurd, and would appear ridiculous did not one know that the division of Corsica into the land on the nearer and on the farther side of the mountains is historical, and very ancient, and the character of the inhabitants of the two halves fundamentally different.—*Gregorovius*, p. 105.

The houses, though palace-like, have no art nor noble materials ; the stranger meets here not a single specimen of beautiful architecture.

Marbœuf, who ruled Corsica for sixteen years, is buried in the handsome church of St. John the Baptist.

The views towards the coast and south of Bastia surprised me ; for there the mountains, which, like almost all the mountains in Corsica, are of the finest pyramidal forms, recede farther from the coast and sink into a smiling plain. The great lagoon of Biguglia lies picturesquely there, girded by sedge, still and dead, scarce furrowed by a narrow fishing boat.—*Gregorovius*, pp. 106–110.

Corsica is extremely well supplied with fish. I never, indeed, could hear of any other fish in their rivers or fresh water lakes, except trout and eel. These, however, are found in great plenty, very fat, and of an uncommon size. But the rich treasure of fish for Corsica is in its sea ; for on all its coasts there is the greatest variety of all the best kinds, and in particular a sort of ton or sturgeon, and the small fish called sardine, which is of an exquisite taste. And in several places the Corsicans have beds of oysters remarkably large.—*Boswell*, p. 37.

"No lights but the stars of heaven burned in the steep and narrow streets of Bastia," says Gregorovius. [There is gas now.—E. L.]

The town of Bastia, built at the northern extremity of the eastern site, is at present the richest, most commercial, and industrious of Corsica. It owes its prosperity to its geographical position, to its place opposite Italy, to its continual communication with Leghorn, and to its proximity to the richest and best cultivated basins of the island.—*Grandchamps*, p. 42.

The port of Bastia is the most frequented of Corsica, but wants extent, and is difficult to enter, and eventually a new port must be made.—*Grandchamps*, p. 95.

Bastia owes its name to the principal bastion of the castle founded in 1383 by Leonello Lomellino. The Genoese made it their principal stronghold in the north of the island, and the residence of the governor of the province. It was the first town attacked by the French in 1553. From 1669 the

a broad street, paved in a first-rate manner with flags after the Tuscan fashion, and with many new and large buildings, gives one an impression of having suddenly arrived at Leghorn or Naples. At the Hôtel de France I get a spacious quiet room, and among the good things of a well-served breakfast in the trattoria on the ground floor, let not the fresh anchovies—for which this coast is famous—be forgotten, nor the cherries and strawberries of the Cap Corse gardens.

The afternoon passed in exploring the town, as well as in making a drawing of it from near the new pier or breakwater, now in course of construction; but there is not much to be got out of Bastia in a picturesque sense. A drawing might, indeed, be made of the old port, by way of displaying shipping, &c. ; but to portray all its tall narrow houses, backed by high green hills, would take a longer time than I can afford it. Somewhat of Genoa memories revives as you walk along the lanes in the lower part of the city (the wide streets and new quarter—where there are blocks of stone-built, handsome, and solid houses—are all in the upper part of it), shop windows exhibiting gourds prettily set with stoppers and chains of silver, small silver and coral models of Corsican daggers, miniature remembrances of bygone days of Vendetta ; but there is little novelty or beauty of any sort to detain a traveller long in a place, the most striking characteristic of which is its industrous and bustling character.

May 24. —After ascertaining times and distances as accurately as I can, the best way of disposing of the ten or eleven days of my remaining stay in Corsica seems as follows:—to employ two at Cap Corse, starting thither early to-morrow ; three for the lower Balagna, and two for the upper part of it ; and from Corte (which I must pass through once more) the remaining time may perhaps admit of my returning to Ajaccio by Ghisoni, Marmáno, and Zicavo, if the above plan can be carried out without hindrance from weather or otherwise. Meanwhile, what little there is for me to do at Bastia on its south side can be easily despatched to-day, leaving leisure withal for letter writing in some country nook, for this city doth not possess the charm of quiet, nor is a return through its streets desirable at broiling mid-day. So I make an early start before 5 A.M., G. carrying an over-night-bespoken breakfast as well as folios, &c.,

States of the Terra de' Communi were held in the citadel of Bastia. In 1794 Bastia fell into the power of the Anglo-Paolists, and remained two years in the hands of the English. Retaken in 1796 it was the chief place of the department of the Golo till 1811, and now is the *chef lieu* of an arrondissement.— *Grandchamps*, p. 44.

On the rock promontory between the two coves, the northern called Porto Cardo, the southern Porto Vecchio, the Genoese built a fortress which, towards the year 1407, Nicoroso de Manicipio, then Governor for the republic of Genoa, was obliged to sell for 700 Genoese livres to Vincentello d'Istria, successor of Arrigo. This fortress fell later into the power of the Genoese government.—*Galletti*, p. 91.

and getting coffee in a café by the way, walk on some four miles; the view of the city looking eastward cannot be executed till later, the sun rising fully opposite me; and instead of attempting it I make a drawing from a high point near the road, close to the spot I fix on for the day's halt.

In the latter part of summer, the great extent of marshy flat between this and the sea—a tract then totally deserted—must be as dreary to look at as dangerous to remain near; but just now the high road and the seaward paths among the fields are lively with peasants working at the hay-harvest; the bright sun, though extremely hot, is tempered by a pleasant breeze, and the pale aloes are beautiful in broad light and shadow. Beyond the white city of Bastia you see a long way up the coast of Cap Corse, but the single and tame line of the hills seems to contain no scenery to be put in comparison with that of Western or Southern Corsica.

From 8 A.M. till 4 P.M. I pass the time in a hay-field below the friendly shade of olive trees, writing letters; a blazing fringe of scarlet poppies and the blueness of sea beyond and sky above, are all day long a charm of glorious colour. A hoopoe or two comes near now and then, and except these, no other bird but one, who sits in a companionable way on the topmost bare bough of an almond tree a few yards off, hour after hour, chattering with a soft multitudinous kind of note, as if he were four or five birds instead of one, chibbly-wibbly-twitter-witter unceasingly, unless when he darts down to the ground to seize a beetle. This shrike—such at least he seems to me—is a restless little fellow, flitting at times from tree to tree, but always returning to his favourite broad branch opposite where I lie. He gives me no little amusement; sometimes, besides his continuous small chatter, he warbles with a good deal of pleasing delicate variety.

Slowly returning at 5 by the dusty road to Bastia, I make a drawing of the city from the entrance, at a spot where, by the usual destiny of discomfort, the only available site was not only close to the cliff, but exposed to the throng of carts and loaded mules, which at this hour fill all the public road. The Suliot, however, did good service, by warding off the latter, and by signing to the drivers of the former to give me a little more room, as well as by cajoling and conversing with the many children who crowded round, and I was enabled to get through an elaborate drawing successfully. Bastia from this point is picturesque, though not beautiful; no charm of architecture commends it in any way; yet the large masses of building on the edges of cliffs, with caves and coves, slips of sand, and clear water, in deep shadow, and all alive with dabbling and swimming children, make a good picture; though the houses are so full of very elaborate detail, and so crowded with peculiarities characteristic of Cor-

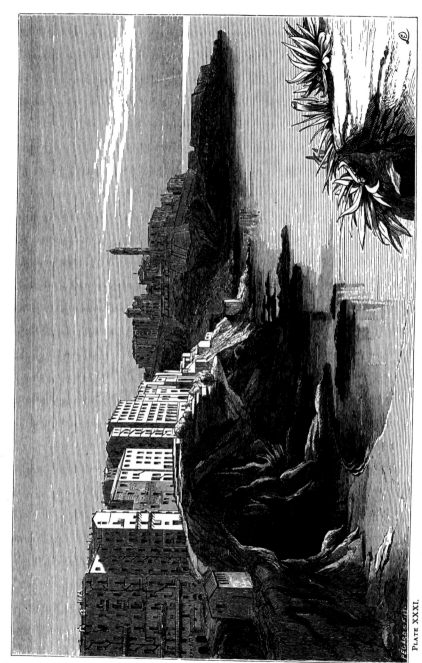

PEGARD.

PLATE XXXI.

BASTIA.

sican buildings, that the view is one requiring much patience to complete. (*See* Plate 31.)

By sunset, passing through the narrow suburban streets and the broader handsome portion of the newer town, I return to dine at the comfortable Hôtel de France.([1])

May 25.—The daily life of cities begins late ; nor in nor out of this hotel can coffee be procured before 5.30 A.M., when I set off with trap, Flora and Cᵒ., to Cap Corse,([2]) to get as far as Luri, Macinaggio, or Rogliano,

([1]) Fontanone is famous for having been the place where, they say, Bernadotte, King of Sweden, was made corporal, at the time of the construction of the road from Bastia to Ajaccio, under Louis XVI. Bernadotte, when corporal, often worked in the bureau of an employé in the town of Bastia, and falling in love with his daughter, asked her in marriage, and was refused. Later, when wishing to marry a girl of Cardo above Bastia, he met with a similar refusal. The woman of Cardo, who had died lately at an advanced age, often related anecdotes of her acquaintance with Bernadotte.—*Galletti*, p. 196.

The common soldier, Bernadotte, once fell in love with the daughter of a peasant of Cardo ; the parents repulsed the povero diavolo. But the povero diavolo became king, and if he had married the lass she would have been queen. Now she goes about carrying water on her head, grieving she is not a Swedish sovereign.—*Gregorovius*, p. 109.

Half a league from Bastia is the little village of Cardo, where, of all the exquisite springs of water in Corsica, exists one of the best. The inhabitants of Cardo sell it at Bastia in the summer for two sous a bottle ; and this unique branch of commerce brings as much as 600 francs a year to some of the poor families of Cardo. The picturesque source of Cardo gushes from rocks hidden in olive, walnut, and chesnut trees ; almost too cold in summer, and temperate in winter, it is abundant, and never dries up. The old fountain made by M. de Marbœuf is now nearly forsaken, and the water is taken from higher up, because one of those immense Corsican walnut-trees, which might yield such profit to industry, chokes the subterranean canal with its roots. Some of these walnut trees yield as much as 120 bushels of nuts ; the most remarkable are those at the village of Asco, in the arrondissement of Corte.—*Valery*, i., p. 31.

An illustrious French soldier acknowledged that the happiest day of his life was that when, a common soldier and obliged to work at making the road to St. Florent, he was named corporal. But there exists in Corsica, besides the road to St. Florent, another and a more singular monument of the work of Bernadotte. During the leisure which his new step allowed him, he was employed by the usher of the old council to copy rolls ; the archives of the council possessed voluminous bundles of the handy-work of the royal and warlike hand of the future successor of the Wasas — all of which writings have since passed to the archives of the préfecture of Ajaccio.— *Valery*, i., p. 32.

([2]) The northern point of Corsica, called Capo Corso, is about thirty miles long, very mountainous and rocky, but covered with vines and olives. There are, in several parts of the island, but particularly in Capo Corso, a great many ancient towers, built about 300 or 400 years ago, to defend the inhabitants against the incursions of the Turks and other pirates.—*Boswell*, p. 21.

[Boswell sailed from Leghorn in a Tuscan vessel, in a calm of two days, and landed at Centuri, and thence went to the house of Signor Antonio Antonelli at Morsiglia. Then to Pino, to Signor Damiano Tomasi. "I got," he says, "a man with an ass to carry my baggage, but such a road I never saw ; it was absolutely scrambling along the face of a rock overhanging the sea, upon a path sometimes not a foot broad. I thought the ass rather retarded me, so I prevailed with the man to take my portmanteau and other things on his back (p. 276)." "Throughout all Corsica, except in garrison towns, there is hardly an inn." "For some time I had very curious travelling, mostly on foot, and attended by a couple of stout women, who carried my baggage on their heads (p. 278)." "I was lodged sometimes in private houses, sometimes in convents, being always well recommended from place to place—at Patrimonio, &c., at Oletta."]

Centuri, though at present but a small harbour, may be greatly enlarged, as its situation is very convenient.—*Boswell*, p. 16.

The inhabitants of Cap Corse, peaceable, honest, laborious, seem really the virtuous Troglodytes of Corsica. No "Vendetta" is known to this interesting population, and from 1825 to 1830 there was not

as may happen. Mountains, richly wooded, and dotted with villas, rise
directly above Bastia, and are prolonged to the northernmost point of
the island ; along their base runs the road, ever close to the sea, a sort
of cornice, which follows all the indentations and sinuosities of the coast.
This highway, besides the hot, dusty, and shelterless road to Bonifacio,

a single case of murder or assassination. The grand line of mountains of Cap Corse fronts magnificent
sea views, with shores rich in vine, olive, and fig.—*Valery*, i., pp. 29, 30.
The social culture of the vine, which is identified with security, ease, and the progress of civilisation,
is not less extended at Cap Corse than on the Continent. The annual amount export of wine reaches
3C0,000 or 400,000 francs. These wines, light and generous, and which keep well, are often sold as
Spanish. It is at Cap Corse only that the production of silk has been successfully attempted. .
This silk, said to be even superior to that of Piedmont, is one of the many neglected sources of riches
and prosperity in the island.—*Valery*, i., p. 30.
The wine of Morsiglia, in Cap Corse, is thought as good as the best muscat.—*Galletti*, p. 107.
Cape Corso is the long narrow peninsula which runs out into the sea, and terminates Corsica
towards the north. The rugged mountain chain, called the Serra, traverses it, rising in Monte
Alticcione and in Monte Stello to a height of more than 5,000 feet, and descending in lovely valleys
towards the coasts.
Here and there an abandoned tower on the shore gives a picturesque aspect to the landscape.
All Corsica is beset with these towers, built by the Pisans and Genoese to protect the coasts
against the predatory Saracens. They are round or quadrangular, built in lonely situations, of
brown granite, and of a height of not more than from thirty to forty feet. All these towers are
now abandoned and falling to decay ; they give an exceedingly romantic character to the Corsican
landscape.
Rambling on these heights at a distance from the sea-shore, one sees little of the charms of this
beautiful district, which lie concealed in the valleys. All Cape Corso is a system of such glens towards
the sea on both sides.
Cape Corso is not, as might be supposed, a mere cape or headland, but a narrow peninsula,
containing a number of villages, and washed on each side by the Tuscan sea ; being about twenty-
five miles long, though only from five to ten miles broad. Nearly the whole area is occupied by
a continuation of the central chain which traverses the island from north to south. The average
height of the range through Cape Corso, where it is called La Serra, does not exceed 1,500 feet
above the level of the sea, but it swells into lofty peaks ; the highest, Monte Stella, between Brando
and Nonza, rising 5,180 feet above the Mediterranean.—*Gregorovius*, p. 32.
The village of Tomino, with a population of 700, has on one side a cheerful view over
mountains and well cultivated valleys ; on the other, an admirable sea view, the isles of Pianosa,
Montecristo, and Elba, of Capraija, and Gorgona, and the coasts of Genoa and Tuscany. Looking at
this prospect, one might almost believe, with Peter of Corsica, that nature arranged all this magnificent
decoration for the particular benefit of his countrymen. Tomino was the cradle of Christianity
in Corsica about the year 580—a fact which gave Cape Corso its ancient surname "Sacrum
Promontorium." Little caves in the woods near Forcore and Cala, which the country people believe
to have served as shelter against the Saracens, were the obscure catacombs of the first Christians of
the island.—*Valery*, i., p. 38.
The bold expedition, started from Macinajo, by which Paoli took the Island of Capraia from the
Genoese in 1767, was principally composed of people of Tomino, whose courage he well knew. The
last soldier of the illustrous Corsican general was from Tomino, and died, aged ninety-two, in 1826.
In the church a beautiful silver tabernacle, executed at Lima, and presented by an inhabitant of Tomino
who had made his fortune there, was offered by the commune to Paoli that it might be changed into
money in order to carry on the war with Genoa.
Macinajo, a small though safe port, insufficient for the commerce of Cape Corse, and very near
Tomino, after having been the point of departure for the Capraia exploit was the scene of the people's
enthusiasm, when Paoli, an exile for twenty years, landed here on July 14, 1790.—*Valery*, i., p. 39.
The port of Macinaggio is, after that of Bastia, the most frequented in Corsica, serving as an outlet
for the produce of great part of Cap Corse, the inhabitants of which, laborious, hardy, and enterprising,
are mostly seamen. But it is much choked with sand, and requires much to be done for its improve-
ment. —*Grandchamps*, p. 96.
The little island of Capraija belongs now to Italy, the Genoese having reserved it to themselves by

and a third, a steep ascent, leading over the hills to the canton of Neb-
bio, seem the only drives about Bastia ; and from what I have observed
of its position, I cannot think it well adapted to be the residence of
those who set their lines in pleasant places. Rambles to the villages
high up on the hills there must needs be, and doubtless many pleasant
ones ; but for invalids, the city—noisy, though cheerful, and exposed to
violent winds in winter, and to excessive heat in summer—cannot, I
fancy, be attractive. Yet, in so short a stay, and with so little scope
for observation, a man may overlook much, and easily jump at wrong
conclusions.

The way onward has plenty of interest ; here the view is never impeded
by high walls, as in the neighbourhood of the northern lakes or the southern
towns of Italy. To the right is the bright calm sea, with Elba on its horizon,
and, looking to the left you seem always in a garden of almond, walnut, fig,
and cherry trees (the Diligence I meet is piled up high with cherry baskets
for the Bastia market), corn, potatoes, and flax, varied at times by olive
groves, while in the roadside hedges, pink convolvulus, scarlet pea, and
honeysuckle are blooming in gay and fragrant wreaths.

Brando, with one or two other villages, is passed ; there is a celebrated
grotto here([1]) —" mais nous en avons tant vu—we have seen so many," and I
will not stop at the grotto.

But Erbalunga, a good-sized and most picturesque place, some nine or ten
kilométres from Bastia, cannot be left so hastily. Standing on a little pro-
montory, with a dark castle in ruin at its point,([2]) and with Elba beyond, this

the treaty of 1768, by which Corsica was ceded to France. Its circumference is seventeen miles, its
population 100. —*Valery*, i., p. 40.

Capraija, which the Corsicans conquered in the time of Paoli, remained in the possession of the
Genoese when they sold Corsica to France ; and, with Genoa, the island then fell to the share of
Piedmont.—*Gregorovius*, p. 101.

The commune of Ersa is the land's end of Corsica ; the commune has three coves or little ports, of
which the largest is called Barcaggio.—*Galletti*, p. 105.

([1]) The pretty cascade of Brando, falling some thirty feet, and about half a league from Erbalunga,
is worth leaving the road to see. It is from Brando that the beautiful stone — a kind of marble which
makes so noble a pavement for Bastia—is brought.—*Valery*, i., p. 34.

" In one of the rocks on the coast is the beautiful stalactite cave of Brando. . . The pale
half light now illuminated this beautiful crypt with such fantastic stalactitic formations as only a Gothic
architect can imagine, in pointed arches, capitals, tabernacles, and rosettes. The grotto is the oldest
Gothic cathedral in Corsica ; nature built it so in her most enchanting whimsical humour." So says the
poetical *Gregorovius*, p. 154.

The grotto of Brando, discovered in 1841 by M. Ferdinandi, a retired commandant, is excessively
curious.—*Galletti*, p. 98.

An account of the Grotto of Brando may be found in Miss Campbell's unpretending and valuable
" Southward Ho ! or, Notes on Corsica" (1868, Hatchard).

([2]) Here was formerly the residence of the most powerful Signori of Cape Corso, and the ancient
castle of the Signori del Gentili still looks down upon Erbalunga, its mighty black walls towering up
from a rocky hill.

. . . . Even at the present day the Corsican mountaineers look down with contempt upon the
gentle and stirring people of the peninsula of Cape Corso. The historian Filippini says of the

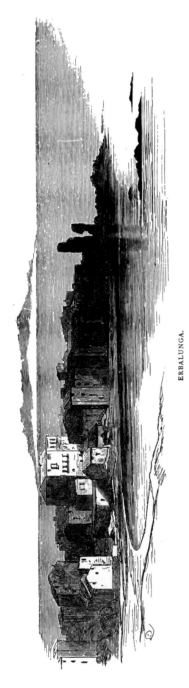

ERBALUNGA.

is one of the very prettiest of scenes, and detains me drawing it till 7 A.M. The still sea, palest of the pale, and more like liquid opal, and the equally pale sky of early morning, are beautifully contrasted with the dark gray of the rocks and houses, at this time in deepest shadow, and with the luxuriant foreground of fig trees and other foliage.

Beyond Erbalunga, this northern Corsican cornice becomes more wild, and resembles that on the southern or Bonifacio district (*see* page 73), except that here there is a frequent growth of aloes, wanting in the south. In both the road runs at times close to picturesque cliffs, or descends sharply inland to the marina (or "port," of some village), which you may see high up on the hill, a half-moon of sand, with a few fishermen's houses, leaving which you again mount up to follow the cliff-cornice, with rocks and "maquis" above you, rocks and sea below.

Sisco(¹) is one of the largest of these

inhabitants, "they dress well, and are, from their commerce, and the vicinity of the continent, much more domestic than the other Corsicans. Their industry is employed solely on wine, which they export to the continent." As early as Filippini's time, the wine of Cape Corso was renowned, and mainly of a white colour. The wines of the greatest repute are those of Luri and Rogliano ; these are among the most excellent growths of southern Europe, resembling those of Spain, Cyprus, and Syracuse. Cape Corso is, however, rich in oranges and lemons. —*Gregorovius*, p. 156.

(¹) The church of Sisco possesses among its numerous relics two of the oldest which the imagination of Catholicism, either Spanish or Italian, has ever originated ; some almonds from the garden of Eden, and some of the clay from which Adam was made. The other principal relics are the rod with which Moses divided the Red Sea, that of Aaron, and some of the manna of the desert.—*Valery*, i., p. 35.

The people of Sisco may feel some pride in possessing such fine things as a bit of the clod from which Adam was modelled, a few almonds from Paradise,

sea-wall villages or marinas beyond Cap Sagro (its church is famous for the

relics it contains); that of Pietra Cor-
bara is a second; of Porticciuolo or
Cognano a third; and from the head
of each of these little bays you look
up a valley wholly green, closed in
by the wall of Cap Corse hills, that
shut out by their direct north and
south course all the western side of
the cape. There is but little variety
in the drive; but the oily-calm deep
blue breadth of sea, and the beautiful
flower-spangled "maquis"—for there
is little cultivation hereabouts except
in the lateral valleys — with every
now and then peeps of the high back-
bone of Cap Corse, prevent the drive
being tedious.

Porticciuolo is the last of these
poor little sea-shore fishing hamlets,
with its crescent of sand, its flat of
grain, and its inland amphitheatre
of heights, before you reach, at the
twenty-seventh kilométre from Bastia,
Santa Severa, the Marina di Luri, a
forlorn and unpromising cluster of
cottages. Here there is a road which
turns inland to the valley of Luri, so
enthusiastically described to me by
Miss C., who advised me by all means
to visit it.

So little remarkable, however, is
the first opening of the vale, that I
feel undecided as to staying here, or
rather whether I should not go on to
Macinaggio, and return to Erbalunga
to sleep. But further on, the thick

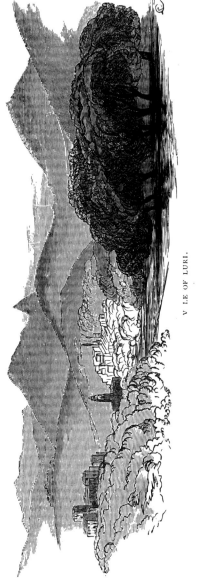

VALE OF LURI.

Aaron's rod that blossomed, a bit of manna from
the desert, a bit of the hide worn by John the Baptist, a bit of Christ's cradle, a bit of Christ's reed,
and the celebrated rod with which Moses parted the Red Sea.—Page 157.

An old tower is shown by the people between Sisco and Pietro-Corbara, believed by them to be the
winter residence of Seneca.—*Galletti*, p. 102

growth of very fine old olives, lemon-groves, walnut, and many varieties of fruit trees give a new character to the scenery, which improves at every minute. All the way along, a tower on a high and remarkable peaked rock, is a landmark on the hills, at the farthest end of the vale—this is "Seneca's tower" —and now that I have advanced to its widest part, I am ready to confess that the valley of Luri is a most lovely place, crowded from end to end with profuse vegetation, shut in by beautiful hill forms with scattered hamlets on their sides, and seeming altogether like a veritable happy valley of Rasselas.(¹)

By 10 the principal village, Piazza di Luri, is reached (collectively all the hamlets are called Luri, but each has its own name), and one cannot help being struck by an aspect of activity and industry in this place widely differing from what is to be observed in South and West Corsican villages. I have forgotten to ask for a letter to the Maire or to some proprietor in

(¹) Switzerland has no view more beautiful than that of Luri, and the latter, besides, has the sea. Cultivated with intelligence, refreshed by a torrent, it is divided by a large and broad road down to the shore. This is protected from the torrent by a wall, a sort of Cyclopean work, made by the inhabitants themselves. The overseer of the works was simply the Juge de Paix, M. Estella, a proprietor of the valley, and one of those able and adventurous Corsicans who during more than twenty years inhabited Peru.—*Valery*, i., p. 42. [M. Estella died April, 1841.—E. L.]

Luri is the most charming valley in Cape Corso, and the most extensive too, though it is only six miles long and three broad. Towards the land side it is enclosed by high mountains, on the highest summit of which stands a solitary black tower, called the Tower of Seneca, because, according to popular story, Seneca passed there the eight years of his exile. . . . I have seen many a glorious valley in Italy, but I remember none that presents so smiling and joyous an aspect as this vale of Luri. . . . Even Ptolemy, in his Corsican Geography, knows the vale of Luri. He calls it Lurinon. . . . The citrons of this valley are said to be considered the best in all the Mediterranean countries. It is principally the species of citrons with thick peel, called Cedri, that is grown here, and especially on the whole western coast of the cape, but most of all at Centuri. This tree, which is extremely tender, demands careful training. It thrives only in warm sunshine, and in the valleys that are sheltered from the wind Libeccio. Cape Corso is a perfect Elysium of this precious tree of the Hesperides.—*Gregorovius*, pp. 158, 159.

A little beyond Porticciuolo is Santa Severa, the Marina of Luri, where a very few boats may be seen. Hereabouts the ancient Laurinum is generally placed, and, in fact, ruins are found in several places around, and in the sea are the remains of some kind of quay.—*Galletti*, p. 103.

Not much importance is generally attached to the cultivation of the orange and lemon, nor are they cared for except in some villages of Cape Corso, Casinca, Marina, in the Nebbio and Balagna, Ajaccio, Bonifacio, Cervione, and Bastia. The garden of Barbicaggio near Ajaccio, and those of Aregno and Corbara in Balagna produce oranges which do not yield in excellence to those of Portugal. A more special attention is given to the culture of the citron, and the inhabitants of Cape Corso, more particularly in communication with the Rivières of Italy, have carried this cultivation to a point of great profit. Wherever there is a streamlet of water they hasten to plant citron trees, and as this part of the island is exposed to the north wind (or Libeccio), the plants are sheltered by high walls, and surrounded besides by a palisade formed with brushwood, broom, heath, or other shrubs, woven together very compactly. Nothing is neglected to ensure the success of a plant which gives three harvests of its fruit annually. When the citrons have reached the size of from two to five kilos weight, they are given to the confectioner. —*Galletti*, p. 42.

The mountain between Luri and Meria is almost entirely covered with larix pines, thanks to the care of the late M. Estella, who, on returning from America to his native country, caused a great extent of land to be sown with pine seed, which in a few years has formed a fine forest. —*Galletti*, p. 104.

the valley, and the people about, all of whom seem busy, say there is no regular hotel here ; but they direct me to a Casa Cervoni, in the upper part of the two or three streets forming the village, just off the main road, at which the opinion seems general that I may be able to find a lodging.

Madame Cervoni, a very tidy bustling little body, comes out of the "general shop," or "store" in the lower part of her house, and is at first rather difficult as to my request —"they are 'occupati' just now ; the silkworms—of which their two adjoining houses are full—are about to change, and require all their attention," &c., &c.—but after a little time she relents, and pleasantly declares she will receive me on condition of my kindly adapting myself to the "circonstanze." And then—yet another marvel of humble lodgings in remote country parts of Corsica—she shows me into a perfectly neat and clean sitting-room up-stairs, with small bed-rooms so completely good in all ways, that I resolve at once—especially that I am now well persuaded of the beautiful character of Luri scenery—to remain here for the night. There will be fully enough work in the valley, and at Seneca's tower, to occupy me this afternoon and a part of to-morrow ; and, finally, since I find on inquiry, that to go on to Tonino or Rogliano would be a journey of hurry and fatigue, not reckoning the way back by the sea-wall to Bastia, I definitely settle that Luri is to be the farthest point I can visit in the north of Corsica. (It is seventeen kilométres from the marina of Luri to Macinaggio, and this doubled, with the addition of five hence to the sea, and twenty-seven of return to Bastia, are in all sixty-six, a distance which would allow of no leisure, even if there are subjects to draw, which is doubtful.)

The breakfast which my hostess, or rather the host's sister, brings up, is a frugal one ; but the nice tidy little woman apologises for its scarcity, on the usual ground that it is not possible to get either fish or meat on so short a notice ; the extreme cleanliness of everything might have done credit to a Dutch inn, and was the counterpart of the hotel at Evisa. As novelties I remark a plate of preserved citron, (1) and that the wine is unlike any known to my Corsican experience, white, and not unlike an inferior Chablis, but stronger. The master of the house, too, comes, and sits down—a plain straightforward man, full of zeal for agricultural progress, and singularly unlike the more apathetic Corsican, so generally typical of the race on the further side of the island. Not being a regular innkeeper, M. Cervoni says, " I beg you to make as much, and as long a use of my house as you please ; this room and the bed-room are at your disposal, and one up-stairs for your man ; and whatever other assistance or information I can give you, pray let me know."

He talks of silkworms, which, he says, do not as yet succeed particularly

(1) The valley of Luri, and all Cap Corse is famous for the cultivation of the citron. According to M. Tommei, the Maire of Luri, the Cape produces 1,600 kilogrammes of this fruit.

well in the valley, but believes that this arises from want of knowledge and
care ; of the different sorts of wines made in Cap Corse ; of general culti-
vation ; and of the Maire, M. Estella, who died in 1841, and whose portrait
hangs in the room, the founder of all prosperity in Luri. And I remark his
Italian to be of the best I have heard spoken in Corsica ; possibly the nearness
of Tuscany influences the dialect of this northern part of the island, though
throughout all this Corsican tour I have been agreeably surprised at finding
no difficulty in understanding the people ; even the peasants talk a sort of
South-Italian or Neapolitan dialect, which was long ago familiar to me.

M. Cervoni, as well as M. Tommei, the Maire (who comes to visit me
on hearing that a stranger has arrived), tells me that I can go up in the
carriage towards Seneca's tower as far as just below the Capuchin convent
at its base, by the road which leads to Pino ; and that from the convent
the ascent on foot is easy. Both host and visitor dissuade me from going
there till sunrise to-morrow, at which hour, they say, the coast of Italy is
clearly visible. Miss C. seems to have been a great favourite here, and to
have delighted all the people by her resolute activity and genial ways.

Later I went with my pleasant intelligent landlord to see his silkworms
—two houses full, in every open-windowed room, on stages from floor to
ceiling, and so placed as to admit of constantly cleaning the "vermi"—
a sight which recalled to me some nights of Cretan discomfort, when the
said "vermi," or caterpillars, were not in possession of a home of their own,
but occupied, very unpleasantly, every inhabitable corner of the dwelling.
Here everything connected with the culture was faultlessly clean.

At 3 P.M. I go out, intending to get drawings of this beautiful valley,
though its position, directly east and west, make it no easy place to study
in ; all the views, from the nature of the place, require you to sit directly
opposite the sun, and the blaze of light at this hour tries the sight extremely.
Some time, therefore, is well spent below a large wych elm, close to the
church, until near sunset, where the schoolmaster gives me some information
respecting the valley. There are fourteen hamlets in it, the combined
population of which is 2,011. Piazza is the name of the principal village ;
Poggio, where the Maire resides, that of the next largest ; Santa Severa is
the marina.

Close to where I sit is the stream which runs through the whole length of
this vale to the sea ; at present but a gentle streamlet, it is a fierce torrent in
winter, only kept in bounds by the causeway which M. Estella was the first
to commence. Growing above the stream are mulberry and massive walnut
trees, ilex, olive, fig, and alder, the great variety of the vegetation in this
valley being one of its first charms, and filling it with exquisite scenery of
the quietest and most delightful kind. No loiterers, who at Olmeto, Vico, or
elsewhere, are so conspicuous an ingredient of Corsican village life, are to be

seen here ; every one is occupied in agriculture, and the only sounds near are
from the school close by, whence there comes a hum of studious children, and
from the low underwood by the water, every bush of which resounds with the
voices of countless nightingales ; and when, later in the day, I make a drawing
above the valley from close to a tufted grove of chesnuts, the multitude of
warblers there is most delightful.⁔

But, unable to encounter drawing for any length of time in face of the
setting sun, I am obliged to desist, not before my eyes have suffered. Every-
body, I observe, as they come up the road to the villages at the west end of
the valley, protect their sight by umbrellas from the direct rays so exactly
opposite. There was little to be done, therefore, but to seek out spots below
the long-armed olives (they are like those at the monastery of S. Procopius in
Corfù), whence I may make a drawing to-morrow ; and so, by degrees, I go
back to the village, never in any way molested by any one in this Rasselas'
" happy valley."

A dinner, more respected in its commencement of soup and boiled fowl,
than in its conclusion of citron and raw peas, concludes the day. It should
not be overlooked that in these places it is expedient to eat up the contents
of the first dishes presented to you, lest no others so good, or even lest none
at all, should follow.

Now that the sun is down, the rich full greenness of this little valley is
delicious ; but if it is so hot now, what must its temperature be in August ?
There is a good breeze, however, and no feverish feeling whatever.

Remembering Olmeto and Sartené, Bonifacio, Tallano, and Vico, how
grateful is the cleanliness of this pleasant little house ! Talk with my land-
lord and his intelligent and agreeable sister passed away the rest of the
evening.

May 26.—The most restless or fastidious might sleep well in the little bed
room of the Maison Cervoni at Luri, the cleanliness of which was so evident
that I did not even have my camp-bed set up. The obliging people of the
house had risen, purposely to get me coffee, at a very early hour, and at 4 A.M.
Domenico and the trap were ready—Flora, perceiving that no luggage was to
be taken, wisely preferring to remain behind.

The carriage road leading from Luri to Pino ([1]) on the west side of Cap
Corse, is one of the more recently made routes forestières of Corsica ; it
soon ascends the hills at the end of the valley, winding up the Cap Corse
backbone, as it were, by beautiful woods of chesnut and ilex above Poggio
and other hamlets—every turn bringing to view fresh charms, either in the
combinations of the convent and the rock of Seneca's tower, or in the long
vista of the vale of Luri, still all in shadow as far as the faint blue sea line.

([1]) The view of the western coast, with its red reefs and little indented rocky bays, and of the

By 5 the top of the ascent is reached, one which it would not be a pleasure to drive down unless with a careful driver, by reason of frequent sharp turns on the edge of steep precipices, and of the absence of parapets. In a narrow cutting of the rock through which the road is carried at its highest point of elevation, a white marble tablet is fixed, at the height of six or seven feet above the ground, and on it is the following inscription :—

> "Dernière pensée d'un Corse, mourant à 2000 lieues de sa patrie—
> ' Ecrivez à nos compatriotes d'ouvrir une route de Pino à Sainte Lucie-sous-Seneque.
> Si l'argent venait à manquer, quelqu'un y pourvoira.'
> 23 Decembre, 1846."[1]

A dying thought, it seems to me, better worth commemoration than many less unselfish which it has been considered right to preserve.

A few steps beyond this cutting you come on the wide expanse of the sea to the west of Corsica, and I should have liked much to have followed the descending road to Pino and other villages, on this side of Cap Corse, especially to Pino, having an introductory letter to M. Piccioni the Maire of Bastia, who resides there ; but of this time would not allow, and I regret extremely to be able to see so little of this Cape, one of the most interesting parts of the island.

From the top of the ascent I now send back Domenico and the trap, and following the footpath which leads up from immediately above the tablet rock, through aromatic " maquis," to the old Capuchin convent, I continue to mount the path, here broken and narrow, to the tower, so-called, of Seneca.[2]

densely wooded piève of Pino, was quite a surprise. Pino has a few château-like houses and beautiful parks, where a Roman duca would not disdain to dwell. There are millionaires even in Corsica, and especially on the Cape, among whom are a few whose wealth has been gained by themselves or their relations in the Antilles, Mexico, and Brazil. . . . Above Pino extends the canton Rogliano, together with Ersa and Centuri, a district distinguished for its wine, oil, and lemons, and vying with Luri in cultivation. The five pièvi of the Cape, Brando, Martino, Luri, Rogliano, and Nonza, have in all twenty-one communes, and about 19,000 inhabitants.—*Gregorovius*, pp. 159, 161.

Pino, remarkable for its many towers and its fine houses. It is the native place of Piccioni, a man who has merited well of humanity, by bequeathing large sums of money to his compatriots for various charities, in dowries for young girls who are in poverty, in helps to educational institutions, in opening new roads, and in many valuable gifts to his parish church. He died at St. Thomas, in America, but his remains have been brought to Pino and buried in a superb tomb. . . Minerbio, a little village of the commune of Barettali, and on the road leading to Pino, is surely the happiest corner of the island ; no crime, nor any of those implacable hatreds which desolate Corsica, has ever troubled the profound calm enjoyed by these peaceable people, who as yet only know the golden age.—*Galletti*, p. 107.

[1] ["Last thought of a Corsican, dying at a distance of 2,000 leagues from his country—'Write to our compatriots to open a road from Pino to St. Lucie-sous-Seneque. If money should be wanting, somebody will provide it.' 23 December, 1846." This modest tablet, I hear, was placed where it now stands by M. Piccioni, the present Maire of Bastia, and relates, I am told, to his father, Signor Piccioni, of St. Thomas's in the West Indies.—E. L.]

[2] This part of the island is full of vague and whimsical traditions of Seneca, exiled to Corsica for seven years, on account of his too great intimacy with Julia, daughter of Germanicus, and from which he was recalled by Agrippina, &c. The hermit of the convent of S. Nicolas did not fail to show us the staircase, the oven, and even the chapel of Seneca, &c. The solidity of construction of the Tower of Seneca must be extreme, exposed as it has been to the tempests of centuries; it was really, under the name of Torre de' Moti, one of the forts of the Signori da Mare, famous in the wars of the fifteenth

But after toiling a good way up I abandon the pilgrimage, because a thick mist covers the sea, and not a symptom of the shores of Italy can be discovered ; the coast of Cap Corse is on this side thoroughly wild and rugged, but does not seem to me to possess any particular interest ; moreover, I am disinclined to encounter any extra fatigue. The latter part of the climb to this old tower—so G. informs me, who went to the top—is very steep and

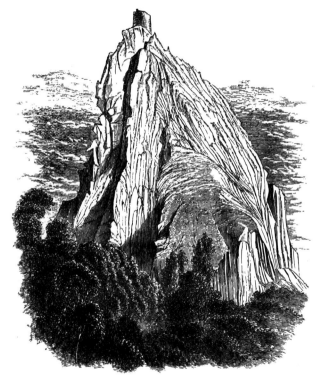

SENECA'S TOWER.

difficult. The building itself, though of early date, does not appear to have anything of Roman times in its composition ; rather it has been erected by the Pisans, or by the Signori di Mare, who ruled this part of the island about

century, allied with and natives of Genoa ; but the philosophic title, more popular, has prevailed.— *Valery*, i., p. 46.

. . The construction of this edifice seems nevertheless to belong to a less remote epoch, and in no way indicates a Roman origin. Whatever it may be, it has always preserved in Corsica the tradition of Seneca's stay there, and the name of it is given to the canton. Above the Tower of Seneca is Pinzo Vergine, where are ruins of Dolmens or Druidical altars.—*Galletti*, p. 104.

Seneca, the philosopher, hath left us two most horrid pictures of Corsica, very false indeed, but

the tenth century. This, theory, however, is treason in the estimation of the good people of Luri, who firmly adhere to their opinion that Seneca, the philosopher, was shut up in it. "*My* father," said one of the inhabitants of the valley to me, "told me that this was told to him by *his* father, and back from father to son for eighteen centuries; you see, therefore, that the story cannot be otherwise than true"—a position I did not attempt to combat. What is more to the purpose, so far as a painter is concerned, is that this rock and tower of Seneca are most picturesque; thick groups of ilex grow at the base of the pinnacle, and all the upper part of it is a bright bare rock.

From the very forlorn and ill-kept garden of the Capuchin convent there

executed with uncommon strength of fancy and expression. . . . He was banished to Corsica, where he remained for seven years. . . . Here he indulged his fretted imagination in the following epigrams :—

> " O sea-girt Corsica ! whose rude domains
> First owned the culture of Phocæan swains ;
> Cyrnus, since thus the Greeks thy isle express,
> Greater than Ilva, than Sardinia less ;
> O Corsica ! whose winding rivers feed
> Unnumbered, as their sands, the finny breed ;
> O Corsica ! whose raging heats dismay
> When first returning summer pours her ray !
> Yet fiercer plagues thy scorching shores dispense
> When Sirius sheds her baneful influence ;
> Spare, spare the banished ! spare, since such his doom,
> A wretch, who living, seeks in thee a tomb !
> Light lay thy earth, in pity to his pains,
> Light lay thy earth upon his sad remains."--*Boswell*, pp. 13, 14.

Seneca surely lived in one of the Roman colonies, Aleria or Mariana, where the Stoic, accustomed to Roman comfort, may have furnished a nice house near the sea, from whence the favourite mullus or tunny had no long journey to his dinner-table.

To the exiled Seneca the island was only a prison to be hated. The little that he says about it in his letter of consolation shows how little he knew about it. For instance—"This island is scarce fertile enough for the sustenance of its own inhabitants ; it produces nothing desired by other nations." *Gregorovius*, p. 166.

Gregorovius, who has some very amusing chapters about Seneca, gives translations of the two epigrams written by or attributed to him during his Corsican exile.

> " Corsican island, thou erst by Phocæan colonists dwelt in,
> Corsica whom they called Cyrnus in language of Greece ;
> Corsica, shorter than great Sardinia, longer than Elba ;
> Corsica, crossed and recrossed by many streams full of fish ;
> Corsica, terrible isle when summer's first heat 'gins to burn us,
> Fiercer yet when his face, Sirius shows in the sky.
> Spare then the exiles—rather the buried already I'd style them —
> O'er poor living men's dust soft be thy covering soil.

> " Barbarous, and by rugged rocks in Corsica guarded ;
> Desert and vast are her fields, barren on every side ;
> No fruits autumn matures, nor corn the summer doth ripen,
> Nor by Pallas' dear gift is the dark winter cheered ;
> Never is spring there blest by the growth of shadowy leafage ;
> Never a plant that will thrive in the poor hapless soil ;
> Here is nor bread nor water, nor life's last boon, even fire, seen ;
> Here is the Banished alone, lone with his Banishment."

Gregorovius. p. 170.

PLATE XXXII.

VALE OF LURI.

are beautiful views from the valley ; but still more so are those from points a little below and beyond the monastery. There is something peculiarly finished and delicate in the succession of slope after slope, all clothed in green, spreading away gradually and more faintly, and diminishing into aerial distance, till the picture is closed by the sea, with Elba, floating as it were—so pale and indistinct is the sea-line—in the filmy atmosphere above it, like Gulliver's island of Laputa. (*See* Plate 32.)

Walking down the hill, I am hailed by some one who is superintending the mending of part of the road, and the agreeable Maire of Luri, M. Tommei, joins me. It would have been a pleasure to have accepted his friendly invitation to visit him at Poggio in this charming valley, and to have explored it more thoroughly with one who knows it so well. M. Tommei thinks that the old Lurinum stood below the village of Mercurie, and he points out to me some distant old towers (not however, to my thinking) of Roman fabrication, which he believes to mark its limits. As we arrived at his village, the Maire presses me to have some refreshment at his house, but when I tell him I dare not lose a minute of working time, now that the sun is so rapidly mounting, and that the great heat and absence of shadow in the valley would soon stop my morning's labours, he leaves me with great good breeding to my own devices.

These consisted in hard work to get such drawings as may recall as much as possible the dense vegetation of this lovely valley, and in returning higher up the road to make some fresh memoranda, a task as irksome, now that I have to look east to a dazzling sun, as that of my western drawing was yesterday evening. My foreground might at least have been embellished by the largest snake I have seen in the island, and, truth to say, it is one of five I have seen in Luri, and of these three were dead, so that it is plain their reputed harmlessness brings them no immunity from persecution.

After this there only remains the completion of drawings commenced yesterday ; and by 10.30 I returned to Madame Cervoni's breakfast, which, to-day, in its excellent stewed fowl and ivory white broccio, shows greater research than on the first essay. The Maire and the village doctor came in afterwards ; and the landlord brings samples of Cap Corse vintage ; a conversazione prolongs itself till Flora and $C^{o.}$ are ready, and I leave these plain and friendly people and the happy valley with regret. Before starting I make enquiries as to the road in the Balagna near the Ponte dell' Asco, Miss C. having very kindly written to me at Bastia warning me that the bridge has been carried away by the river ; the doctor says that from Belgodére there is a road to Moltifáo and thence to Corte without the necessity of passing the Asco at the broken bridge, but my host and the Maire doubt if that way be practicable for my carriage, light one though it be, and advise me to ascertain distinctly well at Belgodére whether it will not be better for me to return to

BASTIA.

Bastia, and thence to Corte—a caution to which, after the Bastelica incident of May 3rd, I am inclined favourably to listen.

At 2 P.M. I leave Piazza di Luri, and passing through the groves of aged white and gray-armed olives, and the rich abundance of fig, lemon, and walnut, soon arrive at the Marina of Sta. Severa by the sea. Far beyond my expectations have been the interest and beauty of the valley of Luri, and long shall I remember its pleasant and industrious people, its quiet and shady gardens and woody hill slopes, and its lofty traditional beacon tower, with its tales of the Roman philosopher.

Very beautiful are some of the mouths of the little valleys of Cap Corse on such a day as this, the pure emerald green water close in shore rippling over the milk-white sand ; the mountains south of Bastia pearl clear on the horizon, and looking seaward—"blue were the waters, blue the sky,"—to the hill of island Elba on the line between them. The coast road—red-legged partridges now and then trot briskly across it—is accomplished as far as Brando, where again I reject Domenico's suggestion that the Grotto should be seen, and shortly afterwards, sending on the trap, I pass an hour, spite of the great heat, in making a drawing of the white city on its promontory, seen between graceful olives bending over the sea. By 6.30 I have walked on to Bastia. Alas for the exclusive and evanescent Moufflon ! After having resided here a week, he has gone back to his home at Serraggio.

CHAPTER X.

Leave Bastia—Ascent—Gardens—View over the Plain of Biguglia—Range of the Nebbio Hills—Gulf of St. Florent—Pass between Rocks—Town of St. Florent—Hôtel des Passageurs—Arrival of Ironclads—Solitude around St. Florent—Picturesque Houses—Excellent Cheer at M. Donzella's Inn—New Beds—Leave St. Florent—Scenery on the North of Corsica—Approach to Île Rousse ; its Picturesque Bay and Rocks—Interior of the Town—Hôtel De Giovanni—The demure Waitress --Leave Île Rousse—Algayola, its deserted appearance—Beautiful Scenery of the Balagna— Village of Lumio—Bay of Calvi, and approach to the Town—Legend of the imprudent Bishop— Forsaken condition of Calvi ; its Fortifications—Civility of Corsican innkeepers—Calvi the Faithful—Neighbourhood of Calenzana.

May 27, 6 A.M.—Off from the Hôtel de France, a very fair inn, with a good cook and very obliging master.

The road to la Balagna(¹)—the two divisions of which, upper and lower, I have just four days to "do"—climbs the steep hill immediately behind Bastia as soon as you leave it, and zig-zags among villas and fruit gardens, with a view of the city ever at your feet, and more and more of a " bird's-eye " nature as you go slowly up the stiff ascent. In many of the gardens I remark a profusion of tall white lilies ; cypresses, too, which are not common in Corsica ; (²) and, for the first time in the island, Japan medlars.

Towards the south, the plain of Mariana and the unhealthy marsh and lake of Biguglia are spread out as if in an unrolled map ; no breeze is stirring, and looking eastward there is not a single ruffle or ripple on the calm water from shore to horizon. So delicately smooth is it, as perfectly to resemble the palest blue-gray satin, with a broad and lovely shimmer of light eastward of Elba—

<div align="center">" A light upon the shining sea."</div>

Higher up, city and cultivation left behind, the now well-known Corsican

(¹) An excellent road first climbs the sides of Monte Bello for a couple of miles. You look down on your left into the plain of Biguglia and Furiani, and into the large lagoon into which the river Bevinco empties itself. When the summit is reached, the road descends towards the western coast, the eastern being lost from sight ; and the enchanting picture of the Gulf of San Fiorenzo suddenly opens out before your eyes. . . . This road was laid down by Count Marbœuf, and it was here that Bernadotte laboured on the roads.—*Gregorovius*, p. 253.

The road from Bastia to St. Florent presents such steep inclines and so many curves, that sooner or later it will be necessary to rectify it by the valleys of the Bevinco and the Aliso. It is little frequented, and the passage of carts meet throughout great difficulties.—*Grandchamps*, p. 104.

(²) I saw but few and small cypresses in Corsica, yet they ought to belong particularly to this island of death.—*Gregorovius*, p. 240.

world of cystus and "maquis" commences, with here and there groups of ilex and gray rocks draped with wild vine, honeysuckle, and purple vetch, with a wondrous affluence of vegetable beauty. Still the road—a capital Route Impériale—ascends, and at 7 A.M. and onwards the Casinca hills begin to be hidden by the nearer Nebbio range of rounded green heights ; at 8 there is a space of level road and a good fountain, and soon afterwards the top of the "Bocca" or pass is reached at, I think, about the eleventh kilométre from Bastia. Beyond this all Eastern Corsica wholly disappears, and you look down on the Gulf of St. Florent([1]) on the north coast of the island, and on a new world of mountains — mountains are never wanting in Corsican landscape ; and nowhere, except in the eastern plain of Aleria and near Bonifacio on the west, has the lover of any other kind of view the faintest chance of being gratified.

The descent to the shore is in steep zig-zags, but at every turn of the road the scenery becomes more interesting, from the richness of olive growth

([1]) San Fiorenzo is an extensive gulf ; it runs about fifteen miles up into the country, and is about five miles across. . . . There are several creeks and bays, particularly on the south side of it, which are quite secure. There is in particular a bay under the tower of Fornali, about two miles from San Fiorenzo, which is highly esteemed, and where vessels of considerable burden may be safely stationed. —*Boswell*, p. 171.

The Gulf of St. Florent, the safest in Corsica, almost recalls the brilliant beauty of La Spezia. Like that, it had attracted the attention of Napoleon, who had entertained a project of fortifying St. Florent, and of making it a station for the fleet, and who went so far as to intend making it the capital of the island.

The Nebbio, of which St. Florent was the chief place, was always, since the defeat of the Romans at the Col di Tenda, the principal scene of the military events of the island, and the occupation of the one has constantly led to the conquest of the other.— *Valery*, i., p. 54.

The situation of San Fiorenzo is so glorious, and the gulf, one of the most beautiful on the Mediterranean, so alluring to a more considerable maritime settlement, that one cannot but wonder at its desolation. Napoleon mentions this place, in Antomarchi's "Memoirs."

On the right the gulf now opened out in its full size, and on the left, far in the background, is the high towering amphitheatre of mountains, which descend in a semicircle towards the sea basin. They are the proud mountains of Col di Tenda, at the foot of which the Romans of old were defeated by the Corsicans. They surmount the district called Nebbio, which encompasses the gulf of San Fiorenzo, and open out only towards that district. From the earliest times the Nebbio was regarded as a natural fortress ; wherefore all conquerors, from the Romans to the French, have endeavoured to force an entrance into it and gain a firm footing in it, and innumerable battles have been fought there. The Nebbio, at the present day, contains four cantons or pièves, San Fiorenzo, Oletta, Murato, and San Pietro di Tenda.

According to Ptolemy, the ancient town of Cersunum must have stood somewhere on the gulf. In the middle ages the considerable town of Nebbio was situated here, whose ruins are half a mile distant from the present San Fiorenzo. The town decayed, like other considerable towns and bishoprics in Corsica, Accia, Sagano, &c.—*Gregorovius*, pp. 254, 255.

The ports in Corsica, numerous on the west side, are three only on the east. Those nearest to France are at the head of the gulfs of St. Florent, Calvi, Sagona, and Ajaccio. Their security is not complete, and in some of them vessels are in danger when the south-eastern winds blow with violence. —*Grandchamps*, p. 82.

[See M. Grandchamps for details about improvements at Fornali, the true port of St. Florent.—E. L.]

On the northern shore of the gulf (of St. Florent) are two or three villages, of which the principal is Nonza. This is properly the key of Cape Corso ; because from the Cape into the interior parts of the island on the western side, there is only one pass, and that leads through this place.—*Boswell*, p. 26.

Nonza, on an inaccessible rock by the sea-side.—*Galletti*, i., p. 109.

—the trees now loaded with blossom—and other fruit trees, and from the gradually widening prospect of "mountain and of cape" northward to Cap Corse, along the south-west corner of which the road to St. Florent in this upper part of its course may be said to be traced. Three or four villages, the most conspicuous of which is Patrimonio, are in sight, among slopes of green and olives in this cheerful landscape.

9 A.M., at the seventeenth kilométre from Bastia, the road being now nearly level with the shore and passing through a broad green vale and scattered olives, turns westward to the mountains which here descend to the sea, leaving only a narrow pass through a rocky screen—the natural boundary on this side of the once warlike canton of Nebbio.([1]) This pass of picturesquely overhanging rocks, with immense hollows or caves below them, is very fine; the dark openings of their gloomy recesses are perfectly fitted for backgrounds of "brigand subjects" and remind me of the great caverns near Eleutheropolis on the road from Gaza to Jerusalem, and by their colour and striped surface, of several similar grottoes near Corpo di Cava of Naples. In face of these caves—where the oleander grows abundantly by a slow streamlet—I halt to draw until 10, and then drive on to St. Florent, which is but a short way beyond this striking rock barrier.

The town of St. Florent([2]) appears even smaller than I expected, consider-

([1]) Marmocchi calls the Nebbio a province full of mountains and steep hills, which description infuriates the Abbé Galletti, who declares that the geographer never was there, but allowed himself to write after the dictation of an eccentric man, who led him into gross errors.—*Galletti*, p. 111.

[See Forester, p. 92, for remarks and details, well worth reading, of a journey through Nebbio, of the beauty of the woods, and of the cultivation in that district, which I regret I could not visit. —E. L.]

([2]) St. Florent, well placed at the entrance of a fertile valley, has but 400 inhabitants ; it owes this to putrid and malignant fevers produced by the lagoon. The land is excellent, and the cultivation of both cotton and sugar-cane has been tried with success in the vicinity. The difficulty of the paths from St. Florent to Île Rousse obliged me to go thither by sea.— *Valery*, i., pp. 55—62.

Half a mile from St. Florent stands the gothic cathedral of Ste. Marie de l'Assomption, not of large size, built of Corsican Travertino. Filippini records that a bell was found in the old Campanile bearing the date 700, the epoch of the Lombard rule. This church, as well as the adjoining ruins of the old episcopal palace, resemble at a distance a real fortress. Such an appearance, however, is quite in harmony with the qualities and prerogatives of those bishops of Nebbio, who took the title of Counts, wore a sword in the assemblies of state, and had two pistols on the altar when they said mass. The church may occupy the site of the ancient town Cersunum ; excavations made in the neighbourhood have brought to light numerous Roman funeral monuments, dating perhaps as far back as the defeat of the Consul Papirius by the Corsicans at the Col di Tenda.— *Valery*, i., p. 56.

Siege of St. Florent by Nelson in 1793.—*Forester*.

San Fiorenzo was one of the first Corsican places that gave themselves to the Bank of Genoa in 1483.—*Gregorovius*, p. 255.

[The journey of Gregorovius along this coast is full of interest, and exactly descriptive of the scenery as well as of the habits of Corsican life in 1852. "On the whole journey I saw not a single conveyance. Now and then came a Corsican on horseback, with his double gun slung over his shoulders, and an umbrella over his head." "Here," he grimly adds, "they shoot a great many wild pigeons and men."—P. 257.]

I had been received at the house of M. Gentili, nephew of the General, and allied through his wife

ing how important a part it has always played in Corsican history, and looks almost too tiny (it has but 750 inhabitants) to have had any history at all. Its one short and narrow street leads to a little Piazza, where there is a little country inn—already favourably known to me by Miss C.'s report— and quite delightful for cleanliness and comfort; this is the " Hôtel des Passageurs," kept by Pietro Giuseppe Donzella, and, like other inns I have had occasion to mention, is a most strange contrast for its excellence to those in some of the larger towns.

A short glance at St. Florent, which stands quite at the water's edge, and is backed by what may be called fortified heights, though of no great elevation, shows me that whatever work there may be for the pencil here will all lie in the direction of the farther side of the gulf, and that the one day I have allotted for this part of the island will abundantly suffice for all I require. M. Donzella provides at noon a capital breakfast ; his inn contains several rooms besides those allotted to me, all clean and decent, the walls newly whitewashed, and profusely hung with little prints, several of them views of Naples, Vesuvius, &c.

Meanwhile this small place has been, since my arrival, a prey to amazement and curiosity, by reason of a war steamer which has suddenly appeared, and having steamed as far as nearly opposite St. Florent, has gone back and disappeared behind the point on the west side of the gulf, making no sign. But at noon she returns, in company with the squadron of French ironclads, which in all the fulness of power and ugliness, are ranged opposite the town, and boats soon coming off, these events communicate to St. Florent as much agitation and life as it is perhaps capable of receiving.

to Paoli. I remarked in the parlour a contemporary portrait of the latter of a much nobler expression of countenance than the ordinary lithograph possesses.—*Valery*, i., p. 57.

St. Florent, a small town, and the least important in the island (if even it can be called a town), has always been witness to the most important political facts. The Gulf of St. Florent has ever been the point of embarkation for new conquerors of Corsica. It was the first Corsican town which, in 1483, gave itself to the Bank of St. George in Genoa.—*Galletti*, p. 112.

Although the Gulf of St. Florent is one of the most vast of Corsica, the town has no port. The safest anchorage of the gulf is at Fornali, and there is only a mole or quay at St. Florent. This town was very recently surrounded by marshes, and its population was decimated by fevers. The works of drainage undertaken some years ago have lessened these evils, though they are not completely extinct. The commercial importance of St. Florent should not be exaggerated, for the town being separated from the centre of Corsica by a chain of mountains, the lowest part of which is 1,200 mètres above the sea, the produce of the interior cannot be economically transported. . In a military point of view the Gulf of St. Florent is of the greatest importance.

This town (St. Florent), founded in 1440, gave itself to Paul de Thermes in 1553, and was recognised by Andrea Doria in 1554. In 1731 Giafferi and Ceccaldi took possession of it ; in 1762 Paoli took it ; and in 1794 the French sustained a remarkable siege against the Anglo-Paolists. In 1796 it fell again into the power of the French. "The situation of St. Florent (said Napoleon I.) is one of the finest possible, close to France, and not far from Italy ; her coasts are safe, commodious, and might receive considerable fleets. I should have made a great and fine town, which should have been a capital ; I should have declared it a fortress, and there should have been constantly vessels stationed there."—*Grandchamps*, pp. 16, 17.

ST. FLORENT.

PLATE XXXIII.

It was 2 P.M. before I went out to draw; the heat was great, and the environs of St. Florent shadeless. A more compact little gulf can hardly be imagined than this, nor one more tranquilly shut out from the world ; formerly the capital of the Nebbio district, it can only be approached by sea, or by crossing mountain passes ; and on realising its position, the old conditions of its existence, when ironclads and high roads were unknown, can easily be understood—days when the Bishops of Nebbio used to read mass sword in hand. And were any one desirous of living a life of great retirement and quiet (barring the near and head-splitting sound of church bells), St. Florent might be well recommended as a fit place, especially that its little hotel is so good—always supposing that the winter climate is a pleasant one, about which I have my doubts, as this side of the gulf is not a little exposed to the north-west winds.

A feeling of extreme loneliness pervades the neighbourhood of the town ; extensive shallows teeming with myriads of fish, and wide marshes, communicate a desolate air to the place, though much of the marshy ground has been drained of late years. The ugly iron ships alone break the spell of solitude which seems to hang over sea and land ; excepting that below the eastern hills is a hamlet and an ancient church, formerly the Cathedral of Nebbio, which I had intended, but had not time to visit. Of course (see rules of destiny, page 169) the only possible spot whence it was practicable to make a drawing of the town and gulf was on a roastingly bare slope of tilled ground, which I contemplated with dread, although preparing to sacrifice myself to an hour's broiling; but on arriving there, I found the Suliot had placed my folio and seat high up below a single lentisk (or schinos) tree of great size, which for the sake of its shade was worth a stiff climb to reach over some rocks —G. meanwhile, who, remembering how Admiral Yelverton at Malta used to take his ironclads to fire at the rock of Silsifla, continually pretends to forbode that the French admiral may suddenly happen to order this big lentisk tree to become the mark for all his squadron to shoot at. No such calamity, however, occurs, and I am able to complete my drawing of a place singularly full of individual character and beauty. (*See* Plate 33.)

At 5 P.M., returning towards the town, I work again near it ; the houses of St. Florent are not à la domino-warehouse, but are aged, irregular, picturesquely gray, and discoloured, and many beautiful little bits may be gathered on the edges of the tiny city, reflected clearly in the water from which it rises.

At the Hôtel des Passageurs, lobster-eating and other festivities are being carried out on a large scale by the sailors of the squadron ; but though the house is quite full, that does not prevent M. Donzella giving me a good dinner of soup and stewed veal, pease, cutlets, and olives, cream-cheese (broccio is out of season or does not exist hereabouts), and the Chablis-like wine of

these parts, as good as the cookery. My host, who is so like a Neapolitan
in dialect and manner, that, coupled with the many views of Vesuvius in his
rooms, I made sure of his being so, is, on the contrary, so completely a
Corsican, that he has never been as far as Calvi, or even out of the Nebbio
farther than Île Rousse, of which he says, "C'est plus belle que Calvi, mais
à Calvi il y a plus de seigneurie—Île Rousse is prettier, but Calvi more
'genteel.'"

My sleeping-room looks out on the sea, now "a sheet of summer glass,"
with the line of great ships dark against the last gleaming of the pale western
sky. So clean is this house, that for a second time in this journey I shall try
the hotel bed instead of my own. The past day has been a thoroughly
pleasant one, and now there remain but nine more of Corsican wanderings.

May 28.—There is little wisdom in trying new beds if you can avoid doing
so ; this one is perfectly clean, as was that of Luri, but each had its pecu-
liarities, arising from some springs or wires of its inner constitution, which
led it to make noises of the most surprising and unexpected kind ; it was
impossible to prepare the mind sufficiently for the sudden sounds which
occurred even on your moving your head, far more when it was a question of
"turning round." At Luri a spring in the mattrass was loose, and at times
made a most remarkable humming ; while in the present instance lengthened
and mouse-like squeakinesses come from some incoherence of the irons ; as the
invalid says in Wilkie Collins's "Woman in White," "Take it away, something
about it creaks ; take it away!" and henceforth, therefore, I forsake not the old
camp folding-bed. For all that, I must record that a nicer little inn, with more
obliging owner and better fare, it would be hard to fall in with, in whatever
part of the world you may travel, than the Hôtel des Passageurs,' at St.
Florent.

At sunrise the gulf resounds with a reveillé of bugles, and a single gun
from the eight ironclads : the squadron goes to Bastia to-day. At 5.30 A.M. I set
off to Île Rousse with Flora and C⁰·; the first part of the day's journey is to
wind round and across the sides of Monte Ruva, the spurs of which form the
western side of the Gulf of St. Florent, and separate Nebbio from Balagna.
We leave on the left the road to Oletta, by the direction of the only human
being in sight, an old woman whom Domenico, with scrupulous politeness,
addresses as "Madame," and then leaving the coast, ascend the hill by what
the landlord at St. Florent calls a "salituccia," along a broad Route Impériale.
The view of the gulf and the little city are very beautiful from here ; an
extremely simple prospect—St. Florent and the whole of Cap Corse, un-
broken by detail, like a single piece of opal, lie reflected in the calm trans-
parent bay, and this view, spite of the dazzling opposite sun, claims a halt
for drawing. (*See* Plate 34.)

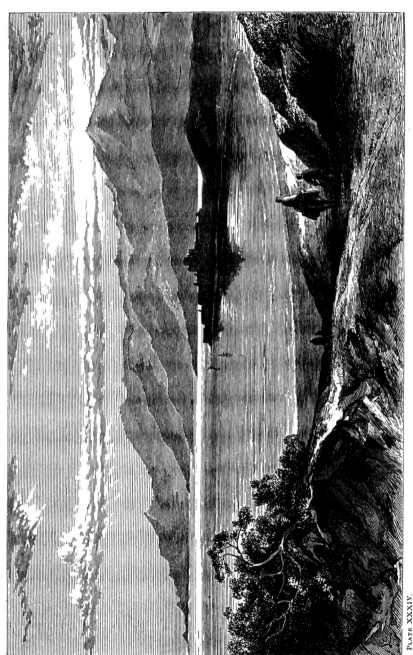

Plate XXXIV.

6.15 A.M.—For some way onward the ascent overlooks portions of the inner land of Nebbio—rounded mountainous distances and a good deal of cultivation; then, threading a lonely and narrow pass by the side of a ravine thickly clothed with underwood, the road leads along tracts of wild country, where once more cystus and asphodel still in bloom, isolated granite rocks and wild olive, are the characteristics of the scenery, and a feeling that one is in a wild unpeopled part of the world prevails, till at 7 A.M., a landscape of more cheerful character is approached, looking towards the St. Florent gulf, with beautiful views of Cap Corse, beyond slopes of pastures and innumerable olives down to the sea. This scenery, charming in colour and varied in outline, is greatly like that about Girgenti in Sicily, and to get some memorandum of it, a halt is ordered till 7.45.([1])

Here and there, though seldom, a wayside house is passed, and for another hour wild "maquis" and rock are the only ingredients in the landscape, as the road, gradually ascending, skirts a vast and savage hollow or amphitheatre, walled in on the south by lofty bare rocks. This rugged scenery, without culture or inhabitants, continues till about 9 A.M., when the top of the ascent is reached and the views east towards the Nebbio and the long line of Cap Corse are exchanged for a truly magnificent panorama of snowy mountains, the great heights above the Balagna and the district of Calvi.

From this point the road rapidly descends in zig-zags to the foot of the hills which divide Nebbio and Balagna, and in half an hour the small plain through which the stream of the Ostricone([2]) flows is reached, and here, at 9.30, after passing a few more scattered houses, is the mid-day halt to be made. Neither for horse or man, for landscape or for shade, is this a favourable spot; there is a fountain close by, but it is dry; a very meagre olive gives but little shelter from the great heat, and even that little is not wanted long, because a colony of ants make the ground below it an undesirable place of repose. On all sides there is a total lack of pretty landscape, and only a few birds give any interest to the locality by their voices, the quit-quit-quit of quails in the corn-field near, the turtle dove's note, and that of the cuckoo. Breakfast, therefore, is, on the whole, uncomfortable, and in half an hour after noon the journey towards Île Rousse is gladly resumed.

([1]) There are exquisite descriptions of the villages and scenery near Île Rousse in Gregorovius; the dreadful tragedy relating to Vittoria Pietri, wife of Muzio Malespino, which had occurred so lately as 1849, is told in it—a shocking history, from which it is a relief to turn to the description of the merry children of Isola Rossa dancing in a ring round a fire, and improvising.

"Amo un presidente
Sta in letto senza dente, &c., &c."—*Gregorovius*, pp. 258, 261, 266.

([2]) At Ostriconi it is believed the ancient Rhopicum of Ptolemy stood, at a point where there is still an old tower in ruins, on the left bank of the torrent, and at its mouth there are said to be others. The air of this valley is unhealthy. The torrent of Ostriconi, which takes its source on Mount Tenda, is the boundary between the provinces of Nebbio and Balagna, and between the arrondissements of Bastia and Calvi.— *Galletti*, p. 117.

In passing along this northern coast of Corsica, how clearly once more is the history of the island commented on and explained by these distinct natural divisions!—this district of Balagna is as much cut off from Nebbio, as Spain from France, or Switzerland from Italy, by mountain ranges. The road, now comparatively level (with good parapets, as, indeed, there have been through all to-day's journey), leads close along the shore, and wonderfully lovely is the pale blue, merging into green of the sea below—moveless, oily-calm lengths of bright sapphire, traced on the space of far dark blue—"cobalt," says the practical artist, "with pale passages spunged or washed out, or dragged light with a half-wet brush." And after passing increasing cultivation, especially of larger and more numerous olive grounds, and more long points—I had fancied this part of Corsica might be rounded, but there is only the long eastern plain in all this island that is not beset by points—Île Rousse is seen afar off, low down at the very edge of the sea on a slender rocky promontory. Arriving nearer to the town, I send on Flora and C⁰·, and at 2 stop to draw what might well be called Paoliopolis, for the place owes its creation to General Paoli, and hardly existed before 1760.(¹) (*See* Plate 35.)

At 3 P.M. I make a drawing on the beach—whence the town, though not

(¹) Isola Rossa is but a little harbour, but has a considerable depth of water, and is defended by a small island against the westerly winds. They talk of erecting a mole to lock it in on every quarter.—*Boswell*, p. 17.

Île Rousse, a place of merchant and custom-house officials, was commenced in 1758 by Paoli, in spite of the endeavours by sea and land on the part of the Genoese to hinder the work. This pretty little town, built to the sound of cannon, received its name from the islet of reddish rock opposite. Paoli wished to attract the mountain population of this part of the island to the seaboard, in order to take vengeance on Algajola, which was devoted to the cause of the Genoese, and at the same time to destroy the influence of Calvi, equally on their side. It is said that on seeing the first houses being built, Paoli observed, "I have planted the gallows on which to hang Calvi." Île Rousse, which counts a population of 1,200, is in effect the outlet for the produce of the Balagna ; and the export of oil to France is to the amount of a million of francs annually, half of the whole export of Corsica.—*Valery*, i., p. 66.

The nearer you come to Isola Rossa the more mighty are the mountains ; they are the romantic peaks of the Balagna, the Corsican promised land, which flows in truth with oil and honey.—*Gregorovius*.

The town of Île Rousse has its name from a neighbouring islet of a reddish colour. This little isle, called formerly l'Île de l'Or, was the haunt of pirates. When the Genoese became possessors of all Corsica, they fortified this island, and united it to the nearest mainland by means of a jetty, and thus delivered this fine district from the frequent incursions of the barbaresques.—*Galletti*, p. 117.

Nothing is more wanted in Corsica than a railway between the ports of Île Rousse, Bastia, and Porto Vecchio, whereby the ports on the coasts may be united by a rapid and easy communication.—*Grandchamps*, p. 107.

The Genoese came with gun-boats to interrupt the work, but the walls rose amidst the rain of their shot, and Isola Rossa is now a place of 1,860 inhabitants, and the important port and emporium of the oil-raising Balagna.—*Gregorovius*, p. 257.

There is the house where Paoli was surprised when the celebrated Dumouriez had contrived a plot against him ; and here Theodore of Neuhoff, King of the Corsicans, landed for the last time, and put to sea again when his dream of royalty was over.—*Gregorovius*, p. 260.

Île Rousse is the natural outlet of Balagna.' This town, founded by Paoli, has increased remark-ably in a short time ; new houses have been built there, and foreign capital has been attracted ; the port, which offered good anchorage, has been improved, and at present it is the most convenient on the west coast. Trade, both in imports and exports, augments yearly, an increase explained by the situation

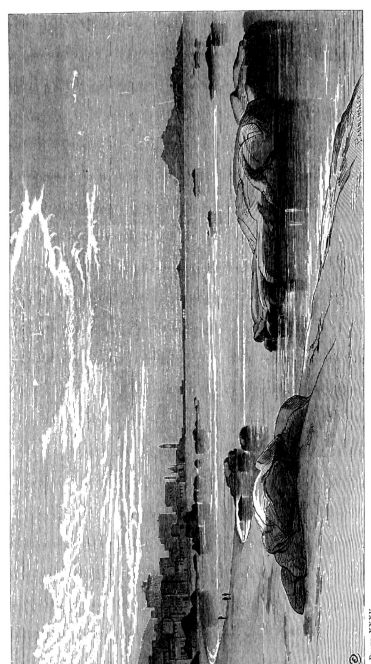

PLATE XXXV.

ÎLE ROUSSE.

in itself possessing any beauty of detail, combines on the whole very pic-
turesquely with its rocky harbour, and the foreground of masses of black
granite scattered on the white sandy beach ; the duties of the day, also, are
varied by a pleasant bathe, for it is not often that hard white sand, gleaming
below clear and not too deep water, presents so favourable an opportunity to
any one who is ignorant of swimming. Then onward to the town.

Île Rousse possesses several large and substantial houses, especially some
in the outskirts, near a Piazza where there are some fountains—one orna-
mented with a bust of Paoli. There is a colonnade-bordered market-place,
and a broad, well-paved street, and altogether the little town shows more
activity and importance than I had been aware existed in Balagna, except in
Calvi. The country immediately in the neighbourhood is full of olive slopes—

> "—— realms of upland prodigal of oil,
> And hoary to the wind"

and on the hills inland are many villages, Monticelli, Santa Reparata, &c.,
giving much life to the landscape, which is completed by a glorious serrated
snow-topped mountain range far above all. A painter lingering some time at
Île Rousse would find that many delightful excursions might be made to the
hills on the south of it, but none such are practicable for me, the limited time
now at my disposal obliging me to adhere to the coast road.

So I ramble through the town and on to the pier, beyond which there are
works in progress connected with a small fort—for there is a little garrison at
Île Rousse—but finding no work to do in the city of Pasquale Paoli, I go to
the Hôtel De Giovanni, to which the landlord at St. Florent had directed me.
The inn is large, and in an airy situation, and the rooms are clean, though not
as much so as at the last place ; as for the people, it is the same thing every-
where—simple in manner and thoroughly obliging ; anxious to please the
traveller, yet free from compliment and servility.

At 6.30 dinner was ready, served by a brisk damsel of no pretensions to

of Île Rousse on that point of the western coast nearest to Marseilles. The French influence in Corsica
would be far greater if an easy means of communication existed between this town and the east coast,
but, unfortunately, the road from Île Rousse to Corte and to Bastia climbs the transversal chain at the
Col S. Colombano, 730 mètres above the sea. This may be avoided by a road, as before named, by
the valley of Ostriconi and the Col de Pietralba, not more than 470 mètres. This is the lowest point of
all the transverse range of mountains, and the only one by which it is possible to establish easy and
rapid communication between Île Rousse and the east coast, that is to say, between France, the centre
of Corsica, and southern Italy.—*Grandchamps*, pp. 18, 19.

In 1760 only a tower built by the Genoese existed at the Port of Île Rousse ; in 1810, a small mole
of embarcation, twenty-seven mètres long, and later of fifty mètres, was constructed. [For details
respecting the possibility of making a larger port, and one which would be the best for the extension
of commerce into France, and for others concerning a proposed railway from Île Rousse, by the sea,
to the mouth of the Ostriconi, up the valley of the Ostriconi, as far as the Col or Bocca Santa Maria
(470 mètres above the sea, where a tunnel 1,200 mètres long would reduce that height 70 mètres), and
then descend to Ponte-alla-Leccia by the left bank of the Golo, and thence by the gorges of the
Golo to its outlet on the eastern coast ; there, dividing, it would go along the plain, north to Bastia,
and south to Porto Vecchio, see *Grandchamps*, pp. 86, 110.]

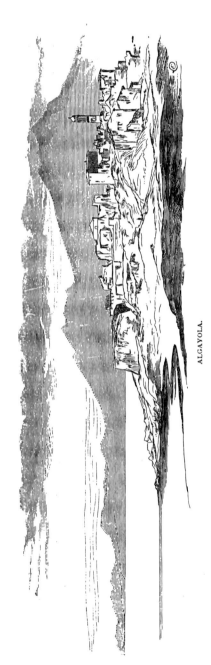

ALGAYOLA.

beauty, but with a look of *espièglerie* and intelligence; always she held a flower in her mouth; at the beginning of dinner it was a rose, latterly a pink. She waited also at a table where seven or eight "continentals"—employés—were dining. The dinner was good and some Balagna cherries and cheese excellent.

Later, when the damsel — who greatly resembled a lady on a Japanese teacup—brought some coffee, I said, "May I venture to ask, without offence, why you continually carry a flower in your mouth?" "And," retorted the Japanese, "may I venture to ask, without offence, why you, a stranger, inquire about matters which are not your affairs, but mine?" "Perdoni," said I, "do not be angry; I only had an idea that there might be a meaning in your doing so." Quoth she, "Che cosa potrebbe mai significare?—what could it possibly mean?" "I thought," said I, humbly, "it might mean you were not to be spoken to; for how, with a flower in your mouth, could you answer?" Whereat the Corsican gravity gave way, and the hotel resounded with long peals of laughter from the Japanese.

May 29, 5.30 A.M.—Flora and Co. are ready to start from the Hôtel De Giovanni, which will be remembered as very comfortable; not only, however, are the high mountains clouded, but some rain falls, and a wet day is threatened. Île Rousse has a look of being larger than it need be for its population—its Piazza

is grass-grown in parts, and the houses on its outskirts are scattered about rather vaguely; yet it is said to be a flourishing and increasing place. The outlines of the hills in its neighbourhood are varied and pleasing, while the long lines of Cap Corse and the hills forming the western side of the Gulf of St. Florent, shut in the sea like a lake; and did it possess any buildings of a shapely form, a pretty picture might be made of Île Rousse from the high ground to the west of it.

The road to Calvi runs coastwise along hill sides entirely covered with corn and olives—these last are in thick groves, large and full trees loaded with bloom, down to the sea-shore; great masses of gray granite cropping out of the soil here and there. The scenery is full of beauty, even on a day so gloomy as this continues to be; Corbara and other villages are seen on the hills; and when the clouds are propitious, snow peeps out on the higher mountains; everywhere there is a richness of cultivation exceptional in Corsica.[1]

About the seventh kilométre from Île Rousse is a small bay, on the shore of which stands a town or village almost all in ruins; fallen and falling walls, and roofless houses, make the few buildings which are still habitable—perhaps a score or two in number—more melancholy by contrast. This sad place, which has an air of having seen better days, is indeed no other than Alga-yola,[2] a town of importance under the rule of the Genoese, but deserted

[1] Monticello contains about 800 inhabitants. In the house of M. Pietri, whose first wife is grand-daughter of Clement Paoli, is a new portrait of the General Pasquale Paoli. M. Pietri also possesses the seal of that illustrious man, like a pound weight, made of iron, &c.

Above Monticello, at Capo Spinello, are the slight remains of the fortress built by Guidice, of the noble Corsican family Cinarca, brought up in Italy, and named Governor of the island by the Pisans in 1280, a man of lofty character, just, conscientious, and indefatigable. After having for fifty years held his ground against the Genoese, he was, when old and blind, betrayed into a nocturnal ambush. He died at ninety-one in the prison of Malapaga at Genoa. The few remains of the fort of Guidice attest the ravages of the Genoese, who destroyed the greater part of the castles of Corsica, in order to efface its memories and its nationality. It is easy to understand the hatred such a rule must have excited, and how, after more than sixty years, the name of Genoese is still considered an injury by the people.—*Valery*, i., p. 74.

On the territory of Corbara, at a spot called Bareale, the coast is strewn with blocks of a superb granite called, but wrongly, of Algayola, of which I have seen the first utilisation for the sub-basement of the column in the Place Vendôme. (Bareale also supplies the beautiful jasper with the green marble of Corsica, so admired in the chapel of the Medicis of Florence.) The working of this beautiful white monumental granite on the edge of the sea, which seems to invite its transport, might be immensely developed, and might give rise to a colony of workmen, as at Carrara, who might create a lucrative and permanent industry for Corsica.—*Valery*, i., p. 69.

From Corbara, one of the prettiest villages of Corsica, came the Doctor Daniele, called to France by Louis XIII., to whom he became physician. M. Valery gives a list of eminent medical men, natives of Corsica—Salicetti, Sisco, Franceschi, and Préla, the learned Jean de Vico, physician of Julius II., and the Doctors Antomarchi; which, he says, seems to prove that the art of curing is natural to the Corsicans. Some also of the most celebrated men of the island have studied medicine, such as Giafferi, and Hyacinthe Paoli, as well as the learned historian Limperani of Orezza, Bernardin Cristini, &c.—*Valery*, i., p. 68.

Monticello, the scene of the tragic history mentioned in Gregorovius, is named in Galletti, p. 119.

[2] Algajola is almost abandoned since the foundation of Île Rousse. Its appearance is singularly melancholy, and one seems to be in a town taken by assault, and from which the inhabitants have disappeared. In the middle of these ruins there exists, over the chief altar of the Church of St. George,

towards the end of the last century, owing chiefly to the rise of Île Rousse, and to the fact that Calvi, during the wars of the patriot party, was a better place of refuge. Rain prevented my making as complete a drawing as I could have wished of the now forlorn but picturesque condition of Algayola.

Fortunately for me, after some heavy showers, the weather became brilliant once more, in good time to array in its fullest beauty what is doubtless one of the finest portions of Corsican scenery, and not a little Sicilian in character, the drive from the ruined and dreary Algayola to Calvi, the long cape and light-house near which are now visible. A succession of pictures of exquisite interest delights the eye as the road passes along new basins or crescents at the foot of high hills, bare at their tops, then terraced into corn-fields all the way down from those rocky heights to the shore; the grain all ripe, and the fields full of busy reapers, dotted with grand old olive trees, standing, not in continuous groves, but singly, or in massive and picturesque groups, some of the trees being quite the finest I have seen in the island.(¹)

a "Descent from the Cross," attributed to Guercino, and said to be the best picture in Corsica.—*Valery*, i., p. 71.

Speaking of the industrious habits of the Corsican fishermen in general, M. Valery excepts those of the pescatori of Algajola, where, M. De Beaumont reports, in a town on the sea-shore, and in his own former sub-préfecture of Calvi, there is not a single fisherman, and the inhabitants wait, with their arms folded, until a Neapolitan boat arrives to fish along their own coast, and sell them their own fish. Nevertheless, the sea around the island has been thought more productive of fish than any part of the Mediterranean.—*Valery*, i., p. 33.

The road from Isola Rossa to Calvi leads along the coast all the way. On the mountains are seen many ruins of places destroyed by the Saracens, and above Monticello are the ruins of a castle of the celebrated Guidice della Rocca, the Pisa lieutenant. I came first through Algayola, an old place by the sea, now quite decayed, and numbering scarcely 200 inhabitants. Many houses stand in ruins and uninhabited, for they have been allowed to stand as ruins till the present day in the state that the war reduced them to sixty years ago, a sad and palpable witness of the condition of Corsica. Even the inhabited houses are like blackened ruins. . . . In the time of the Genoese, Algayola was the central place of the Balagna.—*Gregorovius*, p. 268.

Algajola, anciently the chief place of civil government in the Balagna, and situated on one of the most healthy points of the island seaboard, is a little town now containing less than 200 inhabitants, and, in our day, only presents a heap of ruins to the traveller's search; thus realising the prediction of General Paoli when he founded the Île Rousse, "I am going to plant the gallows for Calvi and Algajola." Into the latter place he had not been able to force an entrance, as it was surrounded by walls and bastions, and well defended by the Genoese. At present the name of Algajola, which has played so important a part in the political vicissitudes of the island, is only known in Corsica by an old proverb still used in our villages, when any one wishes to describe a person given to laziness and love of "dolce far niente." "Pare de' quattro dell' Algajola—he is like the four of Algajola." These were the members of the four principal families of the place, who, wrapped in their cloaks, used to sit at the gate of their city gossiping on all the news of the day with the peasants who passed to and fro.— *Galletti*, p. 121.

(¹) The provinces of Balagna and Nebbio, which are very rich, and afford an agreeable prospect, particularly Balagna, which may be called the garden of Corsica, being highly favoured by nature, and having also had in a superior degree the advantages of cultivation.— *Boswell*, p. 25.

The appearance of the district of the Balagna, with its vegetation of olive, orange, and pomegranate, has a charming effect as one quits the harsh mountains of Nebbio. Its inhabitants know well how to cultivate their lands, nor do they call to their aid, as do the rest of their countrymen, the sober and laborious Lucchesi, who bear away the gold of Corsica.—*Valery*, i., p. 65.

. . . The valley of the Balagna is called the garden of Corsica. It is enclosed by mountains, whose tops reach the clouds, snowy peaks like the Tolo and the mighty Grosso, and eminences of

Farther on a ruined castle crowns one of the highest points, as you continue to drive through this beautiful scenery, with the wide sea ever on your right hand, until after leaving the coast by an ascent of short duration, the road comes suddenly in full view of the bay of Calvi, that town and citadel on its farther side shining out like a gem above the purple water, by the side of a plain running up to the foot of magnificent mountain ranges, some of them the highest in Corsica. Assuredly the Genoese were wise to cling so long and so fondly to this, as it seems to me, fairest part of the island.

Perhaps even the landscape becomes still finer as you turn the sharp corner of the high point you have been ascending (about the tenth kilométre from Calvi), and come down towards the large valleys, which from the coast stretch away to Calenzana and the base of Monte Cinto and the great central Corsican Alps. Few more striking and beautiful places can be seen than Lumio,([1]) close below which the road now runs—a large village with white and

the grandest forms, which would enchant a landscape painter. On the mountain sides are very numerous hamlets all former abodes of the nobility and caporali, and full of reminiscences of old times. The Tuscan Marquises of Malaspina, who were natives of Massa and the marches of Lunigiano, ruled here of old. The Malaspinas built the village of Speloncato, in the Balagna.—*Gregorovius*, p. 313.

The Balagna, separated from the Nebbio by the secondary ramifications of the chain of the Tenda, is the richest province of Corsica ; it includes the valleys of Ostriconi, Regino, Aregno, Fium-Secco, and Marsolino. The slopes of the Ostriconi, the Regino, and Aregno are covered with magnificent olives, and everywhere picturesque villages, well-built houses, and well-cultivated land denote the ease and love of labour of the inhabitants.—*Grandchamps*, p. 18.

The Corsican olive tree, according to the illustrious Humboldt, is, more than any other, capable of resisting the intemperance of the elements ; as, for instance, during the memorable and terrible winter of 1709, when nearly all the olive trees of the south of France were destroyed, those of Corsica did not suffer.—*Valery*, i., p. 75.

It is asserted (says Gregorovius of the Balagna olive trees) that there is no place in Italy where the olive tree reaches such huge dimensions as in the Balagna. Its growth, its fulness of branches, and the abundance of its fruit, are perfectly astonishing. . . . There are many kinds of olives in the Balagna, the Sabinacci, Saraceni, and Genovesi, so called according to their pedigree, like noble families of Signori. The third kind is most frequent ; it is ascribed to the Genoese, who, under the rule of Agostino Doria, compelled the Corsicans to plant the olive abundantly. . . . At what period the olive was generally introduced into Corsica I cannot say. In Seneca's epigram, complaint is made that the gift of Pallas is not to be found in the island ; nevertheless, it seems to me scarcely credible that the olive was not cultivated in Corsica before Seneca's time. The Corsican olive trees enjoy the reputation of defying the changes of the seasons more boldly than all others in the world, a praise which the great Humboldt has bestowed upon them. . . . When the olives begin to fall off they are collected. Twenty pounds of olives yield five pounds of clear oil, which is put into large stone jugs, in which it stands till the month of May ; the trees produce abundantly every third year. The birds come and scatter the olive seeds, and thus the island is covered with wild olive bushes, growing green and rank over hill and dale, and only waiting for improvement by cultivation. . . . At the present day the richest oil-lands of Corsica are the Balagna, the Nebbio, and the region of Bonifacio.— *Gregorovius*, p. 316.

([1]) Lumio, finely placed, produces a fine rock crystal, orange gardens, and formidable hedges of cactus.—*Valery*, i., p. 80.

Lumio possesses many orange orchards, and an astonishing number of cactus hedges, which I only found besides in Ajaccio in such profusion. The cactus here grows to the size of a tree. The view from the hills of Lumio, down to the valley and gulf of Calvi, is beautiful. Calvi, which has about 25,000 inhabitants, divided among six cantons and thirty-four communes, comprises nearly the whole north-western part of the island. Of the mountains and coast-land, not the half is cultivated, for the large coast-strip of Aleria is utterly waste, and only the Balagna is in good cultivation, and the most numerously peopled.

brown flat-topped houses, very like those of Bethlehem or other places in
Palestine, except in their wanting domes—and buried among olive-trees such
as I have hardly seen out of Corfù. Below Lumio are groves of cork and
phyllarea, cactus in great quantity, and an inexhaustibly profuse vegetation,
of which it is difficult to give an idea, filling up every corner and slope not
already cultivated, till lower down is a spread of ripe and broad corn-fields,
with here and there a flat-topped house, just like those in the "country" of
Malta round Valetta, or sometimes surrounded by a walled court-yard,
resembling those round road-side khans in Albania.

10.30 A.M.—From the bottom of the hill—I had sent on Flora and C⁰· to
wait till I had done drawing at Lumio—the drive is less interesting. The
road crosses the Calenzana river, a broad torrent, and later a still larger river
bed, half lost in the tract of marshy ground near the sea, which, whether or
not its creation was the direct result of the imprudent bishop's conduct, is
very pernicious to the atmosphere of his diocese of Calvi.(¹) The approach to
that Genoese stronghold is very fine ; the rock on which the citadel stands,
with the chief part of the city, and the cathedral, together with a church and a
line of houses, close to the edge of the sea, are all reflected in the bay, and at a
distance the whole has an imposing effect.(²) On approaching nearer, however,
you soon perceive that the present condition of Calvi is nowise in harmony

When the Republican General Casabianca had to capitulate, in the year 1794, after the
heroic defence of Calvi against the English, it was one of the articles of capitulation, that the old
inscription above the gate should not be touched. Faithfully has the condition been observed, as may
be read above the gate.—*Gregorovius*, p. 271.

(¹) The neighbouring lagoon of Calvi—which it would be an important benefit to the town to drain—
is called the Vigna del Vescovo (the Bishop's vineyard), and certain remains found about and even in
the lagoon, prove that formerly the vine was really grown there. A popular tradition relates that once,
amid the gaieties of the vintage, the Bishop of Sagona, then resident at Calvi, was led astray by the
fascinations of a young girl, who teased the prelate to place the episcopal ring on her finger ; but at
the moment when the reverend man gave way to her entreaty, the ring rolled away and was found no
more. On the next morning the bishop returned to search for the ring, but the vineyard had sunk in
the earth, and in its place was the lagoon.—*Valery*, i., p. 89.

(²) Calvi is the strongest place in the island ; its safe gulf is the nearest part of the Corsican coast to
France, and but eight hours from Antibes. Built on a rock, although the capital of the Balagna, it is
situated in its least cheerful part.—*Valery*, i., p. 82.

M. Valery, who was ill lodged in an inn at Calvi, and who regrets the hospitality so constantly
offered him in the other parts of the island, says, funnily, " To effect any reform in the detestable and
infrequent inns of Corsica it must be visited by the English, and even they will have enough to do.
But as in Italy their efforts have had success, so, too, here they may chalk their complaints on all the
walls of the rooms, inscribe their names even in the landlord's own book with anathemas against his
hotel, and become, by their shouting, their noisy scenes, and their multitude of followers, the terror of
the establishment."—*Valery*, i., p. 82.

Calvi, founded by Giovaniello in the thirteenth century, became Genoese in 1278. It was the
first place in Corsica which fell into the power of Alfonso of Arragon. Unsuccessfully attacked by
De Thermes in 1553, it stood three sieges in 1555 against Des Ursins and Dragut, and to perpetuate the
memory of its defence the Genoese Senate caused the inscription, still existing, " Civitas Calvi semper
fidelis," to be engraved over the principal gate of the city. Paoli, unable to become master of Calvi,
founded Île Rousse. In 1794 Admiral Hood took Fort Morello, which was held by General Casa-
bianca, and only capitulated at the last extremity.

The town of Calvi, placed at the southern extremity of the Balagna, not far from the mouth of the

with the proud fortress above it, and you are struck with the thinly-peopled village-like nature of the place, and the feeling of loneliness haunting the formidable heights and forts, whose history is concluded, and is only that of the past ; for the beauty of Calvi is that of decay, and its prosperity is departed, though few places are finer in situation, or would make a more beautiful picture.

11 A.M.—I go to the Hôtel de la Marina, the best here ; it stands on the sea side of the single street leading up to the citadel. The civil, but rather mournful proprietors, made their tolerably clean and very spacious rooms pleasant by that courtesy and active wish to oblige so universally met with — a repetition monotonous, but just and necessary—throughout Corsica. A very good breakfast of fresh fish, lobster, and maccaroni, is served before noon, although the landlord apologises for the difficulty of getting what is wanted for travellers who come without warning ; few people, indeed, come to this out-of-the-way place—which is a *cul de sac*, and beyond it no road leads— except those on business connected with Government, for Calvi still enjoys the honour of being a Sous-préfecture.

This morning's drive has been one of great interest, and full of novelty ; the Balagna has always had the reputation of being the garden of Corsica, and, indeed, the completely cultivated look of this district contrasts greatly with that of other parts of the island. The upper Balagna, through which I must pass to-morrow on my way back to Corte, is said to be even more remarkable for beauty, and Miss C. describes it, in some notes she has sent me, as one long succession of pictures. Of the road through it,

valley of the Fiumesecco, has seen its commerce decay in proportion to the increase of that of Île Rousse. Surrounded by uncultivated plains and incompletely drained marshes, Calvi withers from day to day. . . . To restore Calvi to its primitive affluence, the marshes which surround it must be drained, its port improved, and the road along the western shore between Ajaccio and Calvi terminated. —*Grandchamps*, p. 21.

Calvi has greatly decayed since the foundation of Île Rousse, and its population diminishes daily. Whenever the vast and deserted coasts of Filosorma and Galeria are peopled and cultivated, the town of Calvi may possibly become the point of export for the produce of those new colonies, and take a place among commercial towns.—*Galletti*, p. 124.

If the question of the birth of Columbus did not appear settled by the passage in the sublime and affecting will of that great man, which says "born at Genoa" ("en Genova "), the pretensions of Calvi would be specious enough. It was a Genoese colony ; a family still existing there is named Colombo ; the papers relating to that family were carried off, they say, by the Genoese Commissioners, who also are said to have changed the name of a street called "Colombo " into "del filo ;" and, lastly, some inhabitants of Corsica were the first to embark for the new world.—*Valery*, i., p. 88.

Only on one point are Genoa and the ever-faithful Calvi at odds. The Calvesi maintain that Columbus was born at Calvi ; that his family, though undoubtedly Genoese, had long ago settled there. . . . They assert that Genoa took possession of the family registers of the Colombos of Calvi, and re-baptised one of the streets of the town, called Colombo Street, as the street "del filo." I find also a record that the inhabitants of Calvi were the first Corsicans who sailed to America, and I was told that the name Colombo still exists in Calvi.—*Gregorovius*, p. 271.

There exists at Calvi, from time immemorial, a street called Colombo, and the inhabitants of that town believe they have certain proofs that Christopher Columbus was born at Calvi, in a house of the street which bears his name.—*Galletti*, p. 125.

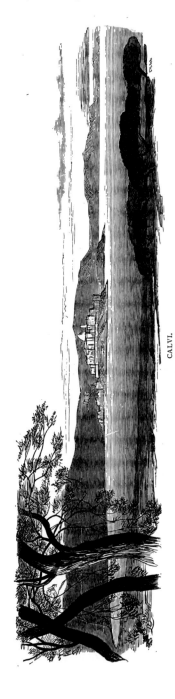

CALVI.

M. Francesco Orsoni, the landlord of the Hôtel de la Marina, who is very intelligent and communicative, gives me information which is valuable, as Domenico does not know the distances. From Lumio (ten kilomètres from here) to Muro, the half-way halt for the day's journey, are twelve kilomètres, and beyond that twenty-two more to Belgodére; at the latter place he names the locanda of a Madame Saëtta as the only lodging he knows of. From Belgodére to Ponte della Leccia are thirty-six kilomètres, and on to Corte twenty-four more—a longer journey than that of to-morrow, but, excepting an hour or two of ascent from Belgodére to Sta. Columbana, the whole is down hill; by all which it is clear that I can carry out my plans pretty exactly, provided there be no delay at the broken bridge over the Asco. M. Orsoni tells me that year by year this city—Calvi—becomes more deserted; even the villagers from places close by do not resort to it, as they are more sure to dispose of their produce either by exchange, or for money, at Île Rousse, and flock thither accordingly.

After noon it rained pretty heavily until between 3 and 4, when I was able to make drawings of the grand and picturesque fortress town from the rocks above it; from immediately behind the town the noble mountain-range beyond the bay forms a magnificent background, and all the scene is characterised by a wild and lonely splendour that is extremely impressive—earth and sea, once, in the days of republican Genoa, so crowded and noisy, now by comparison so desolate and tenantless. The citadel — its walls of an even pallid gray tone of colour—stands beautifully forward in vivid light from the screen of mountains,

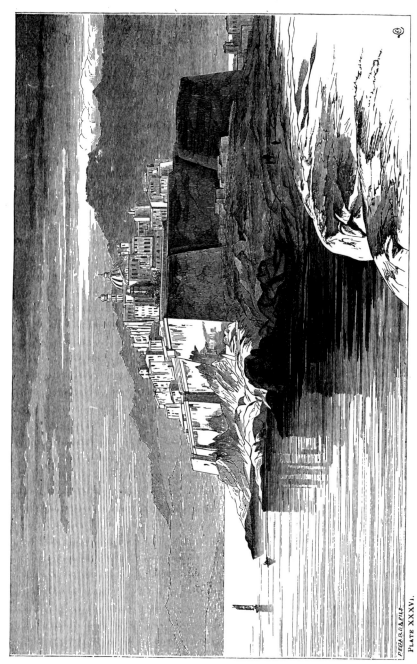

PEGA B.O.&FILI

PLATE XXXVI.

CALV

just now almost black under piles of thunder-cloud, and I doubt if many finer subjects of the sort can be seen. (*See* Plate 36.) Later, I draw on the opposite side of the town until warned off by the chill from stagnant ditches and low frog-frequented pools below flourishing tamarisk, when I go up to the citadel; the street leading to it is cleanly kept and well paved, and had it not been so late in the day I could well have liked to see the upper part of the city, beyond the gate over which the celebrated inscription—

> " CIVITAS CALVI
>
> SEMPER FIDELIS—"

still remains.

I made little progress up the steep narrow lanes between the fortress walls, for the heat of the day and climbing about the rocks had pretty well tired me, and I soon returned to the hotel, the sounds of a pianoforte and the cry of a peacock being—for I saw no living creature—my only memories connected with life in upper Calvi.([1])

[1] [Calvi is the point from which to go to Calenzana, one of the most interesting of Corsican villages, and which, as well as the portion of the west coast from Calvi to Porto, I regret not to see.—E. L.]

Calenzana, one of the most populous of the smaller towns in Corsica, with nearly 2,000 inhabitants, is worth visiting from Calvi. Instead of being on an inaccessible height, as are many villages of the island, Calenzana stands in a fresh and pretty valley, and has a glimpse of the sea. I visited the cemetery of the Germans (Campo Santo de' Tedeschi), where the Corsicans defeated the German auxiliaries of the Genoese under the Austrian general Wactendock. The campaign of the Germans began on August 10, 1731, and lasted eighteen months, and in it they lost more than 3,000 men. At one period the inhabitants of Calenzana, who had but a few score pistols, threw their hives at the heads of the assailants, and this charge of bees threw the enemy's army into confusion, and contributed to the victory of the Corsicans. The scene of that frightful carnage is a verdant and fertile field, and every year, after Good Friday, the clergy visit it, and sprinkle with holy water the earth where the bones of the strangers lie. Near Calenzana, in the midst of some fields, is the Oratory of S. Restituta, spoken of by Filippini—one of the most ancient and venerated sanctuaries of Corsica, most probably of Pisan times, but unhappily it has been modernised. The little church of S. Pierre—a singular building—though also restored, is of the date of the Pisans.

The exploit of the Calenzana bees gives me an occasion of defending the honey of Corsica against three great poets of antiquity, Virgil, Horace, and Ovid, who reproach it for its bitterness. The bitter taste proceeds from the flowers of myrtle, box, lentisk, arbutus, and laurel, on which the bees feed, and prevails during autumn only, for the honey made in the spring is on the contrary very sweet and agreeable, and particularly wholesome. The ancients esteemed the wax of Corsica very highly, and two facts recorded by T. Livius prove the activity of its bees—a first tribute of 100,000 lbs. of wax was paid to the Romans to buy peace; and a second was paid two years later, of 200,000 lbs. —*Valery*, i., p. 92.

There is a vast quantity of honey produced in Corsica, for the island has from the earliest times been remarkable for its swarms of bees. Many people think the bitterness which is in the Corsican honey very agreeable.—*Boswell*, pp. 48, 49.

Calenzana is the most important of the villages named (Lumio, Monte Maggiore, &c.), and is one of the most populous of the island; it is placed in a fertile and well-cultivated plain; its streets are paved, &c.—*Galletti*, p. 122.

Speaking of the defeat of the Imperialists—when of the German auxiliaries sold to the Genoese by the Emperor Charles VI. 500 were left dead on February 2nd, 1732—Gregorovius adds, " The Corsicans buried the foreigners, who had come into their country to fight against liberty, on the beautiful hill-side between Calvi and Calenzana. On foreign but heroic soil rest the bones of

It is strange how the proprietors of these inns, who appear to have no regular customers, are able to provide so well as they do for chance comers. Yet the dinner at the Hôtel de la Marina admitted of no complaint, for there was good soup, preceding a dish of lamprey, followed by boiled meat and potatoes, steaks, and a lobster salad, a pudding, cheese, and cherries.

Late in the evening the storm clouds pass away, and the mountains on the other side of the bay become clear; they are very majestic, though more wall-like and less interesting than when partly hidden by mysterious cloud.

our poor brothers. And on every Easter Saturday, to the present day, the priests come from Calenzana to these graves of their foes—the ' Campo Santo de' Tedeschi,' as the field is called by the people—to besprinkle with holy water the spot where the poor hirelings fell. It seemed to me as if I, who was one of the few Germans who have stood upon the hirelings' graves at Calenzana, and perhaps the only one who thought of them, was bound to thank the noble nation of the Corsicans, in the name of Germany, for this magnanimous and humane fellow feeling. And I dedicate the following inscription to my countrymen :—

" EPITAPH ON THE 500 GERMAN MERCENARIES OF CALENZANA.

Five hundred wretched hirelings here we came,
To Genoa by our own Emperor sold,
The freedom of the Corsicans to slay ;
For the offence we lie here in our blood,
And do sad penance in a foreign grave.
Not guilty call us, but for pity meet ;
The foeman covers us with mercy o'er ;
Revile not, wanderer, that dark age's sons ;
Ye living shall make good our ignominy sore."—*Gregorovius*, p. 276.

I took to the sea again at Calvi, in order to go to the tower of La Girolata and to La Piana, The coast of Galeria is now wholly uncultivated. . . . The little port is not a bad one, and this is one of the many points in Corsica which ought to engage the attention of Government and attract capitalists. It was in the gulf of Girolata that John Doria, by an exploit worthy of his uncle the great Doria, whose galleys he commanded, fought with and took prisoner the terrible Corsair Dragut, who had made such frequent and terrible incursions in Corsica. As he, with all his crew, were being put in chains, Lavalette, afterwards Grand Master of Malta, said to him, "Señor Dragut, usanza di guerra." "Mudanza di fortuna," replied the Mussulman, who had formerly seen Lavalette one of his own slaves.—*Valery*, i., p. 95.

At the end of the gulfs of Girolata and Porto are still seen some huts inhabited by cultivators or shepherds ; these hamlets are called Curzo, Pertinello, &c., all built partly on the ruins of old villages devastated and burned by the Genoese. All this district, mostly uncultivated and wild, is included in the names of Galeria and Filosorma, and it is also called La Balagna Deserta.—*Galletti*, p. 130.

Formerly all this part of Corsica was peopled by a race of peasants of warlike and restless pro-clivities, and the Genoese Government determined on dispersing the whole population by burning their houses and destroying their habitations. All these ancient villages formed two pièves, or cantons, Ermito and Sia. In the time of the historian Filippini there only existed the single village, Luzzopes, belonging to the old piève of Ermito ; but later this also shared the same fate as that of the others.—*Galletti*, p. 128.

The Basins, between Calvi and Ajaccio, ot the Fango, of the Porto, and the Liamone, will be utilised by the working out of the forests which crown their heights, and that of the Fango opening to the gulf of Galeria, will become one of the richest and most fertile of the island. The finest forests of Corsica would be available by the gulfs of Porto and Ajaccio. These valleys, at present wild and uncultivated, would be converted into lands of admirable fertility. Already the Greek colony of Carghésé has shown, on the lands given to them between Paomia and Sagona, what industry can effect.—*Grandchamps*, pp. 22, 23.

Port of Galeria, at the mouth of the river Fango, not safe. No port in the gulfs of Porto and Girolata. Port of Sagona little frequented, and not good at present.—See *Grandchamps*, pp. 89, 90.

CHAPTER XI.

Leave Calvi—Its Grand Position and Mournful Decay—Sadness of Corsican Singing—The Road along the Upper Balagna—Extreme Richness and Beauty of Scenery—Claude-like Landscapes—Cheerfulness of the Valleys, and profuse Vegetation—Lavatoggio and other Villages—Views of Cap Corso from Muro of Balagna—·Pretty Churches and Architecture—Numerous Hamlets—Approach to Belgodére, and difficulty of finding a Hotel there — Position of the Village—Friendliness of M. Malaspina, Maire of Belgodére—His Hospitable House and pleasant Family — Leave the Maire's House—Change of Scenery—Descent to the Valley of the Asco—The Broken Bridges— Village of Ponte della Leccia ; its very indifferent Accommodation and unlively Appearance — Regret at not being able to visit Morosaglia, the Birthplace of General Paoli—Return to Corte— Difference between the Inns of the Country and of the Towns of Corsica.

May 30, 4 A.M. — A fine day is presaged by the clear line of mountain standing out, purple and dark, with silver-snow outline against the sky ; the good people of the Hôtel de la Marina, whose charges are as moderate as their fare is good, make no difficulty in getting coffee for me by sunrise, and thus I can obtain some more memoranda of this Ultima Thule of Corsica before starting. The stately mournfulness of the forsaken Calvi cannot easily be forgotten by a painter who has seen it ; but, however good for the pencil, I cannot suppose it, from its unsheltered position, and from its marshy vicinities, pleasant as a residence, at any rate in summer.

At 5.30 Flora and C$^{o.}$ pick me up, and we proceed ; her master, Domenico, whistling, in harmony with the scenery, a dismal minor air. Soon, the Bishop's vineyard and the unhealthy flat ground are left behind by the fast trotting ponies, and then, from the dark olive plantations below the lofty Lumio, I walk up slowly to the top of the hill, unwilling to lose anything of the beautiful landscape its ascent and summit command.

A little way beyond Lumio the road divides, and the lower, by which I came, is exchanged for that to the right, leading to la haute Balagne ; gradually ascending, it skirts at a great height the large Basin or amphitheatre, the streams from which unite in one running into the sea half way between Île Rousse and the Nebbio hills, near Torre Losari ; towering granite rocks form a wall to the right ; while on the left are terraces of corn and olive trees down to the sea, and at intervals a flat-roofed box-like house, à-la-Maltese, stands in the expanse of ripening grain.

Turning more inland, and advancing beyond the first spurs of hill—from which you see Corbara, Aregno, and Sant' Antonino on your left—the great semicircle or principal Basin of this beautiful canton is entered, and at once you become aware that those who visit Corsica without going through upper

P 2

Balagna, remain ignorant of one of its finest divisions.(¹) For the next hour
and a half's drive (as far as Muro, or Murato, at the twenty-first kilomètre
from Calvi, and half way thence to Belgodére) no description can exaggerate
the beauty of this remarkable tract of mountain background and deep valley,
which, for richness of foreground, cheerful fertility, and elegance of distance,
may compete with most Italian landscapes.

On all the more elevated parts of the district, below the topmost wooded
heights and snow-capped mountains, stand numerous villages (there are
thirty-six communes in all), and the form of this great semicircular theatre—
at the upper edge of which, as it were, these hamlets stand—allows nearly all
of them to be seen at one time ; most, unlike the generality of Corsican
villages, possess extremely picturesque and tall campanili, and often there are
detached chapels away from the hamlets, recalling somewhat of the grace of
those in Southern Italy. Each of these " paesi " is placed amid a profusion
of wood and garden, and below them the hill-side—entirely cultivated in
every part—slopes down more or less steeply from rock, oak, chestnut, olive, fig
tree, and cactus, to a small plain that stretches away to the hills of the Nebbio
and the sea. Beyond all this the landscape (really resembling many of
Claude's) is finished by the blue sea to the east of Île Rousse, and by the
gulf of St. Florent hills, and the long line of Cap Corse delicately traced on
the farthest horizon. (*See* Plate 37.)

There is a life and cheeriness, too, in this canton that well harmonises with
the brilliant and plentiful look of the landscape ; many peasants are met—the
women as usual not riding sidewise—on finer mules than I have yet seen in
the island ; and now and then some " signori " with tall black hats, which, for
their shiny newness of look, might have come this very morning straight from
Lincoln and Bennett's. And besides every other charm of this beautiful
Balagna, there are those of never-failing civility and complete security.

Lavatoggio, Cáttari, Avápessa—still new villages are passed, and still the

(¹) There are everywhere, especially in the vicinity of habitations, perfect Paradises of the most
luxuriant chestnut, walnut, and almond trees, orange and citron orchards, and groves upon groves of
olives. An excellent road leads all the way, skirting the base of the circle of mountains, and com-
manding at every point most charming distant views over the sea or up to the mountains.—*Gregoro-
vius*, p. 314.

The territory of Aregno is plentifully planted with beautiful orange trees ; their fruit the best in the
Balagna.—*Valery*, i., p. 79.

The Abbé Galletti speaks of the " beautiful villages of the Balagna "—Muro, Felucto, Nessa, &c.,
the small commune of Avapessa, and others, at the edge of the carriage road from Calvi to Ponte alla
Leccia, with many more at a distance from it, but still in the district of Calvi. The village of Lava-
toggio is very cheerful looking, and there are beautiful houses in it, of which the best were built with
money gained in America. Cateri, not far from this last-named village, has a church with a cupola of
elegant architecture. The oranges of Aregno are reputed among the best in the island.—*Galletti*, p. 125.

In all the many wanderings of a long life no scene I have observed has ever surpassed the exquisite
panorama of la haute Balagne, and the Corsicans have a right to be proud of it, and may justly wish
it to be seen. Rich though this beautiful district is, the people are so utterly unaccustomed to strangers
that there are no inns, and not even a glass of wine could be procured.—*Campbell*, pp. 69, 70.

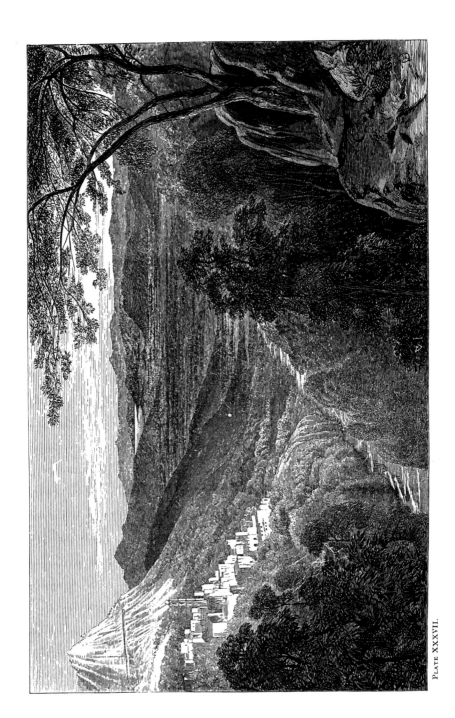

PLATE XXXVII.

eye delights in fresh and enchanting views ; here you pause to look at a particularly graceful hamlet with its tall church spire and cluster of brown flat-roofed houses ; a little way on you are arrested by park-like tracts of oak and corn-fields, dipping down to a broad plain-like flat, edged with Ithome-like hills and promontories, with interlacings of cultivated levels to the shining sea and pale Cap Corse.

Near Muro the mid-day halt is ordained by Flora and C$^{o.}$, and breakfast hastily despatched below a friendly oak, to allow of my walking back three kilomètres in order to make a difficult drawing of the lovely scene near Avápessa, as well as of one or two more near Muro ; for having now seen one side, or wing, so to speak, of this theatre, I have selected these two out of a multitude of almost equally beautiful subjects. Indeed, a theatre is no bad simile as applied to this great basin, by far the most industriously cultivated, the most cheerful and beautiful in all Corsica—the oak woods and the great cliffs above may represent the galleries ; and, next in order, the villages, gardens, and terraces stand for tiers of boxes ; the flat level of olives and corn for the pit ; the sea and remote hills for the stage and scenery.

At 1 Flora and C$^{o.}$ start anew ; the village of Muro, at the twenty-second kilomètre from Calvi, in a corner of one of the great hollows or recesses formed by a projection of the hill, with its high white campanile and com-binations of arches among its houses, would be an elegant subject even on the Amalfi or Positano coast. The road (as usual, excellent) is a regular cornice, running at a great height along the mountain side, and generally close to the villages, of which there is a succession—frequently hidden till you are close upon them—peeping out of little bays of foliage as you wind round the buttresses or spurs of the lofty heights. Feliceto and Nessa are the next hamlets ; Speloncato, Villa, Costa, Occhiatona, are further on, each with its own characteristic beauty, and forming a continuance of mountain-village scenes, such as can hardly be imagined.

It is 2.30 when, always by a gradual ascent, Belgodére ([1]) is approached ; it is the highest and last of all the communes in this remarkable horse-shoe valley, or rather collection of valleys, which unite in the cultivated level area below. As one looks back to the west from about the thirtieth kilomètre from Bastia, there are perhaps the best views of the whole scene ; yet it is on a scale so extensive and varied, that it would be very difficult to convey any idea of it with the pencil ; separately, the hamlets are full of picturesque beauty, but such morsels would not represent the character of the whole landscape ; while the great size of the mountains, together with the tiny proportions the villages

[1] Belgodére, an ancient village of 800 inhabitants, was founded by one of those Marquises di Male-spina, called from Italy by the Corsicans to govern them during the ninth century. The view of the sea and of the cheerful valley of Fiumeregino, so fertile in olives, justifies the choice of the site.—*Valery*, i., p. 74.

bear to them, would prevent it being successfully transferred to paper as a whole.

Along this beautiful drive the great variety of foliage and the evidences of industrious labour are the unvarying characteristics of the scenery—here there are finer oaks, there the chesnut grows more abundantly, now the gardens of cherry trees seem to have no end, or the walnut and fig tree hide the houses and walls, and the olive glimmers lightly against the sky or dapples with thick groves the long level of corn that spreads northward to lines of distance rivalling Grecian landscape ; anon there are bright streams of water sparkling among the foliage, or broad carpets of fern clothing the sloping hill-sides ; extreme richness and fertility are everywhere seen ; nor in all this interesting— and beautiful canton have I met with a single beggar.

Now that I see Belgodére, which I reach at 3 P.M., I regret not having spent more time in drawing one or two of the villages I passed earlier in the day, for I soon perceive, long before reaching the village, that it contains little or no work for my pencil. Placed quite at the farthest and highest limits of upper Balagna, Belgodére looks down over an immense bird's-eye view of the whole district, wooded and olive-dotted to the shore, but though commanding the most comprehensive prospect of the canton, and one conveying the completest idea of its nature, it is, for all pictorial purposes, nearly impracticable.

Flora and Co had been sent on before, but Domenico coming to meet me, says that the locanda Saëtta " non esiste più—exists no more," and that two other lodging-houses in Belgodére—a village considerably larger than any hereabouts—are full ; there is yet a third, which has two rooms, but on going to inspect them I find them by no means tolerable or to be endured ; and as in this instance my going to a private house can involve no loss of time, since there is nothing to do by way of drawing, I resolve to avail myself of an introductory letter given to me by the Préfet to the Maire, M. Malaspina.

From this gentleman a most friendly welcome is forthcoming ; with Corsicans—as in days I well knew of old, with Calabrians and Abruzzese—there is very little compliment and much sincerity. " I am only too glad the inns are full, and that you are thus obliged to give me the pleasure of receiving you, although it so happens that my family are away for the day, and therefore you will not fare particularly well "—was said gravely and evidently in earnest, as M. Malaspina took me to his house—one of the largest in the place—and told Flora and Co where were his stables.

The first floor is that resided in by the family, and that above it contains what may be called the guest rooms, and which are so well and handsomely fitted up that one seems in Paris. A more perfectly comfortable little bedroom than that allotted to me could not be found, and—for the day has been hot, and the landscape painter far from well—I am glad to get some rest in it

till 6 P.M., when I join the Maire and his uncle, both intelligent and gentle-
manly men, the latter an elderly person who has passed many years in
different parts of Italy.

Landscape being my main object in coming to this island, I have through-
out avoided all arrangements by which delays to my work could be occasioned,
and thus have allowed myself to see but little of the Corsicans, a circumstance
I in some senses regret, for whenever I have done so, the making their
acquaintance has been invariably a source of pleasure, and on the present
occasion particularly so. At 7 dinner was announced, and we descended to
the family dining-room, where were the wife of the Maire's son (he himself is
a widower) and his two daughters. I was carried forcibly back to days of
Abruzzo travelling by the friendly ways and hospitable anxieties of these
amiable people, who live in a plentiful and patriarchal style, and whose dinner,
profuse and of excellent quality, gave ample evidence of a well-managed
household. They insisted on the Suliot sitting at the same table, spite of his
appeal to me, and as the service was limited, I thought it best to acquiesce.

What though there were dishes of hare, roast fowl, creams, and many
other good things, only my host the Maire partook of animal food, the rest of
the family eating snails or vegetables only, as it was a vigil or fast day ; none
the less, however, was their attention to their guest unremitting. Their home-
made wine was thoroughly good, but they had two other sorts of Corsican
vintage ; altogether the entertainment was a very pleasant oasis in these days
of doubtful Locande, and well it is for me that M. Géry gave me this introduc-
tion. Later, accompanied by the three ladies, who were all unaffected and
well-bred, we adjourned to the well-furnished drawing-room, to which coffee
was brought, and here we talked till 9.30, when this kindly family wished me
good-night.

These people are quite *au fait* regarding all European intelligence ; and
their remarks on Turkey, Italy, and other subjects, were free from the preju-
dice and violence so frequently met with in proportion to the ignorance of the
speakers. Of their own island they are acquainted with the minutest details
of both present and past condition, physical or political ; and the wide interest
shown upon European and cosmopolitan topics in so remote a mountain
district contrasts curiously with the apathy and blank ignorance noticeable in
many similar positions. There is, however, this difference respecting the Cor-
sican's broad intelligence regarding contemporary history : his own island and
people have been for so long a time actors in the principal European events,
that it is but natural he should become acquainted with facts which are, so to
speak, a part of his own interests, whereas to all other countries they are only
outside occurrences.

Concerning the bridge of the Asco torrent, M. Jean André Malaspina
tells me he has inquired, and finds that though the bridge is not yet

repaired, yet the waters of the river having subsided, a carriage can easily ford them.

May 31.—M. le Maire joins me at sunrise with coffee, and at 5.30 A.M. walks with me a good distance out of the village on my way. Provokingly watchful, my host does not allow me the least chance of conveying a "tip" to the female domestic, a point not easily attained in such houses. I am sorry to take leave of M. Jean André Malaspina. Nothing could be kinder than the behaviour of these amiable people, to whom a stranger and servant coming thus *all' improviso* might well have been somewhat a cause of difficulty.

A long and steep ascent leads eastward from Belgodére; this, the outpost of Balagna, being the last of its villages but one small hamlet, Palasca ; and half an hour having been given to making a last drawing of the " garden of Corsica," the fertile olive-dotted and yellowing plains soon disappear as the shoulder of the mountain is turned, and the line of blue and green Nebbio hills takes the place of more varied and cheerful scenery. A wild uninha-bited space, contrasting strongly with the gay landscape of yesterday is now looked down on as the road winds upwards, and as at this height the heat of the day is not felt, I walk on to the top of the pass, or Bocca di Santa Colum-bana, reaching it at 8.30 (at seven and a half kilomètres from Belgodére, and fifty and a half from Calvi). Little is there to be remarked on the way up— a road to the right towards the top leads to the forest of Tartagine,([1]) to Olmi, and other villages ; to the left, far below, is a wide expanse of sea, and a scrap of Île Rousse and its rocks ; and all else, excepting some groups of cattle at a fountain, is a breadth of maquis-covered hill-tops.

On the southern side of the Bocca di Santa Columbana, the great snowy summits of the highest mountains near Asco and the Niolo are seen, but their bases are cut off by a range of lower hills, among which a very steep descent, which occupies, at a rattling pace, from 8.30 to 10 A.M., leads southward to Corte, mostly by the stony bed of a nearly dry torrent. Ever and anon above the rounded and cystus covered sides of this narrowing gorge peer the jagged and snowy Alp tops, but it is not to be denied that this part of the day's journey possesses very slender interest, and the observer is reduced to the con-templation of perverse stray cattle, who on no account will allow the carriage to pass them, but keep ever foolishly running on for miles ahead of the horses; and of the groups, few and far between, of Corsicans on mules, all in black cloth, but all carrying beaming white umbrellas. Here and there this closely shut-in valley is enlivened by a plot of corn, or two or three walnut

([1]) The valley of Tartagine is in parts very well cultivated ; among others, the canton of Olmi-Capella, where are olive, ilex, and chesnut trees. The inhabitants are cattle breeders, and from this locality come the mules which transport the oils of La Balagna to Castaniccia and to Corte.—*Grandchamps*, pp. 41, 60, &c.

trees, and at intervals a spread of scarlet-blossomed poppies adds a short-lived gleam of gaiety to the winding dulness of this, the least interesting of any part of Corsica I have seen, and the passage through which is not made more cheerful by Domenico's mournful melody of minor moanings, at which, after long continuance, it is clear that only Flora's extreme sense of dignity and what is right prevents her from howling aloud.

It is a relief when the valley opens out and admits some grand mountain distance with groups of ilex and lentisk for foreground, and shortly the bridge

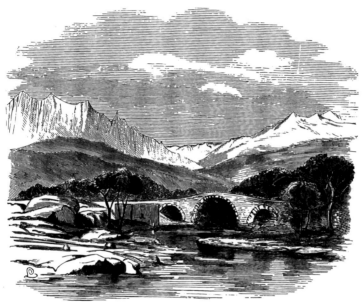

IN THE VALLEY OF THE ASCO.

is reached which should span the torrent that descends from Monte Padro through the valley below Olmi and Castifao; this bridge, though not that of the dreaded Asco river, has also been broken by the heavy winter rains, but a road has been made down to the water—now much lessened, by which Flora and C⁰· pass over. At 10.30 (seventy-two kilomètres from Calvi) is the real difficulty ; here the Asco, which descends from Monte Cinto, and is in the rainy season a formidable torrent, has devastated the whole of the valley, and swept away the greater part of the long bridge built across it. In Corsica, however, these rapid rivers soon exhaust their force, and there is at present but little water in the river bed, so that while Flora and C⁰· go down by the temporary road and ford the river, a system of planks placed at a giddy and

uncomfortable height on the broken bridge piers, enable the foot-passengers to cross it.

Here I remain till 11 A.M., for there are few views of the kind better worth drawing. Looking up the great valley of Asco, the peaks and crags of what I suppose to be the summits of Monte Traunato and Monte Cinto fill the whole of the picture with an array of giant pinnacles, finer in its way than anything I have seen, except Gebel Serbal from Wady Es Sheikh, near Mount Sinai. A small bridge over a tributary stream remains intact, as if to form a foreground with the trees and lower hills above which the long range of delicately pencilled spires rise so majestically. (*See* Vignette, p. 233).

Two more kilomètres are passed, and Ponte della Leccia(¹) is reached—

(¹) [Ponte della Leccia should have been, had time permitted it, my starting-point to see the country of Paoli.—E. L.]

Boswell's "Memorabilia of Pietro Paoli" supply ample materials for any modern Plutarch who would contrast his character with that of his rival countryman, Napoleon Buonaparte. Though Paoli's sphere was narrow, so was that of some of the greatest men in Grecian history ; and, like theirs, it had far-extended relations. The eyes of Europe were upon him ; Corsica was then its battle-field ; and the principles of his conduct and administration are of universal application. —*Forester.*

· In the morning I went to the village of Stretta, where the three Paolis were born. One must see this Casa Paoli fully to comprehend the history of the Corsicans, and to admire yet more those extraordinary men. It is a wretched, blackened village-hovel, standing on a granite rock. A fresh mountain-spring wells up immediately before the door. Everything in the house bears the stamp of a peasant's cottage ; you ascend by a steep wooden staircase to the mean-looking chambers, in which Paoli's wooden table and chair are still standing.—*Gregorovius,* p. 237.

There are several notices of the life of Clement Paoli, the eldest son of Hyacinthus, in Gregorovius—of his courage and persistence, his enthusiasm and religious zeal. When the Genoese were storming the fortified camp of Furiani with all their force, Clement remained unshaken in the ruins for fifty-six days, though the whole place was battered down. He achieved most brilliant feats of arms also after the French had proceeded to assail the Corsicans, in the year 1768. He gained the glorious battle of Borgo, and he fought desperately at Ponte Nuovo, and when all was lost hastened to rescue his brother, and embarked with him for Tuscany. After a convent life of twenty years (at Vallombrosa), he returned to Corsica and died there, in penance and grief.

The convent of Morosaglia is perhaps the most venerable monument of Corsican history. It looks like a hoary legend petrified, brown and gloomy, with a dismal high-towering campanile by its side. At all periods of the national history, parliaments were held in this old Franciscan monastery. Pasquale had rooms and offices there, and was often seen in the summer with the monks, who carried the crucifix into battle at the head of the army. His gallant brother Clement was fond of residing in the same convent, and died in one of its cells in 1793.

Many details of Paoli's life still live here in the mouths of the people. An aged man told me that, when a boy, he was once going along the road with a schoolfellow, reciting a passage of Virgil, Pasquale Paoli happening to come up behind him, tapped him on the shoulder and continued the passage. Old people have seen him walking beneath these chesnut-trees, in his long green coat with gold stripes—the Corsican colours—and in a vest of brown Corsican cloth.—P. 260.

In the year 1790 Napoleon visited the battle-field of the Golo ; he was then twenty-one years old ; but he had probably seen it as a boy.—*Gregorovius,* pp. 243, 260, &c.

[*Valery,* p. 300, speaks of the ancient and picturesque castle of Serravalle, in the valley of Deza, and above the village of Piedigriggio, not far from Corte, as one of the most perfect in Corsica.]

At Morosaglia, the old and vast convent of Franciscans was the summer residence of Paoli during the war of independence. The three or four cells which formed the apartments of Clement Paoli, and where that brave and pious patriot died at an advanced age, at the end of 1793, is now occupied by the gendarmerie. . . The convent of Morosaglia has seen many illustrious guests—the Paoli, Pozzo di Borgo, Lucien Buonaparte, and Napoleon, who came there in 1790 to visit Paoli.

The house of Paoli at Morosaglia stands on the side of a hill, surrounded by wooded mountains, and

a forlorn and dreary-looking cluster of houses by the bridge over the Golo. Here is the junction of the main road from Ajaccio and Corte to Bastia with the Routes Forestières from Calvi and the Balagna, and that from the country about Orezza ; and so important is this spot considered as a centre of communication in the island, that it has been more than once suggested that a city should be founded here. When those plans are carried out, there may perhaps be better cheer for the passing traveller than he finds at present, for, in spite of the "che cosa volete mangiare ?—what will you have to eat ?" asked by the apathetic inmates of the sorry and very dirty house doing duty for a wayside " hotel," nothing but eggs can be obtained, and those eaten with difficulty, on account of the plague of flies which abounded, owing to the unclean state of the floors.

Nor could much be done in the way of drawing at Ponte della Leccia, by reason of the high wind blowing ; and, indeed, standing as it does in the centre of gorges below high mountains, the thought humbly presents itself that the climate of the future city here may not prove of the most delightful kind. I could make only a few memoranda of the large fine bridge and of the great flocks of black sheep arriving from the plains on their way to the high mountain pastures. Somehow, whether it be that the

with a little brook running below it. The house had a little chapel attached. They show the narrow room where Paoli was born. A new stone stairway has been commenced to the upper storey ; the old one is but a kind of wooden ladder. The old people of the place relate that when Paoli returned from Naples, and found that his brother Clement had placed glass windows to the rooms, he broke them all with his stick, &c. The aspect of the house is not changed.

[M. Valery found at Morosaglio the copy which Alfieri gave of his works to Paoli—the volumes, scattered in the disturbances of 1796, and in the pillage of the convent, having been collected by degrees from the peasantry, who had taken away whatever belonged to the chief, in order to preserve them. M. Polidori now possesses the edition in question.]

The peasantry of the canton of Rostino, well-to-do and intelligent, and with whom Paoli ever lived on terms of familiarity, have preserved many memories of the distinguished men who were grouped round him. In spite of the reputation of Napoleon, Paoli has always remained the national hero of Corsica. They have not forgotten that the general, who dressed usually in a green cloth dress embroidered with gold, wore a plain Corsican suit of dark woollen when among them in the mountains.— *Valery*, i., pp. 295, 296.

In the neighbourhood of Ponte alla Leccia, in the valley of the Golo, is the true central point. There the roads to Ajaccio and Bastia, and those from Calvi to Corte and Bastia, cross ; there would pass all the produce of the continent disembarked at Île Rousse or Bastia destined for Central Corsica, and it is marked as a commercial entrepôt. The projected railway from Île Rousse to Bastia and Porto Vecchio, from the Col of Pietralba, the lowest part of the chain dividing Corsica into two slopes, would pass Ponte alla Leccia, and from there by rail the transit would be of less than one hour to Île Rousse or Bastia, three to Porto Vecchio, and two to Corte by the high road. Ponte alla Leccia would then be equally distant from Corte from the three ports which would most influence Corsica—Île Rousse, Bastia, and Porto Vecchio. As a strategic central point also Ponte alla Leccia would be preferable to all others. —*Grandchamps.*

The Ponte à la Leccia is the most central point of the island, as well as one of the most historic scenes of many sanguinary struggles during the wars of independence, &c. Ponte à la Leccia is the spot where the roads centre from Calvi, Corte, Ajaccio, Bastia, to the cantons of Lama, Castifao, Morosaglia, Piedicroce, San Lorenzo, Omessa, &c. It is in this valley, as beautiful as central, where so many roads of communication end, that M. Grandchamps, chief engineer of roads and bridges, has shown in his work on Corsica, printed in 1855, the necessity of founding a town, which would in a short time become populous and flourishing.—*Galletti.*

day is overcast and cloudy, or from the great contrast of the scenery here to that of the gay and beautiful Balagna, Ponte della Leccia seems to me the gloomiest place I have visited in Corsica. Nor do the few people about it enliven it—a grave and solemn set, all dressed in black velveteen; their dialect, however, is perfectly easy to understand, and their civility unfailing.

There are intervals when the most enthusiastic tire of travel, and I confess that the two hours I pass at Ponte della Leccia are of such a kind; I am vexed, too, that I have not time to visit Morosaglia and Ponte Nuovo, and other places. And to-day even the head of the travelling establishment, the little dog Flora, in spite of all her valuable and amiable qualities, is out of favour, for in these unclean places she contracts so large an amount of the only vivacity they possess, in the shape of lively insects, that her propinquity is shunned, to avoid contagion, so that when she enters a room she has to be ejected, an indignity she bears with touching meekness and grace.

2.30 P.M.—Off from Ponte della Leccia; the road running below distant dark-cragged mountains, where stormy effects and gleams of light on snow and granite create many a grand picture, but none of so distinctive a nature as to induce me to halt to make drawings. Many carts, containing great numbers of Italians—Lucchesi as they call them here, on account of their coming chiefly from that part of Italy—are met. These industrious people are returning to Bastia, to embark for Leghorn. ([1])

At Ponte Francardo,([2]) where the river Golo, which descends here from the Niolo, is left, the road proceeds between a pass of narrow rocks, where a drawing might well have been made had the landscape painter been in an industrious mood; but it was otherwise, and Corte—the approach to it from this side (*see* page 173) is assuredly most majestic—was reached by 4˙30 P.M., Domenico driving at a great pace, to have as much leisure as possible for the enjoyment of city life.

On arriving at the little inn I had stayed at during my first visit, I find that the house is full, and as Domenico recommends another, which he says is " Bello e grande, e ci vanno tutti i alti signori—fine and large, and frequented by the greatest persons of Corsica," I go thither, as it is situated at that end of the town from which I have to start to-morrow.

([1]) The Corsicans have, to the present time, maintained their well-founded reputation of shrinking from work. I have had proof of the deep-seated contempt they feel for the poor and industrious Lucchesi, because they leave their homes and work in the sweat of their brow, to take home some little savings to their families.

I often heard the word Lucchese employed as a term of abuse; indeed, in the mountains of the interior especially, all field labour is hated, and deemed unworthy of a free man.—*Gregorovius*.

([2]) Two enormous rocks very near each other, between which the carriage road passes, give to the place the name of Strette d'Omessa, beyond the bridge of Francardo. Here Sampiero held in check the Genoese troops; and all parts hereabouts are full of historical interest.—*Galletti*, p. 203.

But so disgusting is the room I am shown into, that it is not possible to remain in it, and I am at my wits' end, for should I go to the only remaining inn, the Hotel de l'Europe, that also might happen to be full, and then I should have no chance of shelter, for here they would hardly take me in if I returned, and the President, M. Corteggiani, I had already ascertained, was absent from Corte. Fortunately for me, some people at this moment are leaving the hotel, and Giorgio seizing on their room, and giving it a thorough cleaning, it becomes habitable for the few hours I need it. A very tolerable dinner is provided, and the people—let me say what I can of good —are all thoroughly civil.

But oh! for the nice clean little rooms of Evisa, Luri, and St. Florent! or even of Grosseto, Carghésé, or Piana! From all these villages the proud city of Corte may well take long and deep lessons of cleanliness and decency.

CHAPTER XII.

June 1.—At 5 A.M. I leave Corte—nor can I add with regret—once more.
Happy are they for whose noses much suffering is not decreed! but let those
whose sense of smell is delicate avoid Corte until it be blessed with better
drainage and cleaner habits.

It is a clear morning, and the drive up to the beautiful chesnut woods of
Santa Maria di Venaco is delightful. To me this place is one of the most
charming as a summer dwelling, of all I have seen in Corsica, excepting parts
of Paradise-Balagna; besides its high and open position, it has the advan-
tages of a plentiful supply of water, and of lovely walks among walnut
and chesnut groves in every direction. From here I send on Flora and C⁰·
to Vivario, where to-night must be passed, intending to walk thither, the
distance being but fifteen kilomètres.

At Lugo, the first village through which the road passes, there are
triumphal arches and flags, and other unexpected indications of excitement,
with a large inscription of " Hommage à Mariani "—from all which I learn
that the Baron Mariani of Corte is expected here to-day to visit his estates,
and a fête has been promoted in consequence. Enquiring after that very
exclusive beast, the transitory " Moufflon," I hear he is really returned to his
mountain home at Serraggio, and on reaching that place at 8 A.M. I proceed
to ascertain the dwelling of his Moufflonship.[1] " L'animale," however, as the

[1] And there is here a curious animal called muffoli. It resembles a stag, but hath horns like a
ram, and a skin uncommonly hard. It is very wild, and lives on the highest mountains, where it can
hardly be approached, it is so nimble. It will jump from rock to rock, at the distance of many feet,
and, if hard chased to the extremity of a cliff from whence it can reach no other, it will throw itself over,
and with surprising agility pitch upon its horns, without receiving any hurt. Yet, when these creatures
are taken young, they are very easily tamed. M. de Marbœuf, the French commander at the time I was

twenty or thirty youthful Serraggians who collect round me, call him, is even now not easily seen, his master being in the fields, and it was 9 A.M. before his owner came up to the village with the key of his stable, and introduced me to this long-sought-for and respected quadruped. Doubtless he is a magnificent fellow, with a prodigious pair of horns, and he has already lost the savage shyness which marked his disposition when he was first captured at the beginning of last winter, when the snow lay low on the mountains, and he had come down in search of food to the enclosed grounds, into one of which he fell from some rocks, and was captured.

After getting such a sketch of the Moufflon as I was able to ac-

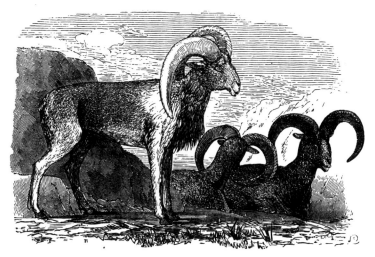

MOUFFLON.

complish by reason of the crowding of intelligent but vexatious villagers, whose natural curiosity I confess was well atoned for by their good-nature

in Corsica, had then one of them, and there are now two of them at Shugborough, in Staffordshire, the seat of Mr. Anson, &c.—*Boswell*, p. 41.

Mouflon, or Musmon.

Found in wild and uncultured parts of Greece, Sardinia, Corsica, and in the deserts of Tartary.

Kamschatkans pass the latter part of summer in pursuit of these animals. Sometimes their horns grow two yards long. Ten men can hardly hold one of these Kamschatkan moufflons. Their horns are often so large that foxes shelter themselves in those which fall off by accident.

Mouflon or musmon, animal neither sheep nor goat ; hair, no wool ; horns like those of a ram ; some grow to an amazing size, measuring above two yards long ; general colour of hair, reddish brown ; found in the uncultivated parts of Greece, Sardinia, Corsica, and Tartary. Form, strong and muscular ; fearful of mankind, and when old seldom taken alive. Frequents the highest summits of mountains. The old rams have furious battles with each other.—*Bewick's* "*History of Quad-rupeds*," p. 64.

From a sort of little stable attached to the convent (Corte), Captain Mariani drove out several Muffoli.—*Benson*, p. 51.

and civility, I go onward down the road as far as the tenth kilomètre from Vivario, and there, below huge trees, establish myself for the mid-day halt and breakfast brought from Corte; making studies of cystus flowers—are they not a part of all Corsican foreground?—and writing letters among the shadowed fern, quickly passing the hours away. No fairer resting place can indeed be found than this—the high arching chestnut trees with the far blue eastern hills seen through them; turf, fern, and cystus all around, a stream of fresh water gurgling close by; and a delightfully sociable blackbird sitting on a rock a little way off, and singing from time to time, for whom the lines—

> "Take warning! he that will not sing
> While yon sun prospers in the blue,
> Shall sing for want, ere leaves are new,
> Caught in the frozen palms of Spring—"

were never intended.

At Serraggio a "Madame" had asked me, with loud accents, to visit her "hotel" for refreshment, but there are many and good reasons for preferring breakfast in the open air to one in the village inns, few of which can be expected to equal those of Evisa and Luri—those, indeed, were rather private lodging-houses than inns at all—here one has fresh air, quiet—excepting the song of blackbirds and nightingales—flowers, and a beautiful prospect; while in those sad little houses you have none of these blessings, but on the contrary, are likely to find noise, flies, and dirt.

The day becomes clouded, and above the mighty heights of Monte Rotondo, on whose sides I am resting, clouds gather, and low growlings of thunder are heard, preluding, perhaps, the ordinary afternoon storm in these parts. And as all at once a blinding flash of lightning comes simultaneously with a peal of crackling thunder, as if fifty pistols had been fired off close to one's ear, warning me that the vicinity of tall chestnut-trees is undesirable— to which many of their split and blackened tops bear witness—I move on towards the Ponte del Vecchio. Rain, however, now sets in, and I can only commence a drawing of this magnificent scene, which I thus pass for the second time without securing, before I am obliged to go on towards Vivario, which I reach at 4.15 P.M., after a not very satisfactory day's work. Now that the fêtes of Corte are over, this road is as unfrequented as any; two mounted gendarmes, accompanying two prisoners tied with a long rope, are the only individuals I have seen since I left Serraggio.

The hotel in the little back alley at Vivario, is, as when I came through here on the 20th, quite full, but I get two rooms in an adjoining house. The ladder entrance to the public eating-room at the inn is not prepossessing, nor is the appearance of the room itself without need of a balance of compensation, which some opine to be a universal law of nature. Such there certainly was at the hotel of Vivario, where it came in the form of a very jovial and pleasant landlady and of two surprising daughters, the sudden appearance of

PLATE XXXVIII.

whom from an inner chamber was most astonishing. For not only were these two girls of extreme beauty, both in face and figure, but they were dressed in the best Parisian taste, their coiffure arranged with the utmost care, and altogether they were a very unexpected sight in so rude a mountain village ; these damsels, however, take no part in the hotel ménage, but only beam forth at occasional intervals.

Of Miss C. the landlady here speaks with the greatest enthusiasm, and adds, " C'est si remarquable qu'elle soit si gaie, parceque toutes les autres Anglaises qu'on voit sont tristes et froides et superbes," a general accusation of my countrywomen I very positively oppose as untrue. My hostess, how-ever, it is but just to say, excepts the Hon. Mrs. A. B., who it seems has lately been here, from this sweeping condemnation, and, like all the rest who have seen that lady, goes into raptures about her beauty.

The Ajaccio Diligence arrives at 6 P.M., when the conducteur, three or four passengers, myself and man, sit down to dinner, at which there are plenty of fine trout and other food of less good quality—but as the good woman says, " Siamo in Corsica, in un villaggio," and at short notice little can be got. While at table the storm clouds roll away, and the mountains all at once become so perfectly clear, that I resolve to go down once more to the Ponte del Vecchio, and, late as it is, to make a third and last trial to draw it. So, sending G. to the lodging for a light folio and a single sheet of paper, the Diligence picks me up as I walk on, and rattling quickly down the hill, drops me close to the bridge by 7 P.M., a help forward cheaply paid for by a franc to the con-ducteur. Here I draw, as rapidly as possible, till 7.45 : the great snowy summit of Monte Rotondo—if that be it which appears to the left up this wild ravine—the line of crags and dark pine woods all along the centre of the gorge, the immense granite precipices hanging just above the rapid stream, its pro-found shadow and narrow depths here and there lighted up with gleams and flashes of brightness, make at this hour a sublime piece of mountain scenery. There is also this association with the scene, that General Paoli, after the battle of Ponte Nuovo, took leave of his friends at the bridge here—not the solid structure now existing, but one of wood—previous to embarking at Porto Vecchio for his long exile in England.

It was 8.30 before I had walked back to Vivario ; but the magnificent bridge scene was worth this, and even more trouble. (*See* Plate 38.)

June 2.—This day is to be allotted to forest journeying—by Sorba to Ghisoni, and thence to Marmáno. The people of Vivario seem of the true idler stamp, so typical of many Corsican villagers, and so great a contrast to those of Cap Corse and La Balagna. The " roba " has to be brought from the lodging to the Piazza whence Flora and C⁰· are to start ; but, though there are some twenty men standing with their hands in their pockets

—Domenico says they are all "landed proprietors"—not one will lend a helping hand. It is, therefore, as late as 5.45 A.M. before we get off; for, with Flora and C⁰, a long time passes before luggage is properly fastened on ; yet, though slow, we are sure, and none has ever come loose or fallen off.

The great mountains Rotondo and d'Oro are perfectly cloudless, the morning delightful. The road for two kilomètres is the same as that to Ajaccio by Bocognano ; and from the heights up which it is carried there are good views of Vivario, but so extensive and full of detail as to require more time than I dare give at the beginning of a long day's journey. Then a Route Forestière, leading to Ghisoni, turns off from the Ajaccio road, and after three more kilomètres, enters the forest of Sorba, which covers the mountain—part, I think, of the great Monte Renoso—on the south of Vivario, and winds with steep and sharp curves, guiltless of parapets, to a great height through the pines, the bocca or summit being at the ninth kilomètre from Vivario. Sorba, one of the smallest forests of Corsica, has naturally no pretensions to rank with those I have previously seen as to extent, but is nevertheless remarkable for the great beauty of its splendid foliage and the great size of its cushion-topped trees, and for their picturesque growth among great rocks and precipices. Moreover, through the whole ascent you have Monte d'Oro and Monte Rotondo in full view, forming the very grandest compositions when combined with the depths of pine, at this early hour all in shadow. All the route to Corte, too, as far as Santa Maria di Venaco, is mapped out below your feet. (*See* Plate 39.)

The steep descent on the other side from the Col di Sorba—the road in such bad condition from the constant passage of heavy timber-cars that I send on Flora and C⁰. to the valley below—is wanting in interest and beauty. High up, one glimpse of the eastern plain (not far from Migliacciara), and of the Étang d'Urbino is seen, and, for a short space, this gives somewhat of a new character to the scenery ; but the greater part of the walk down to Ghisoni is through a tract, once all forest, but now in a process of "exploitation," and completely marred and spoiled. Lower down in the valley—through which, coming from Monte Giovanni (the mountain on whose western face stands Bastelica), the stream of Fiumorbo flows to the sea near Ghisonaccio (*see* page 79)—stands Ghisoni, approached through chestnut woods, and apparently, as one looks down on its roofs, a tolerably large and stirring place ; for it is the point to which the pines are brought from the forests both of Marmáno and that through which I have just passed, as well as the half-way halt between the Casabianda settlement and Corte ; and also it is the nearest place to the branch penal establishment of Marmáno, where I intend to pass the night. But, as the mid-day storm comes on, with pouring rain, just as I reach the Ghisoni "hotel," I hurry on too quickly to allow of much observation along the latter part of the road before I arrive

Plate XXXIX.

FOREST OF SORBA.

there. The scenery from the Col de Sórba is, however, of a commonplace
character by comparison with much I have seen in the island.

The hotel is a clean, nay, a spruce and tidy locanda, the stairs and rooms
splendid when contrasted with those of Vivario ; the walls and ceilings are
painted with landscapes, and groups of fish, game, &c., and there are scarlet
curtains to all the windows. As usual, a good dish of trout for breakfast was
not wanting.

Having a letter of introduction to M. le Maire of Ghisoni, and being
anxious to know something of the distances of to-morrow's journey, I send it
to M. Michele Mattei, who is good enough to call, and give me much infor-
mation, as well as a letter to the doctor residing at Marmáno, in case no notice
of my coming should have been forwarded by M. Beurville, the directeur at
Casabianda. There are five kilomètres, says M. Mattei, from the Marmáno
establishment to the Bocca or Col de Verde at the summit of the forest, and
nineteen thence down to Cozzano ; to Bagni di Guitera there are seven more,
and to Zicavo five out of the main road and five back, so that the whole
distance may be safely reckoned as being under forty-five kilomètres. The
great precipices called the " Insecca," of which I have heard so frequently as
being some of the most remarkable in Corsica, are as much as eleven kilo-
mètres from here on the road to Casabianda, so that although I much wished
to see them, all idea of doing so must be given up, as twenty-two extra
kilomètres would destroy all chance of my getting to Ajaccio on Thursday.

It was nearly 3 P.M. before the violent thunder and rain ceased, and I left
the inn of Giorgio Santi, which is one of the cleanest in these parts. Ghisoni
is placed among such narrow valleys and high overhanging mountains, that
it has an air of gloom from whichever side you see it.

The road to Marmáno goes up the valley immediately below Monte
Renoso, the great snowy lines of which stretch away on the right hand, while
on the left towers a remarkable ridge of stupendous precipices, called by the
people here Monte Kyrie Eleison, but marked in my map as Serra del Prato ;
these rise out of thick woods of ilex, and are some of the grandest and most
noble rocks I have seen. As you proceed, always ascending, the valley narrows,
and at each bend round one of the spurs of Monte Renoso, you advance
amongst scenery of gloomier grandeur, and at length see the end of the valley
of Marmáno, and its dense forests closed in by the wall of Col de Verde, over
which lies to-morrow's road. (*See* Vignette, p. 244.)

Eight kilomètres from Ghisoni the scenery is exceedingly wild : woods
of chestnut trees of immense size, with oak and ilex, fill up the hollow of the
valley ; above these are great rocks and splendid pines, the narrowing triangle
at the head of the gorge being one mass of forest, except a single small
clearing, where a few buildings point out the site of the summer convict
establishment. The pines clothe the lofty heights to the very summit, and

the vast multitude of stems of these gigantic trees, rising tier above tier in the dark forest, on what seems almost a perpendicular screen of cliff, have a very striking effect. Beautiful, too, though in miniature, are the crimson fox-gloves that edge and overhang the precipices, along which the road runs, glowing and gleaming above the dark abyss below.

By the time I reach the end of this second part of to-day's journey—the scenery of which is throughout of a severe and gloomy character—it is 6 P.M.

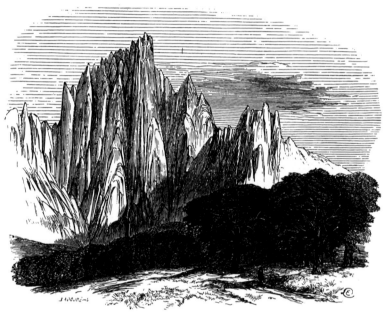

ROCKS OF GHISONI.

At the eleventh kilomètre from Ghisoni you suddenly come on a series of barracks, standing on terraces one above another, and these, which are for the convicts, are the only dwellings in this grim solitude, the house of the doctor, the pavillon of M. le Directeur, and some other offices excepted. Here—for I had sent on by Flora and C°· my letter from M. Mattei—the doctor of the establishment, M. Casanova, comes out to meet me, having already heard from M. le Directeur at Casabianda that I should be here to-day.

Dr. Casanova is most polite and hospitable, but as the pavillon occupied by M. Beureville when here is being enlarged, I am sorry that I am the cause of putting the worthy doctor and his family to some inconvenience. He and Madame, however, make me and my servant share their

evening meal pleasantly enough, and their small children are an intelligent and nice little lot.

The arrangements for the night are not so easy ; in vain I assure these good people that my camp bed is sufficient for me anywhere, and that my servant would be content with a blanket on the floor. A friendly quarrel takes place on the subject, and ultimately nothing can prevent their turning out of a small room, or rather closet, and giving it up for my use, the whole family crowding themselves into the remaining two chambers the house contains. There is just space to insert my camp bed, when put up in one corner, between piles of boxes, groceries, &c., any of which I positively refuse to allow of being moved, and the Suliot occupies a shelf on the other side of the room.

At night the little house is closely barred and watched by the armed guardiani of this prison in a forest.

June 3.—A strange and romantic place is the forest penitencier of Marmáno ; during the winter the number of convicts remaining here is small ; but if Valdoniello through months of deep snow be a dreary spot, what must be this remote and solitary place, with no one but condemned criminals as neighbours through long nights of gloom ? From half June till October, Marmáno is enlivened by the migration from the coast of the whole Casabianda establishment, but at the approach of the cold weather all return to the plain. Meanwhile labour goes on always—gardens are made, pines cut down and cut up, and if the heart of the desert does not sing for joy, at least it resounds with the blows of the hatchet.

At 5.30 A.M. I take leave of the merry and hospitable Dr. Casanova, and walk up the steep zig-zags through the forest of Marmáno—occasionally visited by Flora to see if I am all safe—to the top of the Col de Verde. The road is carried across and across the face of the great heights which close in the Marmáno valley, always among these columnar pine stems— some of them here of extreme size—and in many parts some of the groups of rock and verdure are truly magnificent. Tall beech woods form the upper part of this forest, which, beautiful as it is, is of limited extent compared with those of Aïtone or Valdoniello. How beautiful in early morning are these great woods ! how deep and solemn are the shadows ! how unbroken the silence, except by the cuckoo's note ! nor do I see any live thing all the way but the black and orange lizards which here and there cross the good road.

The Col de Verde, or summit of the forest of Marmáno, is reached at 7.15 (eighty-three kilomètres from Ajaccio), and then follows the long descent into the great valley of the river Taravo, which (*see* p. 36) runs below Bicchisano to the gulf of Valinco at Porto Pollo. For five or six kilomètres the downward winding road continues to lead through sublime forest scenes,

but about 8 A.M. the last pines of the Col de Verde forest are passed, and the valley becomes wider, opening out into glades of fern and asphodel, with woods of ilex at intervals, and an uninterrupted view of verdure and snow-capped heights as far as eye can reach—scenes of far too vast a character to be reduced or condensed into a picture. Towards the west, the mountains sink down in the direction of Bicchisano, and far away in the centre of this green landscape is a village I suppose to be Cozzano, but since the Col was passed there is no one at hand to give information as I am walking on, ahead of the trap, from curve to curve of this serpent-like road.

The hill-sides become less precipitous and the valley more spacious as I proceed, and at 9 A.M., after descending through beautiful woody scenery to about the sixteenth kilomètre, I wait by a roadside house until Flora and C⁰· come up, which at length they do, at a pace so slow that something is evidently wrong. One of the ponies has lost a shoe, and Domenico having left his bag of nails at Vivario orders a halt, and leaving the trap and one pony in the care of myself and G., goes with the other and Flora across the valley to Commanaccie, on a nail procuring expedition.

While waiting for the driver's return, some cantonniers come and beg me to enter and rest in their little wayside house; these good people do not perceive how much more agreeable it is to sit or lie beneath a chestnut-tree contemplating the wide and beautiful landscape, than to encounter the dis-agreeables of a close room ; the more so, in the present case, that besides the cantonniers there is a party of charcoal-burners, who do not seem to be either of the apathetic, or civil and well-bred nature, so characteristic generally of these islanders, two or three of them having been closely examining the luggage for some time past, and having made themselves not a little dis-agreeable. Towards 10 o'clock, however, Domenico returns, and proceeds to shoe the pony, by no means assisted in his work by the riotous group about him, most of these being "elevated" by drink, and one of them apparently an idiot. These fellows profess to help my driver by holding up the pony's foot, but in the middle of the shoeing they purposely give it a jerk, and every time the shoe comes off again by this manœuvre, they dance round the carriage roaring with drunken laughter; which game goes on in a very irritating fashion, in spite of the cantonniers' interference, so that I fear a serious quarrel may ensue. When Domenico's patience is nearly exhausted by these practical jokes, it is thought better to drive off with the shoe only partly nailed on; a sign of defeat on our part greeted by loud shouts of derision, and especially by the idiot, with the wildest shrieks and gestures. I confess I should not have been pleased to have been obliged to pass the night with the society I have just left ; nevertheless, this is the one and only instance, in two months of Corsican touring, of my having received the least molestation, even in the most out-of-the-way places. This vast valley,

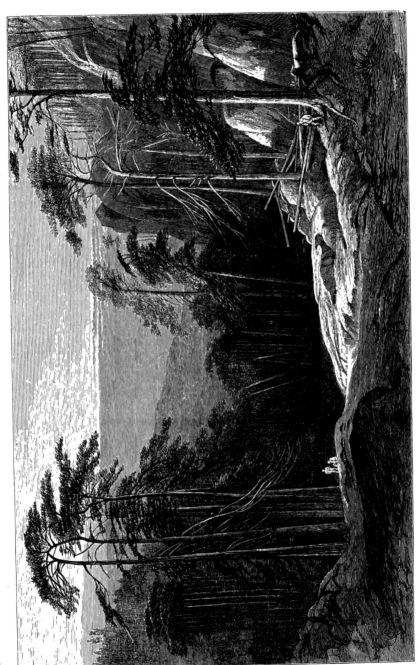

Plate XL.

scantily populated above Guitera and Zicavo, leads only to Ghisoni by the
forests of Verde and Marmáno, seems very little frequented, and thus far
in it I have not seen a single mounted gendarme, who are generally met
with in pairs from time to time on all the roads.

At the sixty-sixth kilomètre from Ajaccio the road passes through Coz-
zano,[1] a village of no especial interest ; all the way thither from the scene of
the horse-shoeing being through a succession of fair landscapes, of beautiful
woods, and wide spaces of fern with groups of chesnut, oak, and ilex ; and
then follows a descent for six more kilomètres through more cultivated tracts,
till the river Taravo is crossed, and the road to Zicavo is passed on the left ;
throughout the latter part of this distance the foliage is most delightful, and
the scenery about the Taravo bridge might be in the very richest Derby-
shire or Devonshire valley ; the hills nearer Guitera are to the full as beauti-
fully wooded as those above the Thames at Clifden.

At noon, in the midst of this lovely wood and river scenery I come to ten
or twelve houses by the roadside, one of which is what Domenico has pre-
viously described as the "bellissimo Hôtel de' Bagni di Guitera," a rustic but
cleanly house, at the back of which are the mineral springs so frequented in
summer by invalids from all parts of Corsica. This place is about thirty-two
kilomètres from Marmáno, and twenty-six from Grosseto ; Zicavo is twelve
distant. I decide therefore on remaining at these baths to-night, the onward
road to Grosseto, which crosses a spur of the mountains, being, according to
Domenico, a steep one ; he, moreover, volunteers if I sleep here to bring me
to Ajaccio early to-morrow afternoon. Thus Zicavo can well be visited from
here later in the day, by taking Flora and C[o.] without luggage up the hill, and
walking back.

While breakfast is being prepared, I go to see the mineral springs
at the back of the hotel, which are very remarkable. A large circular basin
boils over with the hot water, and the overflow is conducted by pipes to a
row of log barracks or huts used as private baths ; for one of these you
pay five soldi twenty-five centesimi ; but if you are economically inclined,
you may bathe gratis in an open public reservoir close to the main springs.
To me, this water, which resembles that of Harrowgate, and has an ancient
decayed-egg flavour, was disgusting ; but I am assured that you come to like
it very much if you will only persevere in drinking it ; and, certainly, some
persons whom I saw, quaffed whole tumblers of it with great apparent relish.

The people of the inn—at the risk of repetition, I must state that they
were thoroughly obliging folk—gave me an exceptionally good breakfast, served
by a damsel very different to those who usually attend on the Diligence
passengers in the Corsican inns, and whose face, without being absolutely
handsome, was very pretty and full of expression, of intelligence and sweet-

[1] Cozzano, whose inhabitants love to beg, exceptional in Corsica. — *Galletti*, p. 216.

ness. When breakfast was ready, there was a stew, which I observed my servant regarding uneasily, for it did not seem to be hare, and was certainly not fowl—" Scusate," said the polite waitress, apologetically, " questo piatto è —o scusate!—di quell' animale nero—scusate!—Please to excuse—this dish is—oh please excuse!—that black animal—excuse!"(¹) More could not be said had the object been a cat, whereas it was sucking-pig; and on bringing a dish of roast meat to table, there were renewed apologies—" Vostro perdono davvero! bisogna scusare si sa—quest' è il parte di dietro della stessa piccola bestia nera!—really I beg pardon—excuse it, you know—this is the hinder part of the same little black beast!" Notwithstanding all these apologies, none were needed, for the little black beast was excellent both stewed and roasted; some apple-fritters also were admirable; and, though the good cheese of Balagna is not found in these parts, the wine was excellent; about which, when I had enquired if they had any good here, the polite reply had been, " not any worthy of your merit, but some we hope you may find drinkable."

This very rustic hotel has many rooms above the ground floor; you ascend by ladder-staircases to the upper chambers; all coarsely whitewashed and as nearly unfurnished as may be; yet there is a respect for cleanliness everywhere visible about the house, the floors and passages are clean, and the whole rural establishment prepossessing, though humble. Round the house—now that one is no longer at Cap Corse or Balagna—loiterers, clad in the usual black velveteen, are not lacking, and stare in at the window fixedly. And, as usual, when the carriage stops at such houses, a small crowd of children swarm into and take possession of the empty vehicle.

The usual afternoon storm and rain having come on, it is 3.30 P.M. before I can start off from Zicavo, the "woody places" of this lovely valley being all fresh and odorous of clematis and honeysuckle. At 4, having retraced the road of this morning for a few kilomètres, a Route Forestière leaves the Ajaccio highway and winds up the side of a deep gorge, where great ches- nut and ilex woods are the chief characteristic, and the villages or communes of Zicavo are thereafter constantly in sight. They may be described as standing in a vast wooded amphitheatre or hollow in the great Incudine mountain range, the plain or plateau of Coscione being immediately beyond the highest summits which tower over the villages, below more distant crags and precipices also partially wooded.

The wide space of rich foliage is brightened by scattered houses gleaming among the woods on the hill-side; and in the principal hamlet there seem some good houses as well as a rather picturesque white church; there, too, Domenico points out the Casa Abbatucci. The great ravine and river far below are full of beauty, and all the rocky descent to the roaring stream is

(¹) [Pig (porco) is never mentioned in Italy by polite folk without an apology, and as all, or nearly all Italian pigs are black, it is called "animale nero."--E. L.]

clothed with a growth of magnificent chesnut and ilex ; yet, on so large a scale is the scenery, that it would be by no means easy to portray Zicavo as a whole, notwithstanding the great beauty of its position. All this, however, I scarcely saw more of than in my approach to the villages, for, unfortunately, violent rain and thunder recommenced after I had sent back Flora and C⁰ to Guitera ; so that after part of the afternoon had been passed in shelter below some rocks, it became too late in the day to advance farther, and I had to make the best of my way back to the Bagni di Guitera.

As I returned to the hotel after the failure of my Zicavo exploit, the beautiful landscape round it was alive with flocks of sheep and goats (all of course black) going up to the mountains for the summer; some of the shepherds and their families were as picturesque as Corsican peasants can be—which in these our days is not saying much, since their old costume, the pointed cap, gaiters, &c., has ceased out of the land. Many scenes in the deep hollows of the Taravo continually remind me of leafy glen-scenery in Yorkshire or Devonshire; perhaps the bridge near Guitera, with its hanging fern and drooping alders, its rocks and foaming river, is one of the loveliest points in this picturesque neighbourhood.

Flora, this being the last day of dining in Corsican rural inns, is invited to dinner—most amiable and intelligent of "small spotty dogs." Afterwards, the rest of the evening was passed in describing the cities of Europe to the pretty daughter of the house, who, notwithstanding her mother's summons, lingered to listen to details of outer-world novelties until the call had been thrice repeated.

June 4.—I rise at 4 A.M., and Flora and C⁰· are off by 5 from the clean little humble hotel, whose managers are the civillest of people. The Hôtel Guitera, kept by Ventura Bozzi, is worth a longer visit, for it is a pleasant and quiet halting-place in the midst of exquisite scenery.

The drive from the baths to the main Ajaccio and Bonifacio road, by Santa Maria Zicché d'Ornano,(¹) is one of the most enchanting in all Corsica.

(¹) My journey over the mountains was very entertaining. I passed some immense ridges and vast woods. At Bastelica, where there is a stately spirited race of people. . . At Ornano I saw the ruins of the seat where the great Sampiero had his residence.—*Boswell.*

Sta. M. d'Ornano is a little village surrounded by mountains. I slept there in the tower of Vanina, a sort of fort, and the highest house in Santa Maria. The ruins of a castle of Sampiero are near S. M. d'Ornano, and of the chapel, separated from the castle by a field, across which Sampiero did not scruple to hear, or rather see, the mass performed from his window.—*Valery*, i., p. 193.

This was the native country of the fair Vannina, and there stands the high brown turretted house which belonged to her, picturesquely situated on an eminence commanding the valley. Near it are perceived the ruins of a castle built by Sampiero, and a chapel in its vicinity where he heard mass. He is said to have contented himself with looking out of the window of his castle when mass was said. He built the castle in the year 1554.—*Gregorovius*, p. 411.

Opposite the ruined house of Vannina Ornano, the wife of Sampiero, there stands a half-destroyed chapel, with a large door. Tradition says it was built by order of Sampiero ; and that from his house he assisted at the sacrifice of the mass ; although some hundreds of mètres distant, he could see the priest officiating at the altar.—*Galletti*, p. 152.

There is a second road along the southern side of this great valley, termi-
nating at Bicchisano ; but that can scarcely be so beautiful, since it does
not include the variety of crossing the mountain spurs that form one of the
most charming parts of the northern line of route. The Route Forestière to
Grosseto soon turns off to the right, and rises gradually by pleasant lanes
among wooded and "maquis"-covered tracts, through landscape which at this
hour is indescribably lovely, and constantly recalls the best and fairest
distances of Claude Lorraine's paintings. After yesterday's rain, every dark

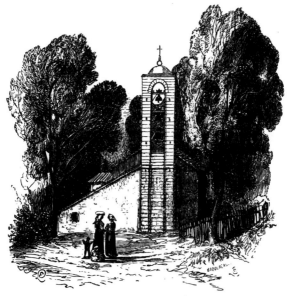

SANTA MARIA ZICCHÉ.

chesnut-leaf sparkles with moisture, and it is impossible to conceive more
beautiful spots than there are at every turn of this road, either looking back
eastward to the heights of Monte Incudine above Zicavo, or westward to the
long long lines of the valley of the Taravo, fading away into the hills near
Sollacarò on the horizon.

Corrà is the first village passed, and one where a landscape painter might
pass a summer with delight. Then another hamlet (Frasseto) with slopes
of immense fern—shading chesnut-trees, ilex of astonishing beauty, and vast
walnut-trees ; and after this follows a long and steep ascent—Domenico was
quite right in dissuading me from attempting it late yesterday afternoon—the
top of which was reached at 8 A.M. Then the road dips down into a deep.

recess of mountains, and, circling round spur after spur, gradually descends to Santa Maria through a succession of villages—Sevato, Quasquara, and others —all full of picturesque beauty, not so much owing to any charm of architecture, as to the combination of the houses with foliage and distance. At about three kilomètres before reaching the main Ajaccio route impériale, at the foot of the ascent to-Col S. Giorgio, a branch road turns off to the village of Santa Maria Zicché, where there is a church with an extremely picturesque campanile ; and thus, a short distance farther, always passing through beautiful scenes of graceful woody landscape, I come for the third time to Grosseto, at the seventeenth kilomètre from Ajaccio, by 9.30 A.M., and once more go to the pleasant little village inn of Madame Lionardi. Undoubtedly the drive hither from Guitera ranks among the first for lovely scenery in all this beautiful island.

The little village of Grosseto is all astir, and something is happening, for the roadside is full of groups of gendarmes. Madame Lionardi explains, with many apologies for not being able to give me breakfast in the sitting-room, that all the house is taken for the General commanding the troops in the arrondissement of Ajaccio, and for other officials, whose luggage is momentarily arriving, on account of a review of gendarmerie, a conscription, &c. But the obliging family of the hotel soon clear out another room, and I occupy an hour till breakfast comes, by drawing some of the grand ilex trees close to the house. This place, and indeed all the valley of Grosseto, and of the Taravo, is truly one for a painter to sojourn in who desires to study the evergreen oak in its most luxuriant growth and finest form. After this, a fine dish of trout, good cutlets, and superb broccio, add one more to the pleasant memories already registered of the Hôtel des Amis.

The son of Madame Lionardi tells me that a brother of Mr. B. arrived at Olmeto about a week ago, and that the dying man was then removed to Ajaccio, where he died on the following day, and that the day before yesterday his body was embarked for Marseilles ; news which, after what I had seen of the poor invalid's condition when I was last in Olmeto, was to me no surprise.

I give an hour to a walk to Santa Maria Zicché, to obtain a drawing (of the picturesque campanile there), probably the last I shall make in Corsica. (An old woman by the roadside asks me for "qual cosa," and this is only the third instance of begging I have known in my eight weeks' tour.) All along this part of the valley there have of late been very violent hail-storms, and the vines, they tell me, have been greatly damaged.

Returning to Grosseto by 1 P.M., Flora and C$^{o.}$ are ready, and I leave the village as the arrivals of gendarmes, walking, riding, and driving, continually increase the hubbub ; soon we have trotted up the Col St. Giorgio, from which I take a last look at these beautiful scenes. How lovely and green is the wide

space of hill and dale! Addio, for the third time, noble and verdant valleys of the Taravo!

Soon the "maquis"-grown crescent of hills beyond the Col is passed; then the familiar village of Cauro, and the far view of Ajaccio is seen on the horizon; the run down to the Piano dell' Oro follows; and I am soon once more in Ajaccio, where the squadron of ironclads enliven the bay, if, indeed, any place may be said to be enlivened by those specimens of naval architecture. My journeys in Corsica are ended; much more there is to see, but time is up, and the glass of Corsican travel is run out; close, therefore, the note-book of research, and lock it up in the closet of resignation.

After the fresh mountain air how hot does Ajaccio now seem! and above all the small rooms of the Ottavi Hotel!

Flora and C⁰· are dismissed with esteem. No better nor more careful coachman could be found anywhere than the youth Domenico, who, by-the bye, is an amateur, having, as he told my servant, property to the amount of 20,000 francs, and who drives about to see the world by choice—" per piacer di veder il mondo, fuori di Corsica no—ma tutta l'isola." Farewell spotty little beast of excellent qualities—Flora, best of dogs!

June 5.—This day has passed—first, in finishing drawings of the town at sunrise; secondly, in packing my 350 drawings and in purchasing gourds and photographs; thirdly, in making PP.C. calls at the Préfecture and elsewhere, and in wandering among the beautiful wild olive and cactus-grown dells beyond the Cours Grandval. In the evening I dine at M. le Préfet's. Admiral Jurien de la Gravière and others are there.

Among other matters I hear that the L. K.'s were in Corsica last winter, and that my old Abruzzo companion in 1843, C. A. K., was also here.

June 6.—A day of last packings. In the afternoon, at 4.30 P.M., I left the worthy Ottavis and the Hôtel de Londres, and came on board the Insulaire steamer, getting the identical berth I came in two months ago. The two trotting poodles were also performing as in times past.

At 6 I make a last drawing of the head of the gulf; beautifully clear and rosily coloured at sunset were the cliffs above Sari, and the snows of Monte d'Oro; gorgeous beyond description the hues on the sea as the sun went down behind the rocky islet gates of the gulf. At 6.30 Miss C. and other returning travellers had come on board, and at 7.30 we started, and soon, beyond the Îles Sanguinaires, lost sight of the gulf of Ajaccio and the wild mountain ranges.

As night came on, the headlands about the gulf of Sagona were the last I could trace of Corsica, and next morning by 9 we were in the harbour of Nice. Soon I was once more at Cannes, and looking at the ever-beautiful Esterelles, than which there are many grander forms, but few more delicately perfect and lovely.

ADDITIONAL NOTES.

—◆—

[IN order to avoid the insertion of too many notes in the text of the "Journal in Corsica," I have thrown into a single chapter some necessary and desirable information on various subjects connected with the island —its natural formation, history, the manners of its inhabitants, &c. The whole is given in the shape of notes, to each of which is appended the authority from which it is borrowed.— E. L.]

Corsica is the third largest island in the Mediterranean, Sicily and Sardinia being both of greater size. It is situated between the 41° and 43° of N. latitude, and between the 6° and 7° of E. longitude. The distance from the coast of Italy is 56 miles, from that of France, 90. Its length is 115 miles, and its greatest breadth about 54. Corsica is a mere mass of Alpine ridges rising out of the sea like a vessel or the roof of a house. The mountains attain their highest elevation in the centre.

There are two mountain ranges which form the island, running longitudinally through it from north to south. The eastern range commences at Cape Corso, a narrow longitudinal mountain, some 3,000 feet high, and more than twenty miles long, the base of which is bathed by the sea both east and west. This range is secondary, calcareous, and descends to the south at a moderate elevation. The second range is primitive, granitic ; it commences near the west coast at Isola Rossa, rises rapidly to a height of 8,000 and 9,000 feet, and runs through the island down to its southern extremity.

The different geological nature of these two mountain ranges has, in the course of countless ages, modified the character of the eastern and western shores.

The eastern range, composed, as was stated, of secondary, calcareous rocks, is more easily disintegrated and washed away by the action of the elements. Owing to this cause, the rivers which descend from their sides, and form the central regions of the island, through clefts which these calcareous mountains present, have deposited at their base alluvial plains of considerable extent. Through these rich alluvial plains several large streams meander to reach the sea. This they accomplish with difficulty, owing to the lowness of the shore and to the prevalence of the scirocco or south-east wind, which constantly throws up large masses of sand at their mouths. Hence the formation, along the eastern shore, of large salt-water ponds, into some of which the rivers empty themselves. Under the burning glare of a Mediterranean sun, these terrestrial conditions, large ponds of brackish water, marshes, and rich alluvial plains liable to periodical overflow, embody all the elements calculated to produce malaria of the most deadly character. By such malaria is this region rendered all but uninhabitable for half the year.

The western, primary, granitic range of mountains is the real backbone of the island. It must have been thrown up long before the secondary eastern range, is very much higher, and is covered in some regions with eternal snow. This range is jagged and irregular in its

outline. It throws out high granitic spurs towards the western sea, which jut into deep water and form deep bays or gulfs, as is usual with primary rocks. These spurs divide the western side of the island into deep wide picturesque valleys. At the bottom of each valley runs a brawling stream, which carries to the sea the watershed of the high snow-clad mountains, and forms an alluvial plain of greater or less extent as it nears the coast. Disintegration, however, during the geological period, has been slow, owing to the granitic character of the mountains, and the rivers have carried less soil to the sea than those of the eastern or calcareous side of the island. The alluvial plains are consequently all but confined to the mountain valleys, and the sea is very deep near the shore. On this side of the island are all the natural ports, with the exception of that of Porto Vecchio on the south-east coast. Thus there are no ponds, the marshes are small in extent, limited by the immediate vicinity of the outlet of the rivers, and malaria and intermittent fever are comparatively, but slightly felt.—*Bennet*, p. 226.

The island of Corsica is divided by a chain of mountains which runs from north to south. The western part presents a granitic formation ; the eastern is calcareous and schistose. Three different climates are distinguishable in this island. Near the sea-shore the severity of winter is never felt, even in January and February ; throughout the greater part of the island, where the population is most numerous, these are the coldest months, and this may be called the second climate. A third exists in the high mountains, but in those parts there are no inhabitants, except in some villages, such as Vivario, the Niolo, Bocognano, &c.
Galletti, p. 33.

The very glorious vegetation of the island is favoured by the climate. The Corsican climate has three zones of temperature, graduated according to the elevation of the ground. The first climatic zone rises from the sea level to a height of 1,903 feet ; the second, from thence to the height of 6,398 feet ; the third, thence to the summit of the mountains.

The first zone, namely, the sea-coast in general, is as warm as the parallel coasts of Italy and Spain. It has, properly speaking, only two seasons, spring and summer ; the thermometer rarely descends here two or three degrees below the freezing point, and then only for a few hours. On all the coasts the sun is warm, even in January, but the nights and the shade are cool at every season. The sky is overclouded only at intervals ; the south-east wind alone, the harsh scirocco, brings prolonged fogs, which are dispersed again by the violent south-wester or libeccio. Upon the moderate cold of January follows soon a dog-day heat of eight months, and the temperature rises from 50° to 72°, and even 90° in the shade. It is a misfortune to the vegetation when it does not rain in March or April, and no unfrequent case either, but the Corsican trees have generally hard and tough leaves, which resist drought, as the oleander, myrtle, cystus, lentiscus, and oleaster. In Corsica, as in all hot climates, the watery and shady districts of the levels are almost pestilential ; it is impossible to walk there in the evening without catching a long and severe fever, which, if total change of air be not resorted to, may end in dropsy or death.

The second climatic zone of the island corresponds to the climate of France, especially of Burgundy and Brittany. The snow that appears there in November sometimes lasts twenty days ; but, remarkably enough, it does no damage to the olive up to the elevation of 3,806 feet (1,160 mètres), but renders it yet more fruitful. The chesnut appears to be the characteristic tree of this zone ; for it stops at a height of 6,398 feet, and then yields to the green oaks, pines, beeches, box, and juniper. In this climate the majority of the people live in scattered villages, on mountain slopes, and in valleys.

The third climate is cold and stormy, as that of Norway, during eight months in the year. The only inhabited places in this zone are the Niolo, and the two forts of

Vivario and Vizzavona. Beyond these inhabited places, the eye can discern no other vegetation than pines clinging to gray rocks. There dwell the vulture and the wild sheep, and there is the storehouse and birthplace of the many streams that rush down to the plains below.

Corsica may thus be considered as a pyramid rising in gradations of three horizontal steps, of which the lowest is warm and moist, the upmost cold and dry, and the middle one partakes of both qualities.—*Gregorovius*, p. 121.

The air is fresh and healthful, except in one or two places, which are moist, and where the air, especially in summer, is suffocating and sickly ; but in general the Corsicans breathe a pure atmosphere, &c.—*Boswell*, p. 15.

Like other mountainous countries, Corsica is exceedingly picturesque. . To the agriculturist who estimates a district by its production, the man who looks at a river with a view to inland navigation, and to the effeminate traveller, who judges of a country by the qualities of its roads and hotels, the rugged mountains, the rich but neglected valleys, the boisterous torrents, and the trackless forests of Corsica would afford no gratification · but to him who can associate and almost identify himself with nature, the island affords a treat of no ordinary kind.—*Benson*, p. 35.

ALTITUDE OF THE MOUNTAIN RANGE IN CORSICA, FROM SOUTH TO NORTH. M

	Mètres.	Feet.		Mètres.	Feet.		Mètres.	Feet.
Monte della Trinità	297	975	Punta di Muro	846	2 446	Castel Vecchio	578	1,897.
„ dell' Incudine	2,056	6,750	Monte Cervello	1,572	5,161.	Punta del Luogo Niello	1,123	3,687.
Renoso	2,257	7,400	Capo Linscinosa	1,545	5,072.	Monte Cerio	1,072	3,519
„ Cardo	2,500	8,208	„ Vitullo	1,278	4,195.	„ Artica	2,440	8,010
„ Rotondo	2,764	9,072	„ di Vegno	1,389	4,559	„ Conia	1,984	6,510
„ d'Oro	2,652	8.708.	Monte Asto	1,402	4,602	„ San Pietro	1,659	5,445.
„ Cinto	2,816	9,240	Guipetta	744	2,440	„ Padro	2,458	8,069.
Punta della Torricella	542	1,779.						

Grandchamps, p. 5.

The eastern part of Corsica possesses but few ports—the cove of Barcaggio, the port of Macinaggio, that of Porticciolo, and the cove of Erbalunga in Cap Corse ; the port of I Bastia, that of Favone, the gulf of Porto Vecchio, and the port of Bonifacio at the extreme south-east point of the island. On the contrary the north-west, west, and south-west coasts being all indented, form several gulfs and ports, as, the little port of Centuri, the gulf of St. Florent, the port of Île Rousse, the gulf and port of Calvi, the gulfs of Rivellata, Crovani Galeria, Focolare d'Elba, Girolata, Porto, Chiomi, Pero, Sagona, Liscia, Lava, Provençal Ajaccio, Valinco, Mortoli, Roccaspina, Figari, and Ventilegne, and the ports of Portobello, Propriano, and Campo Moro.—*Galletti*, p. 36.

The rivers of Corsica, or rather the torrents, are the Golo, which receives the streams of the Asco, the Tartagine, Casaluna, and others, flows into the sea twenty kilomètres from Bastia, near the ruins of Mariana. The Tavignano receives the waters of the Restonica, and, as the Vecchio, the Corsigliese, Tagnone, &c., flows eastward to the sea at Aleria. The Liamone flows into the sea on the west side of the island near the gulf of Sagona, the Bevinco, Fiumalto, and Fiumorbo.

Superficies of the étangs, or salt-water lagoons :—

Diana	570	hectares, anciently port of Aleria.
Chiurlino .	1,800	anciently port of Biguglia.
Urbino . .	750	„ in the plain of Aleria.
Palo	29	„ in that of Fiumorbo.
Balistro . .	29	„ in the gulf of Santa Manza.
Taravo	29	„ near the river of that name.

<div align="right">Galletti, p. 14, &c.</div>

There are several small lakes of fresh water in the mountainous region of the island ; shut up, as it were, in the hollows of granite and porphyry, they are mostly inaccessible. The largest of these lakes is situated at the foot of Monte Rotondo, by which name it is called ; it has a superficies of seven hectares, and in it the torrent of the Vecchio takes its rise. Of less extent than the lake of Monte Rotondo, the Lake Nino (or Ino) adorns one of the ends of the Campotile, and at the opposite end of the same plain is the Lake Creno. The Monte Renoso also contains some lakes, the Upper and Lower Rino, the Bastani, the Vetelacca, and the Bracco ; this last-mentioned lake is almost always frozen.—*Galletti*, pp. 14, 18, 36, &c.

The roads of Corsica are divided into three principal systems :—First, those which unite the eastern and western coasts ; secondly, those which follow the shore and serve successively to each basin as its communication ; thirdly, the route forestière, traced along the principal water-courses, and opening out on to the most frequented ports.

The road which goes round Corsica is divided into four parts—that from Ajaccio to Bonifacio traverses the valleys of the Gravona, the Prunelli, the Taravo, the Rizzanese, and the small secondary valleys comprised between Sartéré and Bonifacio, touching at the ports of Ajaccio, Propriano, and Bonifacio, and climbing successively at great heights the edges which separaté the basins of the Prunelli, the Taravo, Rizzanese, and Ortolo, goes through Grosseto, Olmeto, and Sarténé, and serves the southern part of all the western slope.

The road from Bonifacio to Macinaggio follows the eastern coast in all its length. Less irregular than the last, it presents, nevertheless, several inclines.—*Grandchamps*, p. 103.

In the first years after the conquest of the island by the French, the government made a carriage-road from Bastia to Corte and Ajaccio. During the Republic, the First Empire, and the Restoration, the roads were not enough attended to ; but with the reign of King Louis Philippe, the regeneration of Corsica commenced, and under that of the Emperor Napoleon III. works have been accomplished, which, to the older natives of the island, seem to be dreams rather than realities.—*Galletti*, p. 53.

The coasts of Corsica are lighted by five lighthouses of the first class, and by four lanterns or beacons. The lighthouses are placed at the point of Cap Corse (on the island of la Geraglia) ; at the point of la Revellata, near Calvi ; on the Grand Sanguinaire, near Ajaccio ; at the point of Pertusato, near Bonifacio ; and at Porto Vecchio, on the point of la Chiappa. The lanterns are at the entrances of the ports of Île Rousse, Ajaccio, Bonifacio, and Bastia.— *Grandchamps*, p. 97.

The sulphurous waters of Corsica are Pietrapola, Puzzichello, Guitéra, Caldaniccia, and Guagno. Orezza is the principal ferruginous source.—*Galletti*, p. 20.

[In the Abbé Galletti's book may be found a very interesting and detailed account of the mineral waters of Corsica, given by M. le Docteur Constantine James. Those of Pietrapola were anciently known, as there are still vestiges of Roman baths to be seen there. These waters are spoken of with the highest commendation. Doctor J. augurs a great future for Guitéra, and states that the source of hot springs now in use forms but a small fraction of

the mineral riches of this locality. Valuable information on the subject of malaria, or other causes of unhealthiness, in various parts of Corsica, may be found in Dr. Bennet's "Winter in South of Europe," and in a paper communicated by him to the *Lancet*, Aug. 1, 1868.]

The most populous of the Corsican towns are found on the shore, near the mouths of streams. Bastia, not far from the Golo ; St. Florent, at the mouth of the Aliso. Others probably existed at the mouth of the Ostriconi, Liamone, and Tavignano. These were all destroyed in the middle ages by Mediterranean pirates, and their inhabitants, seeking shelter in the mountains, founded new villages among inaccessible rocks. The successive migrations from the sea-side to the higher districts may be easily fixed ; those from the Ostriconi founded Palasca ; those from the Osari built Belgodére ; those from the mouth of the Fiume-Secco, Calenzana ; and everywhere the inhabitants of the mountains own, at the present day, the plains watered by the streams at the sources of which they settled. When Corsica ceased to be desolated by the incursions of pirates, it was no longer possible to reconstruct the villages which once stood on the shore ; for the plains, having become marshy, were uninhabitable, and as they are at this day, unhealthy and uncultivated, hence all the produce of the valleys, which should have been shipped from the shore to the continent, has to be taken up to the villages, to be transported later to a place of embarkation.— *Grandchamps*, p. 11.

Like the agriculture of Corsica, its manufactures are in a very sorry state. They are C confined to the most indispensable wants of trade and nourishment ; the women almost everywhere weave the coarse brown Corsican cloth (panno Corso) also called *pelone;* the herdsmen make cheese and the cheese-cake broccio ; salt works there are only in the gulf of Porto Vecchio. Sardines, tunny, and coral, are taken on many parts of the coast, but the fisheries are conducted with no vigour. The commerce of Corsica is likewise very inconsiderable. The chief export is oil, of which the island possesses such a quantity that, with more extended cultivation, it could produce it to the value of sixty millions of francs ; but also lemons, wines, pulse, chesnuts, fresh and salt fish, timber, dyes, hides, coral, marble, and manufactured tobacco, especially cigars, for which the leaves are imported. The chief imports are corn, grain, rice, sugar, coffee, cattle, silk, cotton, linseed, leather, iron-ore, and hardware, tiles, glass, and pottery. The chief commerce of the island belongs to the ports of Bastia, Ajaccio, Isola Rossa, and Bonifazio.—*Gregorovius*, p. 127, &c.

The position of Corsica between France and Italy, its climate, its fertility, the brilliant ʀ qualities of its people, unite to claim attention to this privileged spot. Unhappily, labour has not as yet called forth its natural riches ; agriculture is neglected ; its streams descend from C mountains to feed infectious marshes in the plains ; its ports are sand choked ; its coasts remain desert and abandoned ; rivalries are transmitted from father to son for ages ; and the population, idle in the midst of universal progress, seems condemned to a fatal immobility. What does this country need to give it movement and life—to develop in it the love of work —to extinguish that thirst for vengeance which so frequently provokes murder and conflagration ? Throughout three centuries the wisest edicts remain without force against the rooted prejudices of a people. Encouragement, repression, séverity, all have failed before the proud contempt of the Corsicans for agriculture. It is necessary, in order to draw Corsica from its isolation, to bring the island more in communication with the neighbouring continent. Then, and not till then, will prejudices fall, and the face of the country be changed. · · The hour is come for Corsica to join in the European movement of progress. --*Grandchamps*, Introduction, p. vi.

The greater number of the Basins or valleys of Corsica are independent of each other, and at first sight it would seem that in the interior of the island there exists no centre of action

sufficiently powerful to react on the whole country, and to unite the population of the eastern with those of the western sides. This fact explains the history of Corsica, the enmities of great families established in separate Basins separated by high mountains, and the fruitless attempts of the Corsicans to establish their nationality.

Immense riches, vegetable and mineral, lie concealed in Corsica ; and it is necessary to study the different Basins of the island to discover the best mode of favouring their natural development, and the part each have to play in the general regeneration of the country.

The colonisation of Corsica by France will commence naturally by the Basins of the Western watershed. All are important, but that which permits the easiest communication between the two mountain slopes of Corsica is the Basin of Nebbio, which opens on the Gulf of S. Florent, and is at once the nearest to France and Italy, and one of the richest and best cultivated of the island.

The Basins on the eastern side of the island contain, on a larger scale, the same elements of riches and the same causes of unhealthiness. Everywhere there are uncultivated plains devastated by the flocks, and burned by the wild carelessness of the shepherds. Death seems to reign in the midst of these desert shores, although Nature, prodigally generous to their inhabitants, places every gift at their disposal.

It is requisite, in order to colonise Corsica, that the population now fixed in the mountains should be attracted to the shore ; that those towns which are called by their position to exercise a decided influence over the great divisions of Corsica should be developed ; that a new town, destined to become the pivot of Corsican interests, should be founded in the heart of the country ; and that a railway should be opened between the eastern and western sides to unite all the towns, and facilitate their relations with the neighbouring continent.— *Grandchamps*, pp. 4, 6, 16, 33, 49, &c.

[Referring to the influence which the isolation necessarily produced by the physical formation of the country must needs have upon the character of its inhabitants, M. Grandchamps points out the difficulty of fixing on a central site from which to govern the island, and insists on the necessity of founding a town in the heart of the country, to be equally accessible from the shore and from its interior. This spot, from which the work of renovation and colonisation should be commenced, he maintains must be that nearest to Marseilles and Toulon, and at the same time the one by which communication with the centre and eastern side of Corsica can most easily be attained. Île Rousse, he asserts, unites these two conditions, as it is at once the port nearest to France, and to the lowest pass over the mountains which divide Corsica into two parts. He therefore suggests that a railway be formed from Île Rousse to Bastia and Porto Vecchio, by the valley of the Ostriconi, the Col di Pietralba, the valley of the Golo, and the eastern plain, by which, in eight hours at most, the centres of population most remote from Île Rousse would be reached. For details as to the choice of Île Rousse as a starting-point for a railway, the selection of Ponte alla Leccia as a central site for a new town, and the establishment of French colonies at the mouths of the rivers Ostriconi, Sagona, &c., and at Solenzara, Aleria, and other places, see various parts of M. Grandchamps' work.]

A colony of Phocæans from Asia Minor are the first inhabitants of Corsica whom history mentions ; these, or the Carthaginians who succeeded them, founded Alalia, or Aleria. Carthage conquered by Rome, Corsica became Roman, and new cities were built by Marius at Mariana, and by Sylla at Aleria.

On the division of the Roman power, Corsica was attached to the eastern empire, and so continued till A.D. 460, when the Vandals conquered it under Genseric ; after their expulsion by Belisarius and Narses, it continued a dependency of the Greek empire, as part of the Exarchate of Ravenna, until 750, when it was taken by the Saracens. These were finally defeated early in the ninth century under Charlemagne, and Corsica was granted to Boniface, Count of Tuscany, whose descendants for some time governed the island.

About the year 1000 a succession of feudal lords became the rulers of Corsica ; but in 1077 these were opposed by the people, who rose against them, and gave themselves to the Popes, who, in 1081 (Urban II.), transferred the sovereignty of the island to the Bishop of Pisa. The Republic of Genoa protested against this act, and in 1133 Innocent II. divided the Corsican bishoprics equally between Pisa and Genoa, an arrangement which by no means pacified the island, and the two Republics continued to make it their field of battle until, in 1347, the contest was ended by the capture of Giudice della Rocca and the defeat of the Pisans, when Corsica fell under the yoke of the Genoese, who thenceforth held it for 400 years.

The government of the Pisans in Corsica was mild and just ; that of the Genoese is, on the contrary, accused of having been always the opposite, nor do they appear ever to have been regarded by the Corsicans with any feelings but those of hatred.

Early in the fifteenth century, Alfonso of Arragon claimed the island as having been granted to Spain by Pope Boniface VIII., but the Spaniards were defeated in 1541, and the French, who had intervened, evacuated the island in 1559, leaving Genoa its sole mistress.

The oppression and cruelty of the Genoese was such that the islanders revolted from them in 1564, under Sampiero of Bastelica, and after this rebellion was put down, the Republic governed Corsica with unchanged severity until 1729, when, under Ceccaldi and Giafferi, an insurrection broke out, which led ultimately to the defeat of the Genoese and their final withdrawal from the island.

Genoa then solicited aid from the Emperor Charles VI., and the troops he sent were defeated by the islanders ; and in 1732 a peace was signed between the two parties, of no long duration, since war again broke out in 1736, when the Corsicans chose themselves a king in Theodore, Baron von Neuhoff. In 1737 the Genoese were again obliged to call for assistance, this time from the French, and the war, on the part of the Corsicans against them and the Republic of Genoa combined, continued until 1741, when the island submitted once more to the Genoese, and the French quitted it.

Soon, however, under Gaffori and Matra, and later under the great Pasquale Paoli, the Corsicans once more rose against their oppressors, and succeeded in nearly wresting the island from their hands, except some of the fortresses, which at that time Genoa made over to the French.

Paoli, meanwhile, who ruled the interior of the island from 1755 to 1769, continued to make war on the Genoese, and by degrees dispossessed them of their hold in all parts of the island, when the Republic at length, finding itself everywhere completely beaten, entered into a secret treaty with M. Choiseul, minister of Louis XV., by which all Genoese rights over Corsica were formally transferred to the French nation.

This was in 1768, and thenceforward the French fought with Paoli and the Corsicans on their own account alone. Ultimately, after several reverses, they completed the final subversion of Corsican liberty at the battle of Ponte Nuovo, May 9, 1769.

From that time the French supremacy has been acknowledged in Corsica, with the exception of the short period, 1794—1796, when, after some troubles, during the period of the French Revolution, George III. of England was proclaimed King of Corsica, a sovereignty which lasted for two years only.

Since 1796 the dominion of the French has not been disturbed ; and from that date the peaceful progress of the island and its population, once so divided and harassed, has been ensured and gradually developed.—*Benson, Fries, Gregorovius, Grandchamps, &c., &c.*

The Abbé Galletti, speaking of the allegorical figure of Corsica represented, by order of Sixtus V., in the Vatican (above the battle of Constantine and Maxentius), speaks of that Pope as Corsican by origin, and of his forming a regiment of Corsican guards, &c.

And it was by the care of this Pontiff that a number of Corsican families, oppressed by the Genoese, combined to form a colony, and established themselves in a spot which is stil

called Vallecorsa. This place, in the Rio di Vallefratta, near Anagni and Frosinone, is now a little town of 3,500 inhabitants.—*Galletti*, p. 8.

Born at Rostino, on April 25, 1725, Pasquale Paoli was second son of Giacinto Paoli, one of the leaders of the Corsican people in their last great struggle against the tyranny of the Genoese. Compelled by the course of events to retire to Naples in 1739, Giacinto Paoli was accompanied by his son Pasquale, who, inheriting his father's talents and patriotism, there received a finished education, both civil and military. Being much about the court, the young Corsican acquired, with high accomplishments, those polished manners for which he was afterwards distinguished, &c. Recalled to Corsica in 1755 to take the supreme command of affairs, in consequence of the divisions prevailing among the patriot leaders, the expulsion of the Genoese became his first duty ; and he soon succeeded in freeing the interior of the island, and confining their occupation to the narrow limits of the fortified towns on the coast. His next step was to remodel, or rather to create, the civil government ; and in so doing he introduced an admirable form of a representative constitution, founded, as far as possible, on old Corsican institutions. It was, in fact, a Republic, of which Pasquale Paoli was the chief magistrate and commander of the forces. One of the earliest acts of his administration was a severe law for the suppression of the bloody practice of Vendetta, followed in course of time by measures for the encouragement of agriculture, and by the foundation of a university at Corte. With a small squadron of ships, which he got together and equipped, he succeeded, after repulsing the Genoese fleet, in wresting the island of Capraja from the Republic. Intestine divisions having always been the bane of Corsican independence, the party of Matra opposed to Paoli rose in insurrection, and calling in the Genoese to their aid, it was only after a long and bloody struggle that Paoli and the nationals became firmly settled in power, and grew in strength, until the Genoese found themselves unable to cope with a brave and united people. After some further ineffectual attempts, they applied once more to France for succour, and that power, by the treaty of Compiègne, 1764, limited the occupation of the strong forts of the island to a term of four years. In this position they preserved a strict neutrality, the patriots having entire possession of the country, excepting the fortified places, and thus, under the firm and active administration of its wise chief, the commonwealth flourished, and the Genoese power in Corsica shrunk to nothing. It was at this time that Boswell visited the island, &c. The time for the evacuation of Corsica by the French having arrived, they had withdrawn from Ajaccio and Calvi, when the Genoese, finding themselves incapable of retaining possession of the island, offered to cede their rights to the King of France. In 1768, the Duc de Choiseul resolved on annexing Corsica to France, and crossed the neutral lines on the eastern side of the island.

Pasquale Paoli and his brother Clement led the people *en masse* against the threatened tyranny, and the French troops were signally defeated at Borgo. But Chauvelin being recalled, Comte de Vaux became general, and ultimately 40,000 Frenchmen decided the fate of Corsica at Ponte Nuovo in 1769. Pasquale Paoli and Clement Paoli, with 300 followers, embarked at Porto Vecchio for England.

Pasquale Paoli was, and ever will be, the popular hero of the Corsicans. He fought their last battles for the national independence ; moulded their wild aspirations for liberty and self-government into a constitutional form ; administered affairs unselfishly, purely, justly ; encouraged industry, and checked outrage. He was a man of the people, one of themselves, and he never forgot it, nor have they.—*Forester*, pp. 165, 169.

In his last letter to his friend Padovani, Paoli says, when reviewing his life with humility, "I have lived long enough, and could it be granted to me to begin my life again, I would decline the boon, unless accompanied by the rational cognition of my past life, to correct the errors and follies that have attended it." One of the Corsican exiles announced his death in

these terms, in a letter to his native country :—" London, June 2, 1807. It is true, alas, that the public papers are guilty of no error about the death of the poor General. He lay down on Monday, February 2, at half-past eight o'clock in the evening, and at half-past eleven o'clock on the night of the following Thursday he died in my arms. He bequeaths to the school at Corte, or to the university, an annual salary of £50 sterling for each of four professors ; and a new mastership to the school of Rostino, which is to be established at Morosaglia. He was buried on the 13th of February, at St. Pancras, where almost all Catholics are interred. His funeral must have cost nearly £500. About the middle of April last, Dr. Barnabi and I went to Westminster Abbey to find a place where we can erect a monument to him, containing his bust."—*Gregorovius*, p. 236.

During Paoli's administration, there have been few laws made in Corsica. He mentioned one which he has found very efficacious in curbing the vindictive spirit of the Corsicans. There was among them a most dreadful species of revenge, called " Vendetta trasversa," collateral revenge, which Petrus Cyrnæus candidly acknowledges. It was this :— If a man had received an injury, and could not find a proper opportunity to be revenged on his enemy personally, he revenged himself on one of his enemy's relations. So barbarous a practice was the source of innumerable assassinations. Paoli, knowing that the point of honour was everything to the Corsicans, opposed it to the progress of the blackest of crimes, fortified by long habits. He made a law, by which it was provided that this collateral revenge should not only be punished with death, as ordinary murther, but the memory of the offender should be disgraced for ever by a pillar of infamy. He also had it enacted that the same statute should extend to the violations of an oath of reconciliation, once made. *Boswell*, p. 338.

Mothers of families, whose husbands have been assassinated, preserve the dress of the deceased until their children grow up to manhood, and then show them the clothes tinged with the blood of their fathers, and exhort them to vengeance ; and in dispute with others the latter taunt them if they have not revenged themselves. Thus these unhappy children have no alternative than to live dishonoured, or to destroy the murderers of their parents, and they rush headlong into crime.--*Benson*.

[Many interesting particulars relating to criminal trials in Corsica are related by Benson ; but none more extraordinary than that of Signor Viterbi, who, himself a judge, was condemned to death in 1821 on an accusation of occasioning the assassination of some of the Frediani family, between which and his own an implacable animosity existed. Continually professing his innocence, and resolved not to suffer the disgrace of a public execution, Viterbi starved himself to death, and during the eighteen days which intervened between his first abstinence from food and his death, actually registered every change in his physical system with the utmost exactness, till, unable to write, he dictated minutely every sign of his approach to death, until his decease occurred. " I am about to conclude my days with the peaceful death of the just," were among his last words. " The few moments which I have to live are passing away placidly. . . . The lamp is nearly extinguished." This was signed by his own hand, but he lingered two days longer, till the 20th December, 1821. His wishes regarding his burial are set forth minutely in a letter addressed to his wife a few days before he died ; in this singular document (see *Valery*, vol. i., Appendix, note to p. 19), Viterbi strictly charges his family to swear " eternal hatred to his persecutors " over his grave, while kneeling].

The Vendetta is a barbarous justice ; and the Corsican sense of justice is acknowledged and praised even by ancient authors. Wo, then, to him who has slain a Corsican's brother or kinsman ! The deed is done, the murderer flies, in double fear, of justice which will punish murder, and of the deceased's kindred, who will avenge it. For no sooner has the

deed become known than the fallen man's relations seize their arms and hasten to find the murderer. He has escaped to the bush, to the eternal snows, and is living with the wild sheep ; his track his lost. But the murderer has relatives—brothers, cousins, a father ; these know that they must answer for the deed with their blood. So they arm, and are on their guard. The life of those who suffer the Vendetta is extremely miserable. Whoever has cause to fear the Vendetta, shuts himself up in the house, and barricades the doors and windows, in which he leaves only loopholes open. The windows are stopped up with straw and mattresses, a proceeding which is called "inceppar le fenestre." A Corsican house in the mountains, naturally high and narrow, almost like a tower, and with a very high flight of stone steps, is easily converted into a fortress. In this castle the Corsican always keeps on his guard, lest a ball through the windows should hit him. His kinsmen till the ground in arms ; they set a watch, and are not sure of a single step in the fields. Cases were told me in which Corsicans had not left their fortified dwellings for ten or fifteen years, and had passed that large portion of their life under siege and in constant fear of death. For Corsican revenge never sleeps, and the Corsican never forgets. To take no revenge is deemed dishonourable by the genuine Corsican ; the feeling of revenge is with them a natural senti- ment, a consecrated passion. It has in their songs become a worship, which is celebrated as a religion of natural affection.—*Gregorovius*, p. 136.

If any one delay to avenge himself his relations make insinuations, and others slander him for not having avenged himself. The reproach of having borne an insult without revenging it, they call "rimbeccare." The "rimbecco" was punished by old Genoese statutes as an incentive to murder. It is the women especially who instigate the men to revenge, by songs of vengeance over the body of the slain, and by displaying his blood-stained shirt. The mother often fixes a bloody shred from the dress of the murdered man upon that of the son, as a constant reminder that he has to avenge himself.—*Gregorovius*, p. 138.

The Corsican *bandit* was not a thief or "brigand," but, as his name implied, one banned or banished by the law. In the ancient statutes of the island all those are originally called banditti who are banished from the island because justice has failed to get them into her grasp. The bandit often led a life of many years in the wild fastnesses of the mountains over the Niolo and other pathless regions, and innumerable stories are told of their exploits. Many of these, as well of the vendetta, have been worked up into tales ; among them none more charming than that of "Colomba," by M. Prosper Merimée. Others are Teodoro Poli, Gallocchio, Bracciomozzo ; renowned also are Giammarchi, who kept his ground in the bush for sixteen years ; Camillo Ornano, who maintained himself in the mountains for fourteen years ; and Joseph Antommarchi, who was bandit for seventeen years. The tales of the bandit life of Serafino, Arrighi, and Masoni, illustrate terribly and picturesquely the state of things so recently existing in Corsica. One can scarcely believe what the historian Filippini relates, that in his day, in thirty years 28,000 Corsicans were murdered in revenge ! According to the address of the Préfet of Corsica, before the assembled departmental general council, held in August, 1852, 4,300 murders had been perpetrated in Corsica since 1821, and this in an island of 250,000 inhabitants.—*Gregorovius*, p. 195.

"In their own country they are disunited ; but out of it most closely bound together, and their souls are prepared to meet death. They all pertinaciously hold commerce in contempt. They are eager to avenge an insult ; and it is esteemed disgraceful not to take revenge. When they cannot reach him who has committed a murder, they chastise one of his relations. Therefore, so soon as a murder has been perpetrated, all relatives of the murderer imme- diately take up arms and defend themselves." (Petrus Cyrnæus, Archdeacon of Aleria, writing in the fifteenth century. Edition of Peter of Corsica, Paris, 1834.)—Quoted by *Gregorovius*, p. 195.

Here every one (says Gregorovius, writing in 1853) carries double-barrelled guns, and I found half the villages under arms, like barbarians advancing against one another (a

state of things not different from that described by Valery in 1834 (*see* page 45). There is probably no other means of certainly putting down the blood-revenge, murder, and bandit life, than culture and colonisation, laying down roads through the interior, increase of commerce, and productiveness, these, with a general disarming of the country, would put a new life into Corsica, an island possessing the finest climate, fruitful districts, a position commanding the entire Mediterranean between Spain, France, Italy, and Africa, and splendid gulfs and roadsteads, which, moreover, is rich in forests, minerals, medicinal springs, and fruits, and is inhabited by a brave, bold people, capable of great things.— *Gregorovius*, p. 150.

" Besides their ignorance," says Filippini, " one cannot find words to express how great is the idleness of the islanders in tilling the ground. Even the finest plain in the world, of Aleria and Mariana, is desert, and they do not even chase the wild birds. But if they chance to become masters of a single Carlino, they imagine they shall never be in want again, and so they sink down into idleness and doing nothing," which (adds Gregorovius) strikingly describes the nature of the Corsican of the present day. "Why do they not graft the countless wild oleasters ?—why not the chesnut ? But they do nothing, and therefore are they all poor. . . Their hostilities and their hate, their want of good faith and love, are almost eternal ; hence that proverb becomes true which people are wont to say, ' the Corsican never forgives.'"

Filippini's book became nearly extinct, being suppressed as far as possible by the Genoese, of whom he had said in it many bitter truths ; but it must be allowed "bitter truths " were not wanting relating to his own countrymen. On the other hand, he gives them the praise for hospitality. "I can truly say that there is no nation in the world by which foreigners are more cherished, nor where they can travel more securely ; for in every part of Corsica they find the choicest hospitality, without having to disburse a single quattrino for their sustenance."—*Gregorovius*, p. 194.

Would that robbery and pillage, which are so ostentatiously spoken of as never committed by the Corsican, were the darkest sins laid to his account ! Most commonly, the hands of the Corsican bandit have been stained with innocent blood, shed recklessly, relentlessly, in private quarrels, often of the most frivolous description, and not in open fight, as in the feuds of the middle ages ; not in the heat of sudden passion, but by cool premeditated murder.

So low, however, is the moral sense in Corsica with regard to the sanctity of human life, that these atrocities excite no horror, and the sympathies of vast numbers of the population are with the bandits. They are the heroes of the popular tales and canzoni ; one hears of them from one end of the island to the other, round the watch-fires of the shepherds on the mountains, in the remote paese, by the road-side. They are the tales of the nursery ; the Corsican child learns, with his Ave Maria, that it is rightful and glorious to take the life of any one who injures or offends him. To a passionate and imaginative people these tales of daring courage and wild adventure have an inconceivable charm ; though stained with blood, they are full of poetry and romance. Such stories have been eagerly seized upon by writers on Corsica ; they make excellent literary capital. Unfortunately, " *banditisme* " forms so striking a feature in Corsican history, that it must necessarily occupy a conspicuous place in a faithful review of the genius and manners of the people. There are, doubtless, traits of heroism worthy of a better cause, and sometimes of a redeeming humanity, in the lives of the banditti ; but one regrets to find—though happily not in the works of the English travellers who have given accounts of Corsica—a tendency to palliate so atrocious a system as blood-revenge. *Vendetta*, the name given it, has a romantic sound ; and it is treated as a sort of national institution, originating in high and laudable feelings, the injured sense of right, and the love of family ; so that with the glory shed around it by a false heroism it is almost raised to the rank of a virtue.

To take blood for blood, not by the hand of public justice, but by the kinsman of the slain, was, we are reminded, a primitive custom, sanctioned by the usages of many nations, and even by the laws of Moses. We know, however, that among our Anglo-Saxon ancestors the laws humanely commuted this right of revenge for fines commensurate with the rank of the murdered person. And, while the Mosaic law forbade the acceptance of any pecuniary compensation for the crime of manslaughter, and expressly recognised the right of "the avenger of blood" to exact summary vengeance, it provided for even the murderer's security until he was brought to a fair trial. But Corsica, alas, has no "Cities of Refuge," and examples, drawn from remote and barbarous times, can afford no apology for the inveterate cruelties of a people enjoying the light of modern civilisation, and professing the religion of the New Testament.

The *Vendetta* is also represented as a kind of rude justice, to which the people were driven in the long ages of misrule, during which law was in abeyance or corruptly administered. There is, no doubt, much truth in this as applied to those times ; but the prodigious amount of human slaughter shown in the statistics just quoted, as well as the continuance of this atrocious system to the present day, long after the slight shadow of any pretence of legal injustice has vanished, seem to argue that the ferocity which has shed such rivers of blood, if not instinctive in the national character, at least found a soil in which it took deep root.—*Forester*, pp. 79—89.

The insurmountable difficulty met with by those who govern in Corsica has arisen from the character of the people—their exaggeration of all things, their fanaticism in devotion, in their implacable revenge, and in their modes of thought. The most futile motives suffice to light up secular enmity. To the most susceptible self-love is joined the constancy of friendship and most exclusive family affection. To the aid of their passions and enterprises they bring a tenacious will, a remarkable quickness of intelligence, and the endless resources of a dexterity of design never at fault. The richest inhabitants of each locality are at the head of rival and inimical parties ; all seek public places, which offer them the double advantage of protecting friends or relations and humiliating enemies—intrigues without end. There were numerous edicts of Genoese governors and French kings, but always ineffectual, more or less ; edicts against carrying arms, and against banditism in 1560; and against collateral revenge in the years 1548, 1560, 1569, 1573, 1768, 1769, 1770, 1778, and 1811, laws—all of the severest nature—were made against carrying arms and against banditism. It results from these documents that successive administrations in Corsica have many times endeavoured to disarm the people, and to put an end to the murders which have filled this unhappy country with blood ; yet, spite of the rigour of the edicts, the same crimes are reproduced for three centuries with more or less intensity, according to the degree of power and energy of the governments. The number of murders for between 1821 and 1850 was 4,319.

The Duc d'Orleans, after a tour in Corsica, thus expressed himself on the character and faults of the Corsicans, in a letter addressed to M. Dupin, Nov. 18, 1835 :—"In Corsica my task has been an easy one. The remedy for the social misfortune which torments this country is apparent at the first glance. Perseverance and firmness will result in overcoming those qualities, which are the only obstacle to all amelioration. Let the Corsican be no longer armed ; let the lower grade of functionaries be chosen from Continentals ; cease to encourage civil war and contempt of the laws ; let the lazy, sluggish, but not idle population learn wants, which will force it to work more than it does at present, when chestnuts picked up in the woods are all that is necessary to existence, and the shade of trees for shelter. Let all this be accomplished by degrees, and the condition of Corsica will be changed."—*Grandchamps*, p. 52.

[Some of the best pages of information on the hateful condition of Vendetta and Banditism are to be found in *Grandchamps*, at pp. 60 to 80.]

A population which has for many centuries, indeed, until quite recently, lived in a state of

constant warfare against foreign tyranny and oppression cannot all at once calm down to the social condition of countries that have for centuries ceased to fight for their existence. Thus is explained the exceptional social condition that, until very recently, reigned in Corsica.

Many Corsicans, in those days, spent years of their life barricaded in their houses, which they durst not leave for fear of their pursuers. Myself made the acquaintance, at Isola Rossa, of a gentleman, one of the leading proprietors of the island, who, a long while ago, actually lived for two years in the upper flat of a house in that town to avoid the "Vendetta," &c.

A few years ago (1854) very extreme measures were adopted. . Two laws were passed by the French Chambers. By the one the entire population was disarmed. . . . By the other law, all persons harbouring or concealing outlaws are liable to imprisonment.— *Bennet*, pp. 232, 240, 242.

The character of the Corsican dirges is to be understood from the nation's rites with regard to the dead, which are very ancient . . There is something dark and striking in the fact, that the most favourite poetry of the Corsicans is the poetry of death, and that they compose and sing almost exclusively in the intoxication of grief.

When death has entered a house, the relations stand round the bed of the deceased, and raise a cry of lamentation. The body is now laid on a table, called the *tola*, against the wall ; they watch and lament beside the tola often the whole night through. But the grand lamentation begins on the early morning before the funeral, when the body is laid on the coffin, and before the funeral friars come to lift the bier. To the funeral come friends and relatives from all the neighbouring villages, and the assembled throng is called the *corteo*, or the scirrata ; *andare alla scirrata* they say in Corsica, where the women go in procession to the house of mourning ; if the deceased has been slain, they say *andare alla gridata*, to go to the howling. As soon as the chorus enters the house the lamenters greet the mourners, &c., &c. ; they make a circle, the *cerchio* or *caracollo* round the *tola*, and perform their evolutions around the deceased, howling the while, expanding the circle, or closing it again, and always with a cry of lamentation and the wildest tokens of grief. . . .

. Among the mountains far in the interior these ceremonies exist in the old heathen force, resembling the funeral dances of Sardinia. The dancing, lamenting, and singing, are performed by women only, who, with hair dishevelled and shed wildly over their breasts, with eyes that dart fire, with black mantles flying, execute evolutions, utter a howl of lamentation, strike the flat of their hands together, beat their breasts, weep, sob, cast themselves down by the *tola*, &c., &c. . . . Suddenly one woman springs up from the circle and strikes up a song or vocero to the deceased, like an inspired seer. She delivers the song in recitative, strophe by strophe, and every strophe ends with a wo ! wo ! wo ! &c., &c. . . . It is not always the usual chorus-singers that sing, but frequently the relatives of the dead, the mother, wife, and especially the sisters . . . moreover the form of the dirges is constant, so that when affliction comes, the Corsican woman must have already had frequent practice in the dirges, which go from mouth to mouth, as other songs with us. Thus, an atmosphere of gloom hangs constantly over men's heads here. When Corsican girls sit together, they are sure to strike up a lament, as if they wished to rehearse for the heart-lament which, perhaps, each of them may have to sing at the *tola* of a brother, a husband, or a child. The *voceri* themselves may be divided into two classes—the gentler complaint on the death of a person deceased, or the wild, fearful song of revenge. · ·

I know no example in the whole course of popular poetry, in which the horrible and fearful has, to such a degree, become the subject matter of the popular song ; and here is displayed the wonderful power of poetry in general, which is able to mitigate even the most terrible with an air of melancholy beauty. The Corsican nature is also in the highest degree capable of the tenderest sentiments ; the ineffable guilelessness and touching native simplicity of many *voceri* remove us quite from our world to the world of children, shepherds, and patriarchs.— *Gregorovius*, pp. 279, 288.

I have selected one out of the many affecting *voceri* published in Gregorovius, to give an idea of the dialect in which most are written.

Some of these *voceri* are extremely sad and touching, especially—

> Of Nunziola, on the death of her husband.
> Of a girl, on the death of her two brothers, both slain in one day.
> Of a herdswoman of Talavo, on the death of her husband.
> Of a sister, on the death of her brother, the Bandit Canino.
> On the death of Romana, daughter of Daviola Danesi, of Luani ; &c.

OF A MAIDEN OVER THE BODY OF HER MURDERED FATHER.

(The girl comes with a torch.)

Eo partu dalle Calanche
Circa quattr'ore di notte ;
Mi ne falgu cu la teda
A circà per tutte l'orte,
Per travellu la mio vabu
Ma' li avianu datu morte.

From Calanche I am come ;
Midnight had just come and fled,
When by torchlight in the gardens
I did seek with anxious tread
Where my father was delaying—
In his blood I found him dead.

(Another girl enters, seeking a kinsman also slain.)

Cullatevene più in sù,
Chi truvarete a Matteju ;
Perchè questu è lu mio vabu
E l'aghiu da pienghie eju.

Further up-hill thou must climb,
For there lies Mattéo slain ;
But this is my father here,
Mine 'tis for him to complain.

Via, pigliatemi a scuzzale,
La cazzola e lu martellu,
Non ci vulete andà, vabu ?
A travaglia a San Marcellu ?
Tombu en'hanu lu mio vabu,
E feritu u mio fratellu.

Take his apron and his hammer,
And his trowel homeward bear ;
Wilt thou not to San Marcello,
Father, to thy work repair ?
They have my own father slain,
Wounded, too, my brother dear.

Or cereatemi e trisore,
E qui prestu ne venite ;
Vogliu tondemi i capelli
Per lupalli le ferite ;
Chi di lu sangue di mio vabu
N'achiu carcu le miò dite.

Go and seek a pair of scissors,
Bring it me, and be not slow ;
I would cut a lock of hair,
And with it stanch the blood's fast flow ;
For my fingers are defiled,
With the blood a reddened row.

Di lu vostro sangue, o vabu,
Bogliu tinghiemi un mandile ;
Lu mi vogliu mette a collu
Quandù avrachiu oziu di ride.

A mandile will I dye,
Redden it in my father's gore,
Which I'll wear when I have leisure
Mirth and laughter out to pour.

Eo collu per le Calanche
Falgu per la Santa Croce,
Sempre chiamanduvi, vabu ;
Rispunditemi una voce !
Mi l'hanu crucifissata
Cume Ghesù Cristu in croce.

To Calanche I will bring thee,
To the Church of Holy Cross,
Ever calling thee my father !
Answer with thy loved voice !
They have crucified my father
Like the Christ upon the cross .

Some information on the very curious habits of the larva or caterpillar of the *Bombyx processionis* is to be found in Kirby and Spence's " Entomology," vol. ii., pp. 18, 23. The two following letters relating to the same insects appeared in the Magazine entitled *Land and Water* :—

Sir,—The pine procession caterpillar (*Bombyx processionis*), is almost as much to be dreaded as the scorpion of the South. It lives in large colonies under a common web

in the early stage. When they are full fed, however, they sally forth in procession, one following the other in military order, and woe betide the unlucky man who breaks their ranks. Mr. Jeston, British chaplain at Kissengen, told me that he was once attacked by a colony of these insects, from incautiously touching one of their number. He immediately felt a severe pain in his arm, and was dangerously ill for some days, and after the lapse of eight years continued to feel occasional inflammation and pain in the part over which the insects had crawled. It is not likely that they had a malicious intent, but that their sharp hairs being broken off by friction, entered the skin and occasioned this violent irritation. This is in accordance with the common theory, but some spirits of wine in which a number of these caterpillars had been preserved having a most irritating effect on the skin, I think it must have some poisonous secretion. —*Land and Water*, Feb. 8, 1868.

SIR,—I send for exhibition in the office a dozen specimens of the caterpillar of *Bombyx processionis*, preserved in spirits. The interesting account of the insect by Mr. Groom-Napier seems to me to be perfectly accurate, except that I think he has been led by his reverend informant a little to over-estimate the dangerous qualities of the insect. I have known of two authentic instances of actual injury. In one case a caterpillar falling from a tree upon the neck of a lady, caused considerable irritation for the moment, and afterwards raised blisters. Red marks, with a sensation of heat in the part touched, lasted for several days. In the other case, an English gentleman not long resident in this country, a zealous, but not a very well-informed entomologist, took up a handful of the caterpillars for inspection, and felt the effects for a week afterwards in a burning sensation in the skin of his hands. The greatest harm they do is to the very extensive pine forests in this part of Portugal. It is not too much to say that every hundredth tree—in some places a much greater proportion—contains on its topmost shoot the web, accurately described by Mr. Groom-Napier, in which the caterpillar protects itself while in the pupa state from birds, or perhaps from wind, rain, and scorching sun-heat. The trees selected are generally young ones, and much stunting of growth and curvature of trunk arise from the eating out of the crown of the tree by the hungry broods of caterpillars. I have not been long enough in this country to give much information upon the habits of the insect. I have never seen it either in the developed or in the nympha state, but I have no doubt that the great bunches of pine leaves which I very frequently observe high up in the trees, and which, when I examined some last autumn, contained remnants of the dried skins of the caterpillars, are the untenanted, gregariously formed cocoons of the *Bombyx processionis*. Mr. Groom-Napier is quite correct in supposing that this poisonous insect has no " malicious intent." It stings when it is handled ; not unless. It is even, I think, more torpid than most other caterpillars. The processions are very curious, and as I do not remember to have seen them described, it may interest your readers to hear something about them. A day or two ago, while shooting in the pine woods, I came upon a procession of thirty-five of these caterpillars, slowly moving in a sinuous or snake-like course, and in strict Indian file, the head of each close to the tail of his preceder, so close, indeed, as to make me think they were in actual contact till I touched one to see. I then moved one caterpillar gently out of his place in the line, and watched the result. The whole procession stood still, and while I waited—about five minutes—the straggler had not taken his vacated place in the line, nor had the procession resumed its march. This telegraphing both to the van and to the rear of some disturbance in the line of march, strikes me as very singular. An accident or disturbance of this sort would seem to disorganise the whole band. I once found a procession of about thirty caterpillars in a lane, the first three or four of which had been trodden upon and killed, and though this must have happened some hours before, for their bodies were dried up by the sun, the others had not stirred from the spot, the line being still perfectly preserved. I am quite disposed to agree with your correspondent that the irritating effect on the skin does not arise merely from the wounds caused by the numerous needle-like hairs of the caterpillars, but that it resides in some poisonous excretion which these hairs convey with them into the wounds they make. Did the irritation only result from the pene-

tration of the hairs, we should expect it to be no greater than what is caused by handling some species of aloe, or by touching the hairy skin of a prickly pear. ˙ In either case the irritation is a mere trifle compared to the inflammation set up by the contact of *Bombyx processionis.* So convinced am I of the presence, on or in the caterpillar itself, of some acrid principle, capable of raising blisters on the skin, that it has more than once occurred to me, looking to the great abundance of the insects in this country, whether it might not be possible to substitute the dried and powdered bodies of this caterpillar for the commonly used *Cantharis vesicatoria,* whose tendency to produce strangury and other derangements is so great an objection to its employment in medicine. I should be glad to send the insects to any one desirous of experimenting, but I would rather not be the "*corpus vile*" on whom to make those experiments. I have noticed these insects, or an allied species, in Italy, and I think in Greece and Turkey; but I believe. subject to correction from better entomologists than myself, that *Bombyx processionis* is not a native of Great Britain. I cannot find the insect described in Messrs. Westwood and Humphrey's great work, and I hope this destructive species may never find its way to our country.—EXSUL (Oporto), *Land and Water,* March 7, 1868.

———LIST OF

SOME OF THE PRINCIPAL PUBLICATIONS

RELATING TO CORSICA.

——◆——

1. PETER OF CORSICA—Petri Cyrnæi de Rebus Corsicis, libri quatuor. Coming down to A.D. 1492.
Published, from the MSS. in the Library of Louis XV., by Muratori in 1738, and in Paris, 1834.

2. FILIPPINI.

"Filippini's is the chief work on Corsican history. . . . The first worker at it was
Giovanni della Grossa, a lieutenant and secretary of Vincentello d'Istria. He collected the
old legends and traditions of the island, and brought its history down to the year 1464. His
pupil, Monteggiani, continued it to the year 1525 ; Ceccaldi brought it down to the year
1559 ; and Filippini to 1594, in which year it was first published at Tournon. Of the
thirteen books of the whole, he thus wrote only the last four ; but, as he revised the whole
work, it now bears his name. M. Pozzo di Borgo earned great thanks from his country by
setting on foot a new edition of Filippini, conducted by the learned Corsican, Gregori, &c.
It appeared at Pisa in 1827 (five vols)."—*Gregorovius*, p. 193 ; *Valery*, i., p. 24.

3. AN ACCOUNT OF CORSICA. By James Boswell. 1768.

"Boswell was the first Englishman who penetrated into Corsica, and his account of it is
valuable for its research, its description, and its history of the times. The details contained in
it concerning Paoli are only equalled by his Johnsoniana for the minute and vivid portraiture
of his hero's life, opinions, character, and habits."—*Forester*, p. 168.

4. SKETCHES OF CORSICA ; OR, A JOURNAL WRITTEN DURING A VISIT TO THAT ISLAND IN
1823. By Robert Benson. London. 1825.

The experience of Mr. Benson, who visited Corsica on business connected with the will of
General Paoli, was confined to Ajaccio and Bastia, and to the road between those places,
but his book will be found full of interesting information concerning the state of the island at
the period of his visit, and abounding with accurate description of the scenery, and of the
manners and habits of the Corsicans.

5. VOYAGES EN CORSE, À L'ÎLE D'ELBE, ET EN SARDAIGNE. Par M. Valery, Bibliothécaire du
Roi, &c. Paris. 1837.

A work replete with valuable details, and by no means open to the censure of the author
of Murray's "Handbook for Corsica," who says the author of the "Voyages" did not
"venture far off the high roads." M. Valery, on the contrary, during a stay of five months
in the island, visited nearly every spot in it, not excepting the summit of Monte Rotondo ; and
his cheery enjoyment of travelling gives a great charm to his book, none the less interesting
from his having become nearly blind during the latter part of his stay. I should be ungrateful
not to acknowledge the value of his book to me, for it was the only one I had in Corsica.

6. HISTOIRE DE LA CORSE. Par M. Camille Friess. Bastia. 1852.

7. ABRÉGÉ DE LA GÉOGRAPHIE DE L'ÎLE DE CORSE. Par F. C. Marmocchi. Bastia. 1852.

8. CORSICA IN ITS PICTURESQUE, SOCIAL, AND HISTORICAL ASPECTS : the Record of a Tour in the Summer of 1852. By Ferdinand Gregorovius. Translated from the German by Russell Martineau, M.A. London. 1855. Longman and Co.

This volume is full of delightful reading from end to end, abounding with true and beautiful description, as well as with information as to the history of Corsica, the habits of the people, its landscapes, poetry, and picturesque legends. The author's description of his wanderings on the northern shore of the island, especially in the vicinity of Île Rousse, his particulars of the life of King Theodore, his account of Bonifacio and its caverns are all interesting. Dr. Bennet does well in recommending those who go to Corsica to read Gregorovius, and all should provide themselves with so pleasant a companion.

9. LA CORSE, SA COLONISATION ET SON RÔLE DANS LA MÉDITERRANÉE. Par Conte Grandchamps, Ingenieur des Ponts et Chaussées. Paris. 1859. Hachette et Co.

A valuable scientific work, particularly in its numerous details concerning the present condition of the island, its means of communication, &c.

10. RAMBLES IN THE ISLANDS OF CORSICA AND SARDINIA. By Thomas Forester. Longman and Co. 1861.

11. HISTOIRE ILLUSTRÉE DE LA CORSE. Par l'Abbé Jean-Ange Galletti. Paris. 1863.

A laborious compilation of information, illustrated by numerous small engravings.

12. WINTER IN THE SOUTH OF EUROPE. By J. Henry Bennet, M.D. London. 1865.

It is needless to dilate on the reputation of this excellent book ; that part of it relating to Corsica contains one of the best published accounts of the island, and is particularly simple in all details relating to the healthiness of its climate. Dr. Bennet, who has also written articles concerning Corsica in the *Gardeners' Chronicle* for June 20th, 1868, and in the *Lancet*, August 1st, 1868, may be said to have been the first person who pointed out Corsica as possessing a climate to which persons of delicate health may be sent.

13. NOTES ON THE ISLAND OF CORSICA IN 1868. By Thomasina M. A. E. Campbell. London. 1868. Hatchard.

An unpretending excellent little book, written in a pleasant spirit, and with an accuracy derived from personal examination of everything described.

14. DIE INSEL CORSICA. By Dr. A. Biermann. Hamburgh. 1868.

Contains much valuable information on the mineral springs and baths of the island.

15. THE ALPINE JOURNAL. Longman and Co. Nos. 25 and 26.

Contains an article on Corsica by the Rev. W. H. Hawker well worth reading.

16. A WINTER IN CORSICA. By Two Ladies. Sampson Low, Son, and Co.

17. HANDBOOK FOR CORSICA AND SARDINIA. Murray, Albemarle Street. 1869.

INDEX.

PRINTED BY CASSELL, PETTER, AND GALPIN, BELLE SAUVAGE WORKS, LONDON, E.C.